792.0947090411BOW

RUSSIAN AVANT-GARDE THEATRE: WAR, REVOLUTION & DESIGN

NICK HERN BOOKS

London

www.nickhernbooks.co.uk

A Nick Hern Book

Russian Avant-Garde Theatre: War, Revolution & Design
first published in Great Britain in 2014
by Nick Hern Books Limited,
The Glasshouse, 49a Goldhawk Road, London W12 8QP
in association with Victoria and Albert Museum, London and
the A.A. Bakhrushin State Central Theatre Museum, Moscow

Designed and typeset by Nick Hern Books, London
Printed and bound in Great Britain by
Ashford Colour Press, Gosport, Hampshire

A CIP catalogue record for this book is available from the British Library

ISBN 978 1 84842 453 1

Contents

Acknowledgements

The 'Russian Avant-Garde Theatre: War, Revolution and Design, 1913–1933' exhibition at the Victoria and Albert Museum is a part of the UK-Russia Year of Culture 2014–15 and focuses on the constellation of radical artists who today are identified as the 'Russian avant-garde'. Choosing the objects on display has been a difficult task, especially since the very notion of 'avant-garde' is fluid and varied. It could be argued, for example, that the sumptuous designs of Léon Bakst for the Ballets Russes might have served as a practical starting point for our panorama and the rhetoric of Socialist Realism as a conclusion; that works by additional artists such as Marc Chagall, Nikolai Foregger, Natalia Goncharova, Mikhail Larionov and Sergei Yutkevich should have been included; or that material objects such as costumes, props and memorabilia might have enhanced the visual panorama. These are reasonable observations and they have been taken into account, but other factors including installation, condition of works, accessibility and the overriding need to produce a vivid and propitious survey from the wealth of materials at the Bakhrushin, guided our final selection for the dedicated space at the Victoria and Albert Museum.

The exhibition is supported by the Ministry of Culture of the Russian Federation. Grateful acknowledgement goes to the Minister of Culture Vladimir Medinskii, his Depute Elena Milozarova and Director of the Cultural Heritage Department Mikhail Brizgalov, the Ministry of Foreign Affairs of the Russian Federation and Mikhail Shvydkoy, a Special Envoy for International Cultural Cooperation to President of Russian Federation, the Embassy of the Russian Federation to the UK, Russian Ambassador Alexander Yakovenko and Counsellor Artem Kozhin. Our gratitude goes to the directors and staff of the British Council and especially to director of British Council Russia Paul de Quincey.

We are thankful to the staff of the A.A. Bakhrushin State Central Theatre Museum, Moscow, and the Victoria and Albert Museum, London, and their respective

director's Dmitrii Rodionov and Martin Roth for their support. Extended thanks goes to exhibition co-curators Vitalii Patsiukov, Moscow and John E. Bowlt, California, exhibition designer Sergei Barkhin and his assistant Vasilina Ovchinnikova, Moscow of the Bakhrushin Museum and V&A curatorial staff, particularly, Geoffrey Marsh, Kate Bailey and Tim Travis. Special thanks goes to director Natalia Metelitsa and staff of the State Museum of Theatrical and Musical Art, St. Petersburg and Nikita D. Lobanov-Rostovsky for key loans.

Our special thanks goes to: Irina Gramula, Natalia Katonova, Natlia Mashechkina, Tatiana Denisenko, Elena Shpartko, Yulia Danilina, Evgenii Alpatiev, Lali Badridze, Sergeii Uzanov, Evgenii Kaliaev, Nina Artemieva, Anna Fomina, Farkhad Sasikulov, Ekaterina Eremeeva, Nadezhda Savchenko, Liudmila Shemrakova, Lilia Ibragimiva, Elena Morsakova, Yulia Veselova, Alina Donetskaia, Victor Minkin, Leonid Burmistrov, Anna Landreth Strong, Catriona Macdonald, Yulia Naumova, Alena Korotkikh, Gillian Hopper, Stacey Evans, Helen Gush, Alan Derbyshire, Louise Egan, Richard Mulholland, Nickos Gogolos, Clare Inglis, Olivia Robinson, Claude D'Avoine, Matilda Pye, David Robertson, Lucy Hawes, Joanna Jones, Matthew Clark and Victor Batalha.

UK—RUSSIA
ВЕЛИКОБРИТАНИЯ
РОССИЯ/2014

Note to the Reader

Editor's Foreword

Many individuals and institutions have assisted in the preparation of this publication. For their unfailing enthusiasm and support, my first gratitude goes to the directors and staffs of the Bakhrushin State Central Museum, Moscow; the State Museum of Theatrical and Musical Art, St. Petersburg; and the Victoria and Albert Museum, London. Secondly, I wish to thank the contributors to this volume, especially Irina Duksina and Mariia Lipatova, as well as Nina Lobanov-Rostovsky and Nikita D. Lobanov-Rostovsky, connoisseurs of the Russian theatre, all of whom have offered invaluable help and suggestions. I have also drawn amply upon the expertise and talents of the following individuals: Elena Barkhatova, Alexander Chepalov, Mariia Cherkavskaia, Tatiana Denisenko, Ildar Galeev, Lynn Garafola, Nikita Goleizovsky, Elena Grushvitskaia, Billy Gunn, Susannah Hecht, Natalia Katonova, Ketevan Kintsurashvili, Tatiana Klim, Olena Kashuba-Volvach, Irina Malakhova, Natalia Metelitsa, Myroslava Mudrak, Yuliia Naumova, Vasilina Ovchinnikova, Nadezhda Savchenko, Olga Severtseva and Yuliia Solonovich.

In addition, I would like to express my appreciation to the following institutions for their support: Albert and Elaine Borchard Foundation, Los Angeles; Central House of Cinema, Moscow; Gabrichevsky Family Archive, Moscow; Kasian Goleizovsky Family Archive, Moscow; Oton Engels Archive, Moscow; State Russian Museum, St. Petersburg; State Tretiakov Gallery, Moscow; University of Southern California, Los Angeles; and Russian National Library, St. Petersburg.

Finally, I am grateful to the Antique Collectors Club for permission to use bio-bibliographical information from Volume Two of the catalogue raisonné of the Lobanov-Rostovsky collection of Russian stage designs, i.e. J. Bowlt, N. Lobanov-Rostovsky and N.D. Lobanov-Rostovsky: *Encyclopedia of Russian Stage Design 1880–1930*, Ipswich, UK: Antique Collectors' Club, 2013.

John E. Bowlt

Transliteration of Russian into English

Russian words are transliterated into English according to a modified Library of Congress system, the soft sign being either rendered by an 'i' or omitted altogether. Where the name of a Russian artist has its own long-established spelling, that variant is maintained (e.g., Alexandre Benois, not Aleksandr Benua; El Lissitsky, not El' Lisitsky, etc.).

Rendering of Names, Titles and Dates

Titles of works of art, musicals, operas, books, catalogues, journals and newspapers are italicized; titles of short stories, poems, plays, articles, manuscripts and exhibitions are in quotation marks; names of societies and institutions are not.

Dates referring to events in Russia before January 1918 are in the Old Style. Consequently, if they are in the nineteenth century, they are twelve days behind the Western calendar; if they are between 1900 and 1918 they are thirteen days behind.

The city of St. Petersburg was renamed Petrograd in 1914, Leningrad in 1924 and then St. Petersburg again in 1992, although both the names Petrograd and Petersburg continued to be used in common parlance and in publications until 1924. As a general rule, Petrograd has been retained in this catalogue as the official name of St. Petersburg for the period 1914–1924.

List of Abbreviations

The following abbreviations have been used:

CSIAI	Central Stroganov Industrial Art Institute, Moscow
ed. khr.	*edinitsa khraneniia* (unit of preservation). This refers to the item number within a particular file in Russian archives
f.	*fond* (fund). This refers to the file number in Russian archives
GAU	Chief Archive Administration, Moscow
GITIS	State Institute of Theatre Art (now the Russian Academy of Theatre Arts, Moscow)
IAA	Imperial Academy of Arts, St. Petersburg
Inkhuk	Institute of Artistic Culture, Moscow
K	Kiev
l.	*list* (sheet). This refers to the sheet number in Russian archives
IZO	Visual Arts Department of NKP
L	Leningrad
LR	J. Bowlt, N. Lobanov-Rostovsky, N.D. Lobanov-Rostovsky and O. Shaumyan: *Masterpieces of Russian Stage Design 1880-1930*, and J. Bowlt, N. Lobanov-Rostovsky and N.D. Lobanov-Rostovsky: *Encyclopedia of Russian Stage Design 1880-1930*, Ipswich, UK: Antique Collectors' Club, 2012 and 2013 (two volumes).
M	Moscow
MKhAT	Moscow Art Theatre

MIPSA	Moscow Institute of Painting, Sculpture, and Architecture
NKP	People's Commissariat for Enlightenment
op.	(opus). This is the general heading used for a particular section within a Russian archival *fond*
P	Petrograd
p.	Page
RGA	Russian State Archive, Moscow
RGALI	Russian State Archive of Literature and Art, Moscow.
RM	State Russian Museum, St. Petersburg
SCITD	Stieglitz Central Institute of Technical Drawing, St. Petersburg
SP	St. Petersburg
SSEA	School of the Society for the Encouragement of the Arts, St. Petersburg
Svomas	Free Studios
TEO	Theatre Department of NKP
TG	State Tretiakov Gallery, Moscow
Unovis	Affirmers of the New Art
Vkhutein	Higher State Art-Technical Institute
Vkhutemas	Higher State Art-Technical Studios

Martin Roth

Salutation

The exhibition 'Russian Avant-Garde Theatre: War, Revolution & Design, 1913–1933', hosted by the Victoria and Albert Museum, is a contribution to the UK-Russia Year of Culture, 2014–15. Together with other events in this programme, it documents a rich history of cultural exchange and dialogue between Russia and the UK.

The exhibition and this book focus on the constellation of radical artists identified today as the 'Russian avant-garde', and draw primarily on the extensive collections of the Bakhrushin State Central Theatre Museum in Moscow. The Russian avant-garde is recognized as one of the most creative and influential movements of the twentieth century. Its influence can be traced across the V&A's world-class collections of art, design and performance. This exhibition aims to inspire future generations of designers and artists from all disciplines to push the boundaries of their practice.

The kind support of the Director and staff of the Bakhrushin Museum has enabled many of the works in the exhibition to be displayed in Britain for the first time. The State Museum of Theatrical and Musical Art in St. Petersburg has also made its holdings available and private collectors have generously lent several works to the exhibition. John E. Bowlt has contributed extensively to this book and the exhibition. Many other individuals and institutions have previously played a heroic role in preserving the extraordinary works of the Russian avant-garde throughout the upheavals of the last century.

In this respect, the exhibition and this book are not only a record of artistic innovation during a period of conflict and revolution, but a testament to the value of international collaboration between institutions, curators and individuals under similarly challenging circumstances. The V&A was founded in the nineteenth century as an international museum and remains committed to fostering cultural dialogue and exchange across the globe today. For this reason, among many others,

the V&A is proud to host 'Russian Avant-Garde Theatre: War, Revolution & Design, 1913–1933' in 2014 and extends the warmest thanks to the many collaborators who have made it possible.

Dmitrii Rodionov

Light Triumphant:
The Russian Avant-Garde on Stage

The Russian Revolution, in its breadth, in its desire to encompass the whole world (a true revolution cannot desire less; if it is to fulfill this desire or not – that is not for us to divine), is such: it nurtures hopes of raising a global cyclone which will deliver a warm breeze and gentle scent of orange groves to these snow-covered lands; it will moisten the sun-bleached steppes of the South with cool Northern rain… With your whole body, your whole heart, your whole consciousness – heed the Revolution.

(Alexander Blok: 'The Intelligentsia and the Revolution', 9 January, 1918)

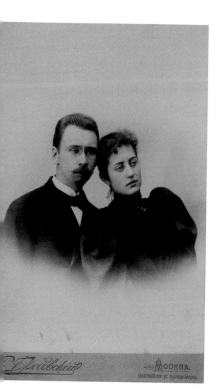

Photographer unknown: Vera and Alexei Bakhrushin, 1895. Bakhrushin State Central Theatre Museum, Moscow, Call No.: KP 61

'Russian Avant-Garde Theatre: War, Revolution & Design, 1913–1933' – the very title of our exhibition bears an inner drama, suggesting new interpretations of intrinsic concepts associated with the notion of avant-garde and theatre in Russia. The reference to war and revolution, words with largely negative connotations, are now combined with a word of very different resonance, i.e. 'design'.

The Russian avant-garde, long rooted in global culture as an enduring stylistic concept, is defined by a complex synthesis of radical artistic innovations in literature, music, theatre, art and architecture just before and after the October Revolution. These innovations informed and moulded numerous genres, movements and schools, some going so far as to call for the total renewal (or even rejection) of traditional communication and typological systems. The resultant multiplicity of styles in avant-garde theatre during the period 1913–33 is manifest in the radical methods which various directors, producers and designers elaborated and applied. Some of those angry young men and women endorsed a kind of aesthetic urbanism on stage, embracing the modern transformation of the world within a plastic or graphic totality. Others reproduced the surrounding world with its sharp contrasts and infinite variety, while opposing the fictional, cardboard two-dimensionality of everyday material life. In all of its manifestations, the Russian

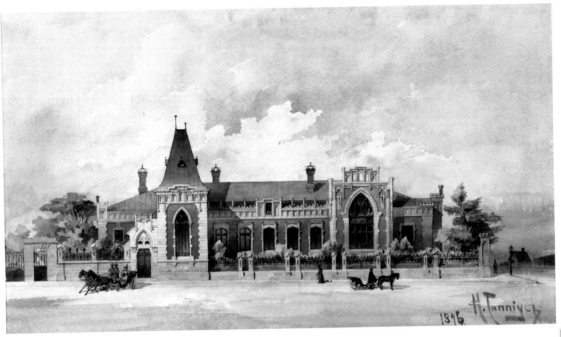

avant-garde was at war with the symbols of the past and expressed its theatrical revolution in new approaches, not only to stage design, but also to the entire world order.

A primary reason for the unprecedented solvency in artistic life just before and after October 1917, was the Romantic perception which the Russian intelligentsia emphasized in its philosophical and aesthetic agenda. In their creative enterprises, intellectuals and artists promoted themselves as heralds of the new era, an era in which a cosmic, destructive tide would sweep away the outdated, the bygone and the redundant. Symbolist poets, such as Alexander Blok, alluded to the mystical and messianic in their bid to 'heed the revolution'. War and revolution were now perceived as a valid context for advancing bold prophecies, aesthetic manifestos and radical innovations. But the utopianism inherent in the ideals of Socialist revolution became evident quickly enough as the horrors of the Great War, the Revolution and the Civil War laid bare the irreversibility of destruction – not only of artistic forms, but also of entire civic institutions. The search for new forms and the practical and psychological problems of restructuring the world were all but too manifest, something which, in turn, impacted the aesthetic and political role

of theatre, now regarded as a mass communication system and a culturally creative force. Theatrical events were of no less significance, indeed, no less 'real', than political events, constituting a kind of meta-text, one divested of conventional cultural codes – and essentially tragic.

In spite of these sociopolitical transmutations (or perhaps because of them), both Europe and America reacted favorably to contemporary Soviet art in the 1920s: in 1922 Berlin hosted 'Die Erste Russische Kunstausstellung', moving on to Amsterdam the following year; in 1924 New York – 'The Russian Art Exhibition'; in 1925 Paris – the 'Exposition Internationale des Arts Décoratifs and Industriels Modernes', where the Soviet pavilion presented every variety of artistic investigation, establishing the new Russia's unquestionable primacy in the European theatre arts; in 1927 Monza (Milan) – the 'Mostra internazionale delle Arti Decorative'; in 1928 Brussels – the 'Exposition d'art russe ancien et modern'; and in 1929 London – 'The Exhibition of Soviet Art'. The success of these exhibitions and the public interest they aroused was so encouraging that, in 1930–31, back-to-back art exhibitions followed in Berlin, Vienna, Paris, Stockholm and Zurich.

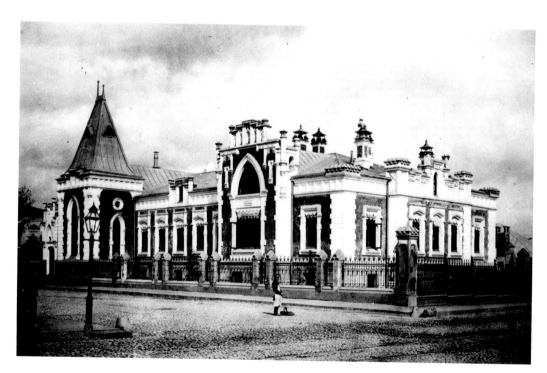

The Bakhrushin State Central Theatre Museum is fortunate to possess the most comprehensive collection of Russian stage designs by avant-garde artists worldwide. Museums, galleries and other institutions, both domestic and foreign, make regular recourse to the Bakhrushin, but this is the first time that its avant-garde collection has been shown with such largesse and variety in a European museum. The curators are specialists in the history of Russian visual culture, i.e. Vitalii Patsiukov (Moscow Museum of Contemporary Art, Moscow) representing the Russian side, and Kate Bailey (Department of Theatre and Performance at the Victoria and Albert Museum, London) and John E. Bowlt (University of Southern California, Los Angeles) representing the British side. Sergei Barkhin (People's Artist of Russia, Moscow) and Vasilina Ovchinnikova (Chief Designer for the Bakhrushin) are responsible for the layout and

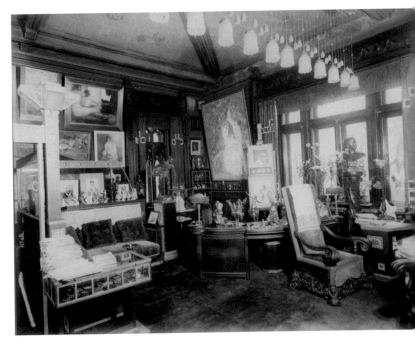

installation of the exhibition. Together they have developed the basic design concept – a spatial or topographical labyrinth advancing backwards and forwards in a centripetal movement – which showcases original and characteristic scenic solutions by the leading artists of the Russian avant-garde. Its trajectory is determined by a dynamic shift of images and themes: from the strong energy of Alexandra Exter's set and costume designs to Liubov Popova's urban contraption for *The Magnanimous Cuckold*; from Varvara Stepanova's machine-men in *The Death of Tarelkin* to the soothing art deco of the Stenberg brothers, and culminating, as it were, in Vsevolod Meierkhold's production of *The Bed Bug*, which designers Alexander Rodchenko and the Kukryniksy trio conceived as a testing ground for time machines. But perhaps the highpoint of the exhibition is also its departure point, i.e. Kazimir Malevich's sets and costumes for the 1913 production of *Victory over the Sun*, where a proto-Communist revolution emerges victorious in the eleven dimensions of the cosmos. This is the first time that such a rich sequence of theatrical designs is being shown in London.

'Russian Avant-Garde Theatre: War, Revolution & Design, 1913–1933' is also the

first major collaboration between the Victoria and Albert Museum and the Bakhrushin State Central Theatrical Museum. Many individuals have helped to bring this project to fruition, but we are especially grateful to Martin Roth, Director of the Victoria and Albert Museum; Geoffrey Marsh, Kate Bailey and Yulia Naumova from the Department of Theatre and Performance; and John E. Bowlt, scholarly consultant to the exhibition and editor of this book.

We are also grateful to Natalia Metelitsa, Director of the State Museum of Theatre and Music in St. Petersburg, for her loyalty to the enterprise and readiness to lend works, without which the scope and range of Russia's theatrical avant-garde would not have been complete. Last, but certainly not least, this complex project could not have been implemented without the steadfast support of the Ministry of Culture of the Russian Federation and the British Council. This accompanying book is an exceptional contribution to our endeavour, uniting an international team of experts on Russian theatre design: Kate Bailey (UK), John E. Bowlt (USA), Irina Duksina (Russia), Mark Konecny (USA), Mariia Lipatova (Russia), Nicoletta Misler (Italy) and Elena Strutinskaia (Russia).

The exhibition 'Russian Avant-Garde Theatre: War, Revolution & Design, 1913–1933' and the publication of this book take place on the centennial anniversary of the Great War. When selecting the set and costume designs, we did not grant any

special significance to this coincidence, but now, with all the works in place and in all their luminosity, we understand that it was the art of the avant-garde – and not military or political strategy – which prevailed one hundred years ago: after all, in wars and revolutions it is art, not strife and conflict, which sustains a permanent victory.

Translated from the Russian by Justin Trifiro

Mariia Lipatova

The Russian Avant-Garde at the Bakhrushin State Central Theatre Museum

Fisher, photographer: Alexei
...hrushin, Moscow, 1900, Bakhrushin State
...tral Theatre Museum

The *fin de siècle* of Imperial Russia witnessed an extraordinary renaissance, not only in the arts, but also in material culture, the sciences and the world of commerce, witness to which was a flourishing community of business people, entrepreneurs and philanthropists, especially in Moscow. Indeed, a key reason for Russia's cultural refurbishment back then lay in the charitable and patronal activities of rugged, solvent and perspicacious businessmen such as Alexei Bakhrushin, Savva Mamontov, Savva Morozov, Pavel Tretiakov and Sergei Shchukin. Today, that culmination of artistic flowering is often associated with the radical movements known as the Russian avant-garde, a constellation of ideas and styles which informed all spheres of creative and intellectual activity, especially literature, painting, architecture, music, dance and dramatic theatre.

The Moscow businessman Alexei Alexandrovich Bakhrushin (1865–1929, who in 1894 founded the world's first private theatre museum, at first collected portraits of actors, directors and artists and other individuals associated with the theatre as well as related documents, books, posters and memorabilia, be that a pair of ballet shoes or a pair of binoculars. Having become a collector by chance or rather as a result of a friendly bid to gather an impressive theatrical collection as fast as possible, Bakhrushin set out to collect in earnest, expanding his holdings with alacrity and agility. In no time he had filled his private mansion, located on the corner of Luzhnetskaia Street (now Bakhrushin Street) and the Garden Ring, with theatrical rarities to the extent that the rooms, one after another, turned into museum storage facilities. Cupboards were filled with books and documents, display cases housed commemorative items and the walls were soon covered with pictures and

drawings. According to Bakhrushin's son Yurii, the 'exhibition' was renewed and amended almost on a daily basis.[1] Between 1909 and 1913, Bakhrushin transferred his treasures to the Academy of Sciences for safekeeping, i.e. before the government granted his museum public status in November, 1913. This procedure helped save the collection from being scattered amidst various institutions throughout Russia after the October Revolution, as was the fate of so many of other private collections which were nationalized and disbursed. The move also permitted the collection to be replenished thanks to state funds when Bakhrushin himself, who chose not to emigrate but to stay in Moscow, fell on hard times. But Bakhrushin was also a social and civic figure, participating in various commissions and committees and offering liberal support for the publication of books, erection of monuments and exhibition installations, visitors leaving heartfelt notes of appreciation in the family guest book.

In any case, the Bakhrushin venture was not the only one of its kind. The year 1913, for example, had also witnessed the transference of the Moscow Theatrical-Literary Museum to the public domain, a move supported by celebrated theatre people such as Vladimir Nemirovich-Danchenko, Mariia Ermolova and Konstantin Stanislavsky. A few years later Bakhrushin donated additional real estate and display space to the museum and he maintained personal and business relations with many actors, directors and artists, who donated souvenirs, documents, sketches, paintings and sometimes entire archives. True, Bakhrushin's personal predilections were influenced by the art of the Maly Theater, although its penchant for the late-nineteenth century did not prevent him from acquiring materials

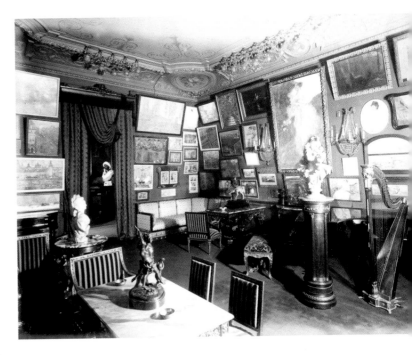

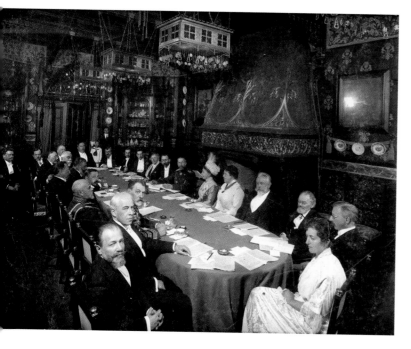

connected with the Moscow Art Theater and its studios, Alexander Tairov's Chamber Theater and the various enterprises of Vsevolod Meierkhold, Sergei Eisenstein and other directors and producers. Paintings and drawings by Alexandra Exter (the Bakhrushin possesses the most complete collection of her stage designs), Boris Ferdinandov, Alexander Golovin, Natalia Goncharova, Aristarkh Lentulov, Isaak Rabinovich and Vladimir Tatlin, among others, soon occupied pride of place in the Bakhrushin collection.

In 1924 the Museum also received the private collection of Sergei Ivanovich Zimin (1875–1942), owner of the eponymous opera theatre in Moscow. Renowned both for its grandiose performances, as well as for its innovative sets and costumes, the Zimin Opera Theater had attracted many important designers such as Fedor Fedorovsky, Ivan Fedotov, Petr Konchalovsky, Konstantin Korovin and Ivan Maliutin, many of whose works had entered Zimin's own collection. In addition, Zimin acquired numerous negative plates and photographic prints and amassed a unique documentary archive.

Apart from the Zimin corpus (which included his private diaries),[2] the Museum was also the recipient of other materials from private and public collections, especially during the 1920s and 1930s, for example, a rich archive pertaining to the Blue Blouse propaganda theatre or so-called 'living newspaper.' Founded in 1923 by Boris Yuzhanin, this touring company consisted of several teams of performers, who, armed with simple props, played out revues based on topical subjects at factories, industrial complexes and workers' clubs. During the ten years of its existence, various designers worked on sets and costumes, including Nina Anzimirova, Nina Sosunova and, above all, Nina Aizenberg, to all intents and purposes the artist-in-residence. The Blue Blouse archive also contains vintage photographs, posters and documents.

In 1938 the Museum of the Meierkhold Theatre was also transferred to the Bakhrushin Museum which it preserved *in toto*, i.e. without distributing the

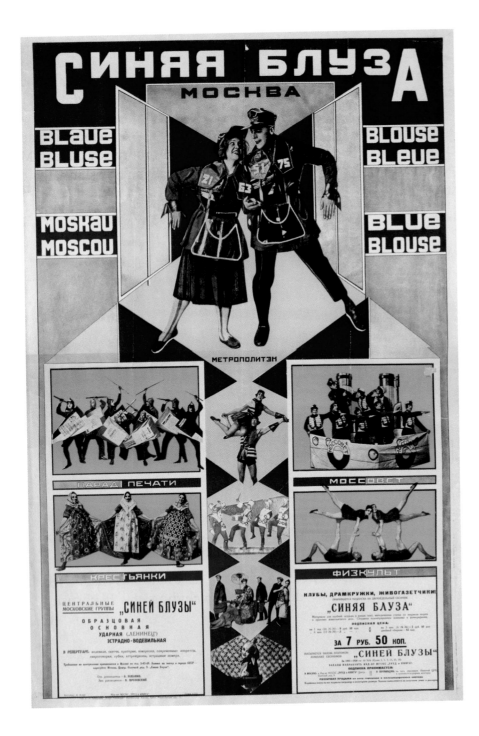

Artist unknown: Poster advertising the Blue Blouse performances in Moscow, ca. 1926. Bakhrushin State Central Theatre Museum

materials amidst different internal departments, thereby creating a unique and synthetic monument to the theatrical reforms of this heroic innovator. Apart from designs and maquettes by Eisenstein, Viktor Kiselev, Liubov Popova, Alexander Rodchenko, Varvara Stepanova and other designers for Meierkhold, the collection contains photographs, notebooks, models, stage props and costume dolls, all of which are still preserved as a single corpus of material.[3] A memorial apartment-museum honouring Meierkhold was opened in 1991 on Briusov Lane in Moscow with the support of Meierkhold's heirs and drawing substantially on the Bakhrushin materials.

After the Chamber Theater closed in 1949, the Bakhrushin inherited the whole of its ancillary museum, containing designs, photographs and posters pertaining to the various domestic and foreign tours which the Chamber company had undertaken in the 1920s and 1930s. During his long tenure, Tairov, director of the Chamber Theater and protagonist of what he called the 'theatralization of theatre', had collaborated with many different artists, granting them every stylistic freedom and welcoming experiments by artists of the most varied factions, including the artists of the Symbolist Blue Rose group, such as Pavel Kuznetsov, and the Jack of Diamonds group, such as Lentulov or the architectural installations of Alexander Vesnin and the posters by the Stenberg brothers. Among other visual materials are set and costume designs or maquettes by Natan Altman, Exter, Robert Falk, Lentulov, Ignatii Nivinsky, Vadim Ryndin, the Stenberg brothers, Alexander Tyshler and Georgii Yakulov.

In the 1950s the museum attached to the State Jewish Theater (GOSET) in Moscow also became part of the Bakhrushin. The success of GOSET had been due to the creative activities of director Alexei Granovsky and the celebrated actor and director Sergei Mikhoels, as well as to a galaxy of brilliant artists such as Nikolai Musatov, Nivinsky, Rabinovich, Tyshler and Falk.

After Vladimir Tatlin's death in 1953, much of his estate was transferred and distributed to various Moscow depositories, including the Bakhrushin, which received not only all of his stage designs, but also some of his projects for clothing, utensils and industrial objects, along with archival photographs of models and projects and other materials. Even Tatlin's prototype for his airplane, *Letatlin*, which survived the initial trial flight in 1932, was designated for the Bakhrushin, but later on was transferred to the Museum of Aviation under the auspices of the

Ministry of Defense. True, Tatlin enjoys broad acclaim for his paintings, reliefs and schemes for the Monument to the III International (the Tatlin Tower) rather than for his work in the theatre. Even so, from 1911 onwards, with the designs for the Moscow staging of *Emperor Maximilian and His Disobedient Son Adolf*, until late in life, the theatre remaining one of the few releases for his creativity, Tatlin was much involved in stage design and the Bakhrushin possesses examples from all phases of his theatrical career.[4]

Over the last ten years, the Bakhrushin has been fortunate to receive collections of stage designs from the museums of the Vakhtangov Theater and the Russian Youth Theater (formerly the Central Children's Theater), both in Moscow. Among items from the former are projects for sets and costumes and sketches of actors in leading roles by Nikolai Akimov, Altman, Vladimir Dmitriev, Nivinsky (for Vakhtangov's production of *Gadibuk* at the Gabima Theatre, Moscow, in 1922) and Martiros Sarian. From the Youth Theater the Bakhrushin received designs by Dmitriev, Nisson Shifrin, Yakov Shtoffer, Petr Viliams and other designers of productions from the 1920s and 1930s, in particular. True, to this day, many Moscow theatres have preserved their own museum collections (for example, the Bolshoi and Maly Theaters and MKhAT), but, even so, the Bakhrushin has representative selections of designs which artists made for those theatres, too – and not just in Moscow, but also in Leningrad/St. Petersburg, including Akimov, Leonid Chupiatov, Boris Erbshtein, Golovin, Mikhail Ledantiu, Moisei Levin, Kuzma Petrov-Vodkin, Sergei Sudeikin and Elizaveta Yakunina. Pride of place is given to the exciting set and costume designs which Revekka Leviton (one of Pavel Filonov's students) made for Igor Terentiev's production of Nikolai Gogol's *The Inspector General* in 1927.

Yet another important dimension to the Bakhrushin holdings is the emphasis on the national schools, such as the Ukrainian avant-garde (Matvei Drak, Boris Kosarev, Vadim Meller, Anatolii Petritsky, Isaak Rabichev, Alexander Khvostenko-Khvostov), the Belorussian contingent (Vladimir Miuller), the Armenian and Georgian schools (Mikael Arutchyan, Iraklii Gamrekeli and Kirill Zdanevich) and Kazan, Siberia, the Far East and other regions of the Russian Federation. Although many of these local contributions have yet to be studied in detail, it is clear that, if, by the early 1930s, the Russian avant-garde had lost much of its energy in the metropolitan areas, the spirit lived on in the republics and regions far from the

centres of political power. Over the last decade or so the Bakhrushin has also been cultivating a strong interest in the work of émigré artists inasmuch as, after the October Revolution, many Russian designers continued to work in Europe and the USA. In some cases, museums of Russian art were established in Czechoslovakia, France and the USA, while a few eager connoisseurs amassed important collections. Some of these wandering stars such as Boris Anisfeld and Goncharova are now returning to the new Russia and their émigré careers are already well represented in the Bakhrushin collection.

The avant-garde constitutes a significant part of the Bakhrushin collection, which contains more than one-and-a-half million items pertaining to the history of the Russian theatre, from the eighteenth century to the present day. Of course, a major role in the preservation and documentation of these theatrical innovations was played by Alexei Bakhrushin, founder of what became the Bakhrushin State Central Theatre Museum: thanks to his dedication and foresight, this unprecedented collection survived the trials of revolution and war, its intrinsic value enhanced constantly by the addition of works by important artists whom Bakhrushin held in such high regard. The result is a unique, comprehensive and variegated resource for the study and appreciation of Russia's modern theatre, one of the most exciting components of her cultural rebirth a century ago.

Translated from the Russian by Mac Watson

John E. Bowlt

From Studio to Stage, from Surface to Space

'Russian Avant-Garde Theatre: War, Revolution & Design, 1913–1933' tells the story of Russian stage design from just before the Revolution of October 1917 until the imposition of Socialist Realism in the early 1930s. Those historic decades, world war, domestic insurrection, civil war and then political dictatorship notwithstanding, were paralleled by a flowering in all aspects of Russian culture, not only in the literary, visual, theatrical and musical arts, but also in commerce and technology. The exclusive mission of this exhibition, however, is to reveal the innovative contribution which radical artists, producers and impresarios made to basic concepts of set and costume, proscenium and auditorium, actor and director in the theatres of Moscow, St. Petersburg/Petrograd/Leningrad, Kiev, Tiflis and other cultural centres. Their combined efforts contributed to what today is promoted as the Russian avant-garde, even if, a century ago, those who are now associated with the 'avant-garde' did not use the term and were certainly not united by a single worldview – and, no doubt, would be vexed by the imaginary cohesion which a panoramic exhibition of this kind suggests.

Left to right: Photographer unknown: Les Kurbas (1887-1942). Bakhrushin State Central Theatre Museum, Moscow, Call N KP 301655/18

Photographer unknown: Vsevolod Meierkhold (1874-1940), 1934. Bakhrush State Central Theatre Museum, Moscow, C No.: KP 180170/4509

Photographer unknown: Alexander Tairov (1886-1950). Bakhrushin State Central Theatre Museum, Moscow, Call No.: KP 203327

Photographer unknown: Evgenii Vakhtan (1883-1922). Bakhrushin State Central Theatre Museum, Moscow, Call No.: KP 168934/2249

In any case, 'Russian Avant-Garde Theatre: War, Revolution & Design, 1913–1933' explores that time of transformation through the prism of the theatre or, rather, of stage design, offering drawings, pictures, posters, prints and maquettes by experimental artists such as Alexandra Exter, Kazimir Malevich, Liubov Popova, Alexander Rodchenko, Vladimir Tatlin and Alexander Vesnin as concrete extensions of the pioneering spirit which left such an indelible impression upon stage design. In turn, the exhibition and this book emphasizes the bold achievements of the new generation of directors such as Les Kurbas, Vsevolod Meierkhold, Alexander Tairov and Evgenii Vakhtangov, innovators who, with their various and disparate homages to folklore, the circus, bio-mechanics, the Classical legacy, Adolphe Appia, Edward Gordon Craig and Max Reinhardt, Emile-Jaques Dalcroze and Isadora Duncan, even Charlie Chaplin and Hollywood, restructured the professional theatre as a laboratory for exploring dramatic interpretation, artistic synthesis, visual resolution and audience reception.

If 'Russian Avant-Garde Theatre: War, Revolution & Design, 1913–1933' points to milestones in the history of modern Russian stage design – from *Victory over the Sun* (Malevich, 1913) to *The Magnanimous Cuckold* (Popova, 1922), from *Salomé* (Exter, 1917) to *Zangezi* (Tatlin, 1923) – it also presents names and productions less familiar to the Western public, such as Leonid Chupiatov (*Red Whirlwind*, 1924) and Iraklii Gamrekeli (*Hamlet*, 1925), Boris Ferdinandov (*King Harlequin*, 1917) and Konstantin Vialov (*Stenka Razin*, 1924). Furthermore, the selection demonstrates that the 'Russian' avant-garde was, in effect, multinational, reliant upon not only ethnic Russian contributions, but also Georgian (Gamrekeli, Georgii Yakulov, Kirill Zdanevich), Jewish (Moisei Levin, El Lissitzky, Iosif Shkolnik), Latvian (Gustav Klutsis) and Ukrainian (Exter, Alexander Khvostov-Khvostenko, Vadim Meller, Anatolii Petritsky, Isaak Rabinovich). In addition, 'Russian Avant-Garde Theatre: War, Revolution & Design,

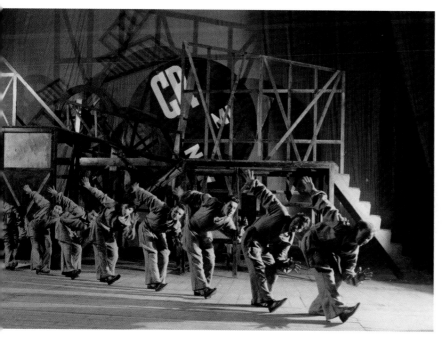

1913–1933' draws attention to the less canonical idioms which attracted the avant-gardists, such as the circus, music hall, operetta, cabaret, *danse plastique* and cinema; and to 'alternative' companies or theatrical ensembles which often served as platforms for performative and visual experiments, such as the Blue Blouse agitational theatre, the Experimental-Heroic Theatre in Moscow and Bronislava Nijinska's Choreographic Studio in Kiev.

A defining episode in the evolution of twentieth-century Russian theatre was the exhibition 'Stage Design in the USSR during the Decade 1917–1927', hosted by the Academy of Arts in Leningrad in 1927.[5] This rich panorama of set and costume designs, assembled by historian and collector Levkii Zheverzheev, artist Alexander Golovin and art critic Erik Gollerbakh, was at once a remarkable survey of drawings, printed materials and models by leading designers of the time, such as Vladimir Dmitriev, Boris Erdman, Exter, Petritsky, Popova and Rodchenko (many of whom are also represented in 'Russian Avant-Garde Theatre: War, Revolution & Design, 1913–1933'), and a summary of the multifarious styles which had impacted the concept of stage design during the 1910s and early 1920s.

Gollerbakh's lead article, 'Theatre as Spectacle', in the book of that remarkable exhibition, merits special note. In evaluating the new and original advances in theatre art, Gollerbakh elaborated a number of arguments which, today, provide a comprehensive context for appreciating the designs included in our own exhibition. Gollerbakh's text is lucid and illuminating, offering theses, sometimes provocative, on the relationship of the studio and applied arts to the modern stage. In particular, Gollerbakh's considerations – that the new theatre, coincidental with war and revolution, differed from its Victorian predecessor by a pronounced move from decoration towards construction, from the stage as a duplication of the easel painting towards a volumetrical or architectonic entity; that 'the ideal costume, is, of course, the absence of any costume at all';[6] that 'until the footlights have been "overcome", the theatre-as-spectacle has every right to exist'[7] – relate directly to the visual resolutions in 'Russian Avant-Garde Theatre: War, Revolution & Design 1913–1933'.

Astute observers of the theatre, such as Gollerbakh, argued that the move from surface to space was paralleled by an orientation towards the application of other scenic devices, especially machines and moving parts (a primary example being Popova's 'windmill' for Meierkhold's production of *The Magnanimous Cuckold*), on

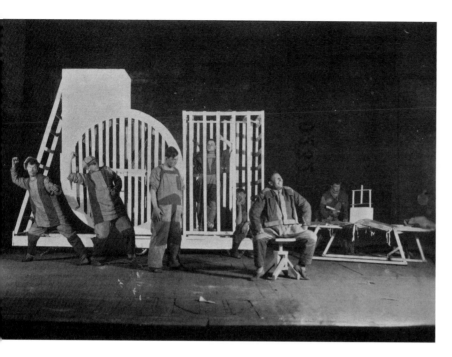

natural, unadulterated, physical materials (such as Tatlin's wooden boards for *Zangezi*), and on improvisation and spontaneity (such as Kasian Goleizovsky's dance sequences for *Satanic Ballet* of 1922). As Alexander Yanov, a foremost expert in theatrical technique and technology, asserted: 'However simplified, however primitive the decoration, its skeleton, its basic structures (constructions) must carry an architectural logic.'[8] Naturally, in the evolution of the theatre and its decoration intrinsic requirements, such as volumetrical construction, kinetic machinery and emotional caprice, were not without precedent: even the traditional *presepe* of the Italian Mezzogiorno (the folkloric recasting of the Nativity) relies on moving parts often operating within a three-dimensional environment, and, no doubt, the buffoons and mummers of Old Russia, who so captivated modern Russian artists (from Alexandre Benois to Tatlin), were just as improvisational as the weird personages which Sergei Eisenstein created for the 1922 dramatization of Vladimir Maiakovsky's *Being Nice to Horses* (1922).

We may assume, therefore, that the 'retheatralization of the Russian theatre'[9] in the 1920s resulted from this renewed emphasis on architectonics (volume), velocity (instantaneity) and caprice (arbitrariness) – demonstrable from a comparison of the foremost exemplars of Constructivist design, such as Varvara Stepanova's sets and costumes for *The Death of Tarelkin* (1922) with the early phase of Serge Diaghilev's Ballets Russes (1909–14). The Ballets Russes artists, such as Léon Bakst, Benois, Golovin and their colleagues, left the audience breathless with their sumptuous colours or encyclopedic historicity, so much so that often the other elements of the presentation (singing, mime, even dancing) assumed a secondary, if not tertiary, position, the 'cult of beautification replacing the cult of beauty.'[10] On the other hand, even though the Ballets Russes never appeared in Russia, something of their languorous luxury could also be seen on the stages of St. Petersburg and Moscow – and the more we examine the evolution of the pre-Revolutionary theatre, the

more we realize that its primary innovators, such as Exter and Tairov, owed as much to Michel Fokine and Bakst, Vaslav Nijinsky and Sergei Sudeikin as to Appia and Craig, and that they maintained, rather than disregarded, what Yurii Annenkov described as the 'dictatorship of the painter.'[11] Are not Exter's sensual bodies in *Salomé* (1917) the immediate progeny of Bakst's ample sultanas in *Schéhérazade* (1910), and is it mere historical coincidence that the Decadent story of Salomé captivated the talents of Diaghilev, Nikolai Evreinov and Vera Komissarzhevskaia, as well as of Goleizovsky, Konstantin Mardzhanov, Tairov and even Meierkhold?

Exter's costumes for *Salomé* were dynamic and her sets architectonic and, the flowing Bakstian veils notwithstanding, she also predicted her own geometrical and efficient costumes for the sci-fi film, *Aelita* of 1924 – which is to say that, while certainly 'avant-garde', Exter was much obliged to the conventions of art nouveau and the style moderne, her cocktail of 'silvery black and silvery blue costumes sparkling against the background of drapery.'[12] At the same time, Exter did advance from surface ornament to spatial construction, manifest in a juxtaposition of her *Salomé* with the later theatrical projects illustrated in the 1930 portfolio of Alexandra Exter. *Décors de Théâtre*. In other words, Exter crossed the boundaries

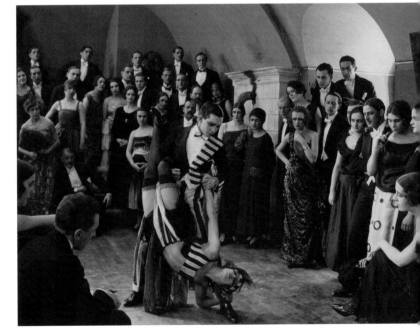

Frame from the film *Aelita* produced by Yakov Protazanov and released in Moscow 1924 with sets by Isaak Rabinovich (assist by Sergei Kozlovsky and Viktor Simov) an costumes by Alexandra Exter (assisted by Vera Mukhina) and choreography by Kasi Goleizovsky et al. Bakhrushin State Centr Theatre Museum, Moscow, Call No.: KP 252504/3764

of the pictorial plane so as to structure forms in their interaction with space, and when Yakov Tugendkhold, critic and historian, observed of her collaborations with Tairov that together they had established an 'organic connection between the moving actors and the objects at rest,'[13] he was implying that Exter was reorganizing the scenic box as a dynamic volume, and constructing, rather than decorating, the stage. Indeed, it was in her designs for the Tairov productions such as *Thamira Kytharedes* (1916) and *Salomé* that traditional, static principles gave way to dynamic resolutions, wherein scenery and performers played equal parts. As early as 1917, Exter was filling up the 'box of the stage from top to bottom with bridges and platforms'[14] (for her unrealized interpretation of *Romeo and Juliet*), just as she did for her Constructivist projects of the 1920s.

Be that as it may, Tairov's Chamber Theater was a place of adjustment and even compromise, and perhaps for this reason survived the terror of the Stalin era longer than other experimental theatres. Essentially, its repertoire was classical (*Romeo and Juliet* with designs by Popova in 1920 and Exter in 1921; *Phèdre* with designs by the Stenberg brothers and Alexander Vesnin, 1922) and its sets and costumes ornamental – such as Vera Mukhina's for *La Cena delle Beffe* and *The Rose and the Cross* (1916) and Sudeikin's for *Le Mariage de Figaro* (1915). All this is to say that the Chamber Theater, with productions such as Arthur Schnitzler's *Der Schleier der Pierrette* (1916), Innokentii Annensky's version of *Thamira Kytharedes* and Paul Claudel's *L'Annonce faite à Marie* (1920), 'legalized' the Symbolist legacy. Indeed, had it not been for Exter's prescient sets and costumes, the Chamber Theater could scarcely be acknowledged as a radical platform, because even Vesnin's celebrated Constructivist installation for *The Man Who Was Thursday* (1923) drew its inspiration from Meierkhold's production of *The Magnanimous Cuckold* of the year before (with 'machinery' by Popova) – although, not surprisingly, Vesnin dismissed the significance of the Popova/Meierkhold collaboration, arguing that, on the contrary, it was *The Man Who Was Thursday* which had really fulfilled the need for volumetrical construction on stage.[15] No doubt, the Stenberg brothers shared Vesnin's opinion inasmuch as they, too, erected ponderous material constructions as, for example, in Tairov's productions of *The Storm and St. Joan* at the Chamber Theater in 1924, before moving on to lighter and more humorous designs for *Day and Night* and *The Hairy Ape* two years later. Yakulov, who worked for the Chamber Theater, designing, for example, *Giroflé-Girofla* in 1920, also had serious reservations about its ability to move with the times, contending that, in general, the theatre was twenty years behind painting.[16] True, Yakulov was neither exclusively Cubist, nor Futurist, or even Constructivist, drawing his artistic force from all these styles, but he did play with chance, coincidence, spontaneity and the fundamental component of theater, the 'principle of perpetual motion',[17] a dramatic game which might result in notable success or dismal failure: 'Art

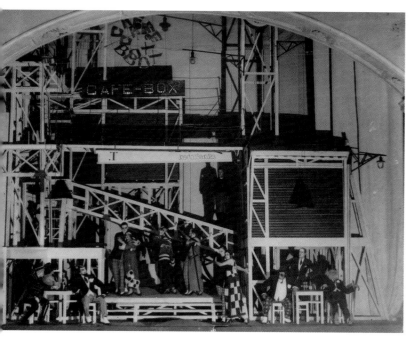

tographer unknown: Scene from G.K.
sterton's *The Man Who Was Thursday*
duced by Alexander Tairov at the
mber Theater, Moscow, in 1923

exists for the ignoramus', Yakulov proclaimed, 'The greatness of art lies in its right to be illiterate,'[18] an affirmation which, however, might not always be especially relevant to his visual resolutions, such as the set for the sophisticated and complex spectacle *Rienzi* (1921–23).

Despite the innovations of Exter, Mukhina, the Stenberg brothers, Vesnin and Yakulov, to many the Chamber Theater was still bound by tradition and unready to take risks and, with its antique repertoire, box-office stars (Alisa Koonen and Nikolai Tsereteli) and very title (Chamber Theater), seemed to uphold the conventional understanding of high theatre as elite entertainment for cognoscenti and socialites. As the critic Sergei Ignatov complained in 1923, the repertoire of the Chamber Theater merely passed from 'harlequinade to tragedy and from tragedy back to harlequinade.'[19]

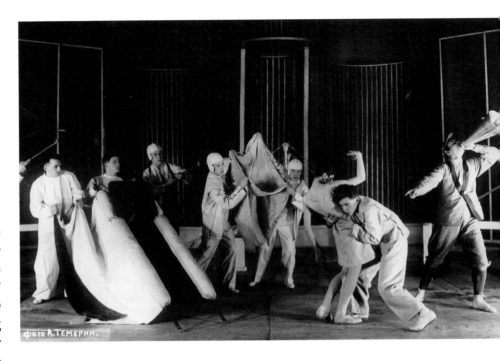

For more radical achievements in Russian performance and stage design, the critical net must be cast more broadly so as to capture the alternative genres of cabaret, music hall, vaudeville, circus and agitational action, avenues of enquiry which bring us, naturally, to Meierkhold's experiments. The significance of the key Meierkhold enterprises, such as *The Magnanimous Cuckold*, *The Death of Tarelkin* and *The Bed Bug* (1929), designed by Popova, Stepanova and Rodchenko respectively, is, of course, indubitable, for they diverged immediately from the theatrical canons championed by less extreme directors, such as Evreinov and Tairov. Even a cursory glance, for example, reveals that Popova's constructions for *The Magnanimous Cuckold* and *Earth on End* (1923) and Stepanova's 'jump suits' and universal furniture for *The Death of Tarelkin* amplified the dynamic volume to which Exter had alluded in her 'Baroque Cubism', turning the stage into a laboratory for experimenting with forms and movements which one day might have been extended into real life.

Photographer unknown: Scene 'Catching Foxtrotters' in Vladimir Maiakovsky's *Bed Bug* produced by Vsevolod Meierkhold at Meierkhold Theatre, Moscow, 1929, with music by Dmitrii Shostakovich and design by Meierkhold, the Kukryniksy and Alexander Rodchenko. Bakhrushin State Central Theatre Museum, Moscow, Call N KP 180170/1549. The photograph is dated 1929

With their elements of farce, slapstick and chance, these three productions, in particular, reinforced the strong tendency towards 'circusization'[20] in early Soviet culture; also manifest, for example, in Ferdinandov's adaptation of clowning and acrobatic techniques to his Experimental-Heroic Theatre as well as in particular productions such as Maiakovsky's *Being Nice to Horses* and *Mystery-Bouffe: A Heroic, Epic and Satirical Depiction of Our Epoch* in Moscow and Kharkov in 1921 – a 'modernized *lubok* [folk print] with elements of the music hall and the circus.'[21]

In his review of Annenkov's and Meierkhold's production of Lev Tolstoi's *The First Distiller* of 1919 (with designs by Annenkov), Viktor Shklovsky pointed to the integration of farce and *moralité* which, in his opinion, was defining, if not, dominating, the new repertoire.[22] Developing his idea, Shklovsky pointed to theatrical precursors which, he felt, had heralded this emphatic tendency, comparing *The First Distiller*, for example, with the 1911 production of *The Emperor Maximilian and His Disobedient Son Adolf*, for which Tatlin had designed sets and costumes. Although *The Emperor* (and *A Life for the Tsar* of 1913, Tatlin's second commission) lacked the volumetrical dimension intrinsic to his subsequent visual formulations for *The Flying Dutchman* (1915–18) and *Zangezi* (1923), Tatlin paraphrased the Neo-Primitivism of Natalia Goncharova and Mikhail Larionov, conceiving of the event as a folkloric spectacle and stressing the elements of caprice and spontaneity, just as Meierkhold and Popova would in *The Magnanimous Cuckold* or Meierkhold and Rodchenko in *The Bed Bug*.

A similar mix of farce and *moralité*, of drama and *balagan* (fairground booth), informed the celebrated opera or, rather 'anti-opera', *Victory over the Sun*, produced at the Luna Park Theatre, St. Petersburg, in December, 1913, with book by Alexei Kruchenykh and Velimir Khlebnikov, music by Mikhail Matiushin and designs by Malevich. As we can see from the costume designs on display, Malevich's personages, exaggerated, rough and ready, would seem to be at home more in the circus arena than in grand opera, as the following contemporary description implies:

> The opera was preceded by V. Khlebnikov's 'prologue' under the title 'Blackcreative Newslets'.
>
> A. Kruchenykh 'read' the prologue against the background of a curtain made out of just a regular bedsheet with 'portraits' of Kruchenykh himself, Malevich and Matiushin daubed on it. You can judge what kind of 'prologue' this was from the fact that it was dominated by such inhuman expressions as:
>
> 'Bytavy, ukravy, mytavy...'

Actually, the audience did understand something, i.e. that the sounds of some kind of 'trumpeting' would soon be flying toward them. Since the Futurists don't want to be like 'everyone else', the curtain after the prologue – was not pulled apart, but ripped in half.

After which there proceeded the 'opera', if I may call it that.

But in the end it became tedious, and it was the audience itself that came to the rescue of the weary Futurists. Almost every cue was followed by some witty word or other and soon the theatre was hosting not one, but two, performances: one on stage, and the other in the auditorium. Whistling and booing replaced the 'music' which, by the way, harmonized very well with the crazy decors and the delirium that resounded from the stage.[23]

Actually, 'inhuman expression', 'whistling and booing' and 'delirium' were primary components of the Russian Cubo-Futurist experience, imbuing the new theatre with an adolescent energy and iconoclastic force. Malevich's clownish figures and 'alogical' backdrops for *Victory over the Sun* posed a tactical and lasting challenge to the traditional dramatic theatre, their disharmony and rawness exerting a formative influence on many later productions – from Meierkhold's adaptation of Maiakovsky's *Mystery-Bouffe* in 1921 (with designs by Vladimir Khrakovsky, Viktor Kiselev and Anton Lavinsky) to Igor Terentiev's production of *The Inspector General* in 1927 (with designs by Pavel Filonov's Collective of Masters of Analytical Art).

Victory over the Sun is important for many reasons, verbal, visual and musical, but especially for its reduction of the libretto from a sequential narrative to a sonic and often nonsensical experiment, and the backcloths from a purely anecdotal function to a visual game of device. This was the kind of pure theatre which radical directors and artists tried to promote just after the Revolution – for example, Annenkov:

Hitherto, the theatre has been merely a medium, a means of presentation, but not an end in itself... there has been no theatre of pure method. Basically, theatre is dynamic. Hitherto, decors have served as backgrounds for the scenic presentation, an environment for the dramatis personae of the play... There is no place in the theatre for dead pictures, because everything is in movement. But until the decor stirs from its place and starts to run around the stage, we will not see a single, organically fused theatrical presentation... Artistically organized, i.e. rhythmically organized, movement is theatrical form.[24]

Along with Meierkhold, Popova, Vesnin and other innovators, Annenkov identified this 'rhythmically organized movement' closely with the agit-action or 'mass presentation'. Together with Evreinov, for example, he produced *The Storming of the Winter Palace* in Petrograd in November, 1920, an ambitious reenactment

involving 6,000 actors, 500 musicians and 100,000 spectators. While the Soviet mass action traced a long, international lineage, at least to the popular festivals at the time of the French Revolution, the apologists of the Soviet version argued for its adjustment to local ideological needs. Alexei Gan, author of the play *We* designed by Rodchenko in 1920, and one of the foremost champions of the agit-movement, expounded that the mass action was not an invention or fantasy, but:

> an absolute and organic necessity deriving from the very essence of Communism… The mass action under Communism is not the action of a civic society, but of a human one – wherein material production will fuse with intellectual production. This intellectual-material culture is mobilizing all its strength and means so as to subordinate unto itself not only nature, but also the whole, universal cosmos.[25]

Still, in the 1920s, at least, the agit-actions, whether dramatizations, promenades or gymnastic parades, were often ill-conceived and unconvincing, demanding enormous manpower which could rarely be harnessed propitiously or tactically. On the other hand, in its looseness and desultoriness, the agit-action pointed towards a theatre of pure method, for, in spite of (or because of) a debt to the morality play, the medieval mystery and public carnival, it undermined the rules of conventional theatre, particularly the rapport between cast and audience. Moreover, what also drew Annenkov, Gan, Klutsis, Popova, Rodchenko, Solomon Telingater and other Constructivists to the mass action was its potential mobility: May Day celebrations and political jubilees, such as Klutsis's decorations for the Moscow Kremlin (1922) or Telingater's for a propaganda lorry (1932), no longer demanded a single, fixed location, narrative or specific distribution of roles, but were fluid, versatile and improvisational. Sometimes the result was chaotic, the universality and uncontrollability of this street theatre being inconceivable within the polite walls of the Moscow Art Theatre or the Chamber Theater.

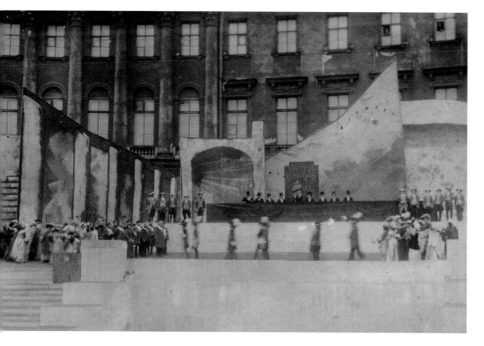

The provisional and mobile nature of the mass action connects organically to the concept of the *peredvizhnoi* or mobile theatre of the 1920s, whereby the stage as well as the spectacle could be moved from one location to another. Once again, wandering minstrels and mummers of Old Russia come to mind, but now, in the post-Revolutionary republic, the travelling performance seemed to cater to, or at least parallel, the ephemeral and laboratorial nature of much Constructivist theatre in general. In turn, this mobility or fleetingness paralleled the widespread phenomenon of the 'non-production' by radical artists and producers, one of the paradoxes of the avant-garde whose fame, to a considerable extent, derives from dramatic and visual projects which never reached production (Tatlin's Monument to the III International being a case in point). Several examples of these Constructivist non-constructions are represented in 'Russian Avant-Garde Theatre: War, Revolution & Design, 1913–1933' such as *The Death of Tarelkin* designed by Exter (1921), *Heartbreak House* by Eisenstein (1922), *Nur and Anitra* by Petritsky (1923), *Inspector General* by Dmitriev (1926) and *I Want a Baby* by Lissitzky (1927–30). As Sergei Tretiakov stated in 1922, the 'sketch, the rehearsal, and the moving around of decorations'[26] were beginning to assume more importance than the finished product, particularly as sequential plotlines were now giving way to improvisations, extemporizing and surprise effects. As cabaret, vaudeville and music hall, such as the Blue Blouse revues (Nina Aizenberg being a major contributor), achieved ever greater visibility, so it seemed that 'serious' theatre would soon disappear. How appropriate that the leading theatre magazines of the early 1920s printed advertisements for depilators, shaving cream, hair dye and other quick-fix cosmetics next to announcements about Constructivist performances.[27]

On this level, Meierkhold's laboratorial presentations of the early and mid-1920s assume a deeper resonance, for they relied as much on unpredictability (for example, Stepanova's 'universal' furniture in *The Death of Tarelkin*, which rarely functioned properly) as on the intentions of the director and designer, and perhaps it was this arresting integration of the serious and the ludicrous which became the identifying feature of the Constructivist movement as a whole. In any case, the architectonic and technological pretensions of Constructivism with its claim that 'function determines form' and 'minimum means should engender maximum effect' informed not only the decorative aspect of the theatre, changing the scenic space into a three-dimensional environment, but also the 'libretto', the

Lissitzky: Set for Sergei Tretiakov's *I Want a Baby*. Prepared, but not produced, by Vsevolod Meierkhold at the Meierkhold State Theatre, Moscow, in 1927-30, with designs by El Lissitzky. Reprise in wood, fabric, metal and glass, 68 x 147 x 72.5. Inv. No. KP 471 Mak 34

musical or other accompaniment and the performers themselves.

Meierkhold's method of bio-mechanics, indebted to the conventions of the Japanese theatre, the work-study programmes of Frederick Winslow Taylor and the eurhythmic system of Jaques-Dalcroze, played a key role in the Constructivist concept of the actor. In 1920 Meierkhold was granted the premises of the former Zon Theatre in Moscow and, stripping the stage of all accretions and exposing the original brick walls, he transformed what had been a traditional, elegant theatre into an alternative space, establishing his new enterprise – the Theatre of the RSFSR No. l, venue to some of the most radical stage productions of the 1920s. Meierkhold's most urgent need, however, was to find an artist who could move from two-dimensional design to three-dimensional construction and conceive the stage as a dynamic continuum – a capacity which he found in the persons of Rodchenko, Stepanova and, above all, Popova.

Popova first came to stage design in 1920 when, *inter alia*, she designed sets and costumes for an unrealized production of *Romeo and Juliet* at the Chamber Theater. After noticing her abstract paintings at the '5 X 5 = 25' exhibition in Moscow in 1921, Meierkhold invited Popova to compile a curriculum for a course in stage design at his State Higher Theatre Workshop – where she elaborated the blueprint of her remarkable installation for *The Magnanimous Cuckold*, informed, incidentally, by suggestions from Eisenstein and Vladimir Liutse. Here Meierkhold interpreted Fernand Crommelynck's risqué farce as an experiment in pure form, 'taking the circus, not literature, as his departure-point': [28]

> The stage was bare – no curtain, no proscenium arch, wings, backdrop, floodlights. On the background of the bare wall of the building with its open brickwork, one saw a simple, skeleton-like construction, a scaffolding designed by Popova consisting of one large black wheel and two small ones, red and white. Several platforms at various levels, revolving doors, stairs, ladders, chutes; square, triangular, and rectangular shapes. [29]

Inevitably, Popova's construction elicited censure as well as praise, Ippolit Sokolov, for example, declaring that it was difficult to imagine anything more insipid than the revolving red-and-black wheels of Popova's construction. But whatever the responses, neither Meierkhold nor Popova regarded their 'unprecedented, purely "circus", acrobatic number'[30] as formulaic, even if it did leave a profound impression on the evolution of stage design, including Stepanova's visual resolution for *The Death of Tarelkin* and Vesnin's *The Man Who Was Thursday*. In fact, true to her radical and contrary artistic nature, Popova conceived of her next and last theatrical endeavor, i.e. her work on *The Earth in Turmoil* of 1923, as a totally representational setting, employing a real automobile, real tractor, real telephones, etc.

Similarly, in *The Death of Tarelkin*, Stepanova organized material elements into a dynamic apparatus, using slats and laths as a kind of Op-Art mechanism to modify the forms of her actors, where

> At last I managed to show spatial objects in their utilitarian context and where I wanted to supply real objects – a table, a chair, armchairs, screens, etc. As a totality, they integrated the material environment wherein the live human material was meant to act.[31]

As in her *sportodezhda* (sports clothes) of 1923, Stepanova now considered emotion, illusion and ornament to be alien to utilitarian function, contending, like Popova, that each profession (factory worker, doctor, actor, sportsman) required its own costume, which was to be constructed according to the norms of expediency and convenience dictated by that profession. *The Death of Tarelkin* provided Stepanova with the opportunity to test her 'uniforms' within a three-dimensional, living environment; and even if some critics did describe the result as 'trashy and pretentious',[32] Stepanova's (and Popova's) experiments were all part of what Gan called the 'passage from composition (an aesthetic symptom) to construction (a productional principle).'[33] Following these precedents, Rodchenko also incorporated real objects into his rendering for Meierkhold's production of *The Bed Bug* in 1929.

Of course, Meierkhold's designers possessed little expertise in technical design or structural engineering, so that, not surprisingly, the wheels in *The Magnanimous Cuckold* often stuck and the revolving stage which Rodchenko projected for *One-Sixth of the World* in 1931 would never have rotated. Perhaps Tairov was right in his censure of such 'dehumanization', arguing that the mechanization of art was a

'malicious reaction both in art and in life – pathetic spanners in the works of the locomotive of human progress'.[34] It was this divorce of art from life that urged Boris Arvatov, champion of Constructivism, to reject the entire phenomenon of contemporary:

> theatre, urging its artists to become designers not of art, but of life: Abandon the stages, the ramps, and the spectacles. Move into life, train and retrain. Learn not aesthetic methods, but the methods of life itself, of social construction. Be engineers, be the assembly workers of everyday life. The working class wants real, scientifically organized forms, not illusions. It needs the construction of life, not its imitation.[35]

Of course, if Constructivism was a primary movement within Soviet culture in the 1920s, it was not the only one, and we should remember that Moscow and Leningrad witnessed the gestation of many other scenic systems – from the Expressionism of Filonov's students for *The Inspector General* in 1927, to the 'piquancy of a refined, tavern-like eroticism'[36] of lyrical hybrids such as Ignatii Nivinsky's designs for Vakhtangov's production of *Princess Turandot* (1923), and the 'candy aestheticism' of Goleizovsky's ballets.[37]

Perhaps the tragic irony of the Russian avant-garde on stage is that it scarcely affected the public for whom it was intended. After all, the new consumer was uneducated, if not illiterate, and had little appreciation of the niceties of Cubo-Futurism, Suprematism and Constructivism. Moreover, the physical denominator to which the new masses might have related, the human figure, was often distorted, fractured, even erased. As Alexander Briantsev, one of the authors of the catalogue for 'Stage Design in the USSR during the Decade 1917–1927', asserted: 'What [the new spectator] needs is the logical interconnection of all three concepts: place, time and action.'[38] Stalin's Socialist Realism restored those three concepts to the theatre, replacing the 'delirium' of the avant-garde with a rational and exuberant ornament, which appealed not to a chosen few, but to the masses. Bearing this in mind, we may well temper our enthusiasm for radical stage design and acknowledge the supremely theatrical nature of Socialist Realism, the merciless and inexorable movement which, in redesigning the world of appearances, conquered and effaced the Russian avant-garde.

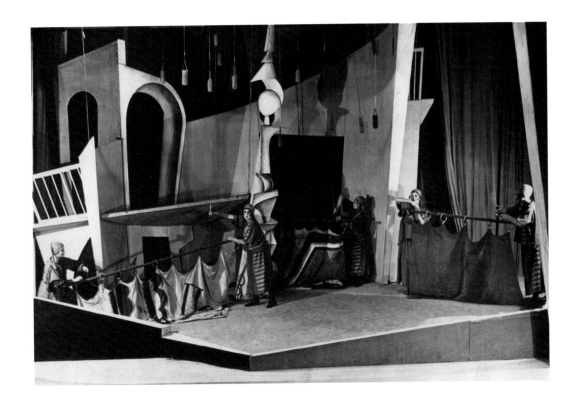

Photographer unknown: Scene from Carlo Gozzi's *Princess Turandot* produced by Evgenii Vakhtangov at the Third Studio of MKhAT (Vakhtangov Theatre) in 1923. Bakhrushin State Central Theatre Museum, Moscow, Call No.: KP 37960

Irina Duksina

Directors as Designers, Designers as Directors

As in preceding decades, the Russian visual and performing arts of the early-twentieth century were deeply interconnected, a condition which informs much scholarly research into Russian and Soviet theatre, especially in the context of styles and movements such as Symbolism, Futurism and Constructivism. The contribution of the artist to the Russian theatre was so important that we often grant exclusive attention to individual stage designers, such as Léon Bakst, Alexandra Exter, Natalia Goncharova and Vladimir Tatlin. However, if we approach each theatrical performance as simply an experiment by this or that designer, disregarding the director, we may lose sight of the actual spectacle, i.e. the end result, or what we might call the rite of passage organized by the creative will of all those involved, especially if we try to promote a certain style or single fashion as an exclusive exemplar.

Early-twentieth-century theatre witnessed radical reforms, bringing far-reaching innovations which left a deep imprint upon the very nature of the actor – his psyche, physical presence and technique. As for Russia, the new theatre created new kinds of actors with new, different and often antagonistic theories of training, ranging from Konstantin Stanislavsky's system of Psychological Realism to Vsevolod Meierkhold's bio-mechanics. But the reforms affecting scenic construction, auditorium and, ultimately, the theatre building itself were no less revolutionary. The performance area was now restructured and advocated as a 'work station' where the actor functioned; then came the repositioning of the stage in relation to the audience and, finally, the renovation of the auditorium and the theatre itself in tandem with the new standpoints and attitudes stemming from the revolutionary changes in society. Issues of this scale could not be settled without the collective forces of director, designer and architect. It is important to remember, however,

that the transformations in the Russian theater were not necessarily linked to the sociopolitical revolution of October, 1917, although this was, of course, a powerful catalyst for the development of trends which had been evolving from the late-nineteenth century onwards.

Following in the footsteps of Europe, Russian culture, including the theatre, welcomed the pervasive idea of artistic synthesis (the Wagnerian *Gesamtkunstwerk*). If Richard Wagner's aesthetic premise and theatrical practice at Bayreuth had been inextricably linked to the 'vision and visual imagery of the stage', the early-twentieth century enhanced this with a new component, i.e. the 'ideal performance', something which went beyond the mere combination of music, song and technical execution of an operatic drama. The result was a visual whole consisting of an indivisible rhythmical and decorative unity of music, word, movement, colour and light in space, but, in order to create this world, what was needed was a demiurge in concert with the synthetic programme of the directorial theatre. The nineteenth-century idea of the director-cum-manager or the director-cum-interpreter (much discussed in the early-twentieth century) was relegated to the past. What was needed was a creative individual who possessed the motivation and initiative to establish a new synthetic form, an individual able to impress his innovative, if subjective, view of the dramatic hero, myth, acting, music – everything – upon both company and audience. Most importantly, this individual was to extend his or her vision to the space and time of the theatrical event via the collective intent of the entire troupe. Leading figures of the Russian theatre were quick to assimilate the idea of a theatre-centered culture, which, in the post-Wagnerian period, had been regarded as being of the utmost importance. Director Alexander Tairov regarded the stage as an autonomous unit, while many others recognized it as an opportunity to construct a new reality.

Of course, Russian theatre of the revolutionary era owed much to the artistic and philosophical debates of the 1900s and 1910s, the era of Symbolism and Cubo-Futurism. For example, directors Stanislavsky and Meierkhold and poets such as Valerii Briusov and Viacheslav Ivanov, along with many other playwrights and critics, had been important contributors to the establishment of a Russian Symbolist theatre. Painters such as the mystical Symbolist Nikolai Sapunov, the ironic Sergei Sudeikin and the magnificent stylist Alexander Golovin introduced an unprecedented expressivity to the stage. Indeed, Russian Symbolist theatre belonged

equally and harmoniously to the director and the stage designer, even if the strong will of one or the other could sometimes upset the balance of their relationship.

Artists now claimed to be creating the overall design of the production and to be offering their scenic resolutions as the main concept behind the performance itself. For example, Alexandre Benois, a founding member of the World of Art group and a prominent easel painter and critic, also assumed the role of director and, in turn, directors saw themselves as the primary creators of the total world presented on stage. Conversely, traditional designers gradually left the new theatre, confronting the director with the empty space of the stage, which, like a musical instrument, lay ready to be tuned anew.

European directors such as Adolphe Appia, Gordon Craig and Max Reinhardt, champions of the new synthesis, came forth against the barren space of traditional theatrical illusion, paving the way for Meierkhold, Tairov and Evgenii Vakhtangov in Russia. Hoping to build an 'autonomous' theatre which refuted the Renaissance tradition of picturesque decoration and ornament, they tried to consolidate their new ambitions by resorting to brave scenic experiments.

The Englishman Craig and the Swiss Appia took on the role of the artist-cum-director, and their experiments found a particular, if somewhat ambivalent, resonance among Russian directors. As Craig asserted, 'Even if well educated, the director who is not an artist is redundant in the theatre, just as the executioner is not needed in the hospital!'[40] Meierkhold liked to repeat Craig's words, although Tairov, founder of the Moscow Chamber Theater in 1914 and its director until 1949, disagreed: 'Gordon Craig is wrong in proposing that the director should do the work of the artist,' continuing, 'Each of them [director and designer] has more than enough of his own work; for each of them to be a true master of his art and not a dilettante, life is hardly long enough life to bring this to fruition.'[41] Such polemics contributed to the creative and heroic parts which Meierkhold and Tairov played in this fascinating drama, even if both of them worked within the one aesthetic reality, grappling with the same artistic and theatrical problems.

For well over a decade, both Craig and the Appia exerted a formative influence on Russian theatre and, more expressly, on the practice of Russian directors. They met and collaborated with Russian directors and designers, they were a main subject of Russian critical appreciation, their statements were published in books and

magazines and their drawings were included in exhibitions. In 1911 Craig and Stanislavsky even staged *Hamlet* together at the Moscow Art Theater.[42]

Although Craig was working with a Shakespeare tragedy and Appia recreating the total viewing experience of a Wagner opera, they both shared a common purpose: to create a new formulation of space on stage, in one case for tragedy, in another for musical drama. They removed all traces of aesthetic style and historical era (after all, *Hamlet* is not dependent upon external attributes) and added universal, ahistorical scenes. In other words, they rejected specificity, filled the space with geometric forms, changing their shape countless times, and allowed for maximum play with the set materials and lighting, without changing the sense of integral unity of place. The stage was now filled with an architectural logic of pure, three-dimensional, Euclidean forms – and with a force of gravity, sense of proportion and volumetric relationship positioned in real, three-dimensional space. The hero existed beyond the everyday, beyond the theatre of concrete reality and history. No longer deterministic, the stage ceased to be just a 'medium', becoming one of space and action. In Craig's productions the space was always a tragic one, embodying eternal philosophical dilemmas such as destiny, passion and the tempers.

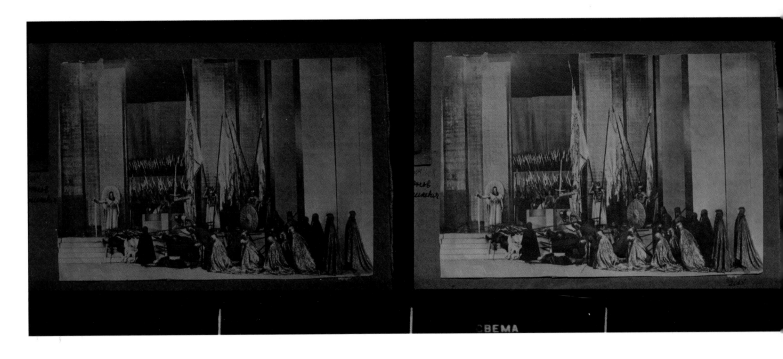

Working from the 1890s onwards with Shakespeare and Wagner, Craig and Appia began to conceive of – and implement – a 'subjectless' theatre, a theatre of pure abstraction. Long before Cubism, they offered a stage which unified the individual with a three-dimensional, spatial environment filled with abstract plastic forms. Appia's epic scenic compositions, consisting of sloping staircases, cubes and platforms, were horizontal and balanced, while Craig's architectonics were more expressive, dynamic and rhythmically intense. Via columns and pillars, their compositions aspired vertically, stretching upwards out of sight. Chiaroscuro also played a major role in the designs, empowering the space and forcing the hero to enter into tragic conflict with these scenic components, both visible and invisible.

Directors as artists, therefore, were creating a scenic score or performance amidst spatial volumes integrated with music and light, Appia even postulating a rhythm of space. The forms denoted universal meanings such as ascent or descent, impediments and battle with, liberation from, or integration with, matter. All these complex scenic experiments set the stage for a new and radical theatre of the twentieth century.

But the deep changes in the aesthetics of the theatre were imagined and elaborated not only by directors, but also by musicians, choreographers and visual artists. The founders of the Russian avant-garde of the 1910s, such as Vasilii Kandinsky, Kazimir Malevich and Vladimir Tatlin, also yielded to the temptation to create a brand-new theatre, designing compositions not on a two-dimensional canvas, but in three-dimensional space, and using the

latest techniques. The stage could not only acquaint the public with innovative plastic forms such as those of Cubism, Suprematism and Constructivism, but also orchestrate public perception and impact the viewer's soul, mind and psyche. Theatrical projects drew upon not only the aesthetic manifestos of new artistic groups, but also the intellectual convictions of luminous and brilliant individuals.

The common mission of the avant-garde directors and designers, often acting self-consciously as the conductors of their own personal performances, was to investigate new forms. Tairov, for instance, saw the primary charge of the director to be the creation of a design, a complex of forms, for the performance as a whole and for each individual ambience in which the actors would be playing – the central issue being one of the plastic art form. Tairov welcomed 'Rayists, Cubists and Futurists' to the theatre,[43] although the artist was not to 'turn the theatre into an exhibition hall; rather, before him stands the new and joyful assignment of [creating] rhythm and plastic constructions not subject to any laws beyond those of inner harmony and the effective composition of the play.'[44]

The 'effective composition of the play' leads us to Kandinsky's theatrical experiments. Although he did not belong to any particular artistic movement and was not invited by Meierkhold or Tairov to work on stage, Kandinsky grasped the full potential of theatrical composition (albeit theoretically), trying to forge a direct link between his easel painting and the theatre. Between 1909 and 1914 he wrote several plays and analytical texts about drama, or what he called 'scenic compositions', in which he expressed a deeply personal vision. He saw a primary task to

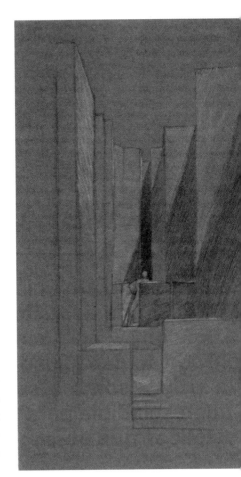

Left: Photograph by Ph. Link & E. Link (signed by Edward Gordon Craig): Maque of stage design for *Hamlet* produced by Edward Craig and Konstantin Stanislavsk the Moscow Art Theatre, Moscow, 1911. Made for 'International Theatre Exhibition in Zurich, 1914. Bibliothèque Nationale d France, Paris (reproduced from A. Herrera Gomez: Edward Gordon Craig. El espacio como espectáculo. Catalogue of exhibition La Casa Encendida, Madrid, Spain, 2009-2010, p.164)

lay in the manifestation of these visions as, for example, in his play *The Yellow Sound*, which one researcher, for example, recognizes as the symbolic performance of a 'loss of innocence under the aegis of higher forces. In this case, the stage was a temple or a religious rite depicting a mystery wherein the very concretization of that mystery was the primary task of the artist-director.'[45] Kandinsky did not consider the project to be utopian and, in 1914, prepared a live performance for the stage in Munich together with Alfred Kubin, Franz Marc and August Macke (which, however, did not come to fruition).

For Kandinsky, the three-dimensional space of the stage was a physical phenomenon, not just a series of plastic ideas. True, he developed some, but by no means all, of these ideas in his abstract paintings, whereas on stage he embodied them in abstract forms and colours in space so that the 'composition' itself evolved in proportion as it was being perceived by the viewer.[46] The result was a harmonization of all the artistic media – coloured light and sound, music, dance, words – constituting the directorial task of the creator of the 'scenic composition'. The ingredients of the performance were now spots of colour, zones of moving light, virtually faceless and shapeless figures, voices projected into the space of the traditional stage with its portal frame, where these components 'acted', now reinforcing, now weakening the intensity of the manifestation. In accordance with Kandinsky's score, these ingredients formed an ensemble in this most ordered of worlds, consistently yielding the lead role one to the other.[47]

Here was the theatre of Kandinsky, a genuine theatre of the avant-garde, which, through stage design, had produced an expressive, plastic super-reality. Still, it is important to distinguish between the 'theatre of the avant-garde' and 'avant-garde theatre'. The theatre of the Russian avant-garde denoted a transference of the artist beyond the realm of easel painting. Radical painters, for example, Cubists (or, in Russia, the Cubo-Futurists), demanded a three-dimensional space and, logically, chose stage design for the further development of this space. When the aesthetic programme of this or that group (for example, the Union of Youth painters, poets and musicians in St. Petersburg) was not confined to the issues of painting and aspired to render a

much broader impact on reality, artists entered the theatre (as well as baiting the public with their scandalous behaviour on the streets and at their exhibitions).

One such encroachment was Mikhail Matiushin and Alexei Kruchenykh's opera *Victory over the Sun*, produced in St. Petersburg in December 1913. After two desultory rehearsals, the performance was delivered on a professional stage accompanied by an out-of-tune piano and a student choir (most of whom were untrained) and, most importantly, with sets, costumes and lighting by Malevich. The opera ran for only two nights (sold out, even if the tickets were expensive), but in its wake left scandals, raucous reviews, vivid memories and notoriety. It was a collective enterprise, the producer being the poet and author of the libretto, Kruchenykh, the composer Matiushin and the artist Malevich, and was a strikingly imaginative combination of *zaum* – transrational language and imagery. Describing the destruction of the sun, a symbol of all past cultures, the opera advanced a new people, a new civilization, a new cosmology and a new mythology – exactly the right kind of environment for such an '*anti-misterium*'. Malevich's design concept was highly innovative, the backdrops, for example, depicting fragments of objects and archaic symbols and, according to memoirs,[48] he also used light to great effect for creating transrational images of the new world and its inhabitants. The poet Benedikt Livshits recalled:

> The novelty and distinction of Malevich's method lay primarily in the utilization of light to create form. This confirmed the existence of an object in space. Principles accepted by painting since Impressionism were transferred for the first time into a sphere of three dimensions… Painterly stereometry was created within the confines of the scenic box for the first time and a strict system of volumes was established, one which amplified the element of change (which the movements of the human figures might have introduced) to a maximum. These figures were cut up by the blades of lights and deprived alternately of hands, legs, head, etc., because for Malevich, they were merely geometric bodies subject not only to disintegration into their component parts, but also to total dissolution in painterly space. Abstract form was the only reality, a form which completely absorbed the entire Luciferan futility of the world.[49]

Later on, Malevich developed his designs for *Victory over the Sun* into his Suprematist system, including the *Black Square*, and heightened his awareness of the potential of the new artistic method. In 1917, he recast his attitude toward the performance of 1913, announcing the messianic role of the theatre and bidding artists to 'move away from the life of the crowd, tearing their bodies and washing their hands stained by the crowd' on to the stage so as to touch 'the spirit of the world'.[50]

Like Kandinsky and Malevich, Tatlin also developed his conception of a new universe by means of the theatre, although his approach was very different and distinctive. After all, Tatlin was not an abstract painter, a transrationalist or a champion of outsider culture. Rather, he was concerned with material in its original form such as wood, metal and paint, with its intrinsic properties and with their palpable existence in space and time. True, Tatlin never completed his early theatrical projects, although it is significant that they were for operas, one of the first being his set and costume designs for the popular and 'official' opera, *A Life for the Tsar*, which he made for the Tercenary of the House of the Romanovs in 1913. Here Tatlin worked within the boundaries of the traditional stage with its portal, making conditional, but still figurative, designs relying on a deliberately archaic technique. His second major enterprise was Wagner's *Flying Dutchman* (1915) – a complex system of images which integrated numerous costume sketches with large and picturesque backdrops and which, with its light priming and glazing techniques, brought to mind conventional easel painting, especially of the Old Masters.[51]

Even if it was not produced, *Flying Dutchman* is a microcosm of the early 'theatrical' Tatlin, demonstrating the indubitable influence of Meierkhold (and perhaps of Appia) in his key interpretation of the proscenium with its slopes and inclines[52] – even if, by 1915, they could have been regarded, of course, as examples of Cubist stylization. Still, Cubism as a consistent lexicon is absent here – the blueness of the designs, luminous and pictorially convincing, is irrational and a long way from Cubist analysis (the network of the ship's rigging in the background is brought into relief only in the lower part of the stage which lacks the horizon line dividing air and water). The natural elements and the foundations of the universe are air, water, earth, light and shadow, i.e. Tatlin dedicates his picture to the elements of the world and to our genesis arising from the collision of the elements. Tatlin creates a pictorial plane, constructing and destroying it simultaneously, while he balances the centrifugal motion of the whole by resorting to a reverse movement back towards the centre of the two dark, translucent masts which could be called shadow rays. Thanks to this transparent portal, concrete reality is practically nonexistent inasmuch as the upper part of the light-coloured mast favours the plane of the portal as if within the spectator's space. The result is a new version of the Wagnerian cosmogony. At the same time we observe a dynamic development of the scenic space, for it has become a world filled with light and music.

Most of Tatlin's early stage designs remained as drafts only. However, one production did involve Tatlin both as director and designer, namely, the staging of Velemir Khlebnikov's supertale, *Zangezi*, at the Museum of Artistic Culture in Petrograd in 1923. Working on this dramatic poem enabled Tatlin to combine his artistic understanding of the elements of the world with the ideas of the great Futurist poet and apply them to the living word. The main character, the prophet Zangezi (whom Tatlin himself played), enunciates his own historical and philological discoveries, i.e. his 'Law of Time', explaining the laws of historical events, and his 'Alphabet of the Mind', a new universal language based on the concordance of sound and meaning.

In the auditorium, Tatlin constructed material forms concomitant to the worldview of Khlebnikov who 'looked at the word as plastic material' and as a 'building block'. Sixty coloured panels bearing words form part of the material construction – primary natural materials and colours correlating to the fundamental elements of speech. On stage, Tatlin built a pyramidal composition in which the dominant feature was a vertical narrow cone, embodying a 'rough, straight cliff, resembling an iron needle'. The vertical tilt of the earth's axis recurred in many of Tatlin's sketches (such as the ship's mast and the lone tree in *Zangezi*) and is one of the archetypes which he used for organizing space on stage throughout his long theatrical career.[53] Tatlin sought to make the artistic work of Khlebnikov accessible to the masses, erecting the *Stairway of the Thinkers* construction, for example, in the auditorium, much to the delight of the spectators. He also used projected lighting, moving the rays back and forth from the thinker Zangezi to the uncomprehending crowd. Tatlin long considered the production, while not completely understood by the public or the critics, to be a remarkably harmonious embodiment of text and scenic space. Until the early 1930s, Tatlin returned to the ideas of *Zangezi* several times.

In productions such as *Victory over the Sun* and *Zangezi*, the artists of the avant-garde pointed the way towards radical developments within the theatre itself, even if they were often too audacious to become mainstream. For example, the startling revelations of the theatre of the avant-garde, such as belief in the existence of 'force-lines' and in the active, spiritual force of light embodying the seeming emptiness of the stage, were seized upon by directors and implemented by radical artists in their new guise as stage designers. Thanks to this strong interest in avant-garde

Opposite: Vladimir Tatlin: Set design for Nikolai Punin's and Vladimir Tatlin's production of Velimir Khlebnikov's drama poem *Zangezi* at the Museum of Artistic Culture, Petrograd, 1923, Charcoal on pap 55 x 76. State Russian Museum, St Petersburg. Inventory No.: SR B 417

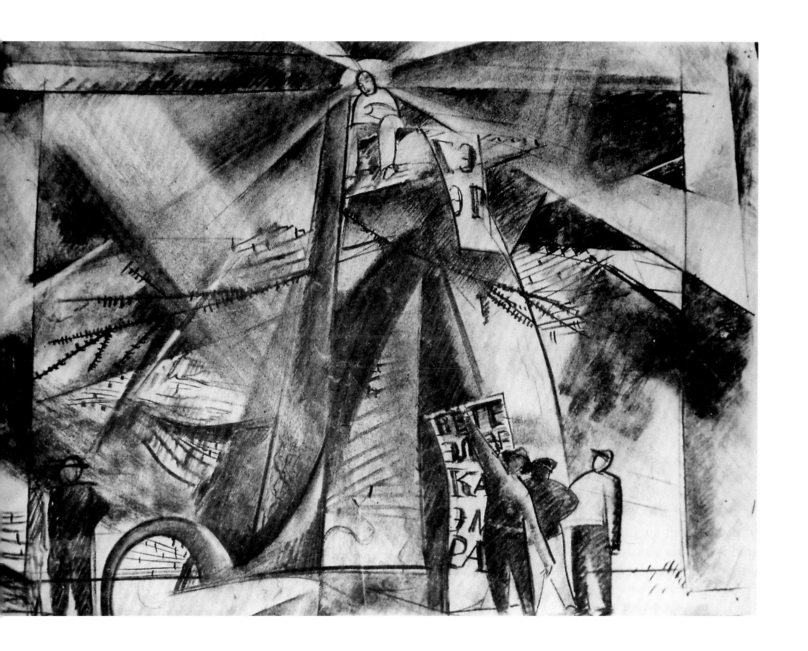

art on the part of directors and actors, Tatlin exerted a profound influence on the avant-garde theatre in general.

Of course, Tatlin's counter-reliefs – the sculptural objects which reflect his concepts most fully – seem far removed from the theatre. However, exhibited in 1915 onwards, they made a strong impression on Meierkhold who, on 25 October 1917, wrote the following about the new Russian art: 'We are all summoned to turn up the soil. In the West there are Reinhardt, Appia (light), Georg Fuchs, Craig. In Russia "Craigism" and "Fuchism" are only transitional stages. Futurism. The internationalism of the Russian direction… Constructivness. Tatlinism for the theater,'[54] – even if, only seven months before, Meierkhold had produced perhaps the most traditional and yet sumptuous performance the Russian stage had ever witnessed, i.e. Mikhail Lermontov's *Masquerade* designed by Golovin. True, during the preceding decade Meierkhold had made numerous theatrical discoveries (putting him on the same level as Appia, Craig, etc.), and his writings demonstrate that he also wished to become a major player on the new, global stage. But Meierkhold now left the strong geometries of Craig and the creative light of Appia behind to cross the threshold of Futurist theatre and encounter a new form in the work of Tatlin – in the autonomous forms of his concrete, fundamental materials. Even so, the 'constructiveness' which Meierkhold associated with Tatlin had little or nothing to do with the theatrical Constructivism of the 1920s, because Tatlin's resolution was not a question of utilitarian, constructive design. Rather, 'constructiveness' was a new property of space, containing the reality of the present, not of the symbolic, and of materials assembled by the hands of the artist. That Meierkhold referred to Tatlin is not accidental: in 1917 he invited the artist to collaborate on the production of a film and mentioned his name over twenty times in his diaries for the summer of that year.[55] The cross-fertilization of

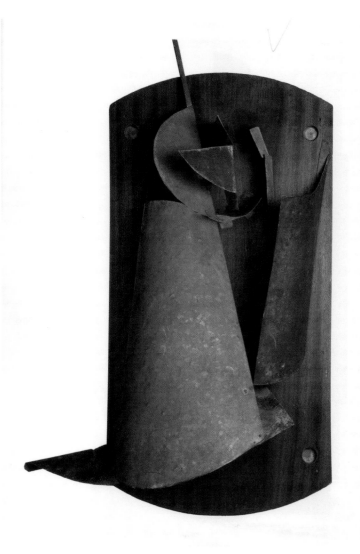

Vladimir Tatlin: *Counter-Relief; Selection of Materials*, 1916. Wood and metal, 100 x ● x 27. The State Tretyakov Gallery, Moscow. Inventory No. 10982

imir Tatlin: *Corner Counter-Relief* (artist's
nstruction of a 1915 work), 1915-25.
, bronze, wood and hawsers. 71 x 118.
Russian Museum, St Petersburg,
ntory No.: PF 200

their ideas has still not been studied sufficiently, although 'Tatlinism for the theatre' surely informed the curriculum which Meierkhold followed in his theatre classes in and around 1918,[56] where students studied to become directors-designers, often creating physical models of stage compositions. One of the students, stage designer Vladimir Dmitriev, even put together a directorial explication of Emile Verhaeren's *Les Aubes* which, in 1920, he adapted to Meierkhold's production at the RSFSR Theatre. In their reviews, critics mentioned Dmitriev's counter-reliefs as being a method of organizing Meierkhold's creative concepts: 'A counter-relief on stage with ropes proceeding upwards and tightened with bent iron' is how Viktor Shklovsky described the staging of *Les Aubes*,[57] and Meierkhold himself pointed to Tatlin's plastic objects as a source of new design concepts: 'If we turn to the latest followers of Picasso and Tatlin, then we learn that we are dealing with similar aims. We construct and they construct... the texture of more important patterns... Give posters to the contemporary audience, let them perceive the materials in the play of surfaces and volumes... with great pleasure our artists will discard the brush and take up axe, pick and hammer and begin to carve decorative scenes from the data of nature.'[58] In *Les Aubes*, Meierkhold confirmed his commitment to Tatlin's aesthetic beliefs, although in a 1926 pamphlet published on the occasion of the fifth anniversary of his theatre, he did express regret that *Les Aubes* had been marred by 'aimlessness'.[59]

Les Aubes was a strongly ideological, revolutionary production which appealed to the new mass audience. Its spatial design, built entirely according to the principles of Appia and Craig,[60] was enhanced by stairs, cubes and a column in the centre as well as by counter-reliefs, even if what Tatlin was calling 'material selection' drew sharp criticism from the establishment. Of more interest is the fact that both director and designer offered elements of non-figurative decoration, familiar from the work of Appia and Craig, as an

allegory of the old world which was then destroyed in the course of the performance. One of Dmitriev's sketches showed how the characters broke up the 'non-figurative' column with sticks, no doubt emphasizing the turning point on stage when universality and unity of spirit and space ceased to be relevant.

It was on the Soviet stage that Cubism, with its apology for three-dimensionality and plastic abstraction, made its last appearance, but after 1921 it was Constructivism which triumphed (the art of utilitarian form with installations for the performers and moving scenery). Liubov Popova's celebrated scenic construction for Meierkhold's production of Fernand Crommelynck's *The Magnanimous Cuckold* in 1922, for example, was indifferent towards a specific space, its portability allowing for performance in any desired place. Constructivism quickly became the fashion, even if, by 1925, it had ceased to evolve or at best enjoy favour in the metropolitan areas, although for several years thereafter traces could still be seen in the provinces, like ripples on water.

At this point the things of everyday and real props began to return to the Meierkhold stage: the production clothing (*prozodezhda*) of Constructivism now yielded to the historical costume and Meierkhold focused his directorial efforts on

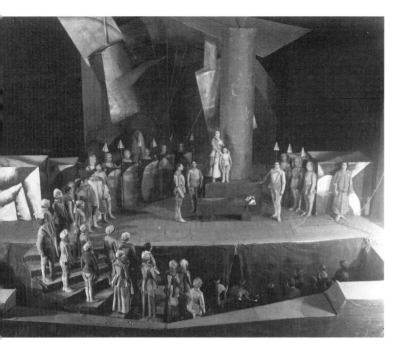

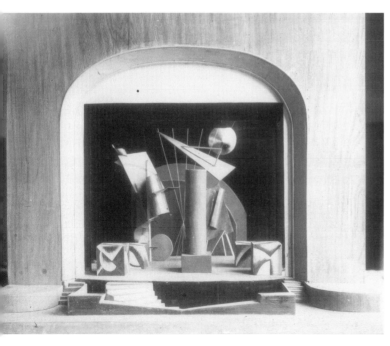

involving the public in the dramatic action. The maquette for Sergei Tretiakov's play *I Want a Baby* (1927-30, not produced), projected by Meierkhold and designed by El Lissitzky, illustrates this quest: practically the entire auditorium was to be converted into a stage, while the space surrounding the proscenium was going to be equipped for audience participation (an amphitheater for the audience which would participate in the discussion of the play), while the proscenium itself was to jut out into the auditorium so as to involve the public.

The maquette served as the prologue to Mikhail Barkhin and Sergei Vakhtangov's design for the new theatre building, which was to have responded to Meierkhold's ideological, aesthetic and practical exigencies. The elliptical scheme, reminiscent of the Wagner theatre at Bayreuth, took the democratic amphitheatre as its starting point. The stage was to consist of two arenas located on a single axis and nestled in the podium of the amphitheatre which were to have none of the attributes of the old stage – no ramps, wings or even fire escapes. At the same time, thanks to theatrical machinery, the arenas could descend into the hold for complete change of design, rotating and functioning at different levels. The theatre was also to be linked directly to the street – with gates on the right and left, allowing crowds of people and even lorries to enter. During intermission, the actor's space would have mingled with that of the spectator, the respective zones demarcated and opened to the public. In this way, the entire building would have become a total theatre, utilitarian and eminently adaptable – separated from Appia and Craig's philosophical, existential and eternal space by a mere two decades. But the project met with a tragic end, dying as a consequence of the sharp changes in aesthetic orientation which took place

in the 1930s. Meierkhold's theater (GOSTIM) was closed in 1938, followed by the arrest and execution of Meierkhold himself.

Let us return to the Modernist 1910s and Constructivist 1920s and to Tairov's work for his the Chamber Theater. Unlike Meierkhold, Tairov excluded the idea of a single producer capable of fulfilling the functions of both director and artist. In any case, Tairov worked with the finest painters of the Russian avant-garde, including Alexandra Exter, Alexander Vesnin and Georgii Yakulov, but, in contrast to the 'theatre of the avant-garde,' these artists of the 'avant-garde theatre' discovered the transcendental in specific phenomena of the theatre, revealing the elemental and the transformative, via the theatrical space of the actor, his body, plasticity, living word and so on. Tairov, director and practitioner, explained: 'I, builder of the stage, penetrate the visible phenomena, and out of the miraculous process of the Universe I take primordial crystals, in the creative harmonization of which is concealed the joy and strength of my art. These primordial crystals are the basic geometric forms which serve as building blocks.'[61]

Tairov's 'primordial crystals' are the objects which fill the tangible theatrical stage on which actors perform and which spectators view, recalling once again the space and stereometry of Appia and Craig. The non-figurative, three-dimensional décor, which Tairov described as 'primordial crystals', can, for example, be equated with the material designs which the Cubist, Exter, executed for the Chamber Theater productions of *Thamira Khytharedes* after Innokentii Annensky's dramatic adaptation in 1916, and of Oscar Wilde's tragedy *Salomé* in 1917.

Tairov and Exter were working along the lines of Appia and Craig, combining their diverse spatial coordinates – horizontal and vertical – and methods of creating the scenic

Vladimir Dmitriev (reconstruction by Yako Shtoffer): Set design (1919) for Vsevolod Meierkhold's production of Emile Verhaere *Les Aubes* at the Theatre of RSFSR No. 1, Moscow, 1920. Bakhrushin State Central Theatre Museum, Moscow. Call No.: KP 180169/473

composition. *Thamira Khytharedes,* for example, relied upon various levels, wide horizontal squares, cubes and narrow vertical cones *à la* Appia, looking like cypresses. The proportions were very important, because, thanks to them, everything was geometrical, devoid of allusions to architectural elements, while the details were perceived as a kind of proto-architecture still at one with nature. Satyrs and nymphs, their bodies painted, were 'living' in this natural environment, while, with its appeal to antiquity, Thamira's clothing emerged as the most architectural of all the costumes. The production may also be described as *à la* Appia, thanks to the lighting scheme which Alexandre Salzmann (Zaltsman), assistant to Appia, had staged at Emile Jaques-Dalcroze's Institute in Hellerau. Tairov wrote:

> While working on *Thamira Khytharedes*, I was lucky to meet a magician of light and to learn of the miraculous secrets with which this genuine and generous artist wished to enrich my work… The scenic box, looking almost like a coffin and unchanged throughout so many quests, in mute impotence parted before a powerful flood of light, permeating the

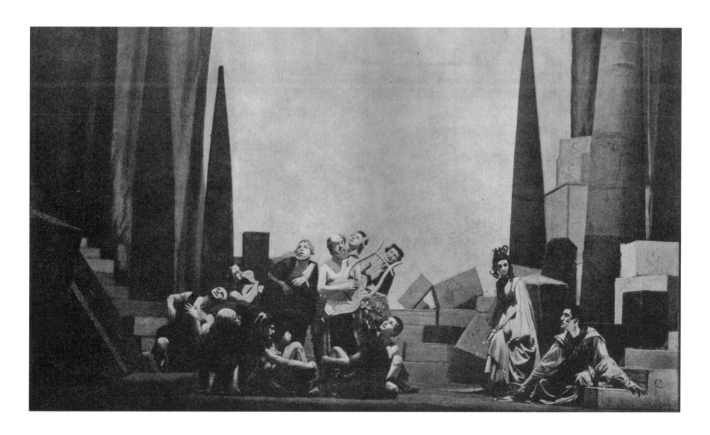

maquette so that walls now vanished, the luminous atmosphere changing colour in response to the slightest pressure of the control lever.[62]

Salomé, on the other hand, was more Craigian owing to the vertical pillars (the tops of which are hidden from the audience) and to the dynamic fabrics and curtains, the ups and downs of which accompanied key moments in the plot. In *Salomé*, Exter created a truly unified stylistic world – a stereometic scenery combined with the geometry of Cubist costumes. Two other performances at the Chamber Theater were put on using the same stylistic system, i.e. Paul Claudel's *L'Annonce faite à Marie* (1920) and Jean Racine's *Phèdre* (1922), the designs for which were made by the Constructivist architect Vesnin.

Exter's third project for the Chamber Theater was *Romeo and Juliet*, in no small degree her own brilliant solo, critics referring to the Baroque plasticity of her Cubist sets and costumes. In the many drafts which she made for each costume, Exter applied the principle of colour dynamics (having worked with this extensively in her graphic work). For *Romeo and Juliet*, she drew upon her rich experience of colour, rhythm and space, so as to create a theatre of the avant-garde rather than an avant-garde theatre, even if critics did note that the sheer effect of the plastic forms might kill the performance. Unfortunately, when speaking about Tairov's presentations, we can never really understand their magical impact on the audience without seeing the actual *mise-en-scène* in space, its rhythm and plastic movement, or without seeing Alisa Koonen, the great actress playing *Phèdre*, hearing her voice, feeling her passion, or seeing her cross the stage in her low *konturni* and crimson cloak.

By way of epilogue we might recall one more performance at the Chamber Theater belonging, however, to a very different epoch. In 1933, Tairov put on Vsevolod Vishnevsky's play *Optimistic Tragedy*, a distinctive 'creative report' on the 17th Congress of the Bolshevik Party which resounded with popular quotations from Lenin: 'The death of the leader of the proletariat, the death of thousands of workers in the struggle for a truly democratic republic, physical death… being the greatest political achievement of the proletariat, the greatest implementation of hegemony in the struggle for freedom.'[63] The main character of the play was a female commissar engaged in a psychological duel with a mob of anarchical sailors which she turns into a combat unit before being slain in battle. It was a very intense and passionate performance with a non-figurative set designed by Vadim Ryndin.

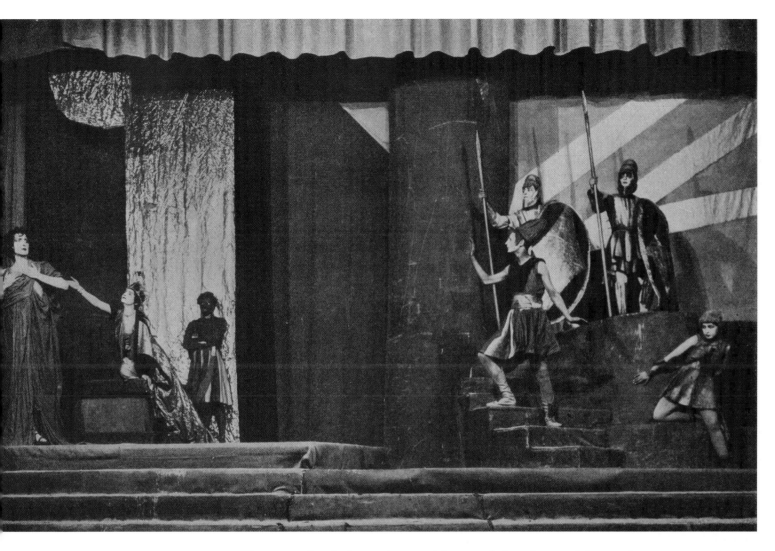

However, in their copious critiques of the play and its performance, reviewers focused on philosophical and aesthetic issues, not on the scenery. Tairov himself mentioned that the tragedy was driven by a 'struggle between centrifugal and centripetal forces, i.e. by "the gradual descent and the ultimate fall of the centrifugal force", and the "increasing strength of the centripetal force".'[64] Ryndin's model is spare in its composition with a low, three-stage amphitheatre, decreasing in size from one side of the stage to the other so as to create the illusion of spatial

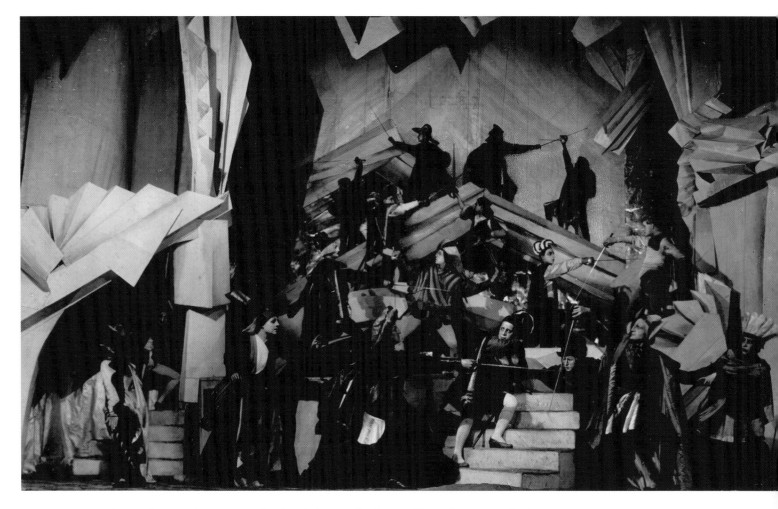

recession, and was located against the backdrop of a boundless horizon (of a theatrical sky) and across the entire floor of the stage. On the left in the middle stood a podium (the initial design and maquette show a small oval amphitheater). As architectural forms, these simple plastic elements were important, because they elicited a wide range of associations – from the culture of antiquity to contemporary reality – and allowed the director to imbue the performance with strong character, with the dialectics of history and with the tragic death of youthful beauty.

The scenery for *Optimistic Tragedy*, sporting everyday objects and real human beings (as opposed to machines), owed much to Appia. But, ultimately, the discovery of abstract forms as the expression of things timeless, eternal and universal, which took place on the stage of the early-twentieth century, formed part of its own genetic code. Ryndin's 1933 set germinated from fundamental theatrical principles and from an era when, so to speak, directors clasped unto themselves the nature of theatre as such, a sentiment which totalitarian ideology was soon to erase from cultural practice.

Translated from the Russian by Justin Trifiro

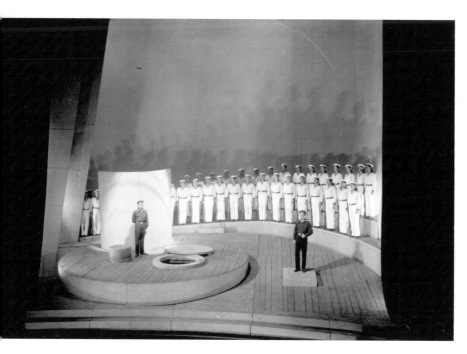

Nicoletta Misler

Precarious Bodies: Performing Constructivism

One way of approaching the issue of avant-garde performance in Russia is to examine the roles or, rather, aesthetic transmutations of the body as they reflected the various stylistic tendencies of the time. Indeed, the relationship of the body to costume and set design, especially in dance, may be regarded as a specific form of what, in the 1920s, was codified as the 'Art of Movement'[65] – an artistic and kinetic phenomenon well represented in 'Russian Avant-Garde Theatre: War, Revolution & Design, 1913–1933'.

The notion of revolution in dance or performance is certainly no less important than that in the visual and literary arts, as Alexei Sidorov,[66] historian of the new dance asserted in 1922: 'Of all the contemporary media in artistic creativity, the brightest star ascending above the grey mundaneness of rebirth is the magnificent and free art of dance.'[67] As secretary for academic affairs at the Russian (State) Academy of Artistic Sciences (RAKhN/GAKhN) in Moscow in the early 1920s[68] and co-director of its Choreological Laboratory (which did much to develop the concept of the 'Art of Movement'), Sidorov had every right to make this statement. This prestigious think tank, established in Moscow in October 1921, under the auspices of the People's Commissar for Enlightenment, Anatolii Lunacharsky, and

Photographer unknown: Russian (State) Academy of Artistic Sciences on Kropotkinskaia St., Moscow, in the 1920s. Gabrichevsky Family Archive, Moscow

directed by literary historian Petr Kogan, became a primary center for research into the theory of movement, its physiological extension and its visual registration. Vasilii Kandinsky was also a founding member of RAKhN, although he left for the Bauhaus in December of that year to continue his own experiments in painting, design and pedagogy, cultivating a particular interest in dance.

In some sense, in its theoretical and practical investigations into the new forms of bodily expression and into both traditional and mechanical ways of recording them, the Choreological Laboratory at RAKhN was trying to recapture the grandiose project of a synthetic or monumental art of which Kandinsky had dreamed so fervently and which the younger generation of the avant-gardists had inherited. The researches conducted by dancers, choreographers and scientists on the art of movement from the early 1900s onwards were manifold and potential, painters and photographers often recording them as immediate visual testimony. Indeed, the repertoire of pictorial and photographic images which has come down to us documents the vast panorama of experiments which were carried out at the Choreological Laboratory in association with other institutions such as the Central Institute of Labour (TsIT – responsible for the development of the scientific principles of bio-mechanics). Experiments there ranged from the *danse plastique* to rhythmical gymnastics, from the ergonomic rationalization of movement in the workplace to cinematic movement (captured in Petr Galadzhev's film posters), from outdoor physical education to acrobatics, from contortionism to the circus.[69]

> We feel that contemporary dance can be created by inoculating it with various elements from the art of the theatre. Dance must become active and imagistic. In this respect, gesture in dance, too, should assume a concrete meaning which expresses this or that psychical agitation or action… Therefore, we must come to terms with the fact that the new dance differs from the old by virtue not only of its content, but also of the purely formal devices which bring it close to the theatre, cinema and the circus.[70]

Such were the words of choreographer and mime Alexander Rumnev, one of the strongest protagonists of the Choreological Laboratory. Like other modern dancers, Rumnev was fascinated by the latest experiments in Expressionist dance in Germany and Austria conducted by Kurt Joos and Mary Wigman, in particular, and by the notion that stage and costume would be 'revolutionized' as a result of the new, transformative attitudes towards the body and of the European fashion for *Korperkultur*.

It was a passion for the circus or, rather, for the art of the circus (now elevated to a superior position within the synthetic arts) which brought practitioners and theoreticians of dance closer to representatives of other performance disciplines. These included Sergei Eisenstein (cf. his costume design for the *Mexican* at the First Labour Theatre of Proletcult in 1921), Alexander Rodchenko (creator of numerous relevant paintings, drawings and photographs) and the choreographer Kasian Goleizovsky who took lessons in acrobatics from the famous clown Vitalii Lazarenko,[71] even if, as a dance professional, Goleizovsky maintained that acrobatics, 'auxiliary and facilitating the immaterial movements of the body',[72] were to be used only as physical exercise and not as pure dance.

Another essential element which the Constructivists borrowed from the circus was the specificity of its stage, i.e. a capacious arena filled with sand which could be supplemented with various props and kinds of equipment according to the interpreters of the diverse acts – clowns, acrobats, tightrope-walkers, contortionists, etc. In turn, during the presence of the performer the arena could be emptied of any mobile structure which he or she might be using rather than the performer having to exit and re-enter during the traditional scene change. Eisenstein's stage design for *Heartbreak House* of 1922 is a case in point – here is a miscellany of circus and gymnastic numbers and methods, eliciting a sense of merriness and playtime just like toys for grown-up children.

To a considerable extent, and for this very reason (the functional and syntagmatic reliance on human exigencies), the new stage, like the circus arena, became the organic extension of the movements of the body. For example, this is manifest in the choreography which Lev Lukin (pseudonym of Lev Ivanovich Saks) composed for the new ballet *Sappho* to music by Artur Lourié in 1923. The only equipment on stage here was a platform in the shape of a diagonal pyramid with concentrically ascending passages, a contraption so essential to the choreographic action that it was re-erected *en plein air* for the photographic sequence which pictorialist Nikolai Svishchev-Paola made.[73] This

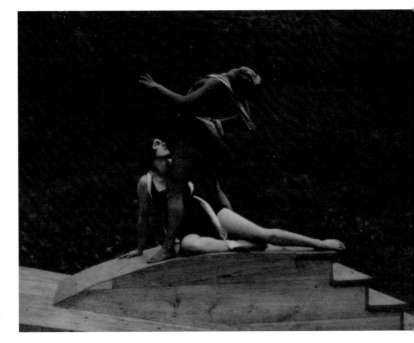

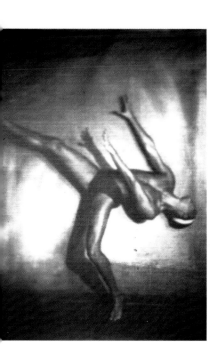

specific installation was intrinsic to the very style of Lukin's dance lexicon, since he tended to emphasize the horizontal thrust in his choreographical applications.

If, historically speaking, the common denominator of Constructivist stage design is Liubov Popova's celebrated stage design for *The Magnanimous Cuckold* of 1922, perhaps an equally striking example of the new approach to scenography (and closer to the worldview of the choreographers of the *dance plastique*) is Alexandra Exter's design for the *Satanic Ballet*, an unrealized production for the Moscow Drambalet which Goleizozvsky choreographed to music by Alexander Skriabin in early 1922. Naked bodies – in keeping with Goleizvosky's interest in the culture of nudist performance – were to have leapt and twisted along diagonal ladders leaning against a void as if to confirm Exter's conviction that 'free movement is the fundamental element of the theatrical act. Above all, the bland contemporary stage should be enriched with movement,'[74] adding, 'only architectonic constructions created by the application of volumetrical forms can fuse with the harmonious plastic whole and its freely moving figures.'[75] In the *Satanic Ballet*, transparent larvae of human figures – naked mannequins of a pre-digital choreography – would have hovered over the minimalist structures of ladders, bridges and platforms like infallible avatars fluttering within abstract multiplications of spaces.

Daughter of the Symbolist tradition, but militant believer in Futurism, Exter sublimated the eroticism of the naked body as if reducing it to virtual skeletons of computer animation – a procedure contrary to the artists and photographers at the Choreological Laboratory who, in the body laid bare, emphasized the transience and instability of its movements, its fleeting interior expressions and even what they recognized as the ephemeral presence of its soul. Testimony to this is provided, for example, in Moisei Nappelbaum's photo-portrait of Rumnev, where, with torso thrown all the way back, he hangs in a precarious balance on one of his long and slender legs.

The visual results of these researches on the naked body, along with other experiments, were displayed at the four 'Art of Movement' exhibitions which the Choreological Laboratory organized between 1925 and 1928. Looking at the objects on display, mainly documentary photographs, but also drawings, sculptures and diagrams of movements, in the only panoramic view which has come down to us (of the second exhibition of 1926), we note that certain Decadent

themes still prevail – harking back to the Symbolist generation of poets and painters and constituting a forceful presence in spite of the prudery of Soviet censorship. Indeed, the protagonists of what was still a marked tendency – such as the scholars Sidorov and Alexander Larionov (co-director of the Choreological Laboratory),[76] artist Boris Erdman, photographer Svishchev-Paola, mime and dancer Rumnev and choreographers Goleizovsky[77] and Lukin, with their refined and unconventional taste and attention to the complex and synthetic relationship of dance, visual arts, poetry and music – may well be regarded as epigones of the great Symbolist tradition.

Photographer unknown: Isadora and Irma Duncan with their young students in Moscow, 1921. Original print, 12.1 x 20.6. Bakhrushin State Central Theatre Museum, Moscow, Call No.: KR 252504/4306

In any case, we can, of course, trace the genesis of free dance in Russia back to the luminous image of Isadora Duncan,[78] who, since 1904, the year of her St. Petersburg debut, often visited Russia and even opened her own school in Moscow in 1921. Her Symbolist connection with Edward Gordon Craig notwithstanding, Duncan initiated the revolution of the body on stage, presenting it as the primary dramatis persona and reducing the stage to an untrammelled field of light, wherein the dance and music 'bear the human body into a fluid of rays, subordinating it to the power of emotional experiences'.[79] This was Duncan's first and fundamental behest for an avant-garde of plastic dance, a condition pregnant with consequence, destined to transcend even the predictions of Duncan herself and resulting in the disappearance of the very stage upon which dancers had been performing for centuries.

It was Georgii and Vladimir Stenberg who implemented a 'choreography of light' in their stage designs for two 1926 productions at the Chamber Theater, i.e. *The Hairy Ape* and *Day and Night*, a resolution recalling Exter's earlier projects there such as *Salomé* in 1917 in which:

> the set… consists of coloured planes moving by means of an electric current. Their dynamism should conform strictly to the action in the drama. The effect of moving coloured planes derives from the emotional power of the harmony of the colours. The light can also be modulated. In this way, the the light in the auditorium and onstage increases, weakens and modulates in colour and intensity, according to the course of the drama.[80]

Later on, Exter developed her 'light theory' more forcefully in her *Don Juan* of 1927 and in the unidentified ballet project which she captioned *Construction of Light* in 1928. Once again, the result is the total assimilation of the body into planes of light and colour and the annihilation of its physicality in the play of light on stage. Earlier on, Exter had even subverted the traditional style of the theatrical costume with the 'Cubo-Baroque'[81] richness of her designs for *Romeo and Juliet* intended for Tairov's Chamber Theater in 1921 (not produced), but by the late 1920s had arrived at a total asceticism of figures, disembodied and, therefore nude, although quite without erotic appeal.

Of course, the subtle discourse between the vested and the unvested body was more complex than a simple dialectic between eroticism and Puritanism. The artists and critics who debated the meaning of the Art of Movement were well aware of that complexity and, in fact, claimed that it was absolutely essential to

unveil the body in order to examine the mechanics of its movements, both physical and psychological. As Sidorov observed:

> First of all, it should be said that the costume for the dance is certainly not the same as for the stage. It is not judicious to conceal the working mechanism of the body…It is not our fault if the public perceives the naked body as some kind of raw and untreated material which nine times out of ten it is. When every point of the body is alive and when even the slightest muscle participates, only then does the performer have the right to appear totally nude. On this level, the issue of costume now passes to the issue of make-up for the body on stage.[82]

Like Exter, other stage designers used a variety of styles and inventions for their costume designs, adapting them to both actor and dancer and to the particular genre of the performance. Erdman, for example, desexualized the performers in a geometric explosion of forms and colours for the production of *The Moneybox* at Boris Ferdinandov's Experimental-Heroic Theatre in 1922. But Erdman also 'undressed' the dancers for Goleizovsky and Lukin, directors who were strong supporters of the naked body on stage,[83] and who, for example, applied Constructivist triangles and circles directly on to the body – which Rumnev 'wore' during his Viennese tournée in 1926.

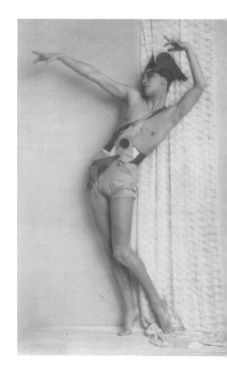

Photograph Studio of Trude Geiringer and Dora Horowitz, Vienna: Alexander Rumnev during the tour of the Moscow Chamber Theater in Austria, 1926. Original print, 22 14.9. Bakhrushin State Central Theatre Museum, Moscow, Call No.: KR 317322/74

Sidorov, too, astute observer of the new dance,[84] emphasized that free dance needed a 'liberated costume', responding to the emancipation not only of the feet from pointe shoes, but also of the whole body from the tutu and the bodice and the institutional accessories of the Classical ballet – a 'liberated costume' of particular value to *ektsentriki* (clowns) performing the sudden shifts and turns of their outlandish dances: 'Throw away the glad rags called costumes and hitherto bearing merely aesthetic significance. In rejecting aestheticism, we reject such costumes. The dancer should be dressed in production clothing, enabling the body to move freely.'[85]

In 1922, perhaps inspired by Exter and their collaboration on the *Satanic Ballet*, Goleizovky and Erdman projected another 'Constructivist' stage design or rather 'stage construction' for the ballet called *Faun* to the music of Claude Debussy. Sidorov has left the following description: 'That's how it is with his [Goleizvosky's] *Faun* placed on its high ladders, convincing us that dance has no need of decors especially of the kind which simply erase the body.'[86] The only surviving photograph shows us a 'real' ladder leaning against the wall creating 'a movement of lines along amazing constructions (the fragmented performance area allows for movement along a vertical, thus making the presentation lighter)'.[87] The graphic interpretation of *Faun* which Galadzhev used as a cover for the journal *Zrelishcha*

[Spectacles] in 1922[88] makes this capacity of the construction manifest, alluding immediately to its acrobatic potential.

In spite of these and other similarities in the design work of Exter, Goleizovsky and Erdman to a gymnastic display, balletic acrobatics were often performed with emotional expressivity and conjugated with ecstasy. The form of the choreographic design itself was close to a Symbolist ornament, reflecting the aesthetic ideology of the Choreological Laboratory with which both Exter and Goleizovsky were very familiar. Even when the Laboratory 'reconstructed' some of the performances outdoors, such as the ballet *Sappho* or the ballet *Faun* (choreographed by Inna Chernetskaia to music by Ernö Dohnányi), it did so not as a mere training exercise for future mass parades. In 1922, for example, *Pan*, was staged triumphantly in the presence of Lunacharsky and two years later was then photographed 'in the wild' by Nikolai Vlasevsky and Boris Zhivago. The formal occasion for this session was an 'Art of Movement' exhibition, but the deeper intention was to render the Dionysian element of the performance, synthesizing body, music, movement and costume into a Wagnerian totality (not by chance did Chernetskaia call her studio Studio of Synthetic Dance).

The rigorous structures of *Satanic Ballet*, *Faun* and *Sappho* were dictated by, or at least, connected to, the musical selections (above all, Debussy and

Skriabin) and thematic subjects (Salomé, for example) peculiar to the Symbolist sentiment – something which free dance often elicited in its devotion to the Silver Age, on the one hand, and in its utopian dash to the future, on the other. Goleizovsky's costume for *Etude* in 1921, dancing and flying in its chromatic scale of purple and blue, reveals the permanence of the Symbolist spirit in the body of the avant-garde. Goleizovsky, this artist-cum-choreographer, often imagined his heroes in the form of flying creatures such as dragonflies, moths or butterflies,[89] as is manifest in his costume design for the dance improvisation *Moths* which he produced at the Mamonov Theatre of Miniatures in Moscow in 1916.

The moth, like the butterfly, must escape from the chrysalis of reality so as to fly free above and beyond. But the moth, like the butterfly, is destined to die within the space of a single day, becoming a symbol of the closure of the impermanence and the precariousness of the body in the dance, an image which Sidorov synthe-

sized perfectly in his metaphor: 'To love a butterfly is difficult; indeed, at the slightest touch dust scatters from its rainbow wings. A butterfly must be loved cautiously and tenderly, for it may fly away whither it had come – to Eden. That is how I imagine the love of the dance'.[90]

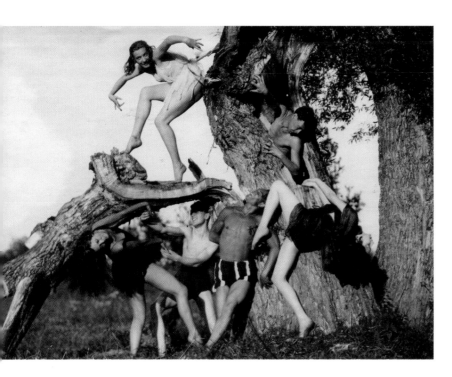

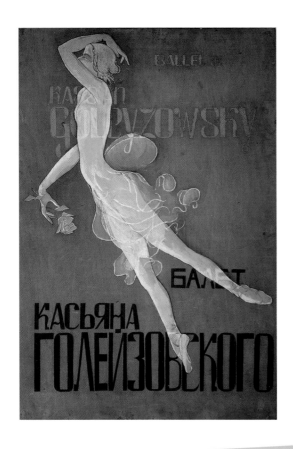

Kasian Goleizovsky: Poster advertising The Kasian Goleizovsky Ballet, 1929, pencil, gouache and whitening on plywood, 10.5 × 71.4. Kasian Goleizovsky Family Archive, Moscow

Mark Konecny

Flying Mice, Stray Dogs and Blue Birds: Russian Intimate Theatre

The cabaret, the café and the music hall provided a rich and fertile setting for the intense exchange of ideas, social, political and artistic, both in pre- and post-Revolutionary Russia. The artists and writers who often visited the clubs brought with them the intellectual ferment of the times: the music, philosophy and art of Modernism was presented to the public in small, smoky cellars with exotic and whimsical names like Bi-Ba-Bo and The Stable of Pegasus, The Bat (in Russian: literally, 'flying mouse') and The Stray Dog, The Blue Bird and The Café Pittoresque.

While we tend to associate the intimate theatres with penniless bohemian artists and writers, in fact, the Russian cabaret, as entertainment, was geared to the taste of an idle class which could spend large sums of money on an evening out. It was, by all accounts, not unusual for a gentleman to attend the late-night performances with his lover or a lady of indifferent reputation with whom he could enjoy a racy farce. Restaurants, bars and small clubs would allow the demimonde to mix with an upper class who wanted a little more excitement. The artistic presentations (usually skits, songs and one-act plays) in the cabaret were brief, which meant that there would be several different writers, actors, singers and artists working at the same time, giving the audience and the artists themselves a chance to compare and contrast a variety of styles and ideas. Vsevolod Meierkhold, for example, brought together artists such as Nikolai Sapunov and Sergei Sudeikin to give his cabarets, *The Strand* (1908) and *The House of Interludes* (1910–11), a specific Neo-Nationalist style, echoing the bright colours and Slavic themes of the Ballets Russes.

Numerous cabarets opened in Moscow and St. Petersburg/Petrograd in the 1910s and early 1920s, some of them decorated by celebrated artists: The Pink Lantern (1913) in Moscow had murals by the Cubo-Futurists Mikhail Larionov and Natalia Goncharova; Sudeikin was mainly responsible for the decorations at The Stray Dog

Cabaret (1911–15); in 1917 Georgii Yakulov, along with Alexander Rodchenko and Vladimir Tatlin, was the artistic force behind The Café Pittoresque. The new generation of directors, such as Mikhail Bonch-Tomashevsky, Nikolai Evreinov, Meierkhold and Alexander Tairov, also moved away from the rigid Naturalism that had dominated Russian theatre towards more abstract conceptions. Whether in reaction to the pre-eminence of radical artistic experiments or because they sensed that the new movements in theatre and art shared a communality, the impresarios and directors of cabarets now commissioned Cubo-Futurists to design sets, costumes, props and murals.

Indeed, Russia's cultural renaissance in the literary, visual and musical arts also left a profound imprint upon the thematic and visual function of intimate theatre, experiments of the 1910s laying the foundations for the revolution in the proletarian theatre of the 1920s. Undoubtedly, the informal performances in the clubs and intimate theatres of c. 1913, for example, served as a source of inspiration for Liubov Popova's installation for *The Magnanimous Cuckold* and Varvara Stepanova's costumes and designs for *The Death of Tarelkin* in 1922 and perhaps even for Alexandra Exter's designs for the film *Aelita* in 1924 – and many other dynamic stage designs which have come to be associated with proletarian theatre. A clear case in point is Malevich's sequence of set and costume designs for *Victory over the Sun* of 1913 which served as the basis for El Lissitzky's marionette interpretation of 1923 (i.e. his portfolio of designs, *Die Plastische Gestaltung der Elektro-Mechanischen Schau 'Sieg über die Sonne'*).

If the Neo-Russian or Neo-Nationalist style dominated stage design in the 1880s and 1890s, it was only in the aftermath of the social and political reforms of 1905 that Russian theatres began to explore the possibility of adjusting to the Western institution of the cabaret, bringing artists, writers and directors into the new 'little' or intimate theatre, resulting in the establishment of, for example, Meierkhold's Strand, Evreinov's after-hours club called Crooked Mirror and Boris Pronin's Stray Dog (supported by Nikolai Kulbin and Lev Zheverzheev), all in St. Petersburg. Furthermore, the many circuses, variety theatre, restaurants, bars, vaudevilles, revues and summer stock theatres, which provided light entertainment, were often identified as 'cabaret' by the Russian audience.

Unlike its European counterpart, Russian cabaret was very much a theatrical venue, emulating the 'high' theatrical venues of music and chamber theatres with

repertoires of one-act plays, operettas and ballets. However, these little theatres avoided political satire in favour of a more widespread reliance on theatrical experimentation. Under the watchful eye of the Tsar, the Russian cabarets and variety theatres with their established repertoires were not conducive to political dissent or irreverent humour, censorship and police control precluding the lively banter so prominent in Weimar cabaret. Each monologue, sketch and song was submitted to the theatrical censor in advance, and any deviation from the set script had to be explained and justified by the directorate of the theatre. Debates, lectures, poetry readings and discussions were also subject to scrutiny, although, evidently, official control was less rigorous.

Direct interaction between the pre-Revolutionary avant-garde and the theatre was erratic and turbulent, manifest primarily in a few performances in hired venues. With the encouragement of Zheverzheev and Kulbin, for example, the Union of Youth in St. Petersburg recast the theatre as a logical extension of the *Gesamtkunstwerk*. Funded for the most part by Zheverzheev, the Union brought together a number of remarkable artists and musicians, including Pavel Filonov, Kulbin, Malevich, Mikhail Matiushin, Iosif Shkolnik and Tatlin, although some of their colleagues, including Konstantin Dydyshko, Peter Lvov and Sviatoslav Nagubnikov, as students of the Academy of Arts, preferred not to work in popular theatre.[91]

Of key importance here was the staging of the 'folk spectacle',[92] *Emperor Maximilian and His Disobedient Son Adolf*, on 27 January 1911, the first Russian 'Futurist' performance, which served as a model for much later experimentation. Adapted by 'A. Spektorsky' (a pseudonym, apparently, of Bonch-Tomashevsky, the director) from Nikolai Vinogradov's publication of the play in 1905,[93] *The Emperor Maximilian and His Disobedient Son Adolf* was performed in St. Petersburg at the Suvorin Theatrical School and then in February at Meierkhold's House of Interludes. The production consisted not only of the drama itself, but also of numbers performed by acrobats, folk musicians and minstrels who strolled through the audience. The play coincided perfectly with the format of the cabaret, combining many different styles of performance and variety theatre. The main action advanced by interludes or phases, with a so-called Cavalry Marshall acting as a master of ceremonies and scene-shifter much as a compère or comedian might solicit and supervise the rapid changes in the cabaret.

One of the most interesting elements of *The Emperor Maximilian and His Disobedient Son Adolf* was the large number of artists who contributed to the sets, costumes, props and general decorations of the auditorium. Evgenii Sagaidachnyi designed the main backdrop, while ancillary spaces and vestibule, creating the impression of a tavern, were decorated by Sofiia Boduen de Kourtene, Alexander Gaush, Mikhial Ledantiu, Iosif Shkolnik, Savelli Shleifer and Georgii Verkhovsky.[94] Sagaidachnyi painted the back panel in a *lubok* style highlighted in gold, while the sets evoked the spirit of both Byzantium and Suzdal.[95] Incidentally, preliminary sketches for the costumes had already been drafted by Boduen de Kurtene, Mikhail Mizerniuk and Zheverzheev the year before.[96]

Many reviewers commented on the success of *The Emperor Maximilian and His Disobedient Son Adolf* precisely as a folk drama, Alexander Rostislavov, for example, asserting that the designers had produced superb costumes and sets recalling the style of the antique *lubok*.[97] Indeed, Russian folk theatre, unlike traditional Western theatre, tended to be a series of vignettes pursuing a narrative by analogy and metaphor, fluid and malleable according to the exigencies of the performers and the audience. In his 1920 study of *The Emperor Maximilian and His Disobedient Son Adolf*,[98] for example, Alexei Remizov noted nineteen distinct variations of the play.

Bonch-Tomashevsky also took his *Emperor Maximilian* to the Moscow Literary-Artistic Circle on 6 November 1911, this time commissioning Tatlin to make the designs.[99] But Tatlin's designs were more stylized, the entire action took place on stage and the costumes were not as exuberant as in the St. Petersburg performances, even if the sets were bright and beautiful as evidenced by the yellow, blue, red and green of Maximilian's tent.

Obviously, the Russian Cubo-Futurists regarded the theatre as a solid platform for promoting their new artistic ideas, the two productions of *Vladimir Maiakovsky. A Tragedy* (designed by Filonov and Shkolnik) and *Victory over the Sun* (designed by Malevich) being a case in point. Performed on 2 and 4 December, and 3 and 5 December 1913, respectively, at the Luna Park Theatre in St. Petersburg, the two events brought together key members of the Russian avant-garde, i.e. poets Velimir Khlebnikov and Alexei Kruchenykh responsible for the libretto, and composer Mikhail Matiushin for the music, of *Victory over the Sun* as well as Filonov, Maiakovsky and Shkolnik working on *Vladimir Maiakovsky. A Tragedy*. A subvention from Zhev-

Bernard Wall, Copper Lithograph portrait Nikita Balieff. *The Russian Players in Ameri The Moscow Art Theatre*, Balieff's Chauve-Souris. Text by Oliver Sayler, New York, Bernard Wall, 1923, p. 34

erzheev enabled them to rent the Luna Park Theatre, pay the actors and build the sets,[100] even if, as poet Benedikt Livshits recalled, the result was far from professional:

> There was no real troupe, dramatic or musical, of which the Futurists might have availed themselves. It so happened that the actors had to be chosen from among students, for whom this unexpected job was manna from heaven. [101]

Whatever the validity of this statement, in fact, the selection was a deliberate one, precisely because the students had had no practical experience.[102] After all, the radical concepts of Maikovsky's monodrama or of Matiushin's Cubo-Futurist 'opera' could never have been implemented by professional actors, even if there had been willing candidates. In any case, as Matiushin indicated, the visual aspect of *Victory over the Sun* was also somewhat lacking:

> And what was happening to Kazimir Malevich, who, for economic reasons, was not allowed to paint with the colours and dimensions he had planned? The costumes were not made according to his drawings and wishes. There was no possibility of making a sufficient number of duplicate costumes. One is amazed at his energy and the fact that he created twenty large pieces of decor in four days.[103]

It is probable, therefore, that Malevich's drawings for the costumes are not representative of the actual sets or of the costumes worn for the performance, and although he never recorded his impressions of the performance, he seems to have been dissatisfied with the result. On the other hand, in his memoirs, Kruchenykh did praise Malevich for the designs:

> The stage was decorated just as I had hoped and wanted, illuminated by the blinding lights of projectors. Malevich's sets consisted of large flats with triangles, circles and machines parts.[104]

Of course, the sets and costumes did represent a landmark for Malevich, who claimed that involvement in the opera inspired his first experiments with Suprematism.[105]

Shkolnik's backdrop for *Vladimir Maiakovsky. A Tragedy* functioned as a guiding metaphor for the dramatic narrative, i.e. the Futurist revolution will take place against the backdrop of the old society and the Futurists are bringing their art out of the studio into the street. Shkolnik also imported metaphors from the dramatic text into the set design – iron sardines, sewer pipes, and pretzels[106] – a mix of poetical and visual imagery which intensified the interplay between the poet (Maiakovsky) and the environment still more, and which turned into the psychological landscape of the poet's creative production. For his part, Filonov used

cardboard cut-outs like paper dolls held in front of the actors, a procedure which actor Alexander Mgebrov described as 'bewildering'.[107]

Although the events at Luna Park were intended to mark the triumphant debut of the Cubo-Futurists in the theatre, in fact, they were their last major collective experiment until after the Revolution. The onset of the Great War and the October Revolution made further such ventures impossible, so that, for better or worse, *Victory over the Sun* and *Vladimir Maiakovsky. A Tragedy* hold the distinction of being the most finished and mature avant-garde spectacles in Russia. Perhaps a more substantive move into cabaret might have culminated in an even more powerful flowering of Cubo-Futurist theatre, although its viability as an ongoing commercial venture, able to impress and scandalize night after night, is dubious, indeed.

It is ironic that in the wake of the October Revolution, the medium of the cabaret, with its subversive content often directed at the philistines and with its strong connections to the avant-garde, would have been regarded as a bourgeois institution. Even though Anatolii Lunacharsky, head of the People's Commissariat for Enlightenment, was supportive of theatrical innovation, it was clear that by 1920 there was little room for variety theater in Russia – Bolshevik taste was for the more traditional theatre of Alexander Ostrovsky, Anton Chekhov and Maxim Gorky, or for the proletarian didacticism of the Blue Blouse company and workers' clubs. Cabaret tended to be regarded as a vestige of the Imperial order and, consequently, its actors and directors alien to the new Russia. Impresarios of the pre-Revolutionary cabarets such as Nikita Balieff (director of The Bat) and Jascha Juschny (director of The Blue Bird), for example, recounted distasteful meetings with Soviet officials which prompted their abrupt departure – and they were not alone, many of their actors, writers and artists also ending up in Berlin,

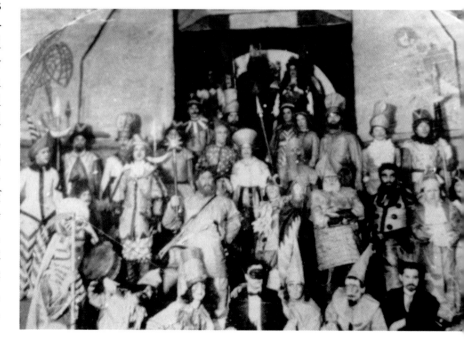

Paris and New York. While some of them were well educated with a proficiency in a language other than Russian, this was not the norm, a defect which presented an almost insurmountable problem for Russian actors and directors abroad. Even artists, ostensibly working in a 'universal' form, lacked the personal connections, name recognition and negotiating skills to function in the West.

It is tempting to suggest that intimate theaters in emigration such as Nikita Balieff's Bat (known as the Chauve Souris) or Jascha Juschny's Blue Bird (Blaue Vogel) were the true heirs to the rich tradition of the domestic cabaret. After all, many of the artists, directors and actors, not least Exter, Boris Romanoff and Evreinov, left Russia to work in the émigré theatres of Europe and the United States, while others decided to make careers in silent film. But that is not the whole truth, for, in fact, the cabaret did continue to influence the professional stage – and stage design – in Soviet Russia. After all, many of the artists who worked in the intimate theatre did remain in Russia and continued to elaborate styles which they had first investigated before the Revolution.

Perhaps the most intriguing set of experiments in adapting cabaret to the new Russia was the Blue Blouse. Created in 1923 by Boris Yuzhanin as a vehicle for agitational propaganda (agitprop), the Blue Blouse was a 'living newspaper' meant to inform and educate workers about current affairs. Performers often carried cardboard cut-outs to identify their characters (a top hat for a Capitalist, a big pencil for a bureaucrat, for example), echoing the earlier experiments of the Cubo-Futurists.[108] In keeping with the idea of the collective hero in Socialism, the Blue Blouse was never centralized into a single troupe and individual actors were not given star roles. Blue Blouse troupes were licensed and established throughout the Soviet Union and their skits and performances left a formative influence on experimental directors such as Nikolai Foregger and his Mastfor (theatrical workshop), and Sergei Yutkevich.[109] By the late 1920s, there were 484 professional companies within the network of the Blue Blouse.[110]

posite: Anonymous photographer, cast *otograph* of Tsar' Maksim'ian, Union of *th* production, *Teatr i iskusstvo*, St. *ersburg*: Z. V. Timofeeva (Kholmskaia), *47*, 1911, pg. 12

ve: Anonymous photographer. Interior of *Chauve Souris*, photograph reproduced *Nikolai Efros, Teatr Letuchaia mysh' N. F. ieva. Obzor desiatletnei khudozhestvennoi oty pervago russkago teatra-kabare. trograd]. Knizhnyi Postavshchik: 18], 43

Émigré cabaret and the Soviet proletarian theatre intersected one more time: in October 1927, the founding company of the Blue Blouse toured Germany, playing to 150,000 spectators, and as a result, Blue Blouse groups were also formed in Germany, Czechoslovakia, Great Britain and the United States.[111] In turn, the costumes, sets and bio-mechanical movements of the Blue Blouse had a profound effect on European theatre, most notably on Berthold Brecht, who witnessed one of their performances at Erwin Piscator's theatre in Berlin.[112] Although the émigré Russian cabarets were resistant to the rhetoric of Communism which the Blue Blouse was exporting, both the Chauve Souris and the Blaue Vogel were careful to incorporate analogous materials into their own repertoires, often updating costumes and sets to reflect a Constructivist aesthetic.

The Russian and Soviet music hall and cabaret have largely been forgotten, and they are mentioned only rarely in the history of theatre; skits, popular songs and vaudeville numbers do not translate well into the modern day. The political puritanism of Soviet theatre during the Stalin era pushed what had been a vital and dynamic art form into the periphery of theatrical enterprise, while other forms of popular culture, especially film, became much more central to public entertainment. However, confronted with the wealth of visual materials produced by the artists who worked in Russian cabaret, we can still sense the creative energy and innovativeness which resulted from the collaborations of writers, directors, impresarios and designers who gathered together in the Russian intimate theatre.

Elena Strutinskaia

Paris 1925: The European Premiere of the Russian Theatrical Avant-Garde

Few are the exhibitions which have changed the trajectory of cultural development to bring entirely new artistic phenomena into the cultural arena. One such event was Joseph Paxton's Crystal Palace at the 'Great Exhibition' in London in 1851, which provided a new perspective in architecture; another was the wave of Impressionist and avant-garde exhibitions at the turn of the century, inaugurating a new era in visual art; yet another milestone was the section devoted to Soviet theatre at the 'Exposition Internationale des Arts Décoratifs et Industriels Modernes' in Paris in 1925.[113] The Exposition summarized the results of investigations undertaken by the Russian avant-garde during the Revolutionary years, presenting a full range of innovative accomplishments from 1917 to 1925 and suggesting new avenues of enquiry for international designers, directors and actors. As a matter of fact, the Exposition held much more importance for the history of Western art than for Russian art, inasmuch as it received only minimal coverage in the Soviet press, with only a very cursory discussion of the theatrical section, and its success in Paris had little effect on the development and destiny of theatre in the USSR.

The First World War had halted meaningful cultural exchange between Russia and Western Europe. Only after Germany and the USSR signed the Treaty of Rapallo at the Geneva Conference in April 1922, was the economic, political and cultural boycott of Russia lifted and international connections re-established. Shortly thereafter, for example, the Moscow Art Theatre (MKhAT) and its First and Third Studios (MKhAT 2 and the Vakhtangov Theatre respectively) and the Moscow Chamber Theater toured abroad. Nonetheless, Europe knew little about Russian theatre and, conversely, Soviet Russia had little information about the

contemporary art of France, Germany, Italy or Great Britain. While preparing for his French tour in 1923, Alexander Tairov, director of the Chamber Theater, voiced his concern that the Russians would be 'knocking at an open door', i.e. that what the Soviets considered to be innovative in theatre had already been 'conceived and assimilated in the West'. But seeing the real state of affairs dispelled his fears: 'The West is dead and will not rise,' he concluded.[114] Actually, far from 'knocking at an open door', the Russian theatre provided an escape out of the aesthetic cul-de-sac into which its European counterpart had fallen, a solution which manifested itself with particular effect just after the Exposition. Indeed, the primary intention of the Exposition was to present not only the artistic currents of 1925, but also those of the previous twenty-five years, a momentous stage in global history: the First World War, revolutions in Russia, Germany and Hungary, the break-up of two empires, the emergence of new nation states across Europe, enormous progress in the sciences, technology and industry. In the wake of the new structures and fast pace of post-war life, collective consciousness – the popular *Weltanschauung* – had changed and impacted the prevailing styles in art.

In 1923 the French government announced its plan to hold an international exhibition of modern industrial and decorative arts from May until October of 1925. In the spring of 1924, preparations were in full swing with participant countries beginning to construct their pavilions. In October of 1924 diplomatic relations between France and Russia, severed after the October Revolution, were reinstated, and on 1 November, the French Foreign Minister, Edouard Herriot, telegraphed the Soviet government, inviting the new Russia to take part in the Exposition.

For the Soviet authorities, participation in an international exhibition of this magnitude was first and foremost a political affair, so they accepted the invitation with alacrity, despite having less than six months to earmark funds for building the pavilion, to select, transport and install the works and, in general, to take care of all the logistics. It should be noted that Germany, whose economy was in equally bad shape, declined to participate.

The organization of the Soviet contribution was entrusted to the State Academy of Artistic Sciences (GAKhN) and the All-Union Society for Cultural Relations Abroad (VOKS). Both institutions had some degree of experience in organizing exhibitions, including one of the first major, post-Revolutionary presentations of Russian artists in Europe – at the 'XIV Esposizione Internazionale d'Arte' in Venice

in 1924. Literary historian Petr Kogan was appointed Chairman of the Soviet Committee for the 1925 Exposition (re-baptized in Paris as General Commissar of the Subdivision of the USSR), while Olga Kameneva, Lev Trotsky's sister and wife of Lev Kamenev, was appointed Chairman of the Artistic Committee (her husband had been director of the Theatre Department at the People's Commissariat for Enlightenment and a key member of the Communist Party Politbureau from 1918 onwards).The regulations for the Paris Exposition were based on a system of thirty-seven 'classes' or types of exhibits, divided into five basic categories: I – architecture (classes one through six), II – furniture (classes seven through nineteen), III – clothing (classes twenty through twenty-four), IV theatrical, urban and landscape design (classes twenty-five through twenty-seven) and V – educational design (classes twenty-eight through thirty-seven). Members of GAKhN participated in the planning stages of the Exposition, for example, Vladimir Morits was assistant chair of the committee, while painter David Shterenberg, assisted by Alexander Rodchenko, was artistic director. The selection committee included Shterenberg as chairman and Rodchenko as deputy chairman, assisted by Morits, art historians David Arkin, Nikolai Punin and Yakov Tugendkhold, Mikhail Kristi (member of the People's Commissariat for Enlightenment), Nikolai Bartram (director of the Toy Museum), critic Viktor Nikolsky, as well as artists and stage designers Sergei Gerasimov, Petr Neradovsky, Isaak Rabinovich, Georgii Yakulov and Alexander Vesnin. The formation of the theatre section was entrusted to a commission of experts led by Shterenberg, assisted by Morits, Rabinovich and Yakulov, who selected the sketches of sets and costumes, models, posters and photographs of performances. Except for Morits, all the commission members were artists directly related to the theatre (film-makers, actors and theatre critics did not take part in the deliberations). After heated debate, the commission shortlisted 305 submissions for the theatre section, including thirty-nine maquettes, numerous set and costume designs, actual costumes, posters and photomontages. A closed competition to design and build the pavilion was also announced, projects being evaluated according to novelty, functionality and economy. The Soviet government afforded a modest 25,000 rubles for the construction of the pavilion,[115] although other national pavilions were far more expensive (for example, according to Kogan, Italy's pavilion cost 250,000-300,00 rubles[116] or five million lire by Ilya Erenburg's account).[117] On 11 January, 1925, six weeks after the competition had been announced, the newspaper *Izvestiia* published the results: Konstantin

Melnikov's project had been selected.[118] Eight days later the architect left for Paris: he had until 19 April to complete the project.

Built out of wood and glass and painted grey, red and white, Melnikov's pavilion was light, austere and functional. Rodchenko chose the colours, while Viktor Bart and Alexandra Exter painted Melnikov's kiosks on the Esplanade Invalides. Melnikov's solution provided maximum use of the exhibition space, facilitating spectatorship and foot traffic and, in the opinion of many critics and architects, the pavilion demonstrated new principles of architectural thinking. Strictly speaking, the pavilion is not germane to our subject, because the theatrical section occupied another space (in the Grand Palais), even if both elements were parts of a single, unified concept. After all, stylistically, at least, Constructivism was the dominant aesthetic in both the architecture of the pavilion and the theatrical projects on display (Melnikov's aesthetic coincided with the designs by Liubov Popova, Rodchenko, Ilia Shlepianov, Georgii and Vladimir Stenberg, Vesnin, Konstantin Vialov et al. on display). In some sense, the pavilion was itself a set design, a mask that presented, albeit in disguise, the face of a Soviet culture still in its infancy, even if, eventually, that infant would be not allowed to mature. Furthermore, the

pavilion combined broader aesthetic and ideological perspectives through a merging of the spiritual and the pragmatic, prompting spectators to recognize ideas and sensations which were divorced from the actual material of the object, but embodied in the abstract. In other words, after seeing the theatre display in the Grand Palais and passing by the myriad different structures of other countries, visitors were returned to the stage in the Soviet pavilion, and not just to the models in the various exhibition booths, but also to the huge theatrical installation that was the pavilion itself – so much so that many visitors felt themselves to be participants in a theatrical performance. The effect did not go unnoticed. In *Art et Décoration*, Gaston Varenne asserted that he was impressed by the provocative ornament and open theatricality of Melnikov's pavilion: 'Perhaps the art of

the theatre is the great national art of Russia? With its audacious simplifications and disregard for verisimilitude (which might amaze the masses), it leaves behind strong impressions – and has a single aim – to achieve the absolute.' Evaluating the functional merits of the structure, Varenne underlined that the project was not simply subject to utilitarian and economic exigencies; rather, the main goal was to show the style of the future, and to do so without returning to tradition or the incremental evolution of forms: 'We see that the Soviet idea strives for the instantaneous transformation of art, with no concern for caution or gradual changes in form.'[119] GAKhN prepared a special collection of articles in French for the Exposition entitled *L'art décoratif U.R.S.S. Moscou-Paris 1925*, featuring the article 'Le Théâtre et le peintre pendant la révolution' by art historian, critic and *gakhnovets* Abram Efros (head of the department of stage design at the Moscow Art Theatre from 1920–26).[120] This was not only a commentary on the history and current state of the Russian theatre arts, but also a survey of contemporary theatre worldwide with brief descriptions of French, German, English, Italian and American theatre, and concluding with the affirmation that the USSR was the mecca of contemporary theatre, i.e. Moscow, where all the latest theatrical trends and

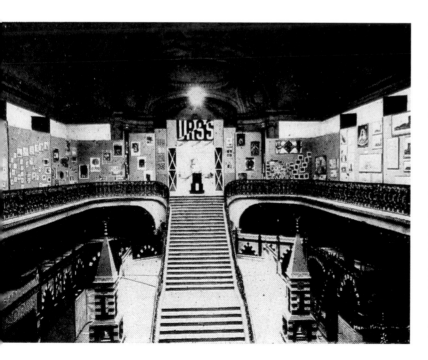

innovations were developing. Journalists and critics writing in the European press seemed to accept the Soviet pre-eminence in theatre, not because of the hypnotic charm of Efros's arguments, but simply because of the amazing variety of the Soviet display. They were struck by the novelty of the forms, the boldness of productions and the imperviousness to foreign influence. The Soviet theatre section occupied the Great Hall on the second floor of the Grand Palais. The designers of the installation, Rabinovich, Rodchenko and Yakulov, tried to convey a general visual impression of each theatre company – which included the Bolshoi, Maly and Chamber Theaters, Vsevolod Meierkhold's Theater of Revolution, the MKhAT Musical Studio and MKhAT Studio No. 2, the Vakhtangov Theatre, the State Jewish Theatre (GOSET), the Experimental-Heroic Theatre, the Moscow Children's Theatre, the Theatre of the

Moscow Soviet (formerly the Zimin) and the Comedy Theatre (formerly the Korsh) from Moscow; the State Academic Dramatic Theatre (formerly the Alexandrinsky) and the Theatre of Young Viewers from Leningrad; the Berezil Theatre from Kharkov and the Georgian State Theatre from Tiflis.

The Great Hall was filled with sketches and models from performances designed by Natan Altman, Vladimir Beier, Viktor Egorov, Boris Erdman, Exter, Robert Falk, Vasilii Fedorov, Fedor Fedorovsky, Boris Ferdinandov, Elena Fradkina, Iraklii Gamrekeli, Dmitrii Kardovsky, Vasilii Komardenkov, Boris Kustodiev, Evgenii Lansere (Lanceray), Moisei Levin, Konstantin Medunetsky, Vadim Meller, Ignatii Nivinsky, Anatolii Petritsky, Popova, Vladimir Shchuko, Viktor Shestakov, Nisson Shifrin, Shlepianov, the Stenberg brothers, Varvara Stepanova, Vesnin, Vialov and Sofia Vishnevetskaia. The exhibition covered the period 1917 to 1925, beginning with Exter's *Salomé* at the Chamber Theater and continuing with Kustodiev's *The Flea*, whose premiere had just taken place at MKhAT Studio No. 2 in February on the eve of the opening of the Exposition. Within those eight years the survey presented a short history of modern Russian theatre, a history of bold discoveries and incredible metamorphoses, a history that had erased the idea of traditional theatre.

Even if years of war and revolution had interrupted the organic evolution and the natural emergence of art movements, Russian theatre was now at the creative centre of the universe and a veritable laboratory of bold experiments. Those who conducted those experiments often quarrelled, accusing each other of counter-revolutionary and bourgeois activity, of trampling over tradition, of plagiarizing and engaging in charlatanism. There were no laws or prohibitions and everyone was forging a 'new' theatre or a 'new' art compatible with the new epoch. Each theatrical event generated an instant response, the audience at once accepting or rejecting this or that spectacle, so that ideas which ten years ago would have remained static throughout an entire season were now being discarded after a couple of months. It was during this era that Russian theatre became a global cultural phenomenon, following in the footsteps of the Russian literary, visual and musical arts. Russian theatre was dazzling and frighteningly modern. It sought – and found – forms to embody the relentless pace of the new era. The Russian tragedy of the Great War, two revolutions, the Civil War, the terror, famine and general social and economic collapse had been devastating. Civil laws, canons and conventions had been swept away, religious faith and national loyalty undermined. The people of *One Sixth of the*

World[121] were now challenged to understand what was happening and to accept – or reject – this new reality with its new ideals and new art. Soviet theatre set out to resolve these issues, seeking the right language, the right repertoire and the right audience, a sociocultural and psycho-therapeutic mission which, until now, has not been fully appreciated. In any case, the results of its experimentation impacted the European arts at a time when few, however, considered the art of the theatre to be important during the era of War Communism and when, according to Ehrenburg, the theatre 'lived beyond a liminal state and was at once joyful and despairing, for life was at once cavernous and a model for the XXI century.'[122] Theatre was in a unique position, even if the Revolution had deprived the intelligentsia of most means of subsistence. Private publishers, independent periodical presses and galleries had been closed down, the art market had fallen into decline and few had the time or inclination to think about the future, even if NEP (New Economic Policy, 1921–29), with its brief return to the free-enterprise system, did generate a partial refurbishment. Even so, the Russian theatre tried to preserve and develop its own domestic evolution: visiting Moscow and Petrograd in 1920, H.G. Wells wrote: 'For a time the most stable thing in Russian culture was the theatre… Amazingly, Russian dramatic and operatic life survived the most extreme storms of violence, and it keeps on to this day. In Petersburg we found more than forty shows going on every night; in Moscow we found very much the same state of affairs.'[123] Russian theatre had now been charged with trying to comprehend and recast this state of affairs within a contemporary dialogue. The greatness – and precariousness – of the Revolution, the very notions of good and evil, human ideals, the power of the spirit, faith and beauty… the theatre and its audience grappled with these issues, seeking reasonable answers amidst extremes: art was either the single link to a Russian culture, now vanquished, or the foundation of a new one, consonant with the Revolution. Certainly, the bid for freedom of creative expression had emerged just at the right moment, when Russian theatre was proving itself willing and able both to create new stylistic forms and to revive traditional ones.

In any case, by late 1924, most primary ideas had already been articulated and assimilated in the Russian theatre. The Paris Exposition revealed the multifarious aims and results of the various artistic leaders such as Alexei Granovsky, Fedor Komissarzhevsky (Theodore Komisarjevsky), Meierkhold, Vladimir Nemirovich-Danchenko, Vasilii Sakhnovsky, Alexander Sumbatov-Yuzhin, Tairov, Evgenii

Vakhtangov and the artists involved with their various theatres. Convinced of paving the way towards a theatre of the future, each advocated his or her independent truth, wielding aesthetic and ideological power over their audience; even if the Paris Exposition presented a unified front, irreconcilable disputes between partisans of extreme positions being left behind. Neither 'bourgeois', nor 'revolutionary' was privileged. Instead, in the quest for a new and harmonious era, what really mattered was being at the leading edge. Of the twenty countries taking part in the Exposition, only France, Great Britain, the USSR, Yugoslavia, Czechoslovakia and Sweden assembled special theatrical surveys for the Grand Palais.[124] Other countries deemed their accomplishment in this area to be less than professional and simply included occasional theatrical exhibits in their national pavilions, i.e. outside of the dedicated space in the Grand Palais. Still, several national contributions did attract particular attention, including Isaac Grunewald's scenography for *Samson and Delilah* (Sweden), Enrico Prampolini's so-called Magnetic Theatre (Italy) and Frederick John Kiesler's experimental projects (Austria). But unlike the USSR, these compositions and installations were outside of the main artistic movements in their respective countries. In the opinion of Pierre Scize and other critics, apart from the Soviet contribution, none of the national representatives expressed a truly synthetic reflection of their respective theatres. 'Fortunately, there are the Russians,'[125] Sczie affirmed, who 'shout, debate and make proclamations.'[126] – and both professionals and common folk alike attested to the truth of his statement. Indeed, the Russian display was the only one to subsume the intended spirit of the Exposition: 'Any sort of fake, copy or imitation of existing styles is strictly forbidden... In the epoch of railways, automobiles, airplanes and electricity needs must be met, and forms... are different than in previous centuries, here are forms of unprecedented beauty.'[127] Efros declared that France and the rest of Europe had expected to renew relations with a Russia 'based on 1915', but had miscalculated: 'The West was convinced that our culture lay dormant... and we were to wake up after a kiss of acceptance in the same pose as in their memories. It is curious that to this day France regards the artists of the World of Art group to be the most contemporary... The triumphant era of the Ballets Russes is still considered our highest peak.'[128] But now that the blockade had been lifted, Soviet Russia was showing Europe stage designs which were utterly unexpected, vivid and extraordinary. During its 1923 Paris tour, European critics had interpreted the Moscow Chamber Theater as an isolated

experiment, comparing it to the Futurist agenda of Prampolini's Magnetic Theatre and Kiesler's Constructivist projects. However, the Soviet contribution to the 1925 Exposition produced the impression not of piecemeal experiments, but, rather, of a more universal theatrical process, one which had been occurring over several years. If European theatre had been advancing through gradual evolution, the renewal of the Russian theatre had come about through revolution, a volte-face which was both fascinating and frightening. The undeniable novelty, force and bold independence of the Soviet display elicited both amazement and unease, especially in its complete disregard of traditional Realist and psychological theatre.

Leading figures in European theatre were unprepared for this encounter with the new Russian theatre. In a letter to Anatolii Lunacharsky, Head of the People's Commissariat for Enlightenment, Nemirovich-Danchenko (with Konstantin Stanislavsky, co-director of MKhAT) asserted that contemporary Russian theatre had, 'in relation to others, leapt forward ten or twenty years.'[129] If, during the first fifteen years of the twentieth century, it might have seemed that analogous processes had been occurring in both Russian and European theatres, after the 1925 Exposition, no one could imagine what kind of metamorphosis would be taking place in the Russian theatre within the ensuring decade.

For the European public, the 1923 Chamber Theater tour was an aesthetic shock, eliciting strong responses just a couple of years before the Paris Exposition. Critics were both delighted (Jean Cocteau, Jacques Copeau, Firmin Gémier, Georges Pitoeff) and appalled (André Antoine). An apologist of Naturalism, especially as practised by the Moscow Art Theatre, Antoine could not accept Tairov's method, regarding the Chamber Theater as a threat to French theatre and as a crash course in how to lose national traditions and destroy acting schools. Antoine was even more taken aback by the Soviet contribution to the 1925 Exposition, which, after all, was bent on undermining convention and accelerating revolutionary change in the figurative arts. Like other French critics, Antoine felt that the Realist Russian theatre could no longer hold its own and, using the maquettes of Popova, Rabinovich, Shestakov, the Stenberg brothers, Vesnin, Vialov and Yakulov as points of reference, concluded that the new conventions were leading the theatre towards abstraction and self-destruction. Indeed, Antoine had cause for alarm inasmuch as these maquettes, created for the post-Revolutionary Moscow stage, embodied the rich stylistic variety and complexity of the new directorial concepts, the more

so since only a few months, if not weeks, separated each performance, which, in turn, seemed to represent a entirely new era each time. Of course, this disparateness and density were fully appreciated only at home, French critics, for example, recognizing the evolution only in directors and designers with whom they were already familiar. On seeing Tairov's work two years after the Chamber Theater tour, for example, Scize was impressed with his radical change in style, comparing the new *mise-en-scène* captured in documentary photographs with complex mathematical formulas. He posed the question: 'What is the goal of contemporary theatre?' To which he answered: 'Simplicity.' According to Scize, illusion and bright colours had disappeared from the stage, leaving a *tabula rasa* with just a few design elements needed for the action. Light was afforded the leading role and now dominated the space so that, with the new technology, an almost Classical expressiveness was being returned to the actor's body. 'This impetuous, feverish activity has engulfed all theatrical movements. Today the art of the theatre is undergoing grandiose changes,' Scize concluded.[130] Varenne saw a new type of theatricality in the Constructivist maquettes: 'Blowing all caution to the winds, the Soviet idea is to strive for the instantaneous transformation of art, irrespective of gradual transitions in form. This idea embodies only the spirit of geometry, it is an aspiration towards the ideal, where there is no place for emotions. In their purity and nakedness, in their logical extremes, these forms strike a definitely theatrical pose, far from genuine simplicity.'[131] Such judgements about directing and acting techniques in Soviet theatre were based on photographs, sketches, maquettes and costumes, and professionals such as Antoine, Copeau and Gémier proceeded from their own practical experience in assessing what they saw. As German playwright Walter Hasenclever wrote:

Theatrical maquettes, and how many of them! Thanks to them we can study what is relevant to the modern Russian theatre and what has impacted the most important European stages of our time, beginning with Stanislavsky and ending with the work of young Russian directors... Europe became acquainted with the style and appearance of the Russian theatre during the tours of the Moscow Art and Chamber Theaters. At the Exposition we encounter Tairov's productions once again, from Oscar Wilde's *Salomé* and Charles Lecocq's *Giroflé-Girofla* to E.T.A. Hoffmann's *Princess Brambilla* and Bernard Shaw's *St. Joan.* Once again maquettes provide the impression of a director's fantasy, moving towards the free performance of his actors through their acrobatic training. The maquettes speak to the new direction in dramatic action. The stage must no longer be flat. Space is conquered. Acting is possible in all corners of the stage. Creative dramatic work, in its known forms, is adapted to the demands of the stage. Even the air is used as a stage for

action. A unity between gesture and word is a new form of performance… The constructive element now prevails on stage. If ours is the age of machines, arc lights and factory construction, maybe it can be reflected only by these means, and perhaps there arises the danger of the dissolution of the performance into abstraction. Isaac Rabinovich's maquette for *Don Carlos* can serve as an interesting example… It is a lucky nation, which, despite war, revolution, hunger and poverty, has preserved its love of the theatre![132]

Both for director and performer the maquettes dictated not only a simplicity, but also an extraordinary precision in visual judgement and the kind of rhythmic-plastic construction which could express the bold and frenetic life of the new era. Generally speaking, throughout its long and varied life, theatre never changed its basic form in consonance with stylistic and formal changes in the concurrent visual arts and architecture, an obvious process which art historians tended to ignore until they were confronted with it face to face as with the Paris Exposition, where the history of the new theatre was presented in stark clarity. Unlike the avant-garde in early twentieth-century European art, experimental, but partial, the Soviet contribution here manifested a unity of forms in set design together with new theatrical systems, wherein set design played an essential role in the overall plan of a given production. From the very favourable reviews, it is clear that critics accepted the Soviet theatre exhibition as a macrocosm, even though, in reality, it was not. True, it did provide an introduction to the Russian adaptations of Cubism, Futurism, Expressionism and Constructivism to the stage in all their essential forms and variants and, in general, illustrated what these avant-garde movements had brought to the theatre. If Expressionist forms were familiar to the European theatre (and, of course, to painting and cinema), then Constructivist installations, in such a variety of forms, were being encountered for the first time, the more so since the phenomenon of Soviet Constructivism was highly complex and heterogeneous. What the Exposition presented was a summary of theatrical activities over the past eight years (1917–25), consisting of three phases in the development of the avant-garde in general and on the Soviet stage in particular.

The first phase, from 1917 until early 1922, was characterized by the influence of Cubo-Futurist painting with its emphasis on volume and expressive colour as in Exter's scenography for *Salomé* (1917), Lentulov's for *Tales of Hoffmann* and *Demon* (1919) and Vesnin's *L'Annonce faite à Marie* (1920) and especially *Phèdre* (1922) wherein pictorial Cubism defined the spatial arrangement of the stage and whither Vesnin transposed his basic painterly idea to the theatrical environment. For his

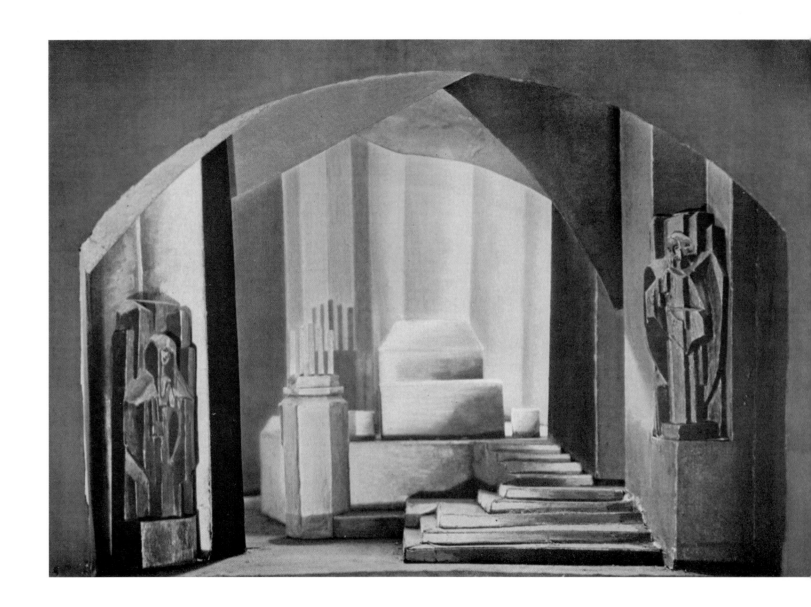

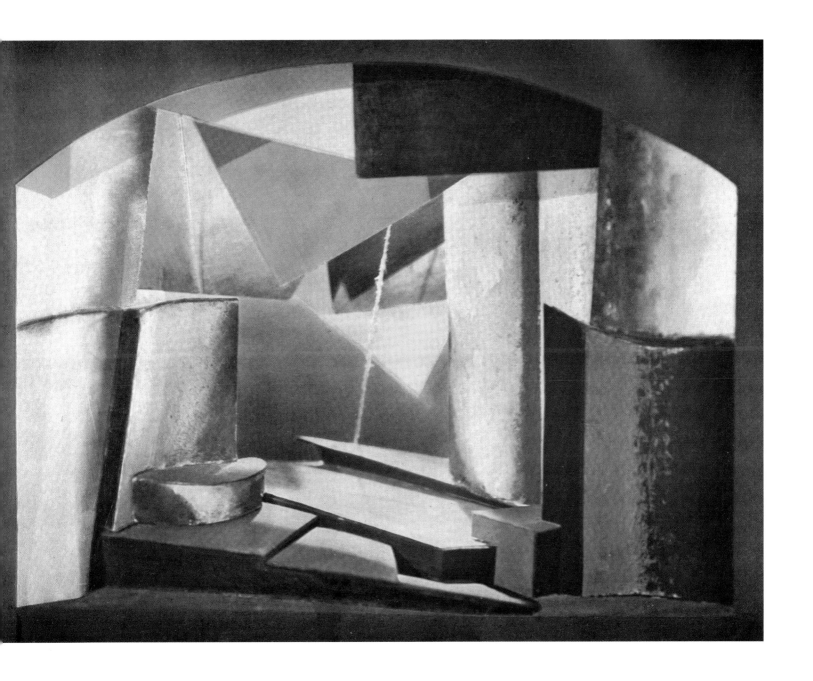

83

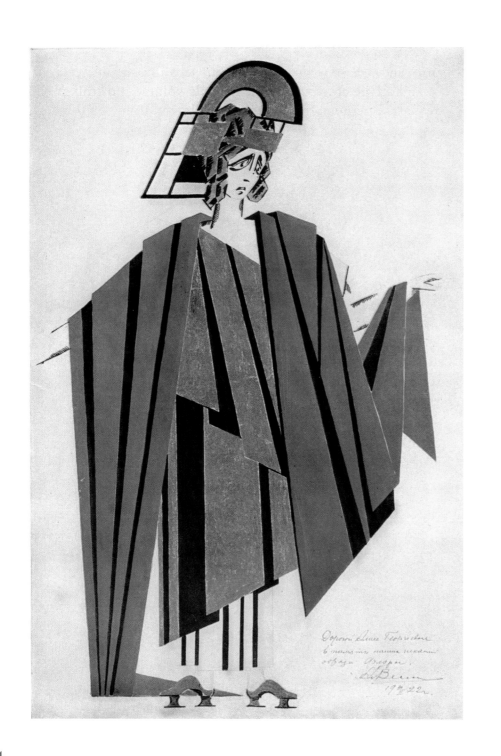

Left: Alexander Vesnin: Costume design for Racine's *Phèdre* produced by Alexander Tairov at the Chamber Theater, Moscow, in 1922

Opposite: Georgii Yakulov: Set design for *Giroflé-Girofla* produced by Alexander Tairov at the Chamber Theater, Moscow, in 1922

1920 *Princess Brambilla*, Yakulov made an expressionistic three-dimensional, painterly form, and in his set for the 1922 *Giroflé-Girofla* he interconnected the graphic arts and architecture to assume a single volume. For this production, Yakulov created something fundamentally different from anything that his colleagues at the Meierkhold theatre might have done: brightly coloured light sets the pace of the play, generating a transformative atmosphere of cheerful and youthful enthusiasm as the action unfolds. Yakulov adduced a sense of rhythm to the configuration of coloured lines, which, according to Viktor Shestakov, produced a 'new scenic grammar'. Efros was right when he wrote that in *Giroflé-Girofla* Yakulov had 'found a form that proved to be more durable than all that he had created thitherto. Yakulovian technology has penetrated all our stages.'[133] The dynamics of life demanded a new figurative means capable of accentuating movement on stage where the rhythm of a given play might suggest three-dimensional structures of various forms with unpainted textures of wood and plywood or, in other cases, bright colours might accentuate the lines and space. The emotional structure of a play was now defined by the ascent and descent of ladders, the slanting flatness of frames and the up-and-down movement of

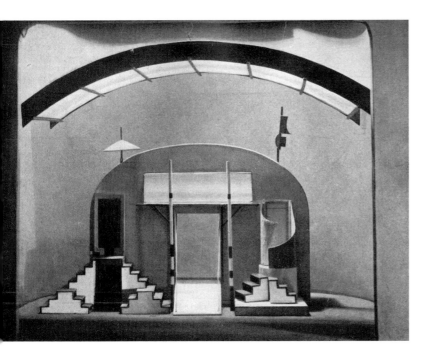

platforms, where actors tried to embody the plastic picture which this or that director had composed. These experiments defined the second phase of development between 1920 and 1923, i.e. the birth of the architectural installation and Constructivist machine. In 1920 Rabinovich introduced quasi-architectural forms into *Philip II* (unrealized) and then into the *Don Carlos* and *Die Kishefmacherin* of 1922 and *Lysistrata* of 1923. Popova, of course, used Constructivist installations for *The Magnanimous Cuckold* in 1922 and *Earth on End* in 1923 as did Stepanova for *The Death of Tarelkin* in 1922, Erdman for *The Moneybox* in 1922 and Vialov for *Camorra of Seville* in 1923. In *Don Carlos*, Rabinovich appealed to the immediate historical texture of the play, abstracting Spain's Gothic arches by reducing them to materialized lines of power. In *Lysistrata* he built a unified provisional architectural installation so as to

match the structure of the performance. In *The Moneybox*, Erdman distributed lathes about the stage and installed a parody of the Eiffel Tower – a rickety structure with which the actors and director engaged during the vaudevillian disorder. While outwardly different, all these architectural installations had one element in common, i.e. they followed a certain rhythm so as to enhance the form and emotional atmosphere of the play. The goal was to reform the stage completely – not just to abandon the old crank-and-pulley system, but also to reinvent pictorial figuration. The term Constructivist referred to different stylistic effects. On the one hand, the 'pure' Constructivism associated with the ideas of 'industrial art' was proclaimed by theorists such as Boris Arvatov, Emmanuil Beskin, Osip Brik and Alexei Gan and applied by Meierkhold to his theatre. But there was also the more decorative Constructivism of the Chamber Theater which remained faithful to its origins in painting.

Meierkhold's productions owed much to the experiments of the Soviet mass spectacle, integrating topical theatre with a sociopolitical message and drawing on the techniques of the poster. For example, commissioned by Meierkhold in 1921, Popova and Vesnin projected an ambitious installation for a mass action on Khodynka Field in Moscow (not realized), which would have been visible from all sides and could have ascended to varying heights, a resolution anticipating Popova's *The Magnanimous Cuckold* and *Earth on End* and Stepanova's *The Death of Tarelkin*. The Constructivist device was well suited to the utopian ideas of the revolutionary theatre. On stage, it was not

Above: Alexander Vesnin: Maquette for G.K. Chesterton's *The Man Who Was Thursday* produced by Alexander Tairov at the Chamber Theater, Moscow, in 1923

Left: Victor Sheskatov: Maquette for Alexei Faiko's *Lake Liul* produced by Vsevolod Meierkhold at the Theatre of Revolution, Moscow, in 1923

Opposite above: Vladimir and Georgii Stenber, assisted by Konstantin Medunetsky: Maquett for George Bernard Shaw's *St. Joan*, produced Alexander Tairov at the Chamber Theater, Moscow, in 1924

Opposite below: Viktor Shestakov: Maquette fe Alexei Faiko's *Lake Liul* produced by Vsevolo Meierkhold at the Theatre of Revolution, Moscow, in 1923

a decoration, but, first and foremost, a material object, a 'thing for acting', defining not only a new look, but also the emergence of a new theatrical system called bio-mechanics. If Adolphe Appia and Gordon Craig had been the first to grant the notion of three-dimensional architectural scenery to the theatre, the Constructivists went further, releasing the volumetrical set from the solid mass of the stage and creating three-dimensionality not from the volumetrical mass of the device itself, but rather from the lines of direction which determined their rhythm and overall design. During the third phase of 1923–25, the theatre abandoned the rigidity and skeletal image of Constructivist forms, restoring an unexpected synthesis of Constructivist abstraction and the authenticity of a new figurative imagery. This did not represent a return to Realism, but simply the partial imposition of specific references to actuality on the stage. Constructivist functionality was now paired with banal truths, albeit somewhat mythologized. Industrial elements were now part of everyday life and, accordingly, art depicted the urban theme as the engine of social life, which then, paradoxically, restored the truths of everyday to Constructivism. In *The Man Who Was Thursday* designed by Vesnin for the Chamber Theater in 1923, and *Lake Liul*, a Meierkhold commission for Shestakov in 1923, the city took the guise of a maze of staircases, multileveled platforms, lifts and moving pavements, combining abstract form with concrete objects – and even advertising signage. The results brought to mind Gustav Hartlaub's 'new objectivity' of the same period.

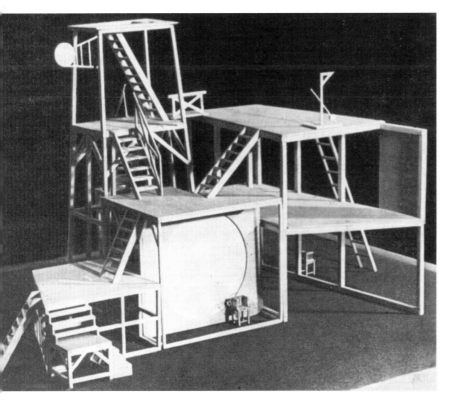

Efros had predicted this as early as January 1921, when he wrote: 'Painting and decor have to leave the stage. They are to be replaced by objects which can provide the same kind of real space and objectiveness as the performing actor does: [like] architecture and sculpture... theatre is aware of the need not for the illusion of space, but for real space, not for the picturesque imagining of objects, but for their real substance.'[134]

During the Chamber Theater Paris tour of 1923, French critics had pointed to the boldness and novelty of the vivid and luxurious colours, the vortex of rhythms and the free use of three-dimensionality in Exter and Yakulov's sets and the monumental power of Vesnin's volumes. But two years later the Chamber Theater at the Exposition not only distanced itself from the *dernier cri* of urbanism, but also showcased the more ascetic compositions of the Stenberg brothers. Their *St. Joan*, *Lawyer from Babylon* and *The Storm* of 1924 (in collaboration with Konstantin Medunetsky) were perceived as models of three-dimensional graphic work, close to the spirit of the Dutch De Stijl movement and, therefore, to the geometric abstraction of Piet Mondrian and Theo Van Doesburg.

Urbanism as a stylistic movement was certainly evident in Meierkhold's productions. He and his artists-in-residence, such as Shestakov (*Lake Liul*) and Shlepianov (*Come on, Europe!* of 1924), now engaged with the kinetics of architectural set design. The moving wall-panels, lifts, trolleys and rhythmical flashing of illuminated advertising in *Lake Liul*, for example, produced a dynamic, shifting form for the play. Shestakov's and Shlepianov's projects were comparable to the formal and spatial researches which European architects and designers such as Robert Mallet-Stevens and Walter Gropius were also conducting. But the Exposition also presented another, parallel perception of the

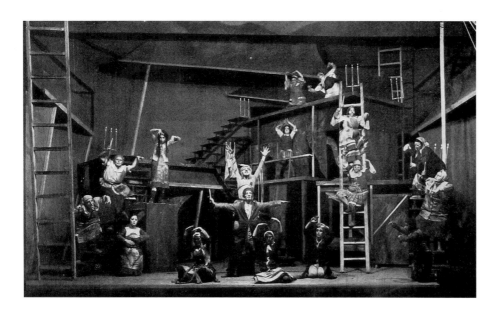

Photographer unknown: scene from the *G(of Revenge*, produced at the State Jewish Th atre, Moscow, in 1922

88

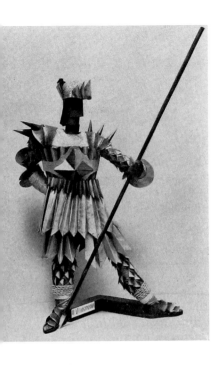

dor Fedorovich: male costume design for
chard Wagner's *Lohengrin* produced at the
shoi Theatre, Moscow, in 1923

world and of its tragic essence, namely, through the human psyche. This more expressionistic image, focusing on the communication of dramatic emotions, was reflected in the work of the artists working for: the State Jewish Theatre, such as Rabinovich's *God of Revenge* (1920), Altman's *Uriel Acosta,* (1922) and Falk's *Night in the Old Market* (1925); the Vakhtangov Theatre, such as Nivinsky's *Princess Turandot* (1922); The Second Moscow Art Theatre, such as Mikhail Libakov's *Hamlet* (1924); The Music Studio of the Moscow Art Theatre, such as Rabinovich's *Carmencita and the Soldier* (1924); and the Comedy Theatre, such as Komardenkov's *Anna Christie* (1923) and *Hinkemann* (1925). Since Germany did not contribute to the Exposition, Czech artists were the main representatives of the international Expressionist style there. Music or musical theatre is a special topic. Visitors to the Exposition, who remembered Sergei Diaghilev's production of *Boris Godunov* with sets and costumes by Golovin and with Fedor Chaliapin in the title role from before the Great War, were struck by the innovative designs for the music theatre, something which testifed to the universal changes in Soviet theatre. The transition of opera design, too, from figurative painting to the scenic dimension started, oddly enough, with the bright and temperamental paintings of Lentulov and Fedorovsky (awarded a Gold Medal and honorary diploma). Lentulov used three-dimensional sets in the opera *Demon*, which Tairov produced at the Opera Theatre of the Soviet of Workers' Deputies in 1919, with a *mise-en-scène* which functioned on different levels. Fedorovsky maintained this application of the three-dimensional architectural decoration in his *Lohengrin* for the Bolshoi Theatre in 1923. An installation consisting of a central rising platform and slender columns, combined with descending panel-cum-curtains, divided the stage in two, eliciting the sense of opposing forces – the bright Kingdom of Elsa and Lohengrin on the right, dark land of Ortud and Telramund on the left. Fedorovsky expressed Wagner's theme of good and evil through streams of light which flooded the stage and which changed their forms as the musical drama developed. The International Jury of the Exposition awarded a Grand Prix to the Bolshoi Theatre for this design.

Rabinovich's designs for *Lysistrata* and *Carmencita and the Soldier*, which Nemirovich-Danchenko and Leonid Baratov produced at the MKhAT Music Studio, on the other hand, maintained a more realistic and metaphorical

decoration, a staple of the operatic stage. In *Lysistrata*, Rabinovich evoked the image of a vivid, luminous and passionate Greece, even decorating the apparatus controlling the drop curtain (the first use of such a curtain device in Russia) and making the decoration, as it were, participate in the action. The bright-blue background, the white columns and the yellow-orange, bright-red costumes challenged the monochrome austerity of Constructivism. According to Nemirovich-Danchenko, Rabinovich 'possessed a wonderful sense of the new tragedy,'[135] a quality reinforced by their collaboration on *Carmencita and the Soldier* of

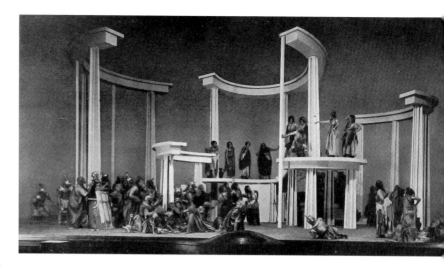

Photographer unknown: scene from Aristophanes's *Lysistrata* set to music by Reingold Glière and produced by Vladimir Nemirovich-Danchenko and Leonid Barato at the MKhAT Music Studio in, 1923 with choreography by Lika Redega and designs Isaak Rabinovich

1924. Here the geometric volumes and tense linear rhythm of its architectural setting, reminiscent of a bullfighting ring, evoked the essential image of a Spain of antiquity, while breaking with the decorative, pictorial conventions of Grand Opera. Architecture on stage now released the passions of the dramatic heroes from long-encrusted ornamentation so as to create a truly modern approach to tragedy in musical theatre. Rabinovich's experiments left a deep imprint on Soviet stage design. The assessment of the International Jury indicated how essential the Soviet theatre had become to global culture. For its theatre section, the USSR was granted twenty-two awards, including four Grands Prix – to the Bolshoi Theatre, the Chamber Theater, Meierkhold's theatre and the MKhAT Music Studio; five honorary diplomas went to the State Jewish Theatre, Vakhtangov Theatre, Theatre of the Revolution and, individually, to Fedorovsky and Vesnin; six gold medals were awarded to the Berezil Theatre, Comedy Theatre and, individually, to Exter, Lentulov, Nivinsky and Shestakov; five silver medals were awarded to the Leningrad Theatre of Young Viewers and, individually, to Erdman, Ferdinandov, Kardovsky and Vialov. In their capacity of members of the International Jury, Rabinovich and Yakulov could not receive official awards, but their services were recognized with honorary diplomas *ex officio*. But just as European directors and designers were recognizing and praising these radical innovations, Soviet theatre found itself on the threshold of a new era, where, once again, art was demanding different solutions. By 1925,

a heightened decoration and a more emotional expressiveness were returning to the Soviet repertoire – part of a global tendency which gained momentum throughout the 1920s and which would soon overshadow the pioneering experiments of the avant-garde.

Translated from the Russian by Mac Watson

Kate Bailey

Avant-Garde and Actuality: Interviews with Stage Director Katie Mitchell and Set Designer Vicki Mortimer

'Russian Avant-Garde Theatre: War, Revolution & Design, 1913–1933' reveals twenty years of radical and revolutionary designs for performance produced between 1913 and 1933 against the backdrop of First World War and Russian revolutions. In this period, Russian culture witnessed an unprecedented creative symbiosis of artists, musicians, directors, and performers. The showcase of these works, most of which have never been seen in Britain before, is a great opportunity to introduce this material to contemporary designers, students and the wider creative industries.

The exhibition and this book includes works by the highly creative, experimental and visionary performance designs of artists like Kazimir Malevich, Alexander Rodchenko, Vladimir Tatlin, El Lissitzky, Alexandra Exter, Liubov Popova and Varvara Stepanova, and reveals how their experiments and collaborations in theatre – through space, light, body, movement, sound and colour inform other practices: architecture, fashion, photography and graphics. It will be relevant for people interested in art, design, architecture and theatre as well as those interested in Russian history.

Selecting the objects has been a difficult task, especially since the notion of avant-garde is fluid and varied. It could be argued, for example that the sumptuous designs of Léon Bakst for the Ballets Russes could be a starting point for our panorama and the rhetoric of Socialist Realism as a conclusion; that works by additional artists such as Marc Chagall, Nikolai Foregger, Natalia Goncharova, Mikhail

Larionov and Sergei Yutkevich should have been included, or that material objects such costumes, props and memorabilia would have enriched the interpretation. Even so, the selection, dictated largely by the strengths of the Bakhrushin State Central Theatre Museum, is judicious and convincing.

Three productions can help us frame the narrative of the selected material. *The Cherry Orchard* set in 1904 provides an introduction to the period that came before: it is a prophetic play which describes the impending gloom ahead for the aristocratic classes and the rise of a new class; *Victory over the Sun*, staged in 1913, is an expression of the optimism for a new world and a rejection of the old; and *The Bed Bug*, a propagandist play directed by Meierkhold in 1929 which demonstrates the fear on the part of radical artists that their work and creativity would be rejected and shut down by the new Soviet establishment.

The Cherry Orchard and other plays by Chekhov provide a helpful and insightful way of understanding the dramatic transformation of Russian society at this time and the resulting impact on art and design. The plays are the bridge between the old and the new worlds and through the characters we can feel the atmosphere of gloom, loss and dispossession amongst the aristocratic ruling class, and the optimism and the new ambitions of the peasant class. We can imagine the real-life struggle between the different classes and different political views.

Directed by Konstantin Stanislavsky, Chekhov's plays were first performed at the Moscow Art Theatre. Stanislavsky set out to create an illusion of reality on stage and wished the theatre to mirror reality and these early stagings of the plays convey meticulous naturalism in design and performances.

Stanislavsky states in his book, *My Life in Art*: 'Like all revolutionists we broke the old and exaggerated the value of the new. All that was new was good simply because it was new. This was true not only of important things but of little things… we wanted a real, artistic scenic truth… We sought for inner truth, for the truth of feeling and experience…'[136]

Chekhov's plays were first staged in the UK in 1909, when *The Seagull*, directed by George Calderon, was performed by the Glasgow Repertory Company at the Royalty Theatre. Calderon had lived in St. Petersburg from 1895 to 1897 and translated the play into English. Although the play was a success, it was not until the 1920s, when Theodore Komisarjevsky (Fedor Komissarzhevsky) directed

Chekhov that the plays became popular and really engaged a British audience. In 1921, Komisarjevsky, a Russian émigré to London, directed *Uncle Vanya* for the Stage Society at the Royal Court Theatre and in 1925, J.B. Fagan directed Calderon's translation of *The Cherry Orchard* at the Oxford Playhouse, thereby embedding Chekhov in British theatre culture. It is apparent that the mood reflected in Chekhov's plays had greater connections with a British audience after the First World War than before it. Thitherto the British economy had been thriving and the first decade of the twentieth century had witnessed the continued rise of music-hall entertainment for a new working class. New music halls remained popular entertainment for these growing audiences and before 1914 the established Edwardian theatres were not ready for a 'foreign' play which dealt with the crumbling fortunes of aristocratic life. After 1918, British society, having seen the horrors of the war, was changing, with the rise of the proletariat, the emancipation of women and the imminent economic depression. Chekhov's plays, directed by Komisarjevksy and Fagan, were staged in the 1920s with extreme naturalism, responding to a new political and economic climate in Britain – a stark and significant contrast to the theatre created by the avant-garde movement in Russia.

Theodore Komisarjevsky was a master of all theatre arts, including directing and designing. His father taught Stanislavsky at the Moscow Conservatory and his sister Vera was one of the great actresses of the Russian stage. Through his teaching and directing, Komisarjevsky was responsible for bringing some of Stanislavsky's methods of training actors to London. Avant-garde in his approach to acting, Komisarjevsky introduced many British performers to Stanislavsky's theories, in particular how to induce an intensity of feeling and a deeper understanding of character. He taught acting classes at the Royal Academy of Dramatic Art in the 1930s and his pupils included John Gielgud, Charles Laughton and Peggy Ashcroft (also briefly his second wife). He directed Peggy Ashcroft and John Gielgud in Chekhov's *The Seagull* at the New Theatre in 1936. This naturalistic production 'was well produced and acted… a high water mark of Komisarjevsky's achievements in this country. The production and acting will delight all who enjoy dramatic technique "beautiful productions full of fine shade and adjustments are pleasure to the eye as to the ear and understanding".'[137]

Playing the Trofimov in 1925 Fagan's production of *The Cherry Orchard*, Gielgud commented that it was 'the first time I ever went on the stage and felt that perhaps

I could really act' and 'playing Chekhov in the twenties and thirties was to us like discovering a new form'.[138]

Chekhov's plays engage international audiences with an understanding of the world that came before the Russian avant-garde movement and also provide us with a sense of the world that was to come. Within ten years of Chekhov's prophetic texts written between 1896 and 1904, Russia and much of Europe was in crisis. Social and political unrest had been building since 1905 with the first Revolution against the Tsar's rule and with the mutiny and uprising by the Russian soldiers on the *Battleship Potemkin*.

Since the 1920s there has been a constant appetite for Chekhov on the British stage. These representations of Chekhov continue to strengthen and shape our views and perceptions of Russia at this time.

The Theatre and Performance Collections at the Victoria and Albert Museum includes designs, photographs and film recordings of many different stagings of Chekhov's plays. From Peggy Ashcroft and John Gielgud in the 1936 production of *The Seagull* to John Bury's designs for *The Cherry Orchard* at the National Theatre in 1978, to Ralph Fiennes as Ivanov at the Almeida Theatre company in 1997.

Chekhov's text and characters remain a source of inspiration and exploration for British actors and directors. His plays and Stanislavsky's system of acting continue to influence and inspire British practitioners and students of drama and literature.

Photographer unknown: Peggy Ashcroft as [N]ina with John Gielgud as Trigorin in [T]heodore Komisarjevsky's production of *The [S]eagull*, 1936. Victoria and Albert Museum

*

Radical theatre director Katie Mitchell and award-winning, highly regarded set designer Vicki Mortimer have been heavily influenced by Russian theatre and practice: in 2012 Katie Mitchell was awarded the prestigious Golden Mask award in Russia.

Kate Bailey. You have said that you made a life-changing trip to Russia and Eastern Europe in 1989? What was it about this visit that was so influential and formative?

Katie Mitchell. There were many things that happened on that trip. I learnt a great deal about the nuts and bolts of the craft of directing and in particular about how to use the techniques developed by Konstantin Stanislavsky. I also saw a theatre culture with a strong social and political function and very full auditoriums. This was inspiring and gave me a concrete picture of the possibility of a theatre culture with a social function. I also travelled to Eastern Europe in early December 1989 just after the Berlin Wall had fallen, and it was a time of enormous political and cultural upheaval. I was constantly encountering the aftershocks of this political event, like the defumigation of the drama school in Tbilisi following a pro-democracy rally that the Communists had attacked, or being told that the rehearsals of Andrezej Wajda (which I was observing) had to stop because Václav Havel was making a flying visit. It was amazing to be present during this enormous historical event and its aftermath.

Photograph by Douglas H. Jeffery: Scene from *The Cherry Orchard* production at the National Theatre (Olivier), 1978. Victoria and Albert Museum

KB. *You are very familiar with staging Russian classics. Why* The Cherry Orchard *now [at time of writing, Mitchell was directing a production for the Young Vic Theatre, London]?*

KM. In 1904 Russia was very much on the brink of a huge social and political upheaval and the play very much focuses on the fear that this imminent (and unknown) instills in all the characters. The play is underpinned by this fear and inevitability of the arrival of a new era and order. Of course, Chekhov had no idea what shape this new order would take and I imagine that the scale of the revolution that occurred, and the Communist order that the revolution installed, would have completely surprised him. I feel that just over a hundred years later we are all feeling very much the same way. We all sense that change is imminent, but cannot quite put our fingers on the shape it will take. Will the environmental disaster suddenly make itself felt, or will the Christian-Muslim conflict suddenly

escalate in a way that we cannot envisage, or will we reach the limits of Capitalism and our economic systems suddenly collapse? None of us knows, but we all sense something lurking and pressing in on us – an unidentifiable change. I suppose that in doing *The Cherry Orchard* now I would like to focus on this feeling of imminent change or disaster and of how it feels to be on the brink of enormous change that you cannot name or predict in concrete terms. This idea is crystallized in the elusive sound of the mine shaft wire snapping in Act Two, one of the hardest moments in the canon of Naturalistic drama to pull off.

KB. Can you tell us a little about your approach to The Cherry Orchard?

KM. We want to make an edgy, fast-moving and frightening production. The aim is to try and do the play much faster than the current UK mainstream tradition of slow, introspective pacing. We would like the evening to run at under two hours and without an interval. We will also set the action in one room and reduce the palaver of scene changes to twenty second shifts of time and place. We would also like the London audiences to be able to imagine the radicalism of the play in its 1900s context, so we will be working towards a much more politically uncomfortable reading of the characters and the situation they are in. Gone will be the gentle introspection around the samovar and instead we will see the cruelty and lack of imagination that privilege brings and class ambition encourage. The production will be in modern dress.

KB. What is the responsibility of the director staging a new version of The Cherry Orchard?

KM. Gosh. I have a responsibility to the original material Chekhov wrote and a responsibility to the audience watching it now. My job is to build a bridge between the two.

KB. There were three major Russian directors in Russia at time of the avant-garde: Tairov, Meierkhold and Stanislavsky. Which one do you associate with and why? What can you learn from their approaches?

KM. The only director I know about in any detail is Stanislavsky and, therefore, identify most strongly with him. He provided a toolkit of exercises that are still essential for most actors and directors today. He also thought very deeply about the meaning and purpose of theatre and this legacy of intellectual enquiry into the purpose and limits of the art form is really important to me.

KB. Stanislavsky and Meierkhold seem to begin together and then Stanislavsky goes one way and Meierkhold another, coming to an unfortunate end. But, actually, most of these productions were created as Stanislavsky was writing My Life in Art *under Meierkhold's direction, and Meierkhold kind of created the Constructivist world with Stanislavsky focusing on acting. I think that the relationship is fascinating.*

KM. Perfect. There is no absolute one system or truth and it is wonderful that two systems, like two colleagues who clearly so loved each other and were so respectful of each other intellectually, should have worked in such different forms alongside each other, and that the senior colleague should have provided the space for his junior, while the latter should have performed in Naturalistic renderings of the former. The two men were so deeply interweaved… If things had not worked out as they did, maybe…

KB. The artists of the avant-garde experienced such an incredible moment of experiment in theatre. We have lots of familiar names associated with the visual arts, whether it is Rodchenko, Popova, or Lissitzky or Tatlin. But, actually, it would seem that their experiments in the theatre crystallized their visions, their styles.

KM. Very rare, isn't it? That the LIFE performance is actually a crucible for the avant-garde's focus, because, normally, it is all about the visual arts, isn't it? Theatre gets left behind.

KB. But this incredible creative moment was suppressed…

KM. It is amazing that the moment did come to pass. It is wonderful, but I also think that in the aftermath, when something ended so brutally and so abruptly, there is an enormous tragedy in the sense that all the ideas that were so dynamically worked through do not move forward through time. So everything becomes

sort of refrigerated in the historical period together with all the breakthroughs. So you can see all the radicalism that was STILL there in Russian theatre in the 1980s, but it was not developed. And few of these ideas really touched British practice, not even indirectly – which is sad.

KB. *Do you think Russian avant-garde theatre practice would find the audience and relevance if one of these plays were to be staged today?*

KM. There is a real chance that a production from the Russian avant-garde theatre would appear rather old fashioned to an audience today. Of course, it is a real pity that this body of work did not make it to the Great Britain when it was first made, as it may well have had a much deeper and more lasting effect on the theatre practice. But I think it is wonderful being in this historical position now and to look at the body of work that was made in an equivalent period, a hundred years prior. I wonder whether there is a connection between historical change and the burst of fantastic changes in art movements. Of course, there is historically, but particularly in terms of live performance, I think it is wonderful that it was so focused around a collective event. After all, everybody needs to be together to see stories, have them told in different, more radical ways. So maybe that is thing for us to note and learn as we investigate this historical period.

KB. *Is there a Russian avant-garde piece on which you would like to work? What would be the easiest and hardest thing to stage?*

KM. *The Bed Bug*, I suppose, because it's really impossible and it would force me to imagine a wholly different way of making theatre.

KB. *Do you think it is time to rediscover Russian avant-garde theatre?*

KM. It is always really important to examine periods of radicalism in the field you are working in, and the Russian avant-garde theatre practitioners of this period were so very important that any re-examination would be enriching. An exhibition may always trigger a period of rediscovery of different ways of theatre-making. Currently there is a new generation in the UK who eschew mainstream traditional theatre and are trekking across Europe, in particular Germany, to find new forms and to inject fresh thinking about theatre-making. For this generation of young practitioners this exhibition may be timely and inspiring.

*

Through the work of Chekhov we see the beginning of the changing world that, in many ways, inspired the emergence of the Russian avant-garde.

The designs included in this exhibition were created after Chekhov, between 1913 and 1933, within a period of extreme social and political unrest and chaos. The crisis was exacerbated by the outbreak of the First World War and the disastrous bloody battle of Tannenberg in August, where 30,000 Russian troops were killed or injured and 60,000 taken prisoner. By the end of 1914, Russian casualties were even higher, with approximately 390,000 deaths and 1,000,000 injuries. Clearly, the military disaster, the abdication of the Tsar, the ineffectual Provisional Government and the general disillusionment in authority contributed to the Bolshevik Revolution of October 1917.

This backdrop of insurrection and change inspired innovative and groundbreaking works created by 'new' artists, both men and women working across Russia's theatres. Sometimes re-imagining existing stories, sometimes working with new propagandist plays. It was an unparalleled and extraordinarily creative and expressive period when the medium of theatre supplied progressive artists with a platform to share ideas, visions and ideals. Many productions were unrealized and very few have been restaged, but this exhibition provides a unique opportunity to re-examine these designs and to explore their relevance and meaning today.

The exhibition also presents us with an opportunity to introduce a new audience – and a new generation – to this material. It also allows us to consider the inter-disciplinary legacy of artists experimenting in the theatre. How did their collaborative work influence other practice – Tatlin's visionary architecture, Eisenstein's films, Stepanova's textile and clothing designs?

Vicki Mortimer is a leading British set and costume designer and judge for the prestigious Linbury Prize for Theatre Design.

Kate Bailey. What is your connection to Russian theatre? Would you say Russian practice has influenced your approach to set design?

Vicki Mortimer. It is in the post-Stanislavsky water.

KB. You are familiar with designing Russian classics and are about to design The Cherry Orchard *with Katie Mitchell [at time of writing about to open at the Young Vic*

Theatre, London, in 2014]. Can you tell us about your approach to this text? How do you set about re-imagining a play that has been staged so many times?

VM. Each Chekhov play is as familiar as a fairytale and as easily glossed with assumptions, my own included. Past British productions have accumulated a set of qualities which are so recurrent that they have even acquired the collective label 'Chekhovian': Languorous… Melancholic… Nostalgic… Bored… Self-Destructive… So it is essential to look beneath my own acceptance of such generalities and see the people, events and contexts anew on the page (my version made with Katie is a first, fresh reading). Astonishingly, the play turns out to be more like a dogma project, with shame and deliberate cruelty at the heart of things, the surface dialogue barely holding them down. *The Cherry Orchard* itself is not a delicate household beauty, but an industrial farming project of huge scale, initiated to rescue the finances of the post-emancipation estate farmer (Lyuba's farther)… It is now infertile, redundant… literally fruitless. We can understand its fate as a genuinely modern paradox… We share the utilitarian frustration of Lophukhin who fights waste and insists on the land's potential, whilst our desire is also to preserve and conserve the beauty of the object and the landscape.

KB. *The Victoria and Albert Museum is hosting an exhibition of theatre designs made by artists of the Russian avant-garde between 1913 and 1933.*

VM. These designs could be described as visions of a new world, creating a new style for a new Russia – and *The Cherry Orchard* represents the end of the old world with a sense of the new…

KB. *Which designs do you feel can be interesting and relevant to this period for a designer working today?*

VM. It has been a hidden world – hence fresh… The creative energies of a new revolution… Necessarily, a political context is primary, it is not just an abstract concept; it is about working for a purpose, one that is also fresh, reflecting a sense of conviction. These images were made for a world without the imagistic saturation of today… All the work of the viewer was still to be done… These new images were puzzles to be solved.

KB. *Many of the artists are more familiar as visual artists, but it seems as if their experiments in theatre, with space and movement perhaps crystallised their work in other*

disciplines, for example, Tatlin in his engineering projects, Rodchenko in graphics and photomontage, Stepanova in clothing design and Eisenstein in film. Why do you think that might be? What are the benefits to artists and designers working in the theatre?

VM. It seems that in the new Soviet reality (when there was a whole new culture to create), there was no room for specialism or separatism – a total reinvention of form required artists from all disciplines to contribute across disciplines. The breaking down of old definitions and roles. This was not an exclusively Soviet phenomenon, of course – there were other movements such as Jugendstil, Deco, Bauhaus, all idealistic, all aspiring to redefine the aesthetic experience of entire populations… but in Soviet Russia the responsibility to enlighten the proletarian fell to all artists. No Ivory Towers, but no limitations either.

Meanwhile what does theatre offer to other crafts and professions? The human ingredient, perhaps? The figure in space, with a story to tell? Marks to be made on the environment? The individual with agency… A time narrative, perhaps – the lending of a beginning and an end to things? An evolution? Then again, composition… A point of view (literal and intellectual)… Theatricality also has a directory of its own – the grand gesture… The common ground with church or ancient ritual.

But all that is probably just anatomising for a neat set of overlaps. Maybe it is just that when we take on a discipline other than our own, we might be more playful… liberated… and then be able to take that back into our own practice?

KB. *The exhibition includes many unrealized productions, predominantly for two main theatres (Meierkhold's and Tairov's) and also shows designers approaching the same play for the same theatre and director. Do you think this is an interesting and helpful practice?*

VM. Theatre is anomalous in that there is only one design in the competition, since we do not have to tender for the work – different to architects and designers in many other collaborative fields. The last time I worked alongside other designers on the same brief was at art school – it certainly made some big demands on the imagination of the director!

KB. *What do you think it takes to create a new artistic movement?!*

VM. The rupture of the string.

KB. What can designers learn from the artists of the avant-garde movement?

VM. Do not look down.

<div align="center">*</div>

In 1913, the year that Tsar Nicholas II celebrated the Tercentenary of Romanov Rule in Russia, the avant-garde, Cubo-Futurist opera, *Victory over the Sun*, was staged in St. Petersburg. An opera in two actions with prologue by Velimir Khlebnikov, libretto by Alexei Kruchenykh and music by Mikhail Matiushin. It was produced at the Luna Park Theatre, St. Petersburg, on 3 and 5 December 1913, with designs by Kazimir Malevich.

The production claimed that 'All's well that begins well and has no end / the world will perish but there is no end to us.'[139] It reveals the revolutionary fervour that gripped the Russian people and their belief in a new order and demonstrates how artists were expressing the idea of transcending the visible world for a higher consciousness; dreaming of a better world and utopian cities for the future.

Malevich designed the backcloths and the costumes for this extraordinary production. It was his use of geometric forms and exploration of space, together with his rejection of the imitation of nature, that paved the way for his painting of a black square, now regarded as the first manifestation of his abstract art and to be one of the greatest masterpieces of the twentieth century.

For Malevich and other artists the theatre stage was a space isolated from the real world, and a space where they could circulate ideas and visions, a world where the distance between the actor and audience could create a platform to explore relationships and theories between form, colour, sound, light and movement. 'We can only perceive space when we break free from the earth, when the point of support disappears.'[140] In the early-twentieth century, the theatre was a powerful medium in which to experiment and express a transforming society, the legacy of which resonates and reverberates across other media and disciplines.

Through the work and life of Meierkhold, we can see how this movement and period of experimentation in theatre thrived for a short period before it came to a catastrophic end in Soviet Russia. We can examine the spirit, ambitions and realities of the avant-garde through the experimental work of Meierkhold and the productions staged at the Meierkhold's theatre in Moscow. In 1929 he produced

The Bed Bug. Written and set as a comedy in nine scenes by Vladimir Maiakovsky with music by Dmitrii Shostakovich and designs by Meierkhold, the Kukryniksy and Alexander Rodchenko, this production was to become one of the last greatest plays of the avant-garde movement.

A student and disciple of Stanislavsky, Meierkhold followed his mentor's advice:

> Create your own method. Don't depend slavishly on mine. Make up something that will work for you! But keep breaking traditions, I beg you.[141]

Reacting against Stanislavsky's quest for naturalism and emotion in performance, Meierkhold believed that the function of theatre was to act as a magnifying glass, enhancing fragments and moments of reality. He restructured plays into fragments and scenes that would engage audiences rationally and poetically rather than, as in Stanislavsky's methods, emotionally. Meierkhold worked towards making the actor's body more physically expressive and sought to bring about an active response in an audience, closer to reactions experienced at a fair, music hall or circus. His students learnt from a wide set of physical skills, including gymnastics, dancing, fencing and juggling and from 'bio-mechanics' – an acting philosophy and a set of exercises that taught actors the economy of movement, awareness of body in space and rhythmic expressiveness. Words were less important than body language and characters became types, lacking in psychological depth. Meierkhold's theatre was of demonstration rather than of identification and experience.

Although many of Meierkhold's productions and other plays included in the exhibition have not been restaged, and are unfamiliar to British audiences, Meierkhold's influence through his use of bio-mechanics continues to influence contemporary practice, preserved and developed by Michael Chekhov in the USA, while in Great Britain his influence can be most strongly felt through modern physical theatre, such as works companies like Shared Experience, Complicité and Kneehigh. Here are productions that convey narrative through highly physical, less naturalistic acting styles, that use less text and stronger visuals to create a cohesive design aesthetic – allowing a careful synergy between the staging and the physical performances.

As the avant-garde artists collaborated to create *The Bed Bug*, a new style was being introduced by Stalin – Socialist Realism, which was to become the approved style

Opposite above: Photographer unknown: Edward Gordon Craig (centre) posing for a photograph with Vsevelod Meierhold (right and Mr. Arosev (left) in Moscow to mark the occasion of Craig's visit to the city. Photograph xeroxed onto cardboard, 1935. Victoria and Albert Museum

Opposite below: Edward Gordon Craig: Set model for *Hamlet* produced by Edward Gordon Craig and Konstantin Stanislavski a the Moscow Art Theatre, Moscow, 1911 (recreated in 1921). Painted plaster. Victori. and Victoria Museum, E.146-1922

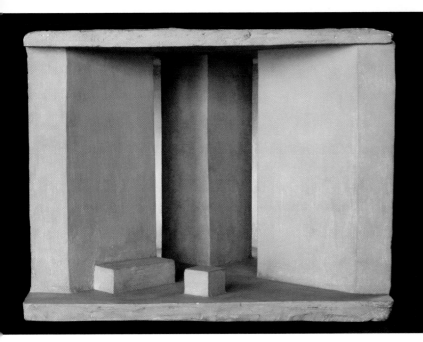

for all the arts across the Socialist world from 1932. The style was to be realistic, not abstract, so that it could be understood by the masses and not just an artistic elite. It was to portray people in a certain way ensuring that the 'hero' was always a worker. The Party and Party members were to be shown in an educative, knowledgeable way, but any depictions of the 'former classes', the bourgeoisie and aristocracy, were to be shown as exploiters, cruel, misguided and ill-educated. Socialist Realist designs often expressed a new, technological and utopian future where industrialisation had spread across the country revealing a future of factories, apartment blocks and machines.

Meierkhold never embraced this new art movement and continued to work in the style of the avantgarde in the 1930s. He was popular, respected and influential, and his rehearsal rooms were often visited by international practitioners, including Berthold Brecht. In 1935, Edward Gordon Craig, the visionary theatre designer and artist who had previously collaborated with Stanislavsky on the Moscow Art Theatre production of *Hamlet* in 1912, returned to Moscow to meet Meierkhold. It was a paid five-week visit at the official invitation of the Soviet Theatre and Craig was welcomed by many of his admirers, including Meierkhold and Tairov.

The meeting of Craig and Meierkhold is also documented at the Victoria and Albert Museum through this intriguing photograph taken in 1935 at their public meeting. A striking image of Meierkhold, ever curious and dramatic in pose and gesture together with Craig, another creative force often described as being ahead of his time. By 1938,

within three years of this official photograph being taken, Meierkhold's revolutionary productions were proclaimed 'alien' to the Soviet People and his pioneering theatre was shut down by Stalin as part of his suppression of the avant-garde movement. This photograph and the *Hamlet* model are today an interesting record of international cultural exchanges during the pre-War period.

The Victoria and Albert Museum also has an extensive collection of Alexandra Exter's work, six of which are exhibited in this exhibition.[142] Exter fled Moscow in 1924 and continued to work in Paris where at the time she was able to continue to design and teach the style of the avant-garde. Like Exter and many other avant-gardists, Meierkhold became creatively and politically 'exiled' as a result of his artistic visions and experiments. Many artists either left Russia to pursue their craft or were forced to adopt a Socialist Realist style in order to survive.

It is remarkable that the designs, models and the Meierkhold archive of his theatre have survived in Russia today, and now the British theatre practitioners, V&A audiences and readers can discover and enjoy this rarely seen work created by artists working in the avant-garde theatre and find out how it is inextricably linked to the world from which it was born.

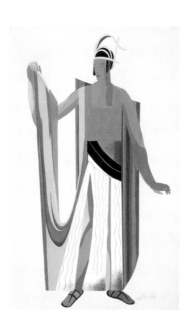
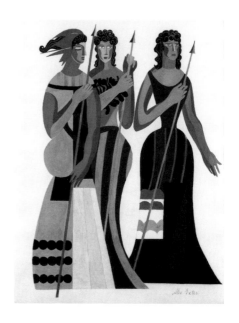

We are grateful to all the institutions, curators and individuals who, through difficult historical times and changing situations, have ensured the safekeeping and preservation of these extraordinary creations, which document and reveal this unprecedented flowering of creativity in the arts in Imperial and early Soviet Russia. In bringing this exhibition to London and in publishing this book, we hope that new audiences will be inspired by the creative methods and esthetic convictions of artists working within the avant-garde, and that the spirit of this movement will live on in contemporary design and theatre practice.

Endnotes

1. Yu. Bakhrushin: *Vospominaniia,* M: Khudozhestvennaia literatura, 1994, pp. 160–61.
2. See B. Pronin and I. Illarionov, eds.: *Istoriia opery Zimina 1903–1917 gg. Sbornik,* M: Pokoleniia, 2005.
3. The Meierkhold collection at the Bakhrushin served as the basis for Alla Mikhailova's monograph, *Meierkhold i khudozhniki,* M: Galart, 1995.
4. The catalogue raisonne of Tatlin's works, i.e. A. Strigalev and J. Harten, eds.: *Vladimir Tatlin, Retrospektive.* Catalogue of exhibition at the Kunsthalle, Dusseldorf, and other venues, 1993–94, relies substantially on the Bakhrushin holdings.
5. E. Gollerbakh, A. Golovin and L. Zheverzheev, eds.: *Teatralno-dekoratsionnoe iskusstvo v SSSR 1917–1927,* L: Komitet vystavki teatralno-dekoratsionnogo iskusstva, 1927.
6. E. Gollerbakh: "Teatr kak zrelishche" in E. Gollerbakh, A. Golovin and L. Zheverzheev, eds.: *Teatralno-dekoratsionnoe iskusstvo v SSSR 1917–1927,* p. 42.
7. *Ibid.,* p. 39.
8. A. Yanov: *Teatralnaia dekoratsiia,* L: Blago, 1926, p. 40.
9. Gollerbakh, Golovin and Zheverzheev, *Teatralno-dekoratsionnoe iskusstvo v SSSR 1917–1927,* p. 34.
10. A. Kugel: "Balet" in *Zhizn iskusstva,* P, 1923, No. 18, p. 2.
11. Yu. Annenkov: *"Teatr chistogo metoda"* (1921). Manuscript in RGALI (Russian State Archive of Literature and Art, Moscow). Call No.: f. 2613, op. 1, ed. khr. 14, 1.8.
12. K. Rudnitsky: *Russian and Soviet Theater 1905–1932,* New York: Abrams, 1988, p. 18.
13. Ya. Tugendkhold: "Pismo iz Moskvy" in *Apollon,* P, 1917, No. 1, p. 72.
14. N. Giliarovskaia: *Teatralno-dekoratsionnoe iskusstvo za 5 let.* Catalogue of exhibition at the Museum of Decorative Painting, Moscow, 1924 (catalogue published in Kazan, 1924), p. 29.
15. A. Vesnin: "Pismo v redaktsiiu" in *Zrelishcha,* M, 1922, No. 4, p. 15.
16. G. Yakulov: "Moia kontr-ataka" in *Ermitazh,* M, 1922, no. 7, p. 11.
17. Quoted in *Giliarovskaia,* Teatralno-dekoratsionnoe iskusstvo za 5 let, p. 45.
18. *Ibid.,* 46.
19. S. Ignatov: "Moskovskii Kamernyi teatr" in *Teatr,* Berlin 1923, No. 1, p. 5.
20. D. Zolotnitsky: "Oktiabr i opyty agitkomedii" in *Yu.* Golovashenko, ed.: Teatr i dramaturgiia, L: Leningradskii gosudarstvennyi institut teatra, muzyki i kinematografii, 1974, p. 48.
21. N-v.: "Pervyi vinokur" in *Zhizn iskusstva,* 1919, No. 259–60, p. 2.
22. V. Shklovsky: "Dopolnennyi Tolstoi" in *Zhizn iskusstva,* 1919, No. 259–60, p. 2.
23. Anon.: ''Peterburg" in *Muzy,* K, 1913, No. 1, p. 20.
24. Annenkov: "Teatr chistogo metoda", pp. 8–9.

25. A. Gan: "Borba za massovoe deistvo" in I. Aksenov et al.: *0 teatre*, Tver: Tverskoe izdatelstvo, 1922, p. 73.
26. S. Tretiakov, "Velikodushnyi rogonosets" in *Zrelishcha*, 1922, No. 8, p. 12.
27. See, for example, *Teatr i zrelishcha*, supplement to *Zhizn iskusstva*, 1927, No. 18, p. 3.
28. "Khronika" in *Ermitazh*, 1922, No. 1, p. 8.
29. Quoted in V. Marquardt, ed.: *Survivor from a Dead Age. The Memoirs of Louis Lozowick*, Washington, D.C.: Smithsonian, 1997, p. 246.
30. "Khronika" in *Ermitazh*, 1922, No. 1, p. 8.
31. [A. Gan]: "Beseda s V.F. Stepanovoi" in *Zrelishcha*, 1922, No. 16, p. 11.
32. S. Bobrov: "V poriadke ideologicheskoi borby: Istoriia ubiistva Tarelkina" in *Zrelishcha*, 1922, No. 18, p. 10.
33. [A. Gan]: "Konstruktivisty" in *Ermitazh*, 1922, No. 13, p. 3.
34. A. Tairov: "Iz zapisnoi knizhki" in *Gostinitsa dlia puteshestvuiushchikh v prekrasnom*, M: 1922, No. 8–9, p. 19.
35. B. Arvatov: "Ot rezhissery teatra k montazhu byta" in *Ermitazh*, 1922, No. 11, p. 3.
36. K. Khersonsky: "Pisma iz Moskvy" in *Zhizn iskusstva*, 1923, No. 6, p. 4.
37. V. Mass: "Deestetizatsiia iskusstva" in *Zrelishcha*, 1922, No. 5, p. 7.
38. A. Briantsev: "Stsenicheskaia veshch i stsenicheskii chelovek" in *Gollerbakh, Golovin and Zheverzheev*, Teatralno-dekoratsionnoe iskusstvo v SSSR 1917–1927, p. 180.
39. A. Bobyleva: *Khoziain spektaklia*, M: Editorial URSS, 2000, p. 38.
40. Quoted in A. Fevralsky, comp.: *V.E. Meierkhold. Stati. Pisma. Rechi*, M: Iskusstvo, 1968, Vol. 2, p. 168.
41. V. Markov, ed.: *A. Ya. Tairov. O teatre*, M: VTO, 1970, p. 178.
42. As a matter of fact, Craig's *Hamlet*, which he staged using a system of screens, elicited a rather negative reaction among critics, Benois even referring to the production as unartistic, even if Stanislavsky did feel that 'Craig had anticipated his time by half a century'. Only one critic, Konstantin Arabazhin, really grasped the true meaning of Craig's reform: '*Hamlet* is a play beyond time and space. For Craig and Stanislavsky it is a tragedy of the spirit in conflict with the world of matter and material illusion. The play allowed for the most audacious decorative experiments' (quoted in O. Radishcheva et al., comps.: *Moskovskii khudozhestvennyi teatr v russkoi teatralnoi kritike, 1906–1918*, M: Artist. Rezhisser. Teatr, 2007, p. 420). A few critics, taken by the decorative aspect in general, approved of the substitution of scene painting with screens and cubes, appreciating the unity of the three-dimensional space with the figure of the actor. Briusov maintained that 'a more diverse selection of 'cubes' should have been created….their colouring made more monotonal and, ultimately, architectural elements for installing the scenes in the open air should also be elaborated.' (*Ibid*., p. 426). Briusov might well have offered his advice to Meierkhold, too, who in 1921 was conjuring with the idea of using a single, mobile scenic installation independent of any specific auditorium.
43. A. Tairov: "Zapiski rezhissera" in *Markov*, A.Ya. Tairov. O teatre, M: VTO, 1970, p. 168.
44. *Ibid*.
45. V. Turchin: "Teatralnaia kontseptsiia V.V.Kandinskogo" in G. Kovalenko, ed.: *Russkii avangard 1910-kh–1920-kh godov i teatr*, M: Bulanin, 2000, p. 96.

46. See N. Avtonomova: "Stsenicheskie kompozitsii V.V. Kandinskogo", *ibid.*, pp. 73–105.

47. The following quotation from Kandinsky's text provides a sense of the interaction of the substantive conditions in *The Yellow Sound*: 'In the orchestra single colours begin to speak. Corresponding to each colour sound, single figures rise from different places: quickly, hastily, solemnly, slowly, and, as they move, they look upward... After that, fatique again overwhelms them all, and they all remain motionless...In the orchestra again single colors are heard. A red light sweeps over the rocks and they tremble' (V. Kandinsky: «The Yellow Sound». Quoted in K. Lankheit ed.: *Wassily Kandinsky and Franz Marc. The Balue Reiter Almanac*, New York: Viking, 1975, p. 223).

48. See Nos. 66–69.

49. B. Livshits: *Polutoraglazyi strelets* (1933). Translated by John E. Bowlt as *Benedikt Livshits: The One and a Half-Eyed Archer*, Newtonville, Mass.: Oriental Research Partners, 1977, pp. 163–64. Incidentally, much of Livshits's description could be applied equally to Appia's stereometric compositions.

50. See Malevich's essay on theatre, i.e. "Teatr" (1917) in A. Shatskikh, ed.: *Kazimir Malevich. Sobranie sochinenii v piati tomakh*, M: Gileia, 2004, Vol. 5, pp. 76-79. The essay bears a curiously theosophical aura.

51. See Nos. 136–140.

52. Apparently, Tatlin was familiar with Meierkhold's programmatic essay 'On the Production of *Tristan and Isolde* at the Maryinsky Theatre on 30 October, 1909' in which the author analyzes the spatial approaches to the Wagner productions. Regarding the scenic space, Meierkhold writes that the «most unpleasant aspect is the floor of the stage. Just as a sculptor moulds his clay, so the floor of the stage should be squeezed...so that it turn into a compact and well coordinated sequence of planes of varying heights' (Quoted in Fevralsky, *V.E. Meierkhold. Stati. Pisma. Rechi*, Vol. 1, p. 155).

53. Tatlin continued to apply the motif of the wooden mast even to his later stage designs.

54. Quoted in O. Feldman: "Studiia Vs. Meierkholda", 1917. Dokumenty in *Teatr*, M, 2004, No. 2, p. 96. It was in this Studio on Borodinskaia St. in February, 1917, that the young Vladimir Dmitriev made designs for two important projects, i.e. *El retablo de las maravillas* by Migeul de Cervantes and Khlebnikov's *Death's Mistake*. For both projects (neither was realized) Dmitriev invented Suprematist compositions of coloured planes consisting of vivid triangles and semicircles bearing white and yellow stars. The coloured planes were meant to move so as to render the Suprematist decoration dynamic. See N. Chushkin: "Yunyi Dmitriev" in O. Feldman et al.: *Teatralnaia Pravda: Sbornik statei*, Tbilisi: Teatralnoe obshchestvo Gruzii, 1981, p. 205. Even if no-one ever saw these as public presentations, the projects mark an important phase in the researches towards a new kind of scenic composition which, however, Meierkhold himself bypassed.

55. See A. Fevralsky: *Puti k sintezu: Meiekhold i kino*, M: Iskusstvo, 1978, pp. 63–65.

56. N. Chushkin: "Formirovanie printsipov izobrazitelnoi rezhissury. Stranitsy tvorcheskoi yunosti V.V. Dmitrieva" in *Teatr*, M, 1979, No. 9, p. 99.

57. See T. Lanina, comp.: *Meierkhold v russkoi teatralnoi kritike, 1920–1938*, M: Artist. Rezhisser. Teatr, 2000. Emmanuil Beskin commented on *Mystery-Bouffe* as follows: "[The proscenium] consists of what seems to be fanciful reliefs, counter-reliefs, force-lines, all

interweaving, but which are actually extremely simple. But each relief, each line, each step starts to play and acquire meaning and movement as soon as the actor's foot treads thereon and the sound of his voice falters" (*Ibid.*, p. 19).

58. V. E. Fevralsky: *Meierkhold. Stati. Pisma. Rechi,* Vol. 2, p. 16

59. *Ibid.,* p. 19.

60. In his review of *Les Aubes* the critic Famarin (pseudonym of Emmanuil Beskin) wrote that the 'hands of the workers strike and destroy the column of power of the old world', while the critic Zagorsky praised the "authenticity of materials and their constructiveness – iron, plywood, cord – so beautiful" integrating with the "authenticity of our revolutionary experiences". Quoted in Lanina, comp.: *Meierkhold v russkoi teatralnoi kritike, 1920–1938,* p. 15.

61. A. Tairov: "Zapiski rezhissera" in *Markov,* A. Ya. Tairov. O teatre, M: VTO, 1970, P. 168.

62. *Ibid.*

63. N. Kolikov, ed.: *V.I. Lenin. Polnoe sobranie sochinenii,* M: Izdatelstvo politicheskoi literatury, 1967, Vol. 10, pp. 7–8.

64. A. Tairov: "Rezhisserskie eksplikatsii" in *Markov,* A. Ya. Tairov. O teatre, p. 332.

65. See E. Sourits: *Soviet Choreographers in the 1920s,* Durham, North Carolina: Duke University Press, 1990; N. Misler: *Vnachale bylo telo. Ritmoplasticheskie eksperimenty nachala XX veka,* M: Iskusstvo XXI vek, 2011; I. Sirotkina: *Svobodnoe dvizhenie i plasticheskii tanets v Rossii,* M: Novoe literaturnoe obozrenie, 2012.

66. As Secretary of RAKhN, Alexei Alexeevich Sidorov (1891–1978) was largely responsible for its ideological orientation. See N. Kozhina and P. Lebedeva: *A. A. Sidorov,* M: Nauka, 1974; N. Sidorova, ed.: *A. A. Sidorov: O masterakh zarubezhnogo, russkogo i sovetskogo iskusstva,* M: Sovetskii khudozhnik, 1985.

67. A. Sidorov: "Ocherednye zadachi iskusstva tantsa" in *Teatr i studiia,* M, 1922, No. 1–2, p. 14.

68. N. Misler ed.: *RAKhN. The Russian Academy of Artistic Sciences.* Special issue of the journal *Experiment,* Los Angeles, 1997, No. 3.

69. On the importance of the circus during the early Revolutionary years see A. Fal'kovsky: "Revoliutsiia na arene (iz neopublikovannoi knigi)" in *Dialog iskusstv,* M, 2013, No. 6, pp. 72-75.

70. V. Drutskaia and A. Rumnev: "Otvet balerine V. Kriger" in *Zhizn iskusstva,* L, 1929, No. 25, p. 14. Rumnev was the pseudonym of Alexander Alexandrovich Ziakin (1899–1965).

71. P. Slavsky: *Vitalii Lazarenko,* M: Iskusstvo, 1980.

72. K. Goleizovsky: "O groteske, chistom tantse i balete. Diskussionno" in *Zrelishcha,* M, 1923, No. 23, p. 12.

73. A. Fomin: *Svetopis Svishcheva-Paola,* M: Iskusstvo, 1964.

74. A. Exter: "The Artist in the Theatre (1919)" in J. Bowlt and M. Drutt, eds.: *Amazonen der Avantgarde/Amazons of the Avant-Garde.* Catalogue of exhibition at the Deutsche Guggenheim, Berlin, and other venues, 1999, p. 303.

75. F. Goziason and A. Exter: "Khudozhnik v teatre. Iz besedy s Alexandroi Exter" in *Odesskii listok,* Odessa, 1919, No. 130, 28 September, p. 4.

76. A man of many talents, Alexander Illarionovich Larionov (1889–1954) was trained in mathematics and physics and also cultivated a strong interest in the history of art,

philosophy, literature, linguistics, gymnastics and choreography. He even lectured on cinematography for Narkompros. See A. Larionov. "Lichnoe delo" in RGALI, Call No.: f. 941, op. 10, ed. khr. 344.

77. M. Molchanova and T. Michienko, eds.: *Khudozhniki teatra Kasiana Goleizovskogo 1918–1932*. Catalogue of exhibition at the Elizium Gallery, Moscow, 2012.

78. E. Suritz: "Isadora Duncan and Prewar Russian Dancemakers" in L. Garafola and N. Van Norman Baer eds.: *The Ballets Russes and Its World*, New Haven and London: Yale University Press, 1999, pp. 97–115. Duncan visited Russia in 1904–05, 1907, 1909 and 1921–22. See E. Surits, ed.: *Aisedora. Gastroli v Rossi*, M: Artist. Rezhisser. Teatr, 1992.

79. Such were the instructions which Duncan herself issued in one of her concert leaflets translated for her Russian audience. See A. Duncan: *Tanets. Aisedora Dunkan s simfonicheskim orkestrom Akademicheskogo teatra Opery i baleta*, SP: Academic Theatre of Opera and Ballet, 1922. p. 2.

80. Exter, "The Artist in the Theatre (1919)", p. 303.

81. The words belong to Yakov Tugendkhold. See his monograph *Alexandra Exter kak zhivopisets i khudozhnik stseny*, Berlin: Zaria, 1922.

82. A. Sidorov: "Boris Erdman, khudozhnik kostiuma" in *Zrelishcha*, 1923, No. 43, p. 4.

83. See K. Goleizovsky: "Obnazhennoe telo na stsene" in *Teatr i studiia*, 1922 No. 1–2, pp. 36–38; and L. Lukin: "O tantse" in *Teatralnoe obozrenie*, M, 1922, No. 4, p. 4.

84. A. Sidorov: *Sovremennyi tanets*, M: Pervina, 1922. p. 41. The cover, however, bears the date MCMXXIII, an apparent contradiction signifying that the book was printed at the end of 1922 and issued commercially at the beginning of 1923.

85. Frank (Vladimir Liutse-Fedorov): "Ektsentricheskii balet (v poriadke diskussii). Mysli o tantse v postanovke Lukina" in *Ermitazh*, M, No. 9, p. 7.

86. Sidorov, *Sovremennyi tanets*, p. 55.

87. Anon.: "Balet K. Goleizovskogo" in *Ekho*, M, 1922, No. 13, p. 9.

88. Cover for *Zrelishcha*, 1922, No. 1.

89. See, for example, Goleizovsky's choreography for the ballet *Tale of a Beetle and Dragonflies* to music by Edvard Grieg, 1922; or his design for a poster showing a "dancer-butterfly" of 1925 (?) (reproduced in Misler, *Vnachale bylo telo*, p. 12).

90. A. Sidorov: "O sushnosti tantsa", M, 1915. Unpublished manuscript, private archive, p. 22.

91. J. Howard: *The Union of Youth: An Artists' Society of the Russian Avant-Garde*, New York: St. Martins Press, 1992, p. 73.

92. This is an approximate translation. The literal meaning of *khoromnaia* is 'in a peasant hut.' However, the word elicited a broader resonance to contemporary listeners: firstly, the word brings to mind the *balagan,* another type of folk performance often seen at fairgrounds; secondly, it carries the connotation of amateur or spontaneous celebration; thirdly, it also carries a reference to the word *khor* (choir) and its Symbolist (Dionysian) associations.

93. See A. Nekrylova and N. Savushkina: *Narodnyi teatr*, M: Sovetskaia Rossia, 1991, pp. 131–50.

94. Program for *Khoromnyia deistva* at the House of Interludes in RGALI. Call No. f. 998, op. 1, ed. kh. 3188.

95. Per-O.: "Khoromnyia deistva Soiuza molodezhi" in *Birzhevye vedomosti,* SP, 1911, 28 January, No. 12146, p. 6 (evening edition).

96. These and other relevant designs are located in the State Museum of Theatrical and Musical Art, St. Petersburg.

97. A. Rostislavov: "Khoromnyia deistva" in *Teatr i iskusstvo*, SP, 1911, 6 February, pp. 127–28.

98. A. Remizov: *Tsar Maksimilian. Teatr*, P: Alkonost, 1920, p. 4.

99. A. Strigalev and J. Harten: *Vladimir Tatlin Retrospektive*. Catalogue of exhibition at the Kunsthalle, Dusseldorf, 1992, Cologne: Dumont Buchverlag, 1992, p. 204.

100. According to Livshits, the Union of Youth financed the entire endeavor, but recouped their investment through high ticket prices. All performances played to full houses. See B. Livshits: *Polutoraglaznyi strelets*, L: Izdatelstvo pisatelei v Leningrade, 1933, p. 445.

101. *Ibid*.

102. See D. Levin: "Ispoved aktera-Futurista" in *Rech*, SP, 1913. 7 December, p. 6.

103. M. Matiushin: "Russkie kubofuturisty" in N. Khardzhiev, ed.: *K istorii russkogo avangarda*, Stockholm: Almqvist and Wiksell, 1976, p. 102.

104. A. Kruchenykh: *Nash vykhod*, M: RA, 1996, p. 71.

105. Malevich wrote to Matiushin: 'The curtain depicts a black square, the embryo of all possibilities... All the many things that I staged in 1913 in your opera *Victory over the Sun* gave me a mass of innovations, except no-one noticed.' Quoted in C. Douglas: "Victory over the Sun" in *Russian History,* Tempe, 1981, No. 8, Parts 1–2, p. 84.

106. M. Davydova: "Teatralno-dekoratsionnoe iskusstvo" in A. Alekseev et al., eds.: *Russkaia khudozhestvennaia kultura 1908–1917*, M: Nauka, 1980, Vol. 1, p. 218.

107. A. Mgebrov: *Zhizn v teatr*e, M-L: Academia, 1932, Vol. 2, p. 275.

108. L. Mally: "Exporting Soviet Culture: The Case of Agitprop Theater" in *Slavic Review*, Champaign, Ill., 2003, Vol. 62, No. 2, p. 325.

109. F. Deak: "Blue Blouse" in *The Drama Review,* New York, 1973, No. 17, p. 37.

110. *Ibid*., p. 46.

111. *Ibid*.

112. K. Eaton: "Brecht's Contacts with the Theater of Meyerhold" in *Comparative Drama*, Kalamazoo, Mich., 1977, Vol. 11, No. 1, p. 6.

113. Henceforth in the text — Exposition.

114. A. Tairov: "Sovremennaia teatralnaia situatsiia (o russkom i zapadnom teatre" (lecture delivered at the Chamber Theatre, Moscow, on 2 February, 1923). RGALI: Call No.: f. 2328, op. 1, ed. khr. 27.

115. RGALI: Call. No.: f. 941 (GAKhN), op. 15, ed. khr. 8, l. 21.

116. P. Kogan: "O Parizhe i parizhskoi vystavke" in *Iskusstvo trudiashchimsia*, M, 1925, № 14, 3–8 March, p. 5.

117. I. Erenburg: "Vsemirnaia vystavka" in *Ogonek*, M, 1925, No. 30, p. 14.

118. *Ibid*.

119. G. Varenne: "La Section de l'Union des Républiques Soviétistes Socialistes" in *Art et Décoration*, Paris, 1925, September, p. 114.

120. A. Efross: "Le Théâtre et le peintre pendant la révolution" in *L'art décoratif et industriele de l'URSS*, Paris-Moscow: Edition du comité de la section de l'URSS à l'Exposition internationale des arts décoratifs, 1925, pp. 67-79.

121. A reference to Dziga Vertov's film of that name and to the revue which Alexander Yarkov's and Nikolai Ravich's produced at the Moscow Music Hall in 1931 with designs by Rodchenko.

122. I. Erenburg (Ehrenburg): *Liudi, gody, zhizn. Kniga pervaia, vtoraia, tretia,* M: Sovetskii pisatel, 1966, p. 370.

123. Герберт Uells (H.G. Wells): *Россия во мгле,* M: Gospolitizdat. 1958, p. 23.

124. Apart from France and the USSR, the following countries were represented at the 1925 Exposition: Austria, Belgium, China, Czechoslovakia, Denmark, Finland, Gt. Britain, Greece, Japan, Jugoslavia, Luxembourg, Monaco, The Netherlands, Poland, Spain, Sweden and Turkey. Germany and the USA were conspicuous by their absence.

125. Scize, p. 203.

126. *Ibid.,* p. 202.

127. Ya. Tugendkhold: *Khudozhestvennaia kultura Zapada. Sbornik statei,* M-L: Gosizdat, 1928, p. 162.

128. Efross, op. cit., p. 67. The reference to the World of Art is to the St. Petersburg group of artists, writers and musicians, active in the late 1890s and early 1900s, who aspired to bring Russian culture closer to the Western mainstream. Led by Sergei Diaghilev, they published a journal (*Mir iskusstva,* 1898–1904) and organized a number of exhibitions both in Russia and in the West. Among their members were Leon Bakst, Alexandre Benois, Mstislav Dobuzhinsky, Nicholas Roerich and Konstantin Somov, some of whom attained universal acclaim for their stage designs for the Ballets Russes (1909–29).

129. A. Smeliansky, introd.: *V.I. Nemirovich-Danchenko. Tvorcheskoe nasledie v chetyrekh tomakh,* M: MKhAT, 2003, Vol. 3 (Letters), p. 205.

130. Scize, p. 193.

131. G. Varenne: "La Section de l'Union des Républiques Soviétistes Socialistes" in *Art et Décoration,* Paris. 1925, September, p. 114.

132. V. Gasenklever (W. Hasenklever): «Na vsemirnoi vystavke v Parizhe» (translation from German into Russian by Samuil Margolin) in *Эхо,* M, 1925, № 5. 15 August, p. 10.

133. A. Efros: *Kamernyi teatr i ego khudozhniki,* M: VTO, 1934, p. XXXVI.

134. A. Efros: "Khudozhnik i stsena" in *Kultura teatra,* M, 1921, No. 1, p. 11.

135. Smeliansky: *V.I. Nemirovich-Danchenko,* p. 170.

136. K. Stanislavsky: *My Life in Art* (Routledge, 1987), p. 300.

137. V Borovsky: *A Triptych from the Russian Theatre: An Artistic Biography of the Komisaravksy's* (C. Hurst & Co. Publishers, 2001), p. 371.

138. L. Senelick: *The Chekhov Theatre: A century of the plays in performance* (Cambridge University Press, 1997), pp. 142, 157.

139. *Victory over the Sun: the world's first futurist opera* / Edited by R. Bartlett and S. Dadswell (Exeter, 2012)

140. K. Malevich: *The Non-Objective World: The Manifesto of Suprematism,* 1926.

141. S. Moore: *The Stanislavski Method: The Professional Training of an Actor. Digested from the Teachings of Konstantin S. Stanislavski* (Viking Press, 1960), p. xv.

142. See Nos. 32, 36–40.

Artists'
Biographies
and Context

Artists' Biographies and Context

The 159 entries here are listed alphabetically according to the primary artist responsible for the design of this or that production.

The date accompanying each entry refers to the date of supposed execution. This has been determined either through the artist's own emendations on the design itself, analogy with similar pieces, reference to the production for which the design was made or in accordance with other documentary evidence. For a variety of reasons, the date of actual execution may not always coincide with the date that appears on the design or it may not correspond to the date of the stage production. Inscriptions on a given design are assumed to be by the artist. Inscriptions in English, French, German, and Italian are repeated; inscriptions in Russian are indicated as such and translated or transliterated.

Works are on paper, unless stated otherwise. Dimensions are in centimetres, height preceding width.

Productions and Projects

Aelita: Film, 1924, Nos. 34, 35

Ali-Nur: Play, 1922, Nos. 52, 53

Anzor: Play, 1928, No. 45

The Bed Bug: Comedy, 1929, Nos. 111–14

Being Nice to Horses: Opera-bouffe, 1921, No. 21

Bolt: Ballet, 1931, Nos. 5–8

La Cena delle Beffe [The Jester's Supper]: Play, 1916, Nos. 78, 79

Circle (Duty and Love): Film, 1927, No. 42

The City: Dance sequence 1920, No. 76

La Dama Duende [The Phantom Lady]: Comedy, 1924, No. 36

Day and Night (Le Jour et la Nuit): Opera-bouffe, 1926, Nos. 120–24

The Death of Tarelkin: Play, 1921, Nos. 31–32; 1922, Nos. 128–30

Decoration of the Moscow Kremlin: 1922, No. 49

Demon: Opera, 1919, No. 58

Don Carlos: Play, 1922, No. 102

Don Juan ou Le Festin de Pierre: Ballet, 1929, No. 40

The Emperor Maximilian and His Disobedient Son Adolf: Tragedy, 1911, No. 131

Etude: Miniature ballet, 1921, No. 47

Etudes: Dance sequence, 1924, No. 38

Flying Dutchman: Opera, 1915–1918, Nos. 136–40

The Footballer: Ballet-pantomime, 1930. No. 92

Fuente Ovejuna [The Sheep's Well]: Play, 1919, No. 97

Gas: Play, 1923, No. 77

Hairy Ape: Play, 1926, Nos. 125, 126

Hamlet: Tragedy, 1925, No. 44

Heartbreak House: A Fantasia in the Russian Manner on English Themes: Play, 1921, Nos. 22–24

I Want a Baby: Play, 1927–1930, Nos. 64, 65

Inspector General: Satire, 1926, No. 15; 1927, Nos. 10–14

King Harlequin (König Harlekin): Comedy, 1917, No. 41

AIZENBERG, Nina Evseevna

Born 14 (26) June, 1902, Moscow, Russia; died 19 December, 1974, Moscow, Russia.

1918–1924 attended Svomas/Vkhutemas, studying under Ilia Mashkov, Alexander Osmerkin et al.; 1924 began to work as a stage designer for various theatres in Moscow and other cities, contributing to productions of both classical and contemporary works; 1925 onwards contributed to exhibitions; 1926 began to work for the Blue Blouse variety theatre, designing, for example, Vladimir Maiakovsky's and Osip Brik's *Radio October* and Mikhail Volpin's *The Queen's Mistake* (1927); 1928 contributed to 'Moscow Theatres of the October Decade,' Moscow; 1928–30 member of the Moscow Association of Stage Designers; 1929 designed the production of *Le Bourgeois Gentilhomme* for the Maly Theatre, Moscow; contributed to the 'First Stage Design Exhibition,' Moscow; 1930–32 member of the October group and in contact, therefore, with other members such as Gustav Klutsis, Alexander Rodchenko, and Sergei Senkin; 1930–33 helped with agit-decorations in streets and squares for parades; 1935 represented at the 'Exhibition of Stage Design Art,' Moscow; 1938–41 worked on designs for various gymnastic displays and parades; 1940s-50s worked on many stage productions for various theatres; 1950s painted landscapes; 1964 one-woman exhibition in Moscow.

Further reading:

E. Lutskaia: *Nina Aizenberg. 40 let v teatre.* Catalogue of exhibition organized by the Union of Artists of the RSFSR, M, 1964.

C. Amiard-Chevrel: 'La Blouse Bleue' in C. Amey et al.: *Le Théâtre d'agit-prop de 1917 à 1932,* Lausanne: L'Age d'Homme, 1977–78, Vol. 1, pp. 99–110.

S. Sabar: *Nina Aizenberg. Transformations.* Catalogue of exhibition at the Hebrew University, Jerusalem, 1991.

A. Sosnovskaia: "The Blue Blouse'. Nina Aizenberg, Costume Designer' in *Bamakh,* Jerusalem, 1994, No. 137, pp. 77–85 (in Hebrew).

A. Sosnovskaya: 'Nina Aizenberg (1902–1974): Russian Designer' in *Slavic and East European Performance,* New York, 2000, Vol. 30, No. 3, pp. 48–73.

LR (Vol. 2) , pp. 10-14.

During the decade 1917–27 the concept of theatre underwent serious reexamination in the Soviet Union. The rapid establishment and liquidation of many experimental theatres during the early years is sufficient proof of the diversity and energy of the new Russian theatre and the fact that the circus, the cabaret and the mass, open-air spectacle now became prominent genres is symptomatic of the abrupt changes which occurred in the orientation and objectives of the traditional theatre. Reasons for this move towards the 'lower' forms of spectacle are several: the theatre-goer was no longer just a member of a privileged intelligentsia or plutocracy, the circus and variety theatre could easily be forged into a political and agitational weapon and the conventional Russian theatre had a limited contemporary repertoire – something which Vsevolod Meierkhold had been complaining about since 1910.[1] As public entertainment, therefore, the dramatic theatre was superseded or, at least, supplemented by the circus, the cabaret, the vaudeville and the so-called 'mass action' or 'mass spectacle', at least in the early years of the Soviet regime. In the 1920s a number of variety theatres such as the Blue Blouse opened in Moscow, Leningrad and other centres.[2] These theatres followed the essential format of the cabaret or vaudeville, although their repertoire differed sharply from that of the pre-Revolutionary cabaret such as Nikita Baliev's Bat (Chauve-Souris).[3] The new variety theatres presented contemporary revues, often of a satirical nature, and they were oriented almost exclusively to the mass audience, the title, of course, eliciting the same kind of association which 'blue jeans' might elicit in the English-speaking world.

The Blue Blouse, founded in 1923 by the journalist Boris Yuzhanin and his friends, produced works written by progressive writers such as Nikolai Aseev, Osip Brik, Valentin Kataev and Sergei Tretiakov. Between 1924 and 1926 it issued (irregularly) its own journal with details of engagements, revues and repertories. True, the Blue Blouse theatre denoted a concept or genre of activity rather than a single institution and at one time there were fifteen collectives calling themselves Blue Blouse in Soviet cities. The themes of the Blue Blouse presentations were simple and topical, dealing with factory life, political events at home and abroad, the inconsistencies of the New Economic Policy, etc., and they were communicated to the audience via declamation, parades, monologues, singing and dancing, even gymnastic displays. Osip Brik described one such popular revue called *Proposing to the USSR*:

A woman wearing a blue blouse with the inscription 'Soviet Russia' came on stage. Then some men also came on stage wearing blue blouses plus top hats and derbies representing England, France, Italy, America. The men sang songs, but they just couldn't get by without proposing to Soviet Russia and kept hanging around her. The woman accepted their collective proposal in a derisive manner and, while making or, rather, singing all kinds of caustic remarks, she agreed to be proposed to.[4]

The Blue Blouse attracted many young artists as designers, including Aizenberg and Boris Erdman, and it was extremely popular, even touring abroad. However, with the imposition of Socialist Realism in Soviet culture in the early 1930s and with the sharp attacks on 'bourgeois' forms of art, the Blue Blouse, along with other vaudeville theatres, was disbanded.

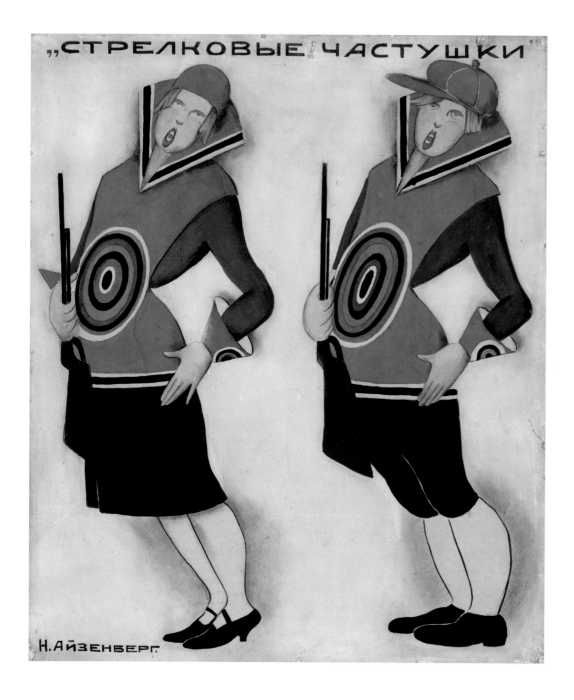

Songs of the Sharpshooters, ca. 1926

1. Costume Designs for Two Performers

Pencil, gouache, tempera and oil on paper on plywood

44.5 x 38.3

Bakhrushin State Central Theatre Museum, Moscow

Inv. No. KP 101644 GKS 3495

Analogous costumes are reproduced by Vladimir Mrazovsky in his article, 'Kostium 'Sinei bluzy" in *Novyi zritel,* M, 1926, 16 November, p. 6; also see *Nina Aizenberg. Transformations,* p. 16 et seq.

Unidentified production, ca. 1926

Costume Designs for a Man and a Woman

Pencil and ink on paper on plywood

8 x 46.8

Bakhrushin State Central Theatre Museum, Moscow

Inv. No. KP 315894/37

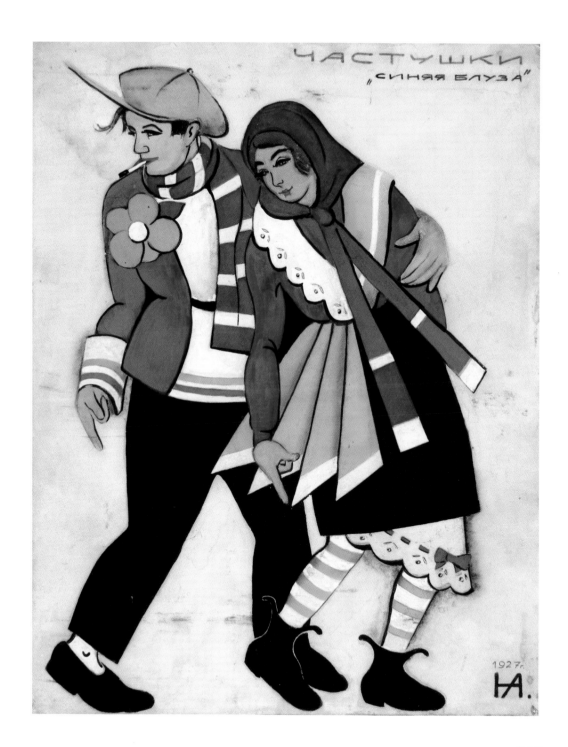

Unidentified production, ca. 1926

3. Costume Design for a Woman

Pencil and gouache on paper on cardboard

42.5 x 30.8

Bakhrushin State Central Theatre Museum, Moscow

Inv. No. KP 315894/84

Note: It is difficult to establish for which production or productions Aizenberg designed these costumes. One possibility is her early commission (she joined the Blue Blouse in 1926) for the play called *Radio October* which Osip Brik and Maiakovsky wrote to commemorate the ninth anniversary of the Revolution. Alternatively, the costumes may have been for Semeon Kirsanov's histrionic poem-play called *How the Young Lads-October Lads, Saying No More Than Was Necessary, Flew across the Seas* in which pioneers (the Soviet counterpart of the boy scouts and girl guides) play a primary role. In any case, all three designs illustrate Aizenberg' basic method of the multi-purpose costume, consisting of:

> painted appliqués which enabled [the actors] to make a 'quick change' in front of the audience: Red Army men changed instantly into sailors, sailors into Budennyi soldiers. All parts of the design and decoration could be packed into portable cases which the Blue Blouse actors took with them as they traveled from club to club.[5]

Both the Stenberg brothers and Boris Erdman tried to follow this system in their work for the Blue Blouse, but without particular success, producing costumes better suited for the more conventional theatre. Aizenberg, however, was one of the few Blue Blouse artists who managed to create efficient, quick-change costumes, while retaining the likeness and personality of the given *dramatis persona*. To some extent, Tatiana Bruni was also supporting the Blue Blouse esthetic in her costumes for *Bolt*.

ANZIMIROVA (SAMOILOVA). Nina Vladimirovna[6]

Born 1879 (?) Perevles, Pronskii Region in Riazan Province; died 22 January, 1963, Moscow.

Father was Vladimir Anzimirov, a nobleman and member of the People's Will movement; 1900s attended classes at Yakov Goldblat's private school in St. Petersburg and also at SCITD; studied at the Higher Construction Courses in Moscow under Ignatii Nivinsky and Ivan Zholtovsky; married the writer Ivan Rodionov; 1912 onwards contributed to exhibitions such as 'Moscow Salon', 'Free Creativity' and 'Artists of Moscow' and worked as assistant designer at the Bolshoi Theater; 1919–26 assistant designer at the Chamber Theatre; travelled twice abroad with the troupe; painted portraits of Alisa Koonen; 1928 contributed to 'Moscow The-

atres of the October Decade (1917–1927)', at the Bakhrushin State Central Theatre Museum, Moscow; 1930 exhibition of her portraits in the foyer of the Chamber Theatre; 1927–32 worked for the Blue Blouse where her son, Yaroslav Rodionov, also worked as an actor; worked for the Romen Gypsy Theatre; late 1930s produced didactic materials for the Museum of Soil Science in Leningrad and the Timiriazev Museum of Biology in Moscow; designed posters for the People's Commissariat for Agriculture; 1941–44 evacuated to Barnaul and then Oirot-Tura (Altai), working at the Altai Scientific-Research Institute; 1942 contributed to 'XXV Years of October' and in 1943 to 'XXV Years of the Red Army', both in Barnaul; member of the Altai Union of Artists; 1945 onwards worked in Moscow, Leningrad and other city theatres, assisting her second husband, Georgii Samoilov, a lighting engineer; 1950 member of Vsekokhudozhnik [All-Union of Cooperative Associations of Visual Art Workers].

Nothing substantial has been published on Anzimirova.

For context and commentary see AIZENBERG, Nina Evseevna.

identified production for the Blue Blouse
upe, 1930

Costume Design for a Sailor, ca. 1930

uache, whitening and graphite pencil on
wood

6 x 19.5

khrushin State Central Theatre Museum,
scow

. No. KP 6184 GKS 4633

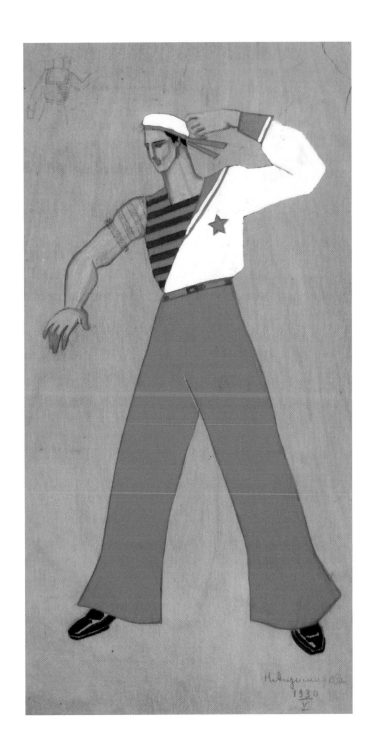

BRUNI, Tatiana Georgievna

Born 24 October (6 November), 1902, St. Petersburg, Russia; died 16 September, 2001, St. Petersburg, Russia.

Born into a musical and artistic family, her father, Georgii, being a professor of music and one of Sergei Prokofiev's early teachers; 1918–20 attended SSEA; 1920–26 attended Pegoskhuma-Svomas under Osip Braz, Alfred Eberling, Nikolai Radlov, and others; 1923 worked as a stage designer for the Institute of Rhythm and the Theatre of the Proletarian Actor, designed Prokofiev's *Visions Fugitives*; also worked on productions for George Balanchine's and Leonid Lavrovsky's Young Ballet company; during the 1920s emerged rapidly as a leading member of the new Leningrad school of stage designers which included Nikolai Akimov and Valentina Khodasevich; worked for the Theatre of Drama and Comedy, Leningrad Ensemble of Stage Workers and other companies; 1931 created the costumes for Dmitrii Shostakovich's *Bolt*; 1937 designed a production of *La fille mal gardée* for the Maly Theatre, thereafter becoming artist-in-residence (designing 24 productions there); 1930s onwards also worked as a designer for other companies, including the Kirov and Leonid Yakobson's Choreographic Miniatures, contributing to the success of numerous productions of classical and modern ballets; 1942 evacuated to Perm where she also designed ballets and operas such as *Swan Lake*, *Don Quixote*, *Giselle*, and *Sleeping Beauty*; 1950s onwards taught at Nikolai Akimov's Ostrovsky State Theatre Institute in Leningrad.

Further reading:

L. Elizarova: 'Tatiana Georgievna Bruni' in E. Davydova, comp.: *Leningradskie khudozhniki teatra*, L: Khudozhnik RSFSR, 1971, pp. 95–121.

T. Drozd: 'Roman ee zhizni' in *Sovetskii balet*, M, 1984, No. 4, pp. 29–32.

E. Binevich: 'Tatiana Bruni' in A. Vasiliev et al., eds.: *Sovetskie khudozhniki teatra i kino*, M: Sovetskii khudozhnik, 1984, No. 6, pp. 78–90.

G. Levitin: *Tatiana Bruni*, L: Khudozhnik RSFSR, 1986.

T. Bruni: 'O balete s neprekhodiashchei liuboviu' in *Sovetskii balet*, M, 1991, No. 5, pp. 33–47.

Tatiana Bruni: The Magic of Russian Ballet and Opera Stage Designs. Booklet for exhibition at the Kirov Academy of Ballet, Washington, D.C., 1999.

Tatiana Bruni, Legend of the Kirov – and a Rare Collection of Russian Avant-Garde Artists from the 1920s and 1930s. Booklet for exhibition at the Russian Cultural Center, Washington, D.C., 2011.

LR (Vol. 2), pp. 132–34.

Tatiana Bruni belongs to a brilliant generation of Soviet stage designers active in Leningrad in the 1920 and 1930s, a generation that also includes Leonid Chupiatov, Moisei Levin and Elizaveta Yakunina. Like Alexandre Benois, Tatiana Bruni hailed from a family of gifted artists and architects (her grandfather was the painter Fedor Bruni, rival of Karl Briullov, and curator of paintings at the Hermitage in 1849–64) and her natural disposition was towards the fine arts. As an impressionable teenager of thirteen, she visited the exhibition of set and costume designs and posters by Konstantin Korovin, Kazimir Malevich, Nicholas Roerich, Sergei Sudeikin, Vladimir Tatlin, etc., from the collection of Levkii Zheverzheev (sponsor of the 1913 production of *Victory over the Sun*) in Petrograd in 1915, a confrontation that resolved her to become a professional stage designer. Bruni's subsequent training, especially under Eberling at Petroskhuma, helped develop her innate sense of colour and precision of form, a combined skill that served her well in the many subsequent commissions, especially for the ballet. Among the more than eighty spectacles that she designed are *Giselle, The Nutracker, Eugene Onegin, Sleeping Beauty* and *Swan Lake*.

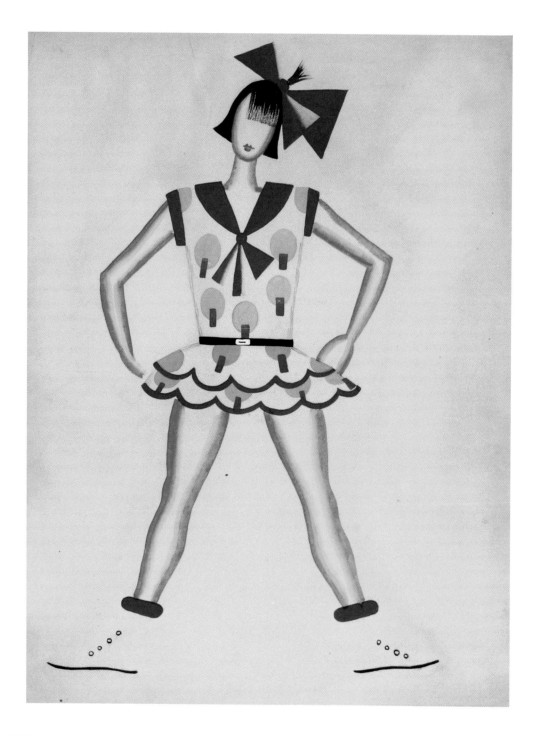

Bolt: Ballet in three acts and seven scenes with mus[ic] by Dmitrii Shostakovich and book by Vikto[r] Smirnov. Dress rehearsed, but not produced, at th[e] Academic Theatre of Opera and Ballet, Leningra[d] on 6 April, 1931, by Viktor Smirnov with choreo[g]raphy by Fedor Lopukhov, costumes by Tatia[na] Bruni and sets by Georgii Korshikov.

Under the supervision of Kozelkov, a Soviet factor[y] running at full steam, symbolizes the dynam[ic] tempo of the new life. But certain negative indiv[id]uals, including a hooligan Lenka Gulba, and h[is] cronies, wish to hinder industrial progress, and the[ir] co-workers dismiss them from the factory sho[p.] Wishing to have his revenge, Gulba tries to persuad[e] the young worker Gosha to break a lathe by inser[t]ing a bolt in it. Boris overhears the conversation an[d] goes to the shop to anticipate their action. Bu[t] Lenka locks him in, thereby compromising him an[d] he is arrested. In the end, however, Gosha tells th[e] truth and Lenka is arrested.

5. *Costume Design for a Girl with Blue Bow* (197[?] reconstruction by Bruni)

Graphite pencil, gouache and whitening on paper

27.5 x 21

Bakhrushin State Central Theatre Museum, Moscow

Inv. No. KP 321255 GKS 4444

Costume Design for a Woman (1979
reconstruction by Bruni)

Graphite pencil, gouache and whitening on paper

7.5 x 21

Bakhrushin State Central Theatre Museum,
Moscow

Inv. No. KP 321256

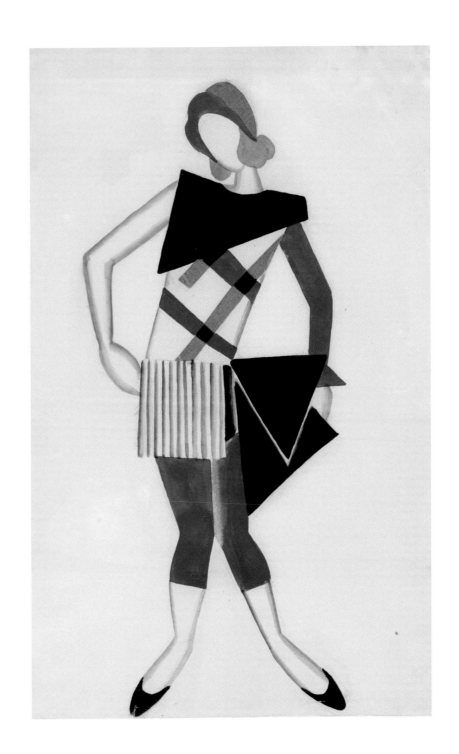

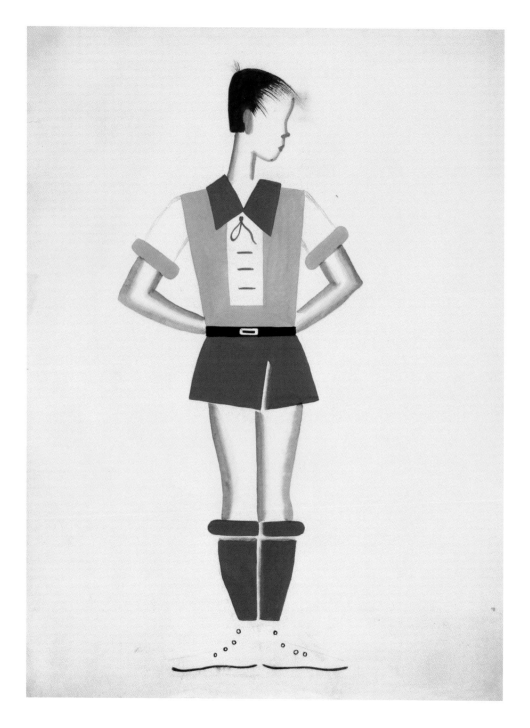

7. *Costume Design for a Young Man* (1979 reconstruction by Bruni)

Graphite pencil, gouache and whitening on paper

27.5 x 20.9

Bakhrushin State Central Theatre Museum, Moscow

Inv. No. KP 321258 GKS 4446

Set Design (1979 reconstruction by Bruni)

encil and gouache on paper on canvas stretcher

9 x 79.5

akhrushin State Central Theatre Museum,
oscow

v. No. KP 310805 GDS 1139

ecreated by Tatiana Bruni after an original design
y her husband, Georgii Nikolaevich Korshikov
899-1944).

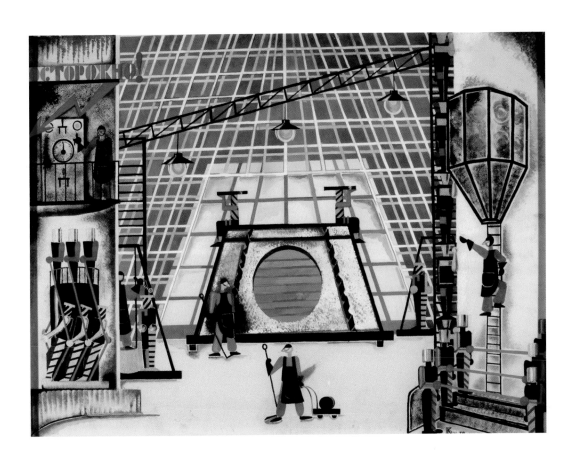

Note: Bolt was one of the several experimental ballets and operas that Shostakovich wrote just before and after 1930, others being *The Golden Age* and *The Limpid Stream*. In all cases, the reception was, to say the least, divided, most critics describing the works as 'formalist' and the depiction of socio-political reality as 'distorted.' Although *Bolt* was an industrial ballet with real hammers and machines (reminiscent, therefore, of Sergei Diaghilev's production of Sergei Prokofiev's *Le Pas d'Acier* in 1927) and relied for its effect, on 'political intermezzi, choreographic posters and radio loudspeakers,'[7] it was regarded as an inaccurate, if not pernicious, portrayal of Soviet industry, and the dress rehearsal was a fiasco. As a result, *Bolt* was withdrawn immediately even though its premiere was scheduled for 8 April (two days after the dress rehearsal) when, in fact, another spectacle was given in its place.[8] The choreographer and the composer were severely reprimanded, a dark presage of the brutal censure of Shostakovich's opera *Lady Macbeth of Mtsensk* in 1936 with its 'leftist confusion instead of natural, human music.'[9] Shostakovich himself was 'in terrible shape. Everything was collapsing and crumbling. Eaten up inside,'[10] and under the pressure of events he published his recantation.[11]

As far as the designs for *Bolt* are concerned, Bruni and her husband Korshikov relied substantially on the 1920s conventions of the agit-theatre, the ROSTA Windows (advertisement windows of the Russian Telegraph Agency) and the TRAM theatres (Theatres of Working Youth) – that wished to 'create a theatre capable of reflecting the most acute, most urgent, and topical questions and problems exciting young Soviet people.'[12] In this way, Bruni tried to present social types rather than individuals, carrying 'general recognizable features of this or that hero.'[13] Art historian Tatiana Drozd described the Bruni costumes as follows:

> Their imagery is rich, their construction is original. The positive heroes – the Sportsman and Sportswoman, the Textile-Worker, the Working Woman and others – were dressed in lightweight, simple costumes which exposed the actor's body to a maximum and revealed its plasticity. The costume-masks for the negative characters – the Drunkard, the Loafer, the Bureaucrat – were more complex, heavier. They concealed the body of the actor, deprived him of individuality, made him look like a moving mannequin.[14]

In spite of the negative response, Bruni maintained that the ballet was 'obviously ahead of its time… In fact, *Bolt*, cruelly destroyed at its birth, subsequently, became an inexhaustible source from which ballet masters still derive specific elements, even today.'[15] Bruni repeated many of her designs in the 1970s.

CHUPIATOV, Leonid Terentievich

Born 17 July, 1890, St. Petersburg; died Leningrad, 1941.

1890s and early 1900s lived in Novgorod; 1908 moved back to St. Petersburg; worked as a draughtsman in the Franco-Russian Shipbuilding Factory; enrolled in drawing classes at the Society for the Engouragement of the Arts; also took private lessons with Elizaveta Zvantseva; 1909–12 studied under Yan Tsionglinsky; 1916 onwards took lessons with Kuzma Petrov-Vodkin, enrolling in the Academy of Arts (Svomas) in 1918; 1917 onwards contributed to many exhibitions such as the 'World of Art' (1917) and the 'First Free Exhibition of Works of Art'; 1919 taught at the Art School of the Baltic Fleet; 1921–26 worked as a research assistant at Vkhutemas (ex Academy); early 1920s elaborated a theory of spatial recession; 1926 moved to Kiev to teach at the Art Institute; 1927 contributed to the 'First All-Ukrainian Jubilee Art Exhibition 10 Years of October'; Konstantin Stanislavsky invited him to help with the design of Vsevolod Ivanov's *Armoured Train 14–69*; 1929 designed Kornei Chukovsky's *Sedi* at the Franko State Theatre; returned to Leningrad to teach at Vkhutein; early 1930s designed a number of plays for Leningrad theatres; late 1930s worked on animation for Lenfilm; died in the Leningrad Blockade.

Further reading:

E. Fedorova et al.: *Polifonia. Da Malevič a Tatjana Bruni 1910-1930. Bozzetti teatrali dell'avanguardia russa.* Catalogue of exhibition at the Padiglione d'Arte Contemporanea, Milan, 1998, pp. 162–63.

N. Kurnikova et al.; *Rakurs Chupiatova.* Catalogue of exhibition at Our Artists Gallery, M, 2013.

Along with Pavel Golubiatnikov and Alexander Samokhvalov, Chupiatov was among the most talented students of Kuzma Petrov-Vodkin, interpreting and exploring the latter's peculiar theory of elliptical and non-Euclidian space. Chupiatov's paintings of the 1920s, in particular, with their acute foreshortening and unusual standpoints, demonstrate his deep interest in alterative codes of perspective and proportion. Chupiatov elaborated these ideas in his major treatise, 'The Path of Authentic Realism' of 1926, which, as Alexander Borovsky has

claimed, indicates that the artist's notion of the pictorial plane was one of 'action and spatial fluency and not an independent, conventional, symbolic or optically engaging value'.[28]

ed Whirlwind: Balletic poem in two processes with
rologue and epilogue with music by Vladimir
eshevov. Produced at the State Academic Theatre
Opera and Ballet, Leningrad, on 29 October,
924, with choreography by Fedor Lopukhov and
esigns by Leonid Chupiatov.

the first Process the common masses replace the
oss as a sign of meekness with the star as a sym-
ol of revolution. In the second Process sailors, Red
rmy soldiers, workers and peasants battle with the
ti-revolutionary elements such as hooligans, mer-
hants and speculators.

Set Design, 1924

/atercolour and Indian ink

4.1 x 49.8

tate Museum of Theatrical and Musical Art,
t. Petersburg

w. No. GK 7070/163 OR 7450

Note: Adapted from Deshevov's symphony *The Bolsheviks* (1918), *Red Whirlwind* was a bold experiment in artistic synthesis with dance, singing, declamation and acrobatics which, however, won little sympathy either with the public at large or with the critics and, after only three performances, was shelved. Led by Elizabeta Gerdt (representing Socialism) and Viktor Semeonov (representing Bolshevism), forty dancers in the first Process interpreted the forces of revolution, although many of the movements were regarded as remnants of the classical legacy. Still paying homage to the past, therefore, Lopukhov was lambasted for his inability to create adequate abstract ideas which would correspond to the spirit of class warfare. As a matter of fact, the audience seemed to be more impressed by the outward glamour and colour of the counter-revolutionary forces than by the drabber appearance of the revolutionaries. One may assume that, for Chupiatov, the political thrust of the ballet was secondary and that he regarded its unconventional form more as a laboratory for artistic investigation into colour and form than as an ideological vehicle. In any case, the energy of the moving crowds, the clashes between friend and foe, the fluidity of the choreographic resolution must have appealed to an artist whose primary concern was with a scheme of '1) movement; 2) relativity or releativistic observation; 3) light; 4) colour; 5) form; 6) subject-matter'.[29]

COLLECTIVE OF MASTERS OF ANALYTICAL ART (the Filonov School)

In June, 1925, the St. Petersburg avant-gardist, Pavel Nikolaevich Filonov (1883–1941), was given space in the Academy of Arts, Leningrad, in order to conduct courses with a group of students – giving rise to the so called Collective of Masters of Analytical Art (or Filonov School). It was among these *filonovtsy* or *filonidy*, who included Nikolai Evgrafov, Tatiana Glebova, Boris Gurvich, Pavel Kondratiev, Revekka Leviton, Artur Liandsberg, Alisa Poret, Andrei Sashin and Mikhail Tsibasov, that Filonov disseminated the principles of his theory of Analytical Art. Although by 1927 the Collective or School numbered over forty, it was never a really cohesive group and, in 1930, divided into two factions. The smaller faction remained loyal to Filonov; the other quickly disbanded and some of its members, e.g., Evgenii Kibrik, assumed a public position hostile to Filonov.

The Collective of Masters of Analytical Art is often referred to as a School, but it would be misleading to regard it as a system or program of regular classes, course-work and homework. As one pupil recalled, the sessions with Filonov 'bore the character of consultations. Pavel Nikolaevich would make brief remarks, some-times they would be abrupt. No-one ever objected'.[16] Filonov addressed his students as comrades and, while quite aware of his own artistic supremacy, main-tained that anyone could learn to be an artist if the principles of Analytical Art (what Filonov called 'madeness') were followed and applied.

The Collective embarked upon several joint ventures, including exhibitions, stage productions (such as the 1927 *Inspector General*) and the 1933 illustrated edition of the Finnish epic *Kalevala* (L: Academia). The Collective was ousted from the Academy in 1927 and five years later ceased to exist officially with the passing of the Party Decree *On the Reconstruction of Literary and Artistic Organizations*.[17]

Further reading:

J. Harten and E. Petrowa: *Pawel Filonow und seine Schule/Pavel Filonov i ego shkola*. Catalogue of exhibition at the Kunsthalle, Düsseldorf, 1990.

N. Misler and Dzh. Boult [J. Bowlt]: *Pavel Filonov*, M: Sovetskii khudozhnik, 1990.

E. Kovtun, intro.: *Pavel Filonov. Dnevniki*, SP: Azbuka, 2000.

E. Petrova: *Pavel Filonov*, SP: Palace Editions, 2001.

Dzh. Boult (J. Bowlt). N. Misler and A. Sarabianov: *Filonov. Khudozhnik. Issledovatel. Uchitel*, M: Agei Tomesh, 2006 (two volumes).

E. Petrova et al.: *Pavel Filonov: Ochevidets nezrimogo/Pavel Filonov: Seer of the Unknown*. Catalogue of exhibition at RM, 2006.

I. Galeev et al.: *Filonovtsy. From the Masters of Analytical Art to the Post-avant-garde*. Catalogue at Art-Divazh Gallery, M, 2006, pp. 64–79.

A. Laks, ed.: *Pavel Filonov. Sbornik statei*, SP: 2007.

N. Misler, I. Menchova and J. Bowlt, eds.: *Pavel Filonov*. Special issue of the journal *Experiment*, Los Angeles, 2007, No. 11.

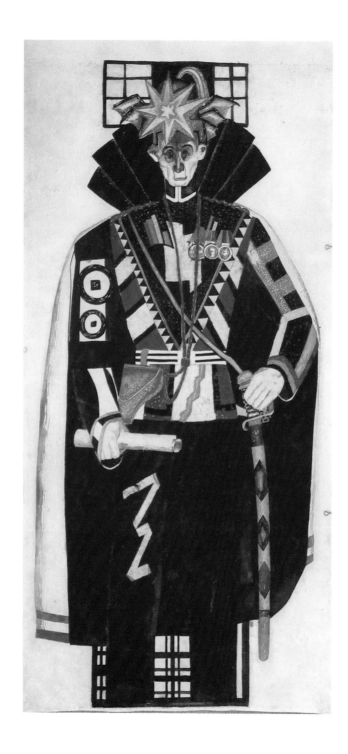

The Inspector General: Satire in five acts by Nikolai Gogol. Produced by Igor Terentiev at the Press House, Leningrad, on 9 April, 1927, with music by Vladimir Kashnitsky and designs by the Collective of Masters of Analytical Art supervised by Pavel Filonov.

The elders of a provincial town, led by the governor, hear that an inspector general from St Petersburg is coming to examine their various institutions. In a case of mistaken identity, they assume that the young fop Khlestakov, a visitor to their town, is the inspector general, and they proceed to deceive, flatter and bribe him in order to conceal the real state of civic affairs. Khlestakov is delighted at this unexpected attention and goes on his way greatly contented with their bounty. But, to the horror of the elders, the real inspector general suddenly arrives, culminating in the famous 'mute' scene as the curtain descends.

Nikolai Ivanovich Evgrafov (1904-41)
10. Costume Design for a Policeman, 1927
Watercolour and ink on paper
49.7 x 24.3
State Museum of Theatrical and Musical Art, St. Petersburg
Inv. No. GIK 12532 OR 18113

Nikolai Ivanovich Evgrafov (1904-41)

1. Costume Design for the Post Master General,
1927

Watercolour, ink and pencil on paper

37.4 x 30.3

State Museum of Theatrical and Musical Art,
St. Petersburg

Inv. No. GIK 1253 OR 18116

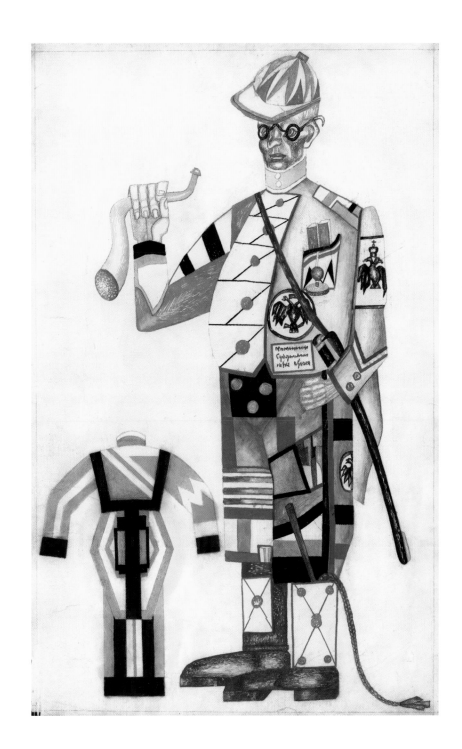

Revekka Mikhailovna Leviton (1906-87)
12. *Backcloth Design for Act 3*, 1927
Gouache and pencil on paper
31.2 x 37.3
Bakhrushin State Central Theatre Museum,
Moscow
Inv. No. KP 297154

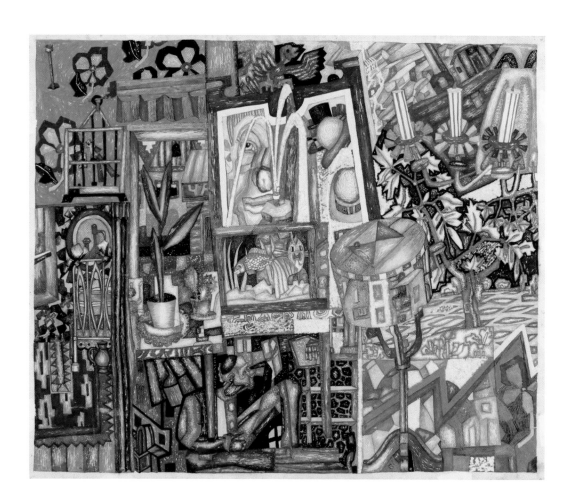

Revekka Mikhailovna Leviton (1906-87)

13. Two Costume Designs: 'To Whom I Love, I Give',
1927

Pencil and gouache on paper

41.4 x 26

Bakhrushin State Central Theatre Museum,
Moscow

Inv. No. KP 297152

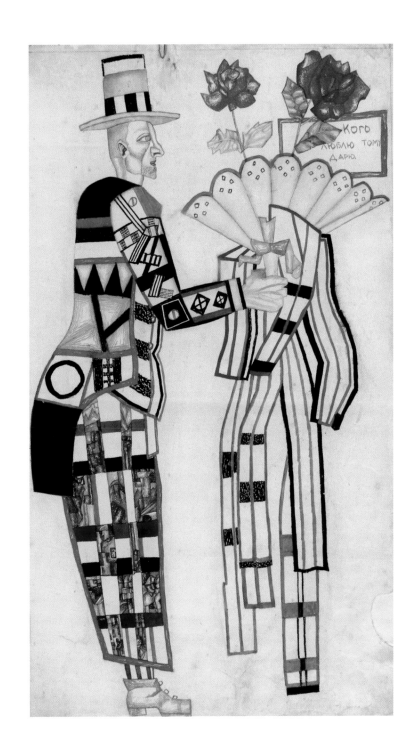

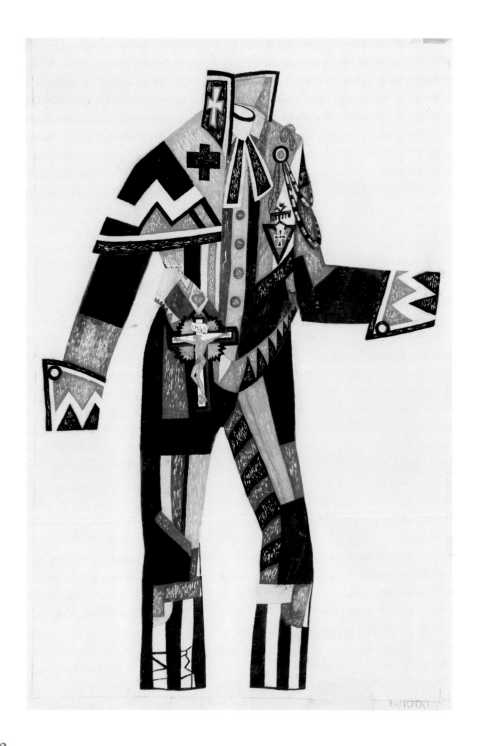

Artur Mechislavovich Liandsberg (1905-63)

14. *Costume Design for the Patron of Philanthropic Institutions*, 1927

Watercolour and gouache on paper

46.5 x 31

State Museum of Theatrical and Musical Art, St. Petersburg

Inv. No. GIK 12431 OR 18063

Note: Early in 1927 the Futurist poet, theorist and painter Igor Terentiev was commissioned by Nikolai Baskakov, director of the Press House, Leningrad, to stage a production of *The Inspector General.* Terentiev accepted the offer and invited Filonov to supervise the sets and costumes, the implementation of which was entrusted to the Collective of Masters of Analytical Art. Terentiev himself had already worked as a producer in Leningrad and Tiflis (Tbilisi) and had just founded a new theatre laboratory at the Press House.[18] Terentiev and Filonov immediately found a common language evident in iconoclastic approach to Gogol's play. But although this commission was a prestigious one, the interpretation so provoked the resentment of public and press that both men and their co-workers became the targets of exceptionally strong censure and abuse.

After several delays, the premiere of *The Inspector General* took place in the remodeled Press House Theatre on 9 April, 1927. The august premises (the Press House occupied what had been the Shuvalov mansion) were also decorated by a 'sculpture-cum-high relief' and 'nightmarish paintings of hallucinations'[19] by Filonov's pupils – what is traditionally called the 'Exhibition of Masters of Analytical Art.' The actual sets and costumes for the production designed by Filonov's disciples[20] were sharply criticized for their 'irrelevance' to Gogol:

> The red, green and blue costumes for the performance, done by the 'masters' of the Filonov school, above all, confuse the viewer. Apparently, Filonov's scenic exercises, these multi-coloured costumes are meant to take *The Inspector General* out of its historical framework… but these costumes are simply a caprice, altogether dilettantish, spurious, provincial and crappy.[21]

Furthermore, the designs, which, incidentally, were contributed collectively and without individual signatures, were linked to what were considered salacious antics in Terentiev's interpretation:

> In these multi-coloured, painted, Chinese-cum-Parisian costumes which reduce decadent esthetism in the theatre to self-sufficient snobbishness, the actor performs a series of very indecent numbers… [The producer] makes the governor sit in a WC, the governor's wife go around in her pantaloons and another guy go about with a night potty… To the strains of Beethoven's *Moonlight Sonata* Khlestakov takes his candle and goes into the toilet depicted in the form of a tall, black box looking like a telephone booth. And that's where Khlestakov perches himself with Mariia Antonova.[22]

In spite of the negative reception of Terentiev's production of *The Inspector General* and the Filonov contribution, Filonov and his Collective were commissioned to

decorate a second stage production in April, 1929. This was the play *King Gaikin I* (also-called *Activist Gaikin*), an agit-presentation where, as Filonov implied in a lecture at one of the performances, 'essentially, the decoration of the spectacle was nothing less than an agitational, traveling exhibition for the *filonovtsy*.'[23] It was staged for the Vasilii Island Metalworkers' Club in Leningrad and, evidently, was not as experimental as *The Inspector General*.[24] In his autobiography, Filonov mentions a third theatrical involvement in the 1920s, for a play called *Lenka's Canary*, but information on this piece is not available.

DMITRIEV, Vladimir Vladimirovich

Born 31 July (13 August), 1900, Moscow, Russia; died 6 May, 1948, Moscow, Russia.

1916–17 attended Elizaveta Zvantseva's Art School in Petrograd; visited Vsevolod Meierkhold's Studio on Borodino Street; 1917 under Meierkhold's guidance prepared designs for a production of Velimir Khlebnikov's *Death's Mistake* (not realized); 1917–18 attended Meierkhold's Kurmastsep (Courses in the Art of Stage Productions); 1918–22 attended Pegoskhuma-Svomas, studying under Kuzma Petrov-Vodkin; 1918 designed a production of Henrik Ibsen's *Nora* for the Luna-Park Theatre; 1920 designed Emile Verhaeren's *Les Aubes* for Meierkhold's production at the Theatre of the RSFSR No. 1 in Moscow; 1921 designed Vasilii Kamensky's *Stenka Razin* for the Theatre of the Baltic Fleet in Petrograd; 1920–22 taught at the Art School for Sailors in Petrograd; helped George Balanchine and Leonid Lavrovsky organize the Young Ballet company; 1923 contributed to the 'Exhibition of Paintings by Petrograd Artists of all Directions, 1919–1923' in Petrograd; 1926 designed Fedor Lopukhov's production of *Pulcinella* for the Leningrad Theatre of Opera and Ballet (Kirov), and in 1927 *Le Renard*; 1928 onwards worked frequently for the MKhAT, designing Lev Tolstoi's *Resurrection* there in 1930 and *Anna Karenina* in 1937; 1930–48 worked frequently for the Bolshoi Theatre, designing, for example, Tchaikovsky's *Queen of Spades* in 1931; 1939 moved permanently to Moscow.

Further reading:

N. Tretiakov: *V. Dmitriev*, M: Sovetskii khudozhnik, 1953.

N. Chushkin and M. Pozharskaia: *Vladimir Vladimirovich Dmitriev*. Catalogue of exhibition at the All-Union Theatrical Society, M, 1954.

E. Kostina: *Dmitriev*, M: Sovetskii khudozhnik, 1957.

F. Syrkina, comp.: *Khudozhniki teatra o svoem tvorchestve*, M: Sovetskii khudozhnik, 1973, pp. 99–143.

N. Chushkin: *Vladimir Vladimirovich Dmitriev*. Catalogue of exhibition at Bakhrushin State Central Theatre Museum, Moscow, 1976.

V. Berezkin: *V.V. Dmitriev*, L: Khudozhnik RSFSR, 1981.

'Vladimir Dmitriev' in S. Barkhin et al.: *Khudozhniki Bolshogo teatra*. Catalogue of exhibition at the Manège, M, 2001, pp. 114–23.

N. Chushkin: 'V.V. Dmitriev. Tvorcheskii put'' in *Mnemozina*, M, 2004, No. 3, pp. 346–92.

Vladimir Dmitriev belongs to the second generation of Russia's avant-garde and, like many of his colleagues in Leningrad such as Valentina Khodasevich, Moisei Levin and Elizaveta Yakunina, chose to develop his artistic talent in the theatre. To a large extent, Dmitriev's orientation was determined by his early exposure to the theatre – his mother was an actress at the Alexandrinsky Theatre and as a teenager he met leading theatre people of the time such as Alexander Golovin, Meierkhold and Sergei Sudeikin. Dmitriev worked for the major theatres of Leningrad and Moscow and, as one of his biographers has remarked, he 'lived by his interests in the theatre; he gave it all his powers, all his distinctive artistic talent'.[25] He designed over 150 theatre productions and also published theoretical essays on stage design.

Dmitriev is often remembered for his early experimental projects such as the designs for Meierkhold's production of *Les Aubes* in 1920 (when Dmitriev was only twenty years old), which, in their emphasis on real materials in three dimensions, anticipated the Constructivist sets by the Stenberg brothers and Alexander Vesnin for the Chamber Theatre. However, in spite of the 'excesses' of *Les Aubes*, Dmitriev tried always to establish an organic link between his sets and costumes and the plot and action of a given play, rather than use them simply as the extension of his own esthetic credo. Consequently, he did not hesitate to create a 'straight' decor

for a production of *Eugene Onegin* at the Kirov in 1925 or the following year to visualize Sergei Prokofiev's *Love for Three Oranges* as a *balagan*. Because of his artistic flexibility, Dmitriev was also able to adjust to the ideological pressures of the 1930s-50s when: the 'wise policies of the Party which sharply condemned formalism in art helped artists, including stage designers, to step on to the road of Realist creativity'.[26]

spector General: Satire in five acts by Nikolai
ogol. Prepared, but not produced, by Vsevolod
eierkhold, at the Meierkhold Theatre, Moscow,
26, with designs by Vladimir Dmitriev.

r plot summary see Collective of Masters of Ana-
ical Art.

. *Set Design*, 1926
ncil and gouache on paper
.6 x 37.5
khrushin State Central Theatre Museum,
oscow
v. No. KP 180169/256

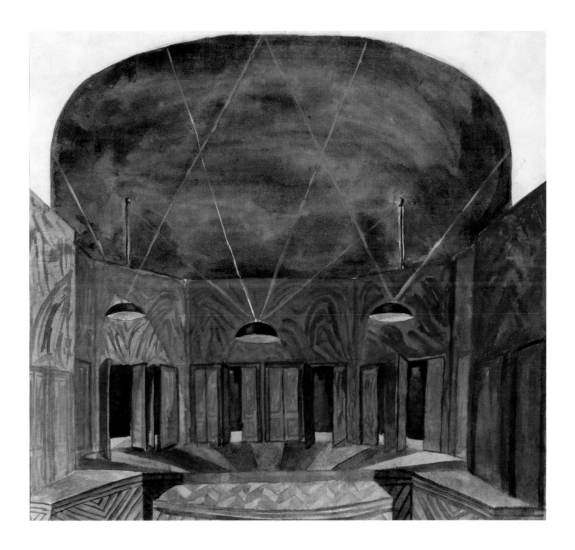

Note: Interested in the Italian Comedy, the *balagan* tradition and the circus, not least, thanks to his association with Meierkhold, Dmitriev was happy to accept the invitation to design *Inspector General*. Eliciting the bold colours of Léon Bakst in his costumes and, more immediately, the expressive geometries of Alexandra Exter, Dmitriev's stage designs were original and effective:

> In the spectacle Dmitriev used a painterly-volumetrical system of decorations… Two exquisite, spiralling, white ladders disappearing into the depths on either side of the stage, a platform in the background and painted backdrops 'inserted' into the general blue ground of the spectacle were what defined the artist's general spatial composition. Painterly effect was achieved not only via the painted landscapes, but also via the combination of the red carpet on the panel with the yellow (on the blue ground) of the long, narrow panels coming down from the gridirons and confining the scenic parameter.[27]

EISENSTEIN (Eizenshtein), Sergei Mikhailovich

Born 10 (23) January, 1898, Riga, Latvia; died 11 February, 1948, Moscow, Russia.

1915–18 attended the Institute of Civil Engineering, Petograd; 1918 joined the Red Army; while enlisted worked in amateur theatre and helped in decorations for the so-called agit-trains; 1920 moved to Moscow where he joined the First Working Theatre of the Proletcult as a designer and instructor; 1921–22 attended the State Higher Directors' Studios under Vsevolod Meierkhold where he helped design a number of productions, including Jack London's *The Mexican*; collaborated with Nikolai Foregger, Meierkhold and other producers; 1923 director of the Proletcult theatre laboratories; studied the circus and music-hall, working with the FEKS group (Factory of the Eccentric Actor); close to the Lef group; 1924 began to direct films and to work for the First State Film Factory, producing *Strike*; 1925 produced *The Battleship 'Potemkin'*; 1927 *October*; 1929 *The General Line*; 1929–32 traveled in Europe and America; 1930–32 on location in Mexico for his film-epic *!Que Viva Mexico!*; 1932 onwards taught at the State Institute of Cinema in Moscow; 1938 produced *Alexander Nevsky*; 1944 produced first part of *Ivan the Terrible* (second part finished in 1946 and released in 1958).

Further reading:

S. Yutkevich, ed: *Sergei Eizenshtein. Izbrannye proizvedeniia v shesti tomakh,* M: Iskusstvo, 1964–71.

S. Yutkevich: *Eizenshtein, Teatralnye risunki,* M: Soiuz kinematografistov SSSR, 1970.

V. Shklovsky: *Eizenshtein,* M: Iskusstvo, 1973.

Y. Barna: *Eisenstein,* Bloomington: Indiana University, 1983.

J. Leyda and Z. Voynow: *Eisenstein at Work,* New York: Pantheon, 1982.

R. Yurenev: *Sergei Eizenshtein. Zamysly. Filmy. Metod,* M: Iskusstvo, 1985.

L. Kleberg and H. Lövgreb, eds.: *Eisenstein Revisited,* Stockholm: Almqvist and Wiksell, 1987.

D. Elliot: *Eisenstein at Ninety.* Catalogue of exhibition at the Museum of Modern Art, Oxford, 1988.

D. Bordwell; *The Cinema of Eisenstein,* Cambridge, Mass.: Harvard University Press, 1993.

I. Axjonow: *Sergej Eisenstein, Ein Porträt,* Berlin: Henschel, 1997.

N. Kleiman, ed.: *Sergei Mikhailovich Eizenshtein. Memuary,* M: Trud, 1997 (two vols.).

N. Kleiman et al.: *Sergei Mikhailovich Eizenshtein. Montazh,* M: Muzei kino, 2000.

L. Hanson and N. Kressel: *Eisenstein at 100: A Reconsideration,* New Burnswick: Rutgers University Press, 2001.

O. Bulgakova: *Sergei Eisenstein. A Biography,* San Francisco: Potemkin Press, 2002.

O. Calvaresi and V. Ivanov, eds.: *Sergej Michailović Ejzenštejn. Quaderni teatrali e piani di regia (1919–1925),* Savveria Monnelli: Rubbetino, 2004.

M. Klejman and M. Sesti: *Ejzenštejn: La Musica del Corpo.* Catalogue of exhibition at the Parco della Musica, Rome, 2004–05.

I. Eskevich: *Opticheskie manevry v okrestnostiakh Eizenshteina i Pikasso,* M, 2005.

V. Zabrodin: *Eizenshtein: Kino, vlast, zhenshchiny,* M: NLO, 2011.

Eisenstein is now remembered for his avant-garde films such as *Strike* and *Battleship 'Potemkin'* and for his bold exploration and application of devices such as montage, frame, cut and closeup. But Eisenstein came to his experimental films after a brief, but intense apprenticeship as a stage designer and actor with brash new companies in Petrograd and Moscow such as FEKS and Mastfor (Nikolai Foregger's theatrical workshop), collaborating closely with young artists and

scenarists such as Georgii Kozintsev, Grigorii Kryzhitsky, Leonid Trauberg and Sergei Yutkevich. The plays that Eisenstein designed then such as *Being Nice to Horses* (1922) and *The Mexican* (1923) made clear reference to the circus and the music-hall and he applied their bright colours and stick figures to his sets and costumes. As he said of his films: 'The center of gravity of their effect lies not so much in the explosion as in the supercharging process of the explosion. The explosion can happen. Sometimes it happens at the intense climax of the preceding suspense and sometimes not, sometimes it's almost absent'.[30] Efficacy, shock, economy, mechanical precision are qualities that Eisenstein continued to emphasize in creative endeavours of the 1920s and early 1930s – until political imposition forced him to entertain more by dramatic narrative and ideologial message as in *Alexander Nevsky* and *Ivan the Terrible*.

Macbeth: Play in five acts by William Shakespeare; produced by Valentin Tikhonovich at the Central Educational Theatre, Moscow, on 25 April, 1922, with designs by Serge Eisenstein assisted by Sergei Yutkevich.

A bold Scottish general named Macbeth receives a prophecy from a trio of witches that one day he will become King of Scotland. Consumed by ambition and spurred to action by his wife, Macbeth murders King Duncan and takes the throne for himself. He is then wracked with guilt and paranoia and soon becomes a tyrannical ruler as he is forced to commit more and more murders to protect himself from enmity and suspicion. The bloodbath and consequent civil war swiftly take Macbeth and Lady Macbeth into the realms of unsufferable arrogance, madness and death.

Set Design, 1921-22
Graphite pencil and watercolour on paper
6.1 x 32.8
Bakhrushin State Central Theatre Museum, Moscow
Inv. No. KP 307260 GDS 1603

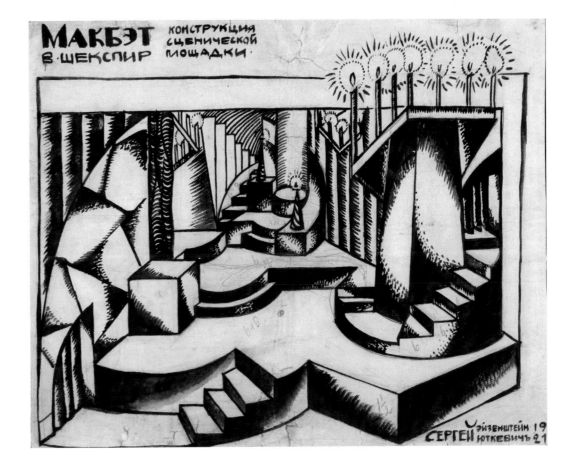

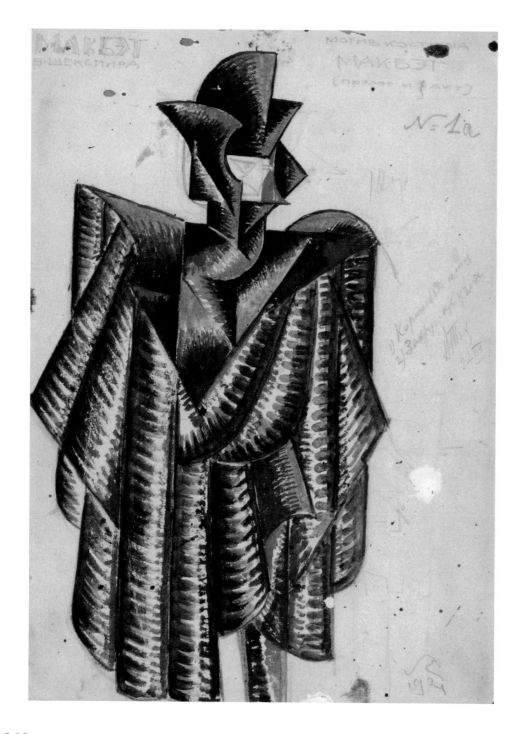

17. *Costume Design for Macbeth*, 1921-22
Watercolour, bronze and graphite pencil on paper
25.7 x 19
Bakhrushin State Central Theatre Museum, Moscow
Inv. No. KP 307256 GKS 4639

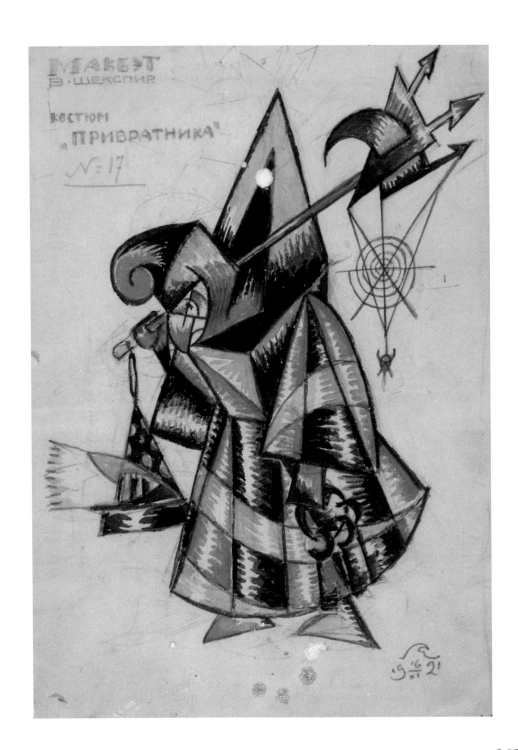

Costume Design for a Doorman, 1921-22
graphite pencil and watercolour on paper
.7 x 18.8
khrushin State Central Theatre Museum,
oscow
v. No. KP 307255 GKS 1824

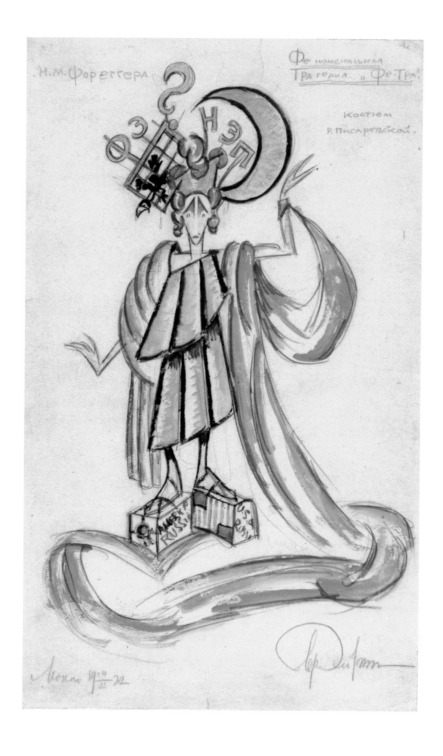

19. *Costume Design for Unknown Production of* Fetra, *a Parody of* Phedre, 1922

Graphite pencil, watercolour and gouache on paper

26.8 x 17.3

Bakhrushin State Central Theatre Museum, Moscow

Inv. No. KP 93865

Note: This costume design, captioned *Fetra,* is part of a parody on the celebrated *Phèdre* which Alexander Tairov produced at the Chamber Theatre, Moscow, in February, 1922 (see No. 145). It is not known for which company or theater Eisenstein made the design or whether the parody was produced, although the success of the Tairov venture did attract many visual and dramatic responses, including satirical interpretations by Nikolai Foregger et al.

[T]he Mexican: Play by Boris Arvatov based on a short [st]ory by Jack London. Produced by Sergei Eisenstein [an]d Valentin Smyshliaev at the First Labour Theatre [of] Proletcult, on 18 October, 1921, with designs by [S]ergei Eisenstein.

[F]elipe Rivera is the son of a Mexican printer who [ha]d published articles favorable to striking workers [in] Veracruz. Federal troops put down the workers, [b]ut Rivera escapes by climbing over the bodies of [th]e deceased—including those of his mother and [fa]ther. Escaping to El Paso in Texas, Rivera contacts [th]e *Junta Revolucionaria Mexicana*. He volunteers to [s]erve the Revolution at the office of the *Junta*, [w]hich, suspicious, puts him to work doing menial [la]bor. He is then sent to Baja California to reestab[li]sh connections between Los Angeles [r]evolutionaries and the peninsula. Rivera, who has [b]een boxing on the local circuit to support the *Junta*, [d]ecides to fight the well-known boxer Danny Ward [i]n order to secure the funds needed by the *Junta*. He [n]egotiates a winner-take-all contract for the fight on [W]ard's condition that the weigh-in occur at ten in [t]he morning rather than immediately prior to the [fi]ght. The fight lasts seventeen rounds, but eventu[a]lly Ward succumbs to Rivera, who is fueled by [v]isions of violent vengeance.

[5]0. Set design. II Act. Boxing Studio of the Kelly [B]rothers, 1921

[P]encil, Indian ink and gouache on paper

[3]0.7 x 29.3

[B]akhrushin State Central Theatre Museum, [M]oscow

[I]nv. No. KP 100683 GDS 1601

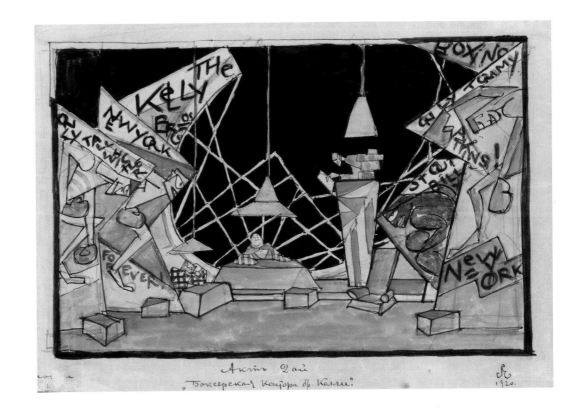

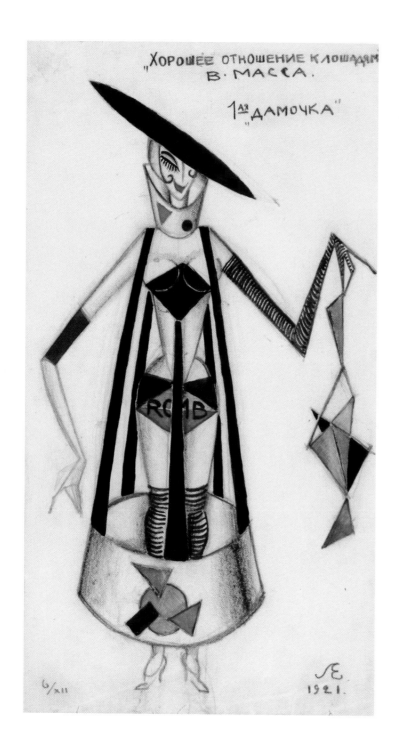

"ХОРОШЕЕ ОТНОШЕНИЕ К ЛОШАДЯМ"
В. МАССА.

1АЯ "ДАМОЧКА"

РОМБ

6/XII
1921.

Being Nice to Horses: Opera-bouffe by Vladimir Mas⁣ based on a poem by Vladimir Maiakovsky. Produce⁣ by Nikolai Foregger for Mastfor (Foregger's theatr⁣ cal workshop), Moscow, on 5 January, 1921, wit⁣ designs by Sergei Eisenstein and Sergei Yutkevic⁣

The poet sees a horse slither and fall down on⁣ Moscow street. While onlookers laugh, he comes u⁣ to the horse to find it weeping and consoles the an⁣ mal by talking to it. The horse gets up, neighs an⁣ continues on its way.

21. Costume Design for the First Little Lady, 1921

Graphite pencil, watercolour and Indian ink on paper

27 x 14.7

Bakhrushin State Central Theatre Museum, Moscow

Inv. No. KP 101602/3 GKS 3422

164

Heartbreak House: A Fantasia in the Russian Manner on English Themes: Play in three acts by George Bernard Shaw. Prepared, but not produced, by Vsevolod Meierkhold at the Actor's Theatre, Moscow, in 1922 with designs by Sergei Eisenstein.

On the eve of the First World War, Ellie Dunn, her father and her fiancé are invited to one of Hesione Hushabye's infamous dinner parties. Unfortunately, her fiancé is a scoundrel, her father is a bumbling prig and, anyway, Ellie is in love with Hector, Hesione's husband. This bold mix of farce and tragedy lampoons British society as it blithely sinks towards disaster.

22. *Set Design*, 1922

Ink, string and collage on paper

34.7 x 48.5

Bakhrushin State Central Theatre Museum, Moscow

Inv. No. KP 62005

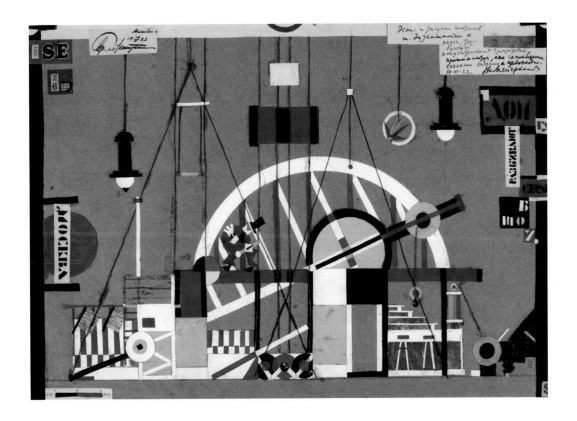

165

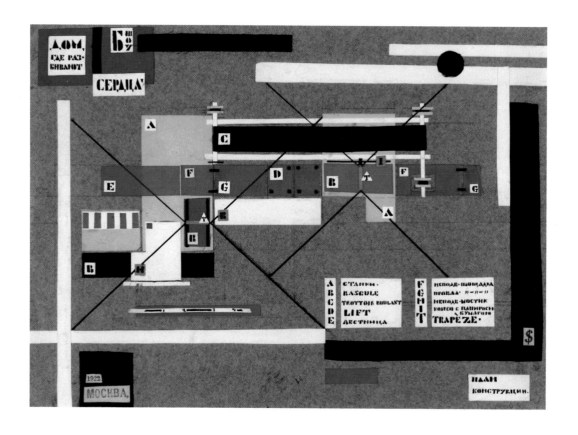

23. *Construction Plan for the Proscenium*, 1922
Collage and ink on paper
24.9 x 34.4
Bakhrushin State Central Theatre Museum,
Moscow
Inv. No. KP 180169/1501

166

*4. Costume Designs for Hesione Hushabye, Hector
Hushabye and Nanny Guinesss, 1922*

Collage and ink on paper

28.7 x 43

Bakhrushin State Central Theatre Museum,
Moscow

Inv. No. KP 180169/1502

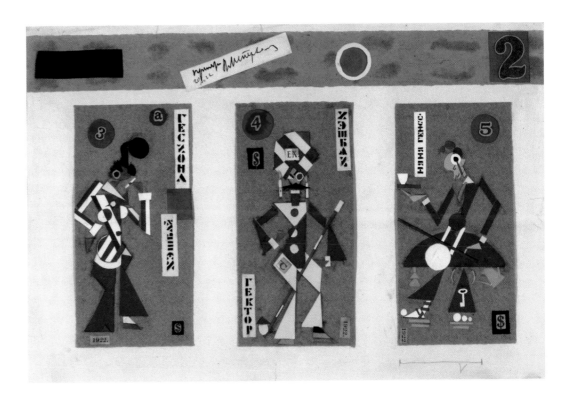

Note: Before his more celebrated film productions such as *The Battleship 'Potemkin'*, Eisenstein accrued considerable experience in the dramatic theater with his designs for plays often of a lighter genre. He was a prolific stage designer, manifesting an appreciation of many styles and historical epochs, especially in the 1920s when he was close to Foregger, Meierkhold, Yutkevich and other avant-garde theatre people. At that time Eisenstein investigated various methods, although, obviously, he was especially drawn to Constructivism.

ERDMAN (also known as Drutskoi and Drutsky), Boris Robertovich

Born 4 (16) February, 1899, Moscow; died 28 February, 1960, Moscow.

Brother of the playwright and producer Nikolai Erdman (1902–70). Ca. 1917 took lessons from Ilia Mashkov; 1917–18 actor at the Chamber Theatre, Moscow; 1918 made his debut as a stage designer in Smolensk; 1919 joined the Circus Section of TEO NKP; 1920 designed a production of *The Stone Guest* for the Safonov Theatre, Moscow; ca. 1920 close to the Imaginist group of writers headed by Vadim Shershenevich; designed and illustrated some of their literary works; 1920s worked in GITIS in Moscow, collaborating with Vsevolod Meierkhold and other celebrities; 1923 worked with Nikolai Foregger and Kasian Goleizovsky on experimental dance; designed productions for the Blue Blouse variety theatre; 1925 contributed to the 'Exposition Internationale des Arts Décoratifs et Industriels Modernes' in Paris; designed Sergei Vasilenko's ballet *Joseph the Beautiful* staged by Goleizovsky at the Bolshoi Theatre, Moscow; 1925–30 designed choreographic productions by Natalia Glan, Goleizovsky and Lev Lukin for Vera Drutskaia's and Alexander Rumnev's Evenings of New Dance in Moscow; ca. 1927 lived in Odessa; worked with Isaak Rabinovich; 1930 designed Yurii Olesha's *Three Fat Men* for MKhAT; 1941–45 headed the Art Section of the State Circus, Moscow; 1950–60 headed the Art Section of the Stanislavsky Dramatic Theatre, Moscow.

Further reading:

Sherpets: 'B. Erdman. Imazhinizm v zhivopisi' in *Sirena*, Voronezh, 1919, No. 4, pp. 63–68.

A. Sidorov: 'Boris Erdman, khudozhnik kostiuma' in *Zrelishcha*, M, 1923, No. 43, June, pp. 4–5.

I. Merzliakov: 'Khudozhnik-eksperimentator teatra' in *Rabochii i teatr*, M, 1935, No. 12, pp. 5–7.

E. Lutskaia: 'Khudozhnik satiricheskogo spektaklia' in *Teatr*, M, 1955, pp. 117–26.

A. Svobodina, ed.: *Nikolai Erdman. Piesy. Intermedii. Pisma. Dokumenty. Vosmpominaniia sovremennikov*, M: Iskusstvo, 1990, passim.

N. Misler: *Vnachale bylo telo: Ritmoplasticheskie eksperimenty nachala XX veka*, M: Iskusstvo XXI vek, 2011, passim.

V. Vulf, ed.: *Nikolai Erdman. Angelina Stepanova: Pisma*, M: AST/Astrel, 2011.

I. Duksina, comp.: *Khudozhniki teatra Kasiana Goleizovskogo 1918–1932*. Catalogue of exhibition at Elizium Gallery, Moscow, 2012, pp. 234–51.

LR (Vol. 2), pp.158–59.

A vital force in the crucible of early Soviet culture, Boris Erdman was in close touch with the leading reformers of that era, including Meierkhold, Valentin Parnakh, Vsevolod Pudovkin and Viktor Shklovsky, and some of his magazine illustrations, caricatures and set and costume designs are connected directly with them. Erdman made drawings for the main theatrical magazines of the early 1920s such as *Ermitazh* [Hermitage] and *Zrelishcha* [Spectacles], he collaborated with important troupes such as the Chamber Theatre, the Experimental-Heroic Theatre, Goleizovsky's Chamber Ballet, Nikolai Foregger's Mastfor (Foregger's theatrical workshop) and the Blue Blouse agit-theatre, and he paid particular attention to the less orthodox media of theatrical expression, especially the cabaret and the circus.

Erdman belonged to the first Soviet generation of stage designers that also included Boris Ferdinandov, Petr Galadzhev, Valentina Khodasevich, Vasilii Komardenkov, Nikolai Musatov, Ilia Shlepianov and Sergei Yutkevich. Drawing upon the geometric traditions of Alexandra Exter, in particular, their art was distinguished by a refractive, almost metallic finish, by geometric precision and by a 'miniaturization' that presented the human body as a robot or automaton, and their designs, often inspired by the cinema, might best be described in the cinematic terms of

montage, cut, framing, closeup and dissolve. Naturally, their art reflected the main features of the 'Roaring Twenties' – commercial advertising, mass communication, the circus and the cabaret, and Erdman's designs were also laboratorial in the way that Goleizovsky's Chamber Ballet, Alexander Tairov's Chamber Theatre and Boris Nevolin's Intimate Theatre were, i.e., confined spaces for the cultivation of rare species observed by an élite. Erdman drew upon the acrobatics of Vladimir Fogel, the clowning of Vitalii Lazarenko, Parnakh's jazz and Foregger's 'machine dances.'

The critic and historian Alexei Sidorov, one of Erdman's earliest advocates, said of his costumes that 'in their play with right angles, asymmetry, and contrast, [Erdman's] costumes resolve the tasks of the inner character.'[31] In collaboration with Eisenstein, Galadzhev and Yutkevich, Erdman designed the installations that Foregger used for his so-called parades at Mastfor. Extracting 'maximal comic effect from the absurd incongruity of form and content,'[32] Foregger and Erdman drew upon the staccato technique of the cabaret in which short numbers or skits pass before the audience in rapid succession like the frames of a film. Together with Galadzhev, Musatov and Goleizvosky, Erdman also designed some of Goleizovsky's eccentric dances and Spanish dances for the Chamber Ballet in 1922–23, rendering the almost nude dancers as streamlined components of a machine. These exercises were one more manifestation of the 'eccentric culture' that Parnakh identified with 'unexpected combinations of movements, peripatetics and unprecedented harmonies (syncopation, dissonances, new tempos).'[33]

The Moneybox (La Cagnotte): Vaudeville by Eugene Labiche and Alfred Delacroix produced by Boris Ferdinandov and Vadim Shershenevich at the Experimental-Heroic Theatre, Moscow, on 10 (?) February, 1922 with designs by Boris Erdman.

Gamblers pool their financial resources so as to party and carouse, although some dream of family happiness and good company. Accompanied by burlesque misunderstandings and witty surprises, the gamblers are accused of thievery and put in jail.

5. Two Costume Designs, 1922

Watercolour, gouache, pencil and collage on paper on cardboard

59.8 x 46

Bakhrushin State Central Theatre Museum, Moscow

Inv. No. KP 101768

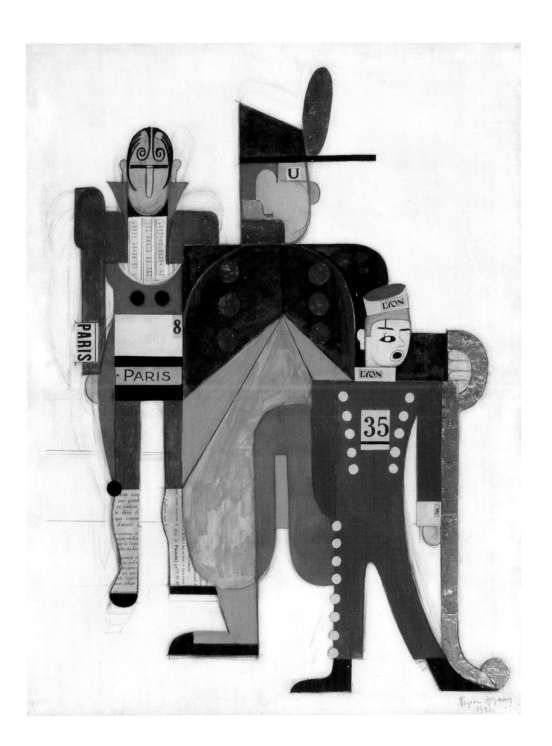

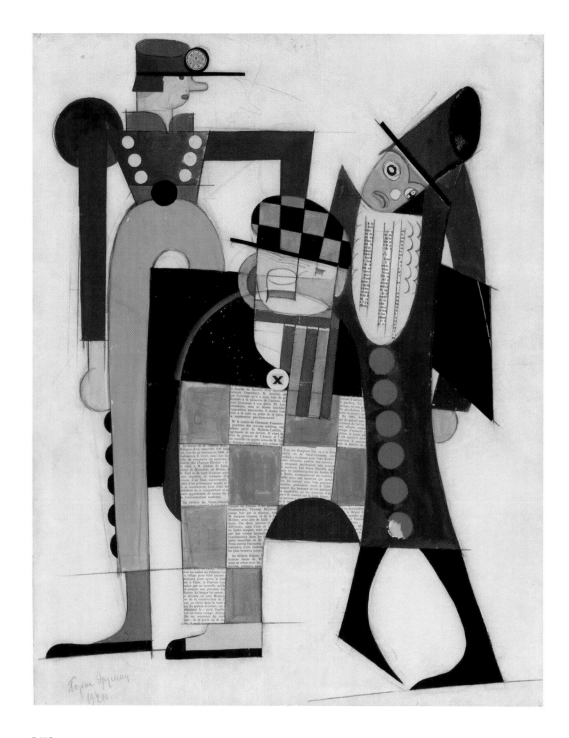

26. *Costume Designs for Office Boy, Butler and Policeman*, 1922

Graphite pencil, gouache, collage and foil on paper

59.6 x 48

Bakhrushin State Central Theatre Museum, Moscow

Inv. No. KP 101769 GKS 4325

7. *Costume Designs*, 1922

Gouache and collage on paper

69.8 x 45.8

Bakhrushin State Central Theatre Museum, Moscow

Inv. No. KP 93866

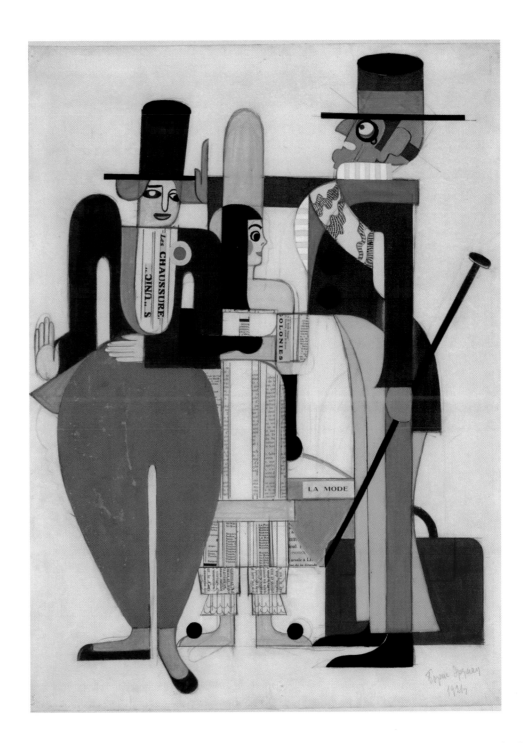

Note: In February, 1919, TEO NKP under Anatolii Lunacharsky established a special Circus Section. Ilya Ehrenburg, Erdman, Goleizovsky, Vasilii Kamensky, Sergei Konenkov, Pavel Kuznetsov, Pavel Markov and other artists, writers and producers worked for the Section, the purpose of which was to 'care for the artistry of the circus, to help the laborers of the circus… to cleanse their art of impurity… to determine [its] strength, agility and courage, to incite laughter and to delight in a brilliant, vivid and exaggerated spectacle.'[34] Like Foregger and Goleizovsky, Vladimir Bekhteev and Georgii Yakulov, Erdman wished to bring the discipline of the circus into closer contact with the 'high' art forms of the ballet and the drama, to which end he published a number of statements on the subject.[35] His approach to the circus costume was serious and innovative and he tried to adopt the lessons of Cubism and the geometric style to his own resolutions as in his designs for *The Moneybox*.[36]

EXTER, Alexandra Alexandrovna

Born 6 (18) January, 1882, Belostok, Ukraine (now Białystok, Poland); died 17 March, 1949, Fontenay-aux-Roses, near Paris, France.

1892–99 attended St. Olga Women's Gymnasium in Kiev; 1901–03 attended the Kiev Art Institute; 1904 married her cousin, the lawyer Nikolai Ekster (Exter), who died in 1918; 1906–08 re-enrolled in the Kiev Art Institute; 1908 onward was a regular visitor to Paris and other European cities; contributed to several Kiev exhibitions, including David Burliuk's 'Link,' the first of many involvements with the avant-garde; first book illustrations; 1909–14 lived abroad frequently; acquaintance with Apollinaire, Braque, Picasso, Soffici and other members of the international avant-garde; 1910 contributed to the 'Triangle' and 'Union of Youth' exhibitions in St. Petersburg; 1910-11 contributed to the 'Jack of Diamonds' exhibition Moscow; 1912 moved to St. Petersburg; associated with the Union of Youth; 1913–14 lived mainly in France; 1914 organized the 'Ring' exhibition in Kiev; 1915 prompted by Kazimir Malevich and Vladimir Tatlin began to investigate non-objective painting; 1915–16 contributed to 'Tramway V' and the 'Store'; began her professional theatre work with designs for *Thamira Khytharedes* produced by Alexander Tairov at the Chamber Theatre, Moscow; 1917 designed

Salomé for the Chamber Theatre; 1918–19 ran her own studio in Kiev where many artists of later fame studied such as Isaak Rabinovich, Alexander Tyshler and Pavel Tchelitchew; 1918–20 worked intermittently in Odessa as teacher and stage designer; 1920 moved to Moscow; married the actor Georgii Nekrasov; worked at the Theatre of the People's House; 1921 contributed to the exhibition '5 x 5 = 25,' Moscow; designed Tairov's book *Zapiski rezhissera* [Notes of a Director]; 1921–22 taught at Vkhutemas; 1923 turned to textile and fashion design for the Atelier of Fashions, Moscow; member of design team for the *Izvestiia* Pavilion at the 'All-Russian Agricultural Exhibition', Moscow; began work on the costumes for the film *Aelita* (released 1924); 1924 emigrated to Paris; contributed to the Venice Biennale; with Léon Zack and Pavel Tchelitchew worked for the Ballets Romantiques Russes; taught at Léger's Académie Moderne; 1925 contributed to the 'Exposition Internationale des Arts Décoratifs et Industriels Modernes' in Paris; during the 1920s and 1930s continued to work on stage and interior design; 1925 designed costumes for seven ballets performed by Bronislava Nijinska's Théâtre Choréographique; 1926, with Nechama Szmuszkowicz, created a set of marionettes; 1927 exhibition at Der Sturm, Berlin; 1929 exhibition at Quatre Chemins, Paris; 1937 exhibition at the Musée des Arts et Métiers, Paris; 1937–46 illustrated a number of elegant editions for children such as Marie Collin-Delavaud's *Panorama de la Montagne* (Paris: Flammarion, 1938) and *Panorama de la Côte* (Paris: Flammarion, 1938) and her own *Mon Jardin* (Paris: Flammarion, 1936).

Further reading:

Ya. Tugendkhold: *Alexandra Exter*, Berlin: Zaria, 1922.

Ausstellung Alexandra Exter. Catalogue of exhibition at Der Sturm, Berlin, 1927.

Alexandra Exter. Théâtre (Maquettes, Décors, Costumes). Catalogue of exhibition at the Galérie Quatre Chemins, Paris, 1929.

A. Tairov: *Alexandra Exter. Décors de Théâtre*, Paris: Quatre Chemins, 1930.

Alexandra Exter. Théâtre. Catalogue of exhibition at the Musée des Arts et Métiers, Paris, 1937.

P. Faucher: *Alexandra Exter: divadlo: skizy, dekorace, kostymy.* Catalogue of exhibition at the Uměleckoprůmyslové Muzeum, Prague, 1937.

A. B. Nakov: *Alexandra Exter*, Paris: Galérie Chauvelin, 1972.

A. Koval: *Ausstellung Russische Avantgarde. Alexandra Exter. Michel Andreenko.* Catalogue of exhibition at the Galerie Werner Kunze, Berlin, 1974.

S. Lissim et al.: *Artist of the Theatre, Alexandra Exter.* Catalogue of the exhibition at the Center for the Performing Arts, the New York Public Library at Lincoln Center, New York, 1974.

M. McClintic: *Alexandra Exter, Marionettes and Theatrical Designs.* Catalogue of exhibition at the Hirshhorn Museum and Sculpture Garden, Washington, D.C., 1980.

R. Cohen: 'Alexandra Exter's Designs for the Theatre' in *Artforum*, New York, 1981. Summer, pp. 46–49.

E. Tomilovskaia et al.: *Alexandra Exter. Eskizy dekoratsii i kostiumov.* Catalogue of exhibition at the Bakhrushin State Central Theatre Museum, Moscow, M, 1986.

M. Kolesnikov: *Alexandra Exter.* Catalogue of exhibition at the Bakhrushin State Central Theatre Museum, M, 1988.

F. Ciofi degli Atti and M. Kolesnikov: *Alexandra Exter e il Teatro da Camera.* Catalogue of exhibition at the Archivio del '900, Rovereto, 1991.

G. Kovalenko: *Alexandra Exter.* M: Galart, 1993.

D. Gorbachev: 'Exter in Kiev-Kiev in Exter' in *Experiment,* Los Angeles, 1995, No. 1, pp. 299–322.

J. Chauvelin: *Alexandra Exter 1882–1949.* Catalogue of exhibition at the Musée Château de Tours, Château de Tours, 2009.

G. Kovalenko: *Alexandra Exter,* M: Moscow Museum of Contemporary Art, 2010 (two volumes).

P. Railing: *Alexandra Exter Paints,* Forest Row, East Sussex: Artists' Bookworks, 2011.

LR (Vol. 2), pp. 161–78.

Alexandra Exter was one of the few artists of the avant-garde capable of maintaining the theatrical principle that Léon Bakst applied with such aplomb, i.e., the ability to transcend the confines of the pictorial surface and to organize forms in their interaction with space. Exter's awareness of this interaction was evident in her first collaborations with Tairov (when she also worked closely with Vera Mukhina), i.e., the productions of *Thamira Khytharedes* (1916), *Salomé* (1917), and then her later endeavors such as *Romeo and Juliet* (1921) and the *Death of Tarelkin* (1921, projected, but not produced by the First Studio of MKhAT). When the critic Tugendkhold observed of *Thamira Khytharedes* that Tairov and Exter had managed to 'make an organic connection between the moving actors and the

objects at rest,'[37] he was already indicating the direction that Exter would follow. It was precisely in this production that the conventions of the *Stilbühne* were dropped and replaced by a kinetic resolution in which the actors and scenery played equal roles. Exter's concentration on the 'rhythmically organized space'[38] pointed forward to her Constructivist designs for the film *Aelita,* to her costume designs for Bronislava Nijinska's Choreographic Studio in Kiev and then Théâtre Choréographique in England and Paris,[39] and to her set of marionettes of 1926.

In the dynamic medium of film, where focus and sequence change constantly, formal contrast is transmitted by a rapid variability of light, and light itself plays a constructive role, Exter perhaps attained the high point of her scenic career. Her concern with the formative value of light was, however, already evident in her stage designs of 1916–17 in which she relied on saturated lighting as well as on the painted surface for effect: 'From top to bottom the box of the stage is replete with bridges and platforms; mirrors flash.'[40] During the 1920s, as in *Aelita,* Exter incorporated the properties of transparency and reflectivity into her system, much in the way that Naum Gabo and Antoine Pevsner did in their designs for Sergei Diaghilev's production of *La Chatte* in 1927. Exter never ceased to experiment, applying her ideas to drama, the ballet, revues and modern dance and in 1925 she even invented 'epidermic costumes' for a ballet project in which the dancers were painted, not dressed. As her one-time student, Alexander Tyshler, said: 'In her hands, a simple paper lampshade turned into a work of art.'[41]

Salomé: drama in one act by Oscar Wilde based on the Biblical story. Produced by Alexander Tairov at the Chamber Theatre, Moscow, on 9 October, 1917 with music by Joseph Hüttel, choreography by Mikhail Mordkin and designs by Alexandra Exter.

Salomé, daughter of Herodias, is corrupted by the depraved court of King Herod, her stepfather, and she seeks ever new pleasures. Although contrary to the law, the young captain Narraboth lets her see the captive John the Baptist. Fascinated, Salomé tries to seduce him, but in vain. Narraboth, who is enamored of Salomé, cannot endure the scene and kills himself. Salomé dances the Dance of the Seven Veils in front of the desirous Herod, and, as her reward for the Dance, she demands the head of John the Baptist. It is brought to Salomé who kisses the dead lips. Horrified, Herod has her put to death by his guards.

28. Set Model, 1917

Velvet, plastic, cardboard, glue paint, twill and steel wire on wood

50 x 65.5 x 39

Bakhrushin State Central Theatre Museum, Moscow

Inv. No. KP 318303 Mak 67

9. *Costume Design for Three Slaves*, 1917

Gouache, pencil, whitening and distemper on cardboard

7.5 x 51.2

Bakhrushin State Central Theatre Museum, Moscow

Inv. No. KP 61161 GKD 13

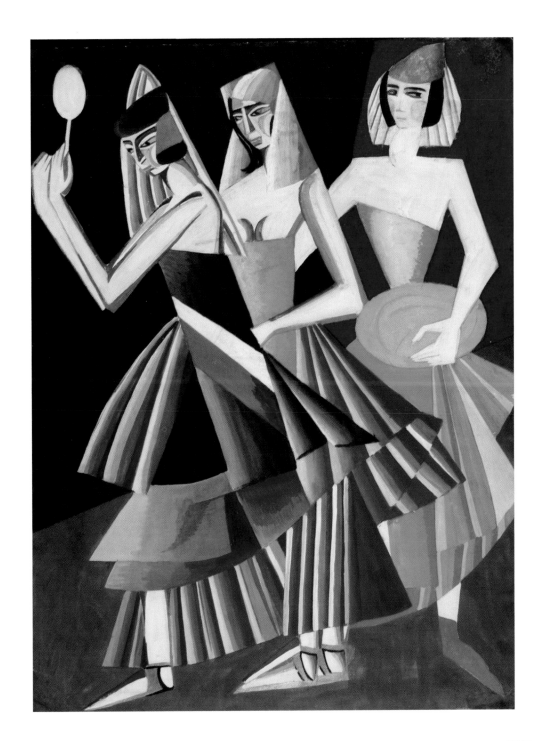

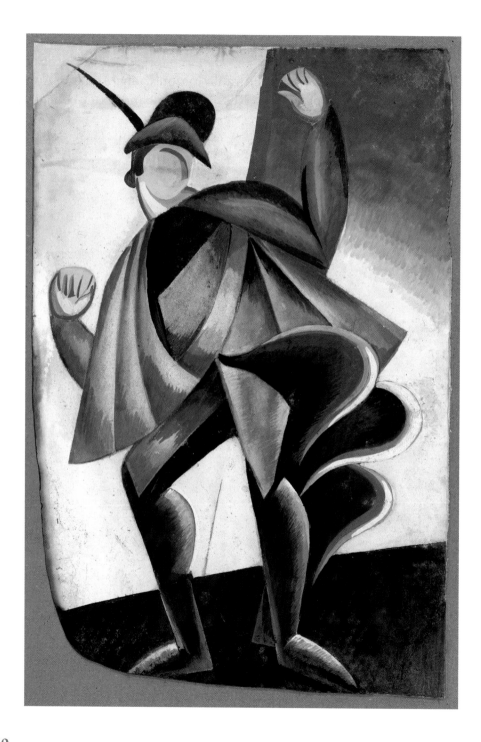

Romeo and Juliet: Play in five acts by William Shake-speare. Produced by Alexander Tairov at the Chamber Theatre, Moscow, on 17 May, 1921, with designs by Alexandra Exter.

During a ball at the House of the Capulets in Verona, Romeo, of the rival Montague family, professes his love for Juliet, a Capulet. Defying the family feud, Romeo proposes marriage, Juliet consents, and they are betrothed by a friar. The two families clash: Tybalt of the Capulets stabs Mercutio of the Montagues. Enraged, Romeo kills Tybalt and is forced to flee. The Capulets demand that their daughter marry Paris, but Juliet, fearing the arrangement, swallows a secret potion and swoons. Believing her to be dead, the Capulets lay the body in the family vault, and on seeing this, Romeo concludes in horror that Juliet has died and drinks a vial of poison. At that moment Juliet awakens, is embraced by the dying Romeo and kills herself with his dagger.

30. Costume Design for the Servant Gregorio, 1921
Pencil, tempera and gouache on cardboard
53.7 x 36
Bakhrushin State Central Theatre Museum, Moscow
Inv. No. KP 238272/1560 GKS 60

Note: Exter worked on three major productions for Tairov's Chamber Theater in Moscow – *Thamira Khytharedes* (1916), *Salomé* (1917) and *Romeo and Juliet* (1921). Much under the influence of Edward Gordon Craig, Adolphe Appia and Sergei Volkonsky (Appia's apologist in Russia), Tairov and Exter conceived the stage as a volumetrical, constructive space, wherein the guiding force of the sets and costumes was rhythm. Paying homage to Appia, in particular, Exter applied his programmatic principle of arranging a counterpoint of particular architectural shapes on stage in order to elicit particular emotional responses, as, for example, in the pointed triangles and gradual inclines of the steps in *Salomé*. Exter's concentration on the 'rhythmic frame of the action',[42] was the common denominator of her stylistic approach to the theater, whether Cubist as in *Salomé* or Constructivist as in the Paris projects of the mid-1920s, whether for a dramatic costume or for a marionette. Exter also designed a special drop curtain for Tairov's production of *Salomé*.

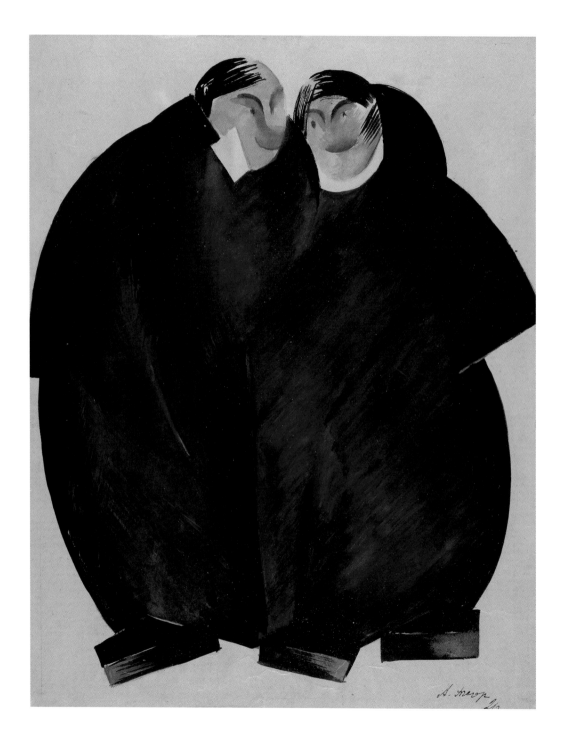

The Death of Tarelkin: Play in three acts by Alexan der Sukhovo-Kobylin. Prepared, but not produced by the First Studio of MKhAT, in 1921, with design by Alexandra Exter.

Tarelkin, the hero of this anti-tsarist satire, fake death in order to avoid his creditors. Taking th identity of a recently deceased neighbor, Korylov, h intends to disappear for a time and then to return b using stolen documents. But his plan is foiled whe his toupee and false teeth are found in his apar ment. He is arrested and interrogated, but set free doomed to spending the rest of his life under h assumed identity of Korylov.

31. Costume Designs for Two Officials, 1921

Watercolour, pencil and gouache on paper on cardboard

45.5 x 35.6

Bakhrushin State Central Theatre Museum, Moscow

Inv. No. KP 6058 GKS 95

2. *Costume Design for Raspliuev*, 1921
ncil and body-colour on buff toned paper
3.8 x 30.2
he Victoria and Albert Museum, London
v. No. E.1596-1953

Satanic Ballet: Ballet based on Alexander Skriabir music for his *Poème Satanique*. Prepared, but no produced, by Kasian Goleizovsky, perhaps for h Moscow Chamber Ballet (or by Olga Chaplygina fo the Studio of Dramatic Ballet [Drambalet], Moscow in 1922, with designs by Alexandra Exter.

The ballet consists of improvisations without the matic sequence.

33. Set Design, 1922

Pencil, guoache, watercolour and Indian ink on paper

48.7 x 55.1

Bakhrushin State Central Theatre Museum, Moscow

Inv. No. KP 93635 GDS 87

Note: Although the *Satanic Ballet* was not produced, many of the stage constructions which Exter designed throughtout the 1920s, especially the prototypes which were silkscreened for the album *Décors de Théâtre* (see below), seem to derive from this 1922 collaboration with Goleizovsky. Exter's use of scaffolding, stairways and inclines, along which the dancers would have moved, responds to the Constructivists' appeal to technology and engineering, in general, and to Goleizvosky's concept of the body as a naked mechanism, in particular. These qualities remind us that Exter and Goleizovsky had moved closely with Bronislava Nijinska in Kiev just a few months before and were well aware of her radical, functional choreography.

Aelita: Film by Fedor Otsep and Alexei Faiko aft‌ the novel by Alexei N. Tolstoi. Directed by Yak‌ Protazanov for Mezhrabpom-Russ, Moscow, wi‌ sets by Isaak Rabinovich assisted by Serg‌ Kozlovsky and Viktor Simov, costumes by Alexa‌ dra Exter assisted by Vera Mukhina and came‌ work by Yurii Zheliabuzhsky and Emil Shiunema‌ Released 25 September, 1924.

During the harsh time of Military Communism, t‌ engineer Los, whose wife is attracted to Erlikh, ‌ 'bourgeois remnant,' constructs a spaceship to Ma‌ to discover a better life. Although he falls in lo‌ with the Queen of the Martians, he sees that Martia‌ society is a feudal one in need of revolution. Aft‌ acquainting himself with the Martians' decade‌ society and organizing a revolution, Los wakes u‌ on earth to realize that it had all been a dream.

34. Costume Design for Aelita, Queen of the Martians, 1924

Indian ink and collage on paper.

68.6 x 45.7

Inscribed mid-left margin in Russian: 'Aelita'

State Museum of Theatrical and Musical Art, St. Petersburg (formerly in the collection of Nina and Nikita D. Lobanov-Rostovsky)

Inv. No. GIK 23272/567

. *Costume Design for Gor, Guardian of Energy,*
924

ouache, pencil and lacquer on paper
gned and dated lower right in Russian: 'A. Exter,
924.'

3 x 35

ate Museum of Theatrical and Musical Art, St.
etersburg (formerly in the collection of Nina and
ikita D. Lobanov-Rostovsky).

v. No. GIK 23272/569

Note: Aelita was Exter's only major commitment to the art of film, although sources mention her involvement in other films such as *Daughter of the Sun*,[43] and she also constructed her marionettes in 1926 for a film projected, but not produced, by Peter Gad in Paris. Based on Alexei Tolstoi's novel *Aelita* of 1923, the film was part of the current fashion for sci-fi culture just before and after the Revolution and it paralleled the serious and less serious examples of 'sky art' contemplated by Alexander Labas, Vladimir Liushin, Kazimir Malevich, Vladimir Tatlin and other artists during the 1920s. In her pioneering designs, Exter set an example that anticipated more contemporary resolutions of space fantasies such as *Star Wars*. With its easy plot, box office stars (Yuliia Solntseva as Aelita and Yurii Zavadsky as Gor) and audacious costumes by Exter, *Aelita* could not fail to attract both Russian and Western audiences, even though film critics do have genuine reservations about this 'cosmic Odyssey.'[44]

Various projects for stage designs

Exter made the following designs between ca. 1925 and ca. 1927. In greater or lesser degree they all relate to the set of fifteen *gouaches au pochoir* or silkscreens which she compiled for the album *Alexandra Exter. Décors de Théâtre* (Paris: Editions des Quatre Chemins, 1930). Prefaced by Exter's old friend, Alexander Tairov, director of the Chamber Theatre, the album was published in an edition of about 150 copies, each silkscreen being identified by its own title. None of the designs seems to have been used for an actual production, although the intensity with which Exter worked on them indicates that she was expecting commissions.

La Dama Duende [The Phantom Lady]: Comedy in three acts by Pedro Calderón de la Barca. Produced by Mikhail Chekhov at the Second Studio of the Moscow Art Theater on 9 April, 1924, with designs by Ignatii Nivinsky, one of Exter's disciples.

This comedy of confused identities treats of the elaborate love affair between one Don Manuel and Doña Angela, the sister of Don Juan. By installing a glass partition between her chambers and the room of her brother's guest, Don Manuel, Doña Angela enamored of Don Manuel, is able to move back and forth quickly and silently. After a skirmish between Don Luis (the brother of Don Juan) and Don Manuel, after the passing of anonymous love letters, after a scolding by Don Juan, solicitous of his sister's welfare (she being a recent widow), Doña Angela, the phantom lady, accepts the hand of Don Manuel, while her maid Isabel accepts the hand of Cosme, Don Manuel's servant.

6. *Set Design*, 1923
Bodycolour on paper
63.4 x 60.5
The Victoria and Albert Museum, London
Inv. No. E.1595-1953

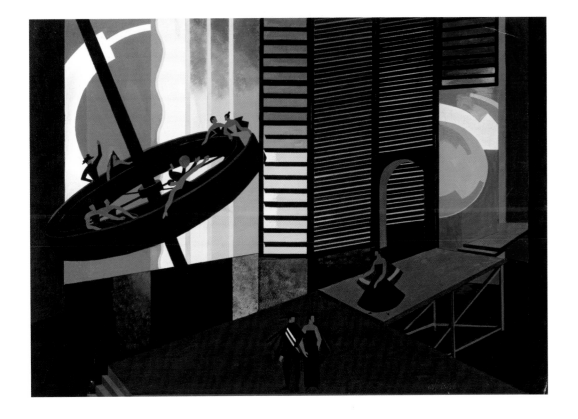

189

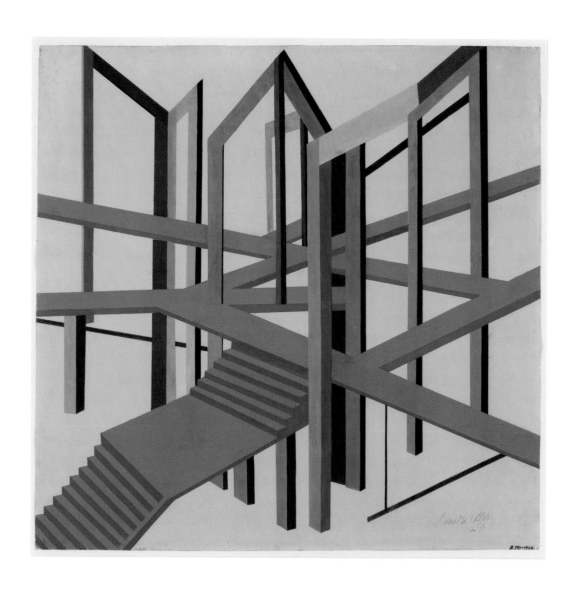

37. *Set Design for a 'Tragedy'*, 1924 (not produced)
Bodycolour on paper
50.5 x 53
The Victoria and Albert Museum, London
Inv. No. E.791-1963

8. Set design for Dance Sequence Based on 'Etudes'
y Franz Liszt, 1924 (not produced)
en, ink and bodycolour on paper
6 x 62.5
he Victoria and Albert Museum, London
ıv. No. E.792-1963

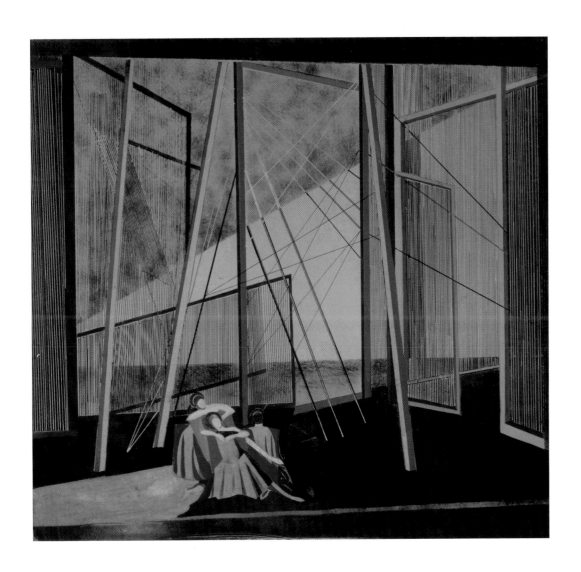

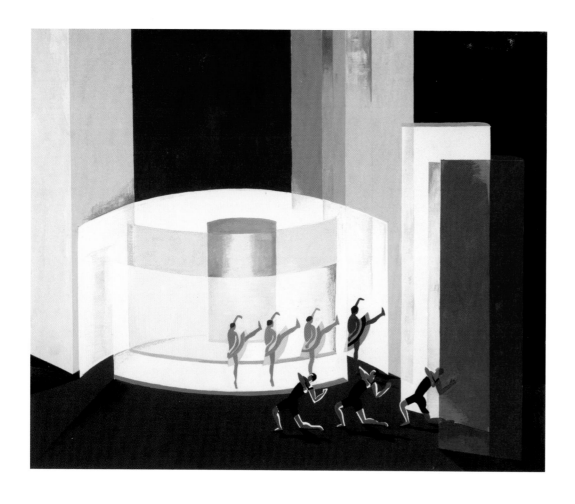

39. Set Design for an Unidentified Spectacle, 1928
Distemper on paper
46 x 56.5
The Victoria and Albert Museum, London
Inv. No. E.3311-1928

on Juan ou Le Festin de Pierre: Ballet in three acts with libretto by Raniere de' Calzabigi and music by Christoph Willibald Ritter von Gluck. Projected, but not produced, for Elsa Kruger (Elza Kriuger) at the Opera House, Cologne, in 1929, with designs by Alexandra Exter.

on Juan serenades Donna Elvira, but her father, the Commander, enters with sword drawn to protect his daughter and, in the ensuing duel, Don Juan kills the Commander. Don Juan is banqueting with friends, when a terrible knocking is heard at the door. Opening the door, Don Juan discovers the marble statue of the dead Commander, which invites Don Juan to dine at his tomb. The Commander steps from his tomb, and although Don Juan confronts the Commander with frivolity, irrevocable judgment is passed upon him: to the strains of a passacaglia, graves fly open, flames rise and Juan descends into Hell.

). Set Design, ca. 1928
odycolour on paper
6 x 60
he Victoria and Albert Museum, London
av. No. E.1594-1953

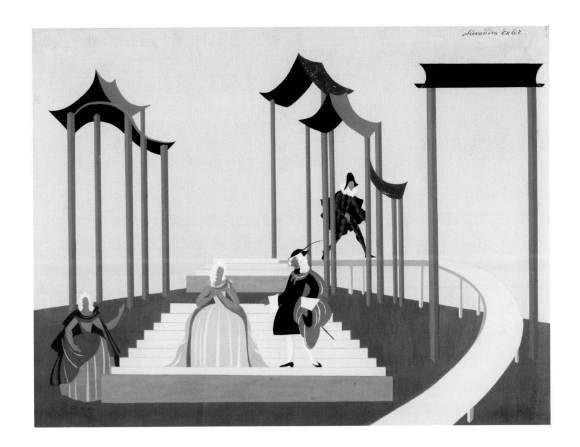

Note: In her Constructivist stage sets Exter manipulates staircases and platforms with their emphatic verticals and diagonals to produce a remarkable play of movement, light and colour, while beams of light seem to dematerialize the scenic space itself. In all these designs, Exter was attempting to illustrate the 'dynamic use of immobile form'[45] that she had applied in her first works for the Chamber Theatre, Moscow. Following the examples of the designers Appia and Thomas Gray, Exter became particularly interested in the architectural possibilities of the stage and often used arches and steps to enhance and 'expand' the space on stage (as, for example, in the sets for *Don Juan* and for Elsa Kruger's preparation of the ballet for the Cologne Opera House in 1929). Exter's student and colleague, Isaak Rabinovich, also supported this system, as evidenced by his sets for the productions of *Don Carlos* at the Comedy Theatre, Moscow, and *The Sorcerers* at the Jewish State Chamber Theatre, Moscow, in 1922, as well as for *The Love for Three Oranges* of 1927.

FERDINANDOV, Boris Alexeevich

Born 27 June, 1889, Moscow, Russia; died Mocow, Russia, 16 March, 1959.

1908 contributed to the exhibition 'Contemporary Tendencies in Art' in St. Petersburg; 1909–11 studied at the Khaliutina Actor's Courses; 1911–12 worked at MKhAT; 1913–14 worked as a designer at the Theatre of Musical Drama, St. Petersburg; 1917–25 worked (intermittently) at the Chamber Theatre, Moscow; elaborated his theory of metro-rhythm as a basic principle of acting; designed many productions including Rudolph Lothar's *King Harlequin*; 1918 acted at Our Theatre in Moscow; close to the writer Vadim Shershenevich; 1921 joined the Safonov Theatre; established the Experimental-Heroic Theatre which, in 1922, became part of Vsevolod Meierkhold's GITIS, but then broke away to reestablish his Theatre which in 1923 was closed down; among his acting roles were parts in Rudolph Lothar's *King Harlequin*, Oscar Wilde's *Salomé*, Arthur Schnitzler's *Der Schleier der Pierrette*, Eugène Scribe's *Adriana Lecouvreur*, Shakespeare's *Romeo and Juliet* and Alexander Ostrovsky's *Storm*; 1925 contributed to the 'Exposition Internationale des Arts Décoratifs et Industriels Modernes' in Paris; 1920s-30s acted in films such as *Your Acquaintance* (1927) and *The Ghost Which Does Not Return* (1929); acted in regional theatres in cities such as Cheliabinsk, Kaluga and Novokuznetsk.

Further reading:

V. Ivanov: 'Bunt marginala. Analiticheskii teatr Borisa Ferdinandova' in *Mnemozina*, M, 1996, No. 1, pp. 211–41.

Ferdinandov belonged to the new generation of Soviet stage designers which also included Boris Erdman, Petr Galadzhev, Valentina Khodasevich, Vasilii Komardenkov, Nikolai Musatov, Ilia Shlepianov and Sergei Yutkevich. Deriving much from the radical conventions of Alexandra Exter and Vladimir Tatlin, in particular, they incorporated mechanical and cinematographic devices, often rejecting florid ornament and reducing the set or costume to geometric essentials. Fascinated by the circus and the cabaret, Ferdinandov sought to expose the intrinsic components of theatricality and, to this end elaborated his theory of 'meter-rhythm' and 'analytical theatre' which, he hoped, would move traditional spectacle away from the narrative basis towards a more formal, but also more musical and balletic entity: 'The spectator will enjoy the same kind of pleasure in the analytical theatre. The movement of lines, colours and voices will nurture in the viewer – spontenously – numerous conditions of consciousness, incomparably stronger than the impression of the usual kind of spectacle'.[46]

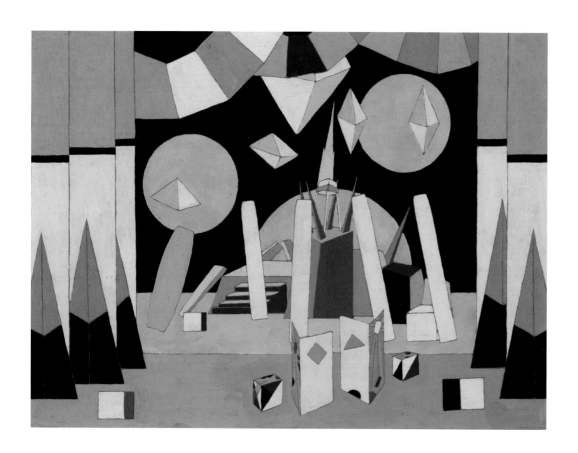

King Harlequin (Kōnig Harlekin): Comedy in four acts by Rudolph (Rudolf) Lothar produced by Alexander Tairov at the Chamber Theatre, Moscow on 29 November, 1917, with music by Henri Forterre and designs by Boris Ferdinandov.

A play based on the traditional theme of Pantalone, Harlequin, Columbine and Pierrot.

41. Set Design, 1917

Oil on plywood

30.8 x 41.5

Bakhrushin State Central Theatre Museum, Moscow

Inv. No. KP 304634 GDS 956

GALADZHEV, Petr Stepanovich

Born 28 December, 1900 (10 January, 1901), Stary Krym, Crimea, Ukraine; died 5 October, 1971, Moscow, Russia.

1909–17 studied at CSIAI; 1910s worked as a set director's assistant at Sergei Zimin's Opera Theater, Moscow; 1917–20 studied at Svomas/Vkhutemas under Vladimir Favorsky and Dmitrii Shcherbinovsky; then attended a studio at the Worker's Art Education Union under Fedor Komissarzhevsky; 1919 first commercial collages and reliefs; started acting career; 1920-25 student at the State Cinematography Polytechnic under Lev Kuleshov; 1921 onwards created designs for The Lukin Ballet Studio, Moscow; started to publish caricatures and vignettes in journals such as *Ekho* [Echo], *Ermitazh* [Hermitage] and *Zrelishcha* [Spectacles]; 1922 created designs for *Fantasy*, choreographed by Kasian Goleizovsky to music by Alexander Scriabin for the Chamber Ballet, Moscow; 1920s worked for prestigious companies such as the Crooked Jimmy Cabaret and the Blue Blouse agit-theater; moved closely with actors, directors, film-makers and choreographers such as Sergei Eisenstein, Nikolai Foregger, Zinaida Tarkhovskaia, and Yurii Zavadsky; 1920s onwards involved in numerous films, either acting (as in Lev Kuleshov's *The Extraordinary Adventures of Mr. West in the Land of the Soviets* of 1924) or designing the sets and costumes; 1925 created cover design for sheet music of Matvei Blanter's *Solara*; contributed to the 'First Exhibition of Graphics' at the Press House, Moscow; 1940 designer for the Soiuzdetfilm (All-Union Children's Film Studios) and later for the Gorky Film Studios; acted in thirty-six films and made sets for over fifty films, including *Kashchei the Immortal, Donetsk Miners* and *When the Trees Were Tall*; directed films; 1965 designated Meritorious Art Worker of the RSFSR; 1971 received a USSR State Prize for his work in the film *By the Lake*.

Further reading:

M. Fedorov: *Petr Stepanovich Galadzhev.* Catalog of exhibition at the Union of Artists of the USSR, M, 1961.

O. Voltsenburg et al., eds.: *Khudozhniki narodov SSSR. Biobibliograficheskii slovar v shesti tomakh,* M: Iskusstvo, 1972, Vol. 2, p. 391.

K. Isaeva: *Petr Stepanovich Galadzhev.* Catalog of exhibition at the Moscow Kino Center, 1990.

J. Bowlt: *Pjotr Galadschew.* Catalog of exhibition at the Galerie Alex Lachmann, Cologne, 1995.

N. Galadzheva: 'Petr Galadzhev – pervostepennyi sluzhitel kino' in *Kino-glaz,* Moscow, 1992, No. 1, pp. 28–32.

V. Winokan: *Pyotr Stepanovitch Galadshev.* Catalog of exhibition at Galerie Natan Fedorowskij, Berlin, 1994.

A. Borovsky: *Petr Stepanovich Galadzhev.* Catalog of exhibition at the House of Photography, Moscow, 2003.

A. Borovsky: 'Galadzhev khudozhnik' in *Pinakoteka,* M, 2006, No. 22–33, pp. 232–35.

N. Galadzheva, ed.: *Khudozhnik kino Petr Galadzhev,* M (publishing-house not indicated), 2010.

Galadzhev's many renderings of drama, ballet, cabaret and film productions in the 1920s, often reproduced as covers or accompaniments of texts in journals such as *Zrelishcha,* if collected and collated, would constitute a vivid panorama of the Constructivist performing arts. Although these are often artist's impressions rather than actual projects, they are also stark exercises in black and white, kinetic miniatures which present the human body as an energic automaton whose steps and gestures move to the calculated rhythm of wheels and levers. Indeed, the refractive, almost metallic, finish of Galadzhev's renderings of Goleizovsky's *Tombeau de Columbine* or Faiko's *Lake Liul,* might best be described in the cinematic terms of montage, cut, framing, closeup and dissolve. But Galadzhev's images also depend for their effect on a microsopic play of force-lines contained within the frame of the text, printed page, stage or screen – and we remember the artist's advice to students: 'Examine an insect under a magnifying-glass and you'll see something unprecedented, something that you could never have imagined!'[47] Galadzhev's drawings are laboratorial in the same sense that Alexander Tairov's Chamber Theater, Goleizovsky's Chamber Ballet and Boris Nevolin's Intimate Theatre were, i.e. strictly delineated spaces for the cultivation of uncommon species observed by a chosen few.

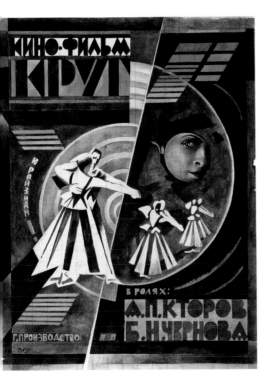

Circle (Duty and Love): Film by Alexander Gavronsky and Yulii Raizman; with script by Sergeii Yermolinsky, camerawork by Leonid Kosmatov and artistic direction by Vasilii Komardenkov, starring Bella Chernova, Petr Galazdzhev, Anatolii Ktorov, Vera Popova et al. Released by Gosvoenkin (State Military Cinema) in 1927.

A prosecutor's aide, Boris Bersenev, neglects his wife, Vera, who is attracted to the playboy, Vladimir Poliansky. But he turns out to be an embezzler of government money and soon appears in court before Bersenev. Having recognized Poliansky as the lawyer who had offered him shelter during his persecution by the Tsarist police, Communist Bersenev decides to let the case proceed along legal channels.

42. *Poster Design for the Film 'Circle'*, 1927
Gouache and blue ink on thick white paper
Initialled lower left in Russian 'PSG.'; the face is of the actress Bella Chernova
80 x 60
Collection of Nikita D. Lobanov-Rostovsky

S.W.D. ('S.W.D.' is the acronym of *Soiuz velikogo dela* = Union of the Great Cause): Film by Grigorii Kozintsev and Leonid Trabuberg with camera work by Andrei Moskvin and art direction by Evgenii Enei; starring Sergei Gerasimov, Konstantin Khokhlov, Andrey Kostrichkin, Sofia Magarill, Petr Sobolevsky et al. Released by Sovkino, Leningrad, in 1927.

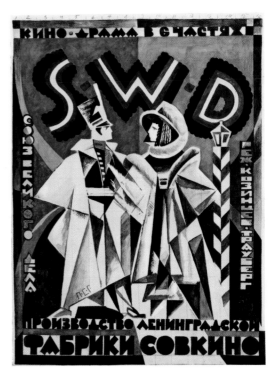

43. *Poster Design for the Film 'S.W.D.'*, 1927
Gouache and blue ink on thick white paper
Initialled lower left in Russian 'PSG'
85.5 x 60

Inscriptions in upper margin: pencil figures from 1 to 16 corresponding to a grid. Other inscriptions (as part of the design) in Russian: across the top, in black: 'cinema drama in 6 parts'; along left margin: 'Union of the Great Cause'; along right margin: 'Dir. Kozintsev-Trauberg'; across the bottom: 'Production of Leningrad Sovkino Factory'
Collection of Nikita D. Lobanov-Rostovsky

GAMREKELI, Iraklii Ilich

Born 5 (17) May, 1894 Goris, Georgia; died 10 May, 1943 Tbilisi, Georgia.

1920s attended the Tiflis School of Painting and Sculpture; 1921 onwards active as the stage designer of plays, ballets, operas and films; close to the producer and playwright Kote Mardzhanashvili (Konstantin Mardzhanov); 1922–43 chief designer for the Shota Rustaveli Dramatic Theatre in Tiflis/Tbilisi where he designed many important productions such as *Hamlet* (1925), *Othello* (1937), and Schiller's *Die Räuber* (1933); 1923 contributed to the 'First Exhibition of the Group of Young Artists' in Tiflis; 1924 contributed to the 'Exhibition of the Society of Georgian Artists' in Tiflis; member of the group of experimental artists and writers called H2S04; 1927 contributed to the 'Jubilee Exhibition of Art of the Peoples of the USSR' in Leningrad; began to work on film designs with his debut in *My Grandmother*; 1930s-40s worked extensively for the Griboedov Russian Dramatic Theatre in Tbilisi; 1932 designed Reingol'd Glière's ballet *Red Poppy* for the Paliashvili Theatre of Opera and Ballet in Tbilisi; contributed to the exhibition 'Construction and Art of the National Republics' in Moscow; 1939 became a member of the Communist Party of the Soviet Union.

Further reading:

N. Gudiashvili: *Iraklii Gamrekeli,* M: Sovetskii khudozhnik, 1958.

Sh. Amiranashvili and L. Lomtatidze: *Vystavka proizvedenii zasluzhennogo deiatelia iskusstv GruzSSR khudozhnika I.I. Gamrekeli (1894–1943).* Catalogue of exhibition of stage sets and costumes organized by the Union of Artists of the USSR, M: All-Union Theatrical Society, 1962.

L. Lomtatidze: *Iraklii Gamrekeli,* Tbilisi: Theatrical Society of Georgia, 1982.

Ts. Kukhianidze: *Iraklii Gamrekeli,* Tbilisi: Khelovneba, 1988.

D. Lebanidze et al.: *Teatris Mikhatvaroba,* Tbilisi: Chubinashvili National Research Centre for Georgian Art History and Heritage Preservation, 2008.

LR (Vol. 2), pp. 194–95.

Gamrekeli was introduced to the world of stage design through Sandro Akhmeteli, Mardzhanov and other distinguished Georgian producers. Indeed, it was Mardzhanov who, after seeing the artist's illustrations to Oscar Wilde's *Salomé* at

an exhibition in Tiflis in 1921, invited him to design a production of *Salomé* at the New Theatre the following year. This was so successful that Mardzhanov again commissioned Gamrekeli to design a production of Lope de Vega's *Fuente Ovejuna* the following year at the Rustaveli Dramatic Theatre – which marked the real beginning of Gamrekeli's 'Constructivist' phase. 'In this work [*Fuente Ovejuna*] you could already see the style that would be characteristic of my subsequent works too,' wrote Gamrekeli later,[48] thinking, no doubt, of the painted volumetrical shapes and special light effects that he had applied and would continue to apply. Under these auspicious conditions, Gamrekeli began his professional career as a stage designer, becoming Georgia's foremost designer of plays, operas, ballets and films in the 1920s-30s.

Gamrekeli's theatrical experiments are distinguished by their subtle, unexpected resolutions, e.g., multi-level constructions or multi-purpose objects – something identifiable with the designs for *Mystery-Bouffe* or for the film *My Grandmother* (1927) in which

> the action in one of the episodes unfolded at a round table on short legs which served simultaneously as a stage. Doors were attached to the outside of this peculiar table-stage – which created the sensation of an endless corridor in some kind of institution, but, from the inside, looked like closets standing behind the backs of the people sitting at the table.[49]

In the 1930s, Gamrekeli adapted to the demands of Socialist Realism and turned to a more traditional, decorative interpretation. Even so, his designs, e.g., for the Georgian plays *Georgii Saakadze* (1940) and *Vasilii Kikvidze* (1941) (both produced at the Rustaveli Theatre), continued to appeal to the histrionic sense of his exuberant audience.

Hamlet: Tragedy in five acts by William Shakespeare.
Produced by Konstantin Mardzhanov and Alexander Akhmaeteli at the Rustaveli Theatre, Tbilisi, on 12 November, 1925, with designs by Iraklii Gamrekeli.

Moved by the celebrated characters of Hamlet, Ophelia, Yorick, Marcellus and Horatio, Hamlet is an exercise in high tragedy. When Hamlet's father dies, his mother remarries to Claudius. The ghost of Hamlet father comes back to tell Hamlet that Claudius killed him. So Hamlet takes his revenge. Ophelia loves Hamlet, but he drives her mad and she dies by drowning. The action concludes with a duel.

44. Set Design, 1925

Pencil and gouache on paper

43 x 60

Bakhrushin State Central Theatre Museum, Moscow

Inv. No. KP 116282

Anzor: Play in four acts by Sandro Shanshiashvili based on Vsevolod Ivanov's play *Armoured Train 14-69*. Produced by Alexander Akhmeteli at the Rustaveli Theatre, Tbilisi, on 28 October, 1928, with music by Ivan Gokieli and designs by Iraklii Gamrekeli.

In Eastern Siberia during the Civil War, a group of partisans, led by a peasant farmer, Nikolai Vershinin, capture ammunition from a counter-revolutionarty armoured train. Amidst turmoil and confusion with Reds and Whites engaged in cruel battle, Vershinin reinforces his faith in the Communist idea after moments of indifference and passivity. Eventually, a Chinese revolutionary lies down on the railroad tracks, forcing the armoured train to stop.

45. *Set Design*, 1928
Graphite pencil, tempera and ink on paper on cardboard
44.8 x 59
Bakhrushin State Central Theatre Museum, Moscow
Inv. No. KP 307270

Note: Gamrekeli was well informed of the latest experiments in Constructivist theatre that Vsevolod Meierkhold was encouraging in Moscow and Leningrad and, no doubt, Vladimir Maiakovsky, who visited Tiflis in September, 1924, discussed the latest Moscow experiments with Gamrekeli. However, his set designs here indicate a more lyrical and even Hollywoodian deviation away from the severity of, for example, Liubov Popova's designs for *The Magnanimous Cuckold* or Varvara Stepanova's for *The Death of Tarelkin*. Judging by the designs here, Gamrekeli conceived of both *Hamlet* and *Anzor* as instruments for the approbation and propagation of the avant-garde in general and not just as a particular play with its defined plot and characters – rather in the way that Meierkhold treated Fernand Crommelynck's *Magnanimous Cuckold*. In other words, the interpretation was liberal, not literal, Gamrekelli adding digressions and extraneous interpolations just as the Georgian Dadaists – the members of H2SO4 – did with their typographies, drawings and poems.

GOLEIZOVSKY, Kasian Yaroslavich

Born 22 February 1892, Moscow; died 7 March, 1970, Moscow.

1906–09 trained at the Choreological Institute in St. Petersburg, attending lessons by Michel Fokine; 1910-18 danced at the Bolshoi Theatre in Moscow; 1916 onwards worked as choreographer and director for the Mamonov Theatre and Nikita Baliev's Chauve-Souris cabaret; co-founded the Research Studio and then the Ballet Art Studio: *Dances from Different Epochs* and *The Faun* were among the classics that entered the repertoire of Goleizvosky's new studio; 1919 the Studio was renamed the First Instructional Ballet Studio under TEO NKP; 1921 renamed the Moscow Chamber Ballet, producing, inter alia, Cecile Chaminade's *Arlechin* and Richard Strauss's *Salomé*; 1922 produced *Faun* (based on Claude Debussy's *L'aprés-midi d'un faune*) at the Hermitage Winter Theatre and Sergei Prokofev's *Visions Fugitives* (presented in their entirety in 1927 and then in 1968 at the Bolshoi Theatre); 1925 invited back to the Bolshoi Theatre as ballet-master, where he choreographed *Joseph the Beautiful* (music by Sergei Vasilenko, costumes and stage designs by Boris Erdman); 1928–29 expanded his repertoire, working for lighter theatres and paraphrasing American music-hall with the number called *Girls*;

1920s studied and recreated traditional Spanish dances often to Georges Bizet's and Vasilenko's music; 1938–40 choreographer-in-residence for the mass gymnastic parades of 1938–40; 1930s onwards choreographed dance episodes for films such as Yakov Protazanov's *Circus* (1932) and *Marionettes* (1934) and for Grigorii Alexanderov's *Spring* (1947); 1960s produced a cycle of *soirées* for the Bolshoi Theatre such as *Polovtsian Dances* (1953), *Skriabiniana* (1962) and *Layla and Majnun* (1964).

Further reading:

N. Chernova: *Kasian Goleizovsky. Zhizn i tvorchestvo,* M: VTO, 1984.

N. Chernova: 'Kasian Goleizovsky and Eccentric Dance' in *Experiment*, Los Angeles, 1996, No. 2, pp. 381–409.

N. Chernova: 'Kasian Goleizovsky: shkola miniatiur' in *Mnemozina*, M, 2000, No. 2, pp. 338–49.

V. Teider: *Kasiian Goleizovsky: Iosif Prekrasnyi*, M: Nauka 2001.

N. Misler: *Vnachale bylo telo: Ritmoplasticheskie eksperimenty nachala XX veka*, M: Iskusstvo XXI vek, 2011, passim.

I. Duksina, comp.: *Khudozhniki teatra Kasiana Goleizovskogo 1918–1932*. Catalogue of exhibition at Elizium Gallery, Moscow, 2012, pp. 102–33.

From early childhood Goleizovsky was exposed to diverse art forms – fine and applied arts at the Stroganov Institute, violin and piano lessons with distinguished violinist David Krein, performance at the Moscow Chroeographical Institute of the Bolshoi Theatre. This synthetic experience stimulated him to regard dance as a highy stratified, polyphonic discipline based upon sculpted rhythm, emotional expression, bodily movement and musicality. Goleizovsky's collaboration with artists such as Petr Galadzhev, Nikolai Musatov and Anatolii Petritsky and with musicians such as Boris Ber, Matvei Blanter and Sergei Prokofiev was enhanced by an immediate mutual understanding. Owing to a broad classical education, Goleizovsky founded his avant-garde researches upon technical expertise, moving easily between different methods and kinds of dance, whether classical, mechanical, eccentric, music-hall or ballroom. Able to move large groups of actors and dancers and to construct acrobatic collective movements (at one time he worked with the circus), Goleizovsky was a master choreographer with a keen

sense of embodied space. In fact, Goleizovsky often selected his dancers for their long and flexible limbs, attributes which allowed them to adopt complex, but elegant poses. Barefoot dancing, costumes reduced to a transparent cloth coloured according to the mood of the performance and fluid and syncopated movements – are among the elements which we recognize in Goleizovsky's most celebrated ballets such as *Faun* which he produced at the Chamber Theatre with Boris Erdman's bold scenic constructions.

Moths: Dance sequence to music by Alexander Skriabin at the Mamonov Theatre of Miniatures, Moscow, in November or December, 1916, with designs by Kasian Goleizovsky.

The ballet consists of improvisations without thematic sequence.

46. Costume Design, 1916
Graphite pencil, watercolour, gouache, Indian ink, collage and bronze on paper
38.4 x 27.7
Bakhrushin State Central Theatre Museum, Moscow
Inv. No. KP 91746 GKS 2560

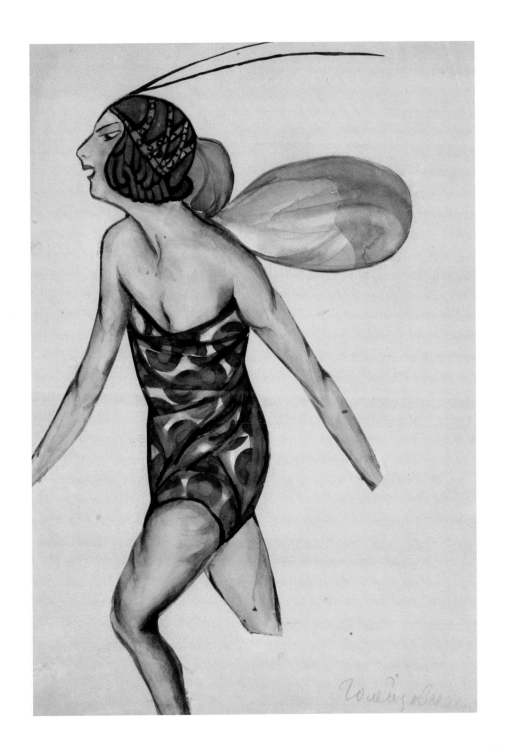

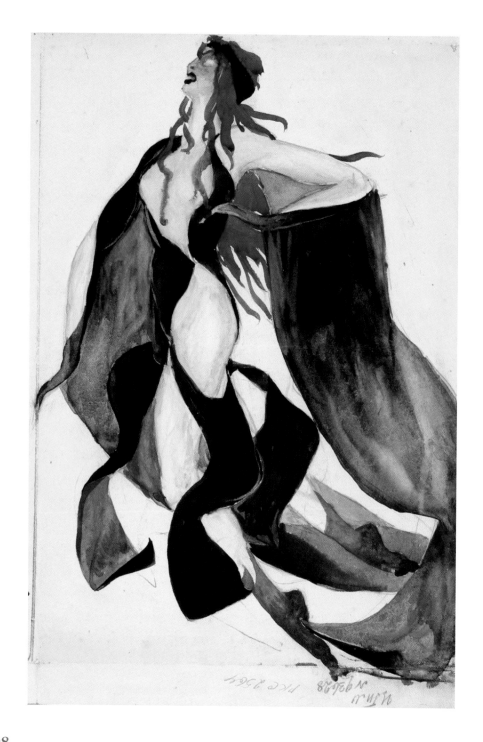

Etude: Miniature ballet by Kasian Goleizovsky base
on music by Alexander Skriabin. Produced b
Kasian Galeizovsky at the Moscow Chamber Ball
in 1921 with designs by him.

The ballet consists of improvisations withou
thematic sequence.

47. *Costume Design for a Female Dancer*, 1921
Graphite pencil, gouache and watercolour on pape
35.1 x 25.4
Bakhrushin State Central Theatre Museum, Mosco
Inv. No. KP 93628 GKS 2564

KHVOSTENKO-KHVOSTOV, Alexander Veniaminovich (also known as Khvostov-Khvostenko, Alexander [Olexander] Veniaminovich)

Born 17 (29) April, 1895, Borisovka, Ukraine; died 16 December, 1968, Kiev, Ukraine.

1907–17 attended MIPSA where he studied principally under Konstantin Korovin; 1914–17 worked as a scene painter in various theatres; 1915–16 contributed to the satirical magazine *Budilnik* [Alam-clock]; 1920-21 with Vasilii Ermilov worked for the UkrROSTA (the propaganda windows of the Ukrainian Telegraph Agency) in Kharkov; 1920 onwards active as a stage designer in Kiev, Kharkov and Moscow, working on important productions such as Vladiimir Maiakovsky's *Mystery-Bouffe* (Kharkov, 1921), Reingold Glière's *Red Poppy* (1929) and Stanislav Moniushko's *Galka* (Kiev, 1949); in 1926–27 also worked on a projected version of Sergei Prokofiev's *Love for Three Oranges* in Kharkov, one of his most experimental endeavors; 1920s-60s contributed regularly to national and international exhibitions.

Further reading:

A. Drak: *Олександр Veniaminovich Khvostenko-Khvostov*, K: Mistetstvo, 1962.

Oleksandr Veniaminovich Khvostov (Khvostenko) 1895–1968. Catalogue of exhibition at the State Museum of Theatrical Art, K, 1986.

D. Gorbachev: *Oleksandr Khvostenko-Khvostov*, K: Mistetstvo, 1987.

D. Gorbacev: 'O kazališnem scenografijama Oleksandra Hvostova' in D. Gorbachev et al.: *Ukraijinska Avangarda 1910-1930.* Catalogue of exhibition at the Muzej suvremenne umjetnosti, Zagreb, 1990, pp. 155–58.

LR (Vol. 2), pp. 231–32.

While a student in Moscow in the 1910s, Khvostenko-Khvostov was confronted with the avant-garde experiments of Kazimir Malevich and Vladimir Tatlin, although it was the colour geometries of Suprematism that left the deepest imprint on his development. Returning to the Ukraine after his Moscow schooling, Khvostenko-Khvostov also turned his attention to the decorative work of Alexan-

dra Exter and her immediate influence can be traced in the cubistic resolutions of his early stage designs. As the Ukrainian historian Dmitrii Gorbachev asserts in his monograph, under Exter's influence Khvostenko-Khvostov moved to a 'volumetrical, constructive design, something that transformed the scenic space.'[60]

Along with Alexander Bogomazov, Vasilii Ermilov and Anatolii Petritsky, Khvostenko-Khvostov was a leader of the Ukrainian avant-garde in the 1920s and made a valuable contribution to both Ukrainian and Russian stage design. Sometimes his sets were remarkably abstract, e.g., for *Die Walkürie* of 1929,[61] although many consider his most experimental costumes and sets to be those for the unrealized production of the *Love for Three Oranges* at the Berezil Theatre in Kharkov in 1926–27.

Mystery-Bouffe: A Heroic, Epic, and Satirical Depiction of Our Epoch: Play with prologue and in six acts by Vladimir Maiakovsky. Produced by Grigorii Avlov at the Heroic Theatre, Kharkov, on 7 November, 1921, with designs by Alexander Khvostenko-Khvostov.

For plot summary see KHRAKOVSKY, Alexander; KISELEV, Viktor; and LAVINSKY, Anton.

48. Set Design, 1921
Pencil, gouache and collage on cardboard
58 x 78.2
Bakhrushin State Central Theatre Museum, Moscow
Inv. KP 310777 GDS 1195

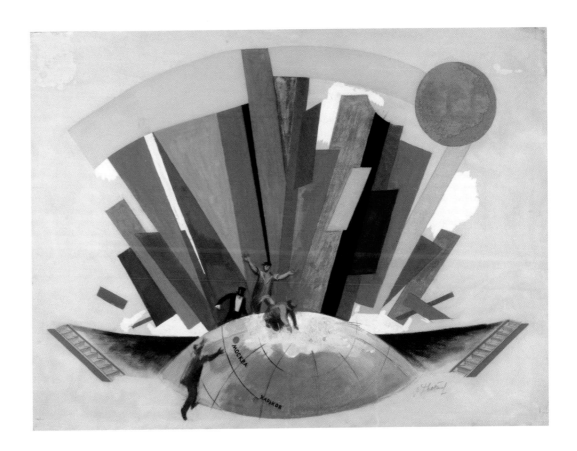

Note: Les Kurbas's transference of his Berezil Theatre from Kiev to Kharkov in 1926 was indicative of a remarkable upsurge of avant-garde activity there in the mid- and late 1920s. While Moscow and Leningrad were coming under increasing pressure to adapt their cultures to a more conservative taste, Kharkov still held out as a progressive center. It provided a forum for the Association of Contemporary Artists of the Ukraine, organized exhibitions of the new art and published important journals such as *Nova generatsiia* (1927–30) and *Avangard* (1929). Khvostenko-Khvostov's dynamic costume for Smeraldina in the *Love for Three Oranges* communicates the dynamism of that highly charged epoch. As Ihor Ciszkewycz has noted:

> Kurbas felt the actor should create a memorable transformation on the stage in order that the audience be shocked and in the end, profoundly influenced by it. This transformation technique could be abstract, psychological, stylized, rhythmical, symbolic, metaphysical and numerous other types. These transformations even occurred in music, drama and stage decor.[62]

KLUTSIS (Klucis), Gustav (Gustavs) Gustavovich

Born 4 (16) January, 1895, Rujena, Latvia; executed 26 February, 1938, Moscow, Russia.

1911–13 attended a teachers' seminary in Volmar (Valmiera, Latvia); 1914–15 studied at the Riga Art Institute under Vilhelms Purvitis (Purvit); 1915–18 studied at SSEA in Petrograd; worked as a scene painter for the Okhta Workers' Theatre there; 1918 moved to Moscow as a rifleman in the Ninth Latvian Infantry and worked in its art studio, painting scenes from army life; attended Ilia Mashkov's private studio; 1918–21 studied at Svomas/Vkhutemas under Konstantin Korovin and Anton Pevsner; contact with Kazimir Malevich; 1919–20 began to work on poster, typographical and architectural designs; 1920 exhibited with Naum Gabo and Pevsner; with Sergei Senkin established his own studio within Vkhutemas; 1920-21 contributed to the Unovis exhibitions in Vitebsk and Moscow; 1920-22 influence of El Lissitzky; became especially interested in constructive projects and photomontage; 1921–23 member of Inkhuk; 1922 began to teach at the Painting Studio of the Sverdlov Club; contributed to the 'Erste Russische Kunstausstellung' in Berlin; 1924–30 taught colour theory at Vkhutemas/Vkhutein; 1925 contributed to the "Exposition Internationale des Arts Décoratifs et Industriels Modernes' in

Paris; 1928 contributed to the 'Pressa' exhibition in Cologne; co-founder of the October group; 1929 designed posters for the art department of the State Publishing-House; late 1920s taught at the Moscow Polygraphical Instiutute and the Communist Academy; 1920s–'30s active as a poster and typographical designer; contributed to Soviet and international exhibitions; 1929–32 member of the Association of Revolutionary Poster Artists; 1937 collaborated on the design of the Soviet pavilion for the 'Exposition Universelle' in Paris; 1938 arrested and transported to a labor camp.

Further reading:

L. Oginskaia: *Gustav Klutsis*, M: Sovetskii khudozhnik, 1981.

J. Bowlt: *Gustav Kluzis.* Catalogue of exhibition at the Galerie Gmurzynska, Cologne, 1988.

Gustavs Klucis. Starp varu un mi lestibull. Catalogue of exhibition at the Valsts Makslas Muzeja, Riga, 1988.

H. Gassner and R. Nachtigaller: *Gustav Klucis. Retrospektive.* Catalogue of exhibition at the Museum Fridericianum, Kassel; and the Centro de Arte Reina Sofia, Madrid, 1991.

Anon.: *Gustav Klutsis; Soviet Propaganda Photomontage.* Catalogue of exhibition at the Ubu Galery, New York, 1997.

M. Tupitsyn: *Gustav Klutsis and Valentina Kulagina: Photography and Montage after Constructivism.* Catalogue of exhibition at the International Center of Photography, New York, 2004.

F. Hergott et al.: *Gustavs Klucis.* Catalogue of exhibition at the Musée d'art moderne et contemporain, Strasbourg, 2005.

A. Snopkov and A. Morozov: *Gustav Klutsis, Valentina Kulagina, Plakat, Knizhnaia grafika, Zhurnalnaia grafika, Gazetnyi fotomontazh, 1922–1937*, M: Kontakt-Kultura, 2010.

S. Khan-Magomedov: *Gustav Klutsis*, M: Gordeev, 2011.

LR (Vol. 2), pp. 237–38.

As in the case of Alexander Rodchenko, Klutsis embarked upon his artistic career as a studio painter, attending schools in Riga, Petrograd and Moscow, but he achieved recognition, above all, as a poster artist and photomontagist. From 1919 onwards Klutsis gave increasing attention to photomontage, using it documentarily, imaginatively, sometimes even capriciously – from the first experiment called *Dynamic City* (1919) to the *Pravda* layout of the mid-1930s. While often propos-

ing utopian renderings of present and future, Klutsis's compositions are taut in their organization and direct in their message, and, from the very beginning, the posters and the street decorations were oriented towards a mass consumer: in fact, *Dynamic City* is intended to be 'viewed from all sides',[63] bringing to mind Malevich's Suprematist compostions.

True, Klutsis's ideas and images are often analogous to those of Rodchenko and the two artists have sometimes been confused. Not surprisingly, Klutsis also contribuited to the Constructivist magazine *Lef* [Left Front of the Arts], publishing his essay on photo-montage there in 1924. He also shared the group's interest in industrial art, programmatic art and the earnest application of art to political ends, to which his propaganda designs bear strong witness. From the series of loudspeakers and radios of 1922 through his remarkable serial illustrations for the book *Lenin i deti* [Lenin and Children] (Moscow, 1925), the sports meets and the reconstruction posters of the 1930s, Klutsis used his talent to disseminate the behests of Marx, Lenin and Stalin. Tragically, Klutsis fell victim to the very ideological machine which he glorified so graphically.

9. Design for Decoration of the Moscow Kremlin Celebrating the VI Congress of the Communist International and the Fifth Anniversary of the Revolution, 1922

Watercolour over ink, crayons and pencil

22.5 x 30.5

State Museum of Theatrical and Musical Art, St. Petersburg (formerly in the collection of Nina and Nikita D. Lobanov-Rostovsky)

Inv. No. GIK 23272/243

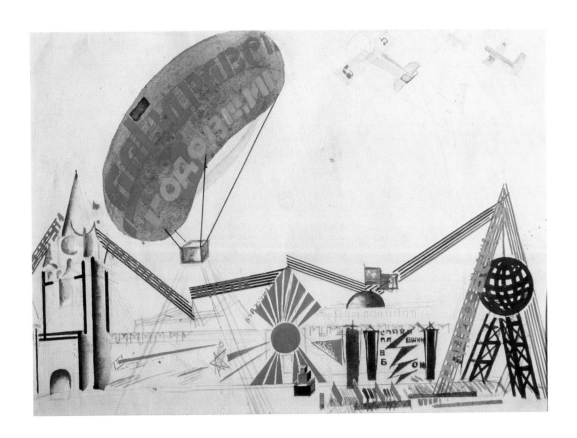

Note: Klutsis devoted much time and energy to his celebratory designs for the IV Communist International and many of his projects for loudspeakers, podiums and screens of 1922 were connected to this important agit-project. Intended for Red Square or even inside the Kremlin (one of the Kremlin towers is visible on the far left of the sketch), the ensemble was to have included 'hi-tech' paraphernalia such as wireless megaphones and also simple slogans, incorporated into the design here, such as 'Long Live the Anniversary', 'Make the Bourgeois Tremble!', 'Glory to the Fallen in Battle' and 'Radio for the Whole of [the proletariat]'. With its simple, dynamic, geometric forms, the ensemble derived immediately from Klutsis's prior abstract experiments in painting and construction, encapsulated in his *Dynamic City* series of 1919.

KOMARDENKOV, Vasilii Petrovich

Born 12 (24) April, 1897, Moscow, Russia; died 15 April, 1973, Moscow, Russia.

Ca. 1910 took private lessons with Dmitrii Shcherbinovsky; ca. 1912 attended CSIAI and then MIPSA, graduating in 1917; 1914–17 worked as occasional scene painter for Sergei Zimin's Opera Company, Moscow; influenced by Vladimir Egorov, Fedor Fedorovsky, Ivan Fedotov and Ivan Maliutin; 1918 debut as a professional stage designer for the production of *Eugene Onegin* at the Opera of the Moscow Soviet of Workers' Deputies, the first of more than seventy stage productions that he designed during his lifetime; close to Sergei Esenin and Georgii Yakulov; frequented the Café Pittoresque; worked in IZO NKP; helped Yurii Annenkov colour his illustrations for the first hundred copies of the original edition of Alexander Blok's poem *Dvenadtsat* [The Twelve]; 1918–19 attended Svomas in Moscow; 1919 co-founder of Obmokhu, contributing to its first and third exhibitions (1919 and 1921); influenced by Vladimir Tatlin; 1918–25 stage designer for Alexander Tairov's Chamber Theatre, Moscow; 1920 frequented the House of Arts; 1922 contributed to the 'Erste Russische Kunstausstellung' in Berlin; 1923 contributed to the 'Moscow Stage Design Exhibition'; 1925 began to work on film designs; contributed to the 'Exposition Internationale des Arts Décoratifs et Industriels Modernes' in Paris; 1926–28 worked on productions for the Terevsat (Theatre of Revolutionary

Satire); 1927 designed *A Midsummer Night's Dream* for the Ivan Franko State Drama Theatre in Kiev; 1929 contributed to the 'First Stage Design Exhibition' in Moscow; 1937 represented at the 'Exposition Universelle' in Paris; 1946 onwards taught at the Higher Art-Industrial Institute in Moscow; increasingly interested in studio painting.

Further reading:

V. Komardenkov: *Dni minuvshie*, M: Sovetskii khudozhnik, 1973.

I. Sats et al.: *Vasilii Petrovich Komardenkov*. Catalogue of exhibition at the All-Union Theatrical Society, Moscow, 1986.

Anon.: 'On govorit o dvukh vystavkakh' in *Sovetskaia kultura*, M, 1987, 3 February.

Vasilii Petrovich Komardenkov. Catalogue of exhibition at TG, 2008.

LR (Vol. 2), pp. 238–41.

The 'Class of '19' at the Moscow Svomas included a number of outstanding painters and designers who contributed much to the second wave of Russia's avant-garde. Besides Komardenkov, Nikolai Denisovsky, Sergei Kostin, Konstantin Medunetsky and the Stenberg brothers – to mention but a few – received their Svomas diplomas that year. Not surprisingly, they held their mentors, especially Tatlin, in high regard, and tended to pursue similar cultural interests. On graduation, they founded Obmokhu which, with its four exhibitions (through 1924), contributed directly to the establishment and development of Constructivism; and many of these young artists, not least Komardenkov, quickly achieved recognition as stage designers.

Komardenkov was affected by many artistic influences and found inspiration in a wide variety of painters, from Fedor Fedorovsky to Aristarkh Lentulov, from Isaak Rabinovich to Sergei Sudeikin. But he was especially drawn to Yakulov's bohemian way of life and to Moscow's café culture during those revolutionary years. Komardenkov even helped decorate the interior of the premises of the All-Russian Union of Poets where Futurists and Imaginists met and polemicized, recalling in his memoirs that 'All kinds of fanciful forms were cut out of paper which were then stuck on the walls. The result was very variegated, but not all that beautiful'.[64] In

fact, it was at the All-Russian Union of Poets that Komardenkov came into close contact with the writers Sergei Esenin, Vasilii Kamensky, Anatolii Mariengof and Vadim Shershenevich. Yakulov, a frequent visitor to the All-Russian Union, was already working at the Chamber Theatre and, no doubt, through this connection Komardenkov received his commission there.

The Machine Wreckers: Play by Ernst Toller with a prologue and in five acts. Directed by Petr Repnin and produced by Vsevolod Meierkhold at the Theatre of the RSFSR, Moscow, on 3 November, 1922, with music by Nikolai Kartashev and designs by Vasilii Komardenkov.

The Luddites, an English social movement, protest the Industrial Revolution by wrecking the new machines which are stealing their jobs.

50. Design for a Bulletin Board on Stage Showing a Mechanical Man, 1922

Pencil, watercolour and ink on paper on plywood

19.3 x 18.3

Bakhrushin State Central Theatre Museum, Moscow

Inv. KP 316845/41 GDS 1605

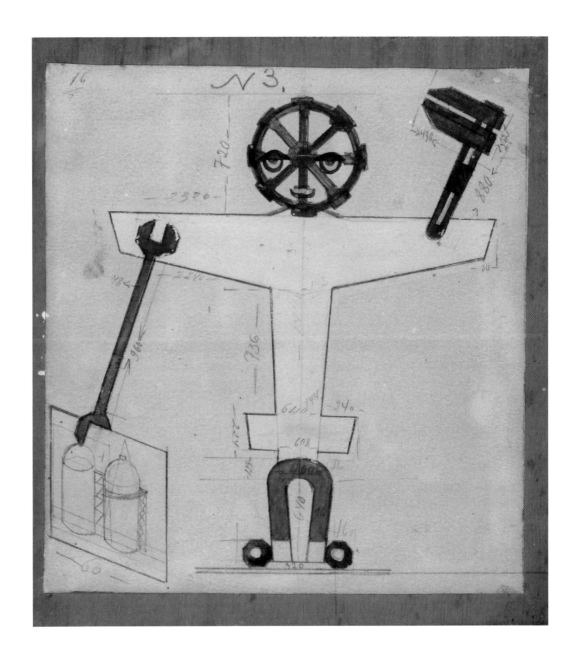

51. Set Design, 1922
Pencil and ink on paper on paper
19 x 26
Bakhrushin State Central Theatre Museum,
Moscow
Inv. KP 316845/44 GDS 1604

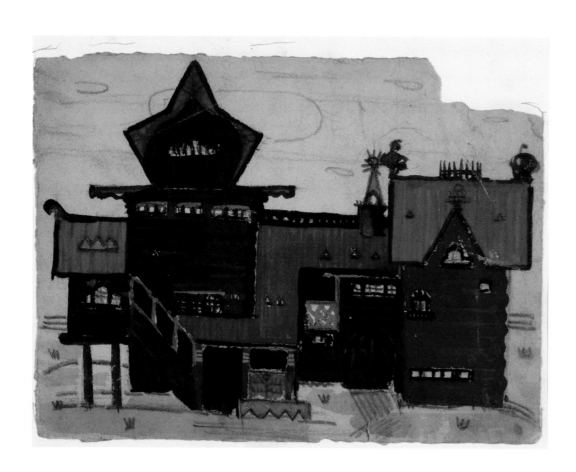

Note: Unlike most modern Russian stage designers, Komardenkov had considerable experience as an actual scene painter, working at Zimin's Opera Company and then at the Chamber Theatre (where he helped with the 1922 production of *Signor Formica*). Komardenkov knew, therefore, about the technical and material aspects of costume and set design and the direct relevance and appropriateness of a given project to its intended function on the three-dimensional stage. Consequently, he tended not to indulge in fantastic ornament, even though, for example, he appreciated Alexander Golovin's florid decorations. Komardenkov produced rational, but still attractive, designs that were both practicable and could be identified easily by the audience. These qualities were evident in his resolutions for *A Midsummer Night's Dream* in Kiev – which he considered to be his most successful endeavor as a stage designer.[65]

KOSAREV, Boris Vasilievich

Born 23 July (4 August), 1897, Kharkov, Ukraine; died 23 March, 1994, Kharkov.

1905–10 studied at the Kharkov Orthodox Eparchial Seminary; 1911–15 studied at the Artistic-Vocational Workshop of Decorative Painting in Kharkov; colleague of Vasilii Ermilov; 1915–18 studied at the Kharkov Art Institute; contact with Mariia Siniakova; influence of Cubo-Futurism; 1917 joined the Group of Seven; first stage design for Boris Glagolin's production of *On the Earth Again*; 1918 designed Glagolin's production of Henrik Ibsen's *Brand*; helped decorate Kharkov for May Day; published the miscellany *Sem plius tri* [Seven plus three]; 1919 aertist-in-residence for the First Soviet Dramatic Theatre; 1920 moved to Odessa; 1921 designed journals, posters, interiors; returned to Kharkov; influence of Constructivism; 1923 taught under the aegis of Proletcult; artist-in-residence for the First State Children's Theatre; 1925 artist-in-residence for the Artem All-Ukraine Social Museum in Kharkov; 1927 contributed to the 'Artist Today' exhibition; with Vadim Meller, Anatolii Petritsky and other avant-gardists joined the Association of Contemporary Artists of Ukraine; 1928 worked for the Red Factory Workers' Theatre of Ukrainian Drama; 1930 contributed to the 'All-Union Pedagogical Exhibition' in Leningrad; 1931–35 professor at the Kharkov Art Technicum; 1930s designed many productions in Ukrainian theatres; 1941–45

evacuated to Pavlodar in Kazakhstan; 1947 awarded a Stalin Prize; 1948–49 professor at the Lvov Institute of Applied and Decorative Art; 1950-86 continued to teach in various Kharkov institutions.

Further reading:

I. Bondar-Tereshenko ed.: *Boris Kosarev.* Catalogue of exhibition at the Palitra Gallery, Kharkov, 1998.

T. Pavlova and V. Chechik: *Boris Kosarev: 1920-ri roki,* K: Rodovid, 2009.

M. Mudrak, ed.: *Borys Kosarev. Modernist Kharkiv 1915–1931.* Catalogue of exhibition at The Ukrainian Museum, New York, 2011.

Kosarev was a foremost member of the Ukrainian avant-garde and, along with Alexander Khvostenko-Khvostov, Meller and Petritsky, in particular, introduced ideas of Cubism. Futurism and Constructivism to Ukrainian Modernism, especially in the realms of stage and book design. Although Kosarev worked for many theatre directors in the 1920s and 1930s, he developed a personal, synthetic style in his set and costume projects, accenting bright colour, geometric clarity and folkloric motifs. In contemplating the new, proletarian audience, Kosarev also imported devices from the circus and music-hall, including caricature, hyperbole and the 'illogical' combination of diverse elements, a mix which coincided with his interest in collage and montage and what might be called linguistic polyphony: after all, the proclamation in *Sem plius tri*, co-signed by Kosarev, announced that the almanac was printed 'in all languages of the world'.[66] Kosarev was also a professional photographer, experimenting with the camera not only as a recording apparatus of the urban fabric of Kharkov, Odessa and Lvov, but also as a method of documenting the installation and interaction of his own sets and costumes on stage.

Ali-Nur: Play by Mikhail Kossovsky adapted from Oscar Wilde's story *The Star-child*. Produced by Sergei Pronsky at the Fairytale Theatre, Kharkov, on 25 November, 1922, with music by Isaak Dunaevsky, choreography by Boris Pletnev and designs by Nikolai Akimov and Boris Kosarev.

After seeing a falling star, two woodsmen try to find its landing place in the hopes of finding gold. They find not gold, but a baby wrapped in a golden blanket and wearing an amber chain, whom one of the woodsmen brings home to his family. Believing the baby to be of royal blood, the townsfolk spoil him and he grows into an uncouth and arrogant lad. One day his mother turns up – recounting that robbers had stolen her son and had left her with a curse. We are left to wonder what will become of the town and of the star-child now that his true parentage has been disclosed.

52. Stage Design, 1922
Graphite and crayon on graph paper
8.9 x 17.9
Bakhrushin State Central Theatre Museum, Moscow
Inv. No. KP 88384/6

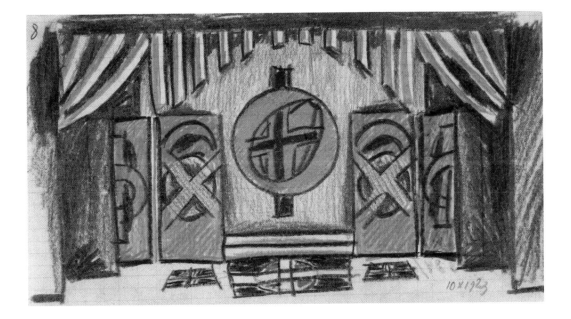

223

53. Set Design, 1922
Graphite and crayon on paper
15.5 x 20.2
Bakhrushin State Central Theatre Museum, Moscow
Inv. No. KP 88384/5

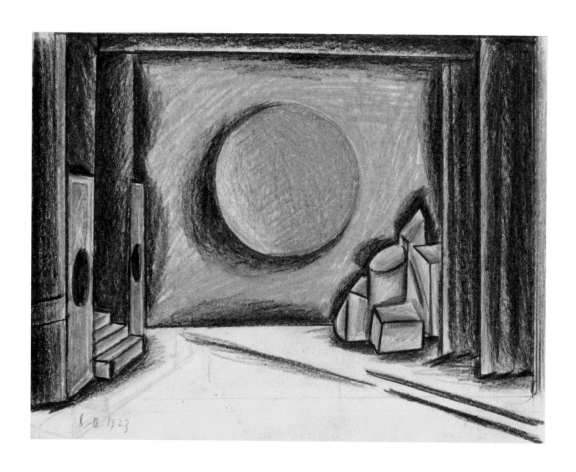

KHRAKOVSKY, Vladimir Lvovich

Born 4 (17) November, 1894 (some sources give 1893), Ponornitsa, Ukraine; died 1984, Moscow, Russia.

Brought up in Glazov, near Viatsk; 1913 graduated from the Realschule in Perm; 1913–17 student at the Art Institute, Odessa; 1918–19 student at Svomas; 1920-30 taught at Vkhutemas/Vkhutein; 1921 1921 co-designer of Vsevolod Meierkhold's production of *Mystery-Bouffe*; 1923–24 taught at the Medical Pedagogical Institute in Moscow; 1924–25 taught at the Krupskaia Academy of Commnist Education; 1927 co-founder of the Society of Moscow Artists; 1920s contributed to exhibitions such as 'Moscow Painters', 'Association of Artists of the Revolution' and the 'Society of Moscow Artists'; 1932 suffered moral crisis; destroyed many of his works; left Moscow; 1941 volunteered for the front, but was posted to the rear; 1950s returned to teaching; member of the Union of Artists of the USSR.

Further reading:

Nothing substantial has been published on Khrakovsky. For some information see:

K. Rudnitsky: *Russian and Soviet Theater 1905–1932*, New York: Abrams, 1988, passim.

A. Mikhailova et al.: *Meierkhold i khudozhniki*, M: Galart, 1995, pp. 150-51.

KISELEV, Viktor Petrovich

Born 31 January (12 February), 1895 (some sources give 19 February [2 March], 1896), Moscow, Russia; died 24 May, 1984, Moscow, Russia.

1906–12 attended CSIAI; 1912–18 attended MIPSA/Svomas under Abram Arkhipov and Konstantin Korovin; 1918 onwards exhibited regularly; taught at Svomas in Riazan; 1920 onwards involved in the theatre as a stage designer; 1918–23 taught at Pegoskhuma/Vkhutemas in Petrograd; 1921 co-designer of Vsevolod Meierkhold's production of *Mystery-Bouffe*; supported Constructivism; ca. 1923 taught at Vkhutemas, Moscow; early 1920s especially interested in the formal experiments of Alexander Rodchenko and Vladimir Tatlin; 1925–27 taught at the Mstera Art-Industrial Technicum; 1926 designed costumes for a production of

Nikolai Gogol's *Inspector General*; 1926–29 member of OMKh; 1929 took part in the 'First Stage Design Exhibition' and 'Results of the Moscow Theatre Season for 1928–29,' both in Moscow; 1932 designed *The Last Victim* at the Ermolova Studio, Moscow; 1935 took part in the exhibition 'Artists of the Soviet Theatre over the Last 17 Years (1917–1934)' in Moscow and Leningrad; 1930s taught at the Moscow Textile Institute; worked for MKhAT and the Central Theatre of the Red Army; continued to exhibit until the 1970s.

Further reading:

O. Voltsenburg et al., eds.: *Khudozhniki narodov SSSR. Biobibliograficheskii slovar v shesti tomakh*, SP: Akemicheskii proekt, 1995, Vol. 4, Part 2, pp. 492–93.

D. Sarabianov: *Viktor Petrovich Kiselev*. Catalogue of exhibition organized by the Union of Artists of the USSR, M, 1983.

LAVINSKY, Anton Mikhailovich

Born 1893, Sochi, Crimea; died 1968, Moscow, Russia.

1913 graduated from the Architectural and Building Department of the Technical Institute, Baku; 1914 enrolled at the IAA; 1915–17 mobilized; 1917–18 taught in Sochi; 1918–19 studied under Alexander Matveev and Leonid Shervud at Svomas, Moscow; 1919 student at the Saratov Svomas; involved in decorations for Lenin's Plan of Monumental Propaganda; with Viktor Sinaisky designed a monument to the October Revolution; 1920-26 student at Vkhutemas, Moscow; 1921 member of Inkhuk; 1921 co-designer of Vsevolod Meierkhold's production of *Mystery-Bouffe*; 1922 contributed to the 'Erste Russische Kunstausstellung' in Berlin; 1923 member of Lef and contributor to its journal; 1923–25 designed kiosks for the State Publishing-House; 1920s designed posters for ROSTA (Russian Telegraph Agency) and films, including *The Battleship Potemkin*; 1925 contributed to the 'Exposition Internationale des Arts Décoratifs et Industriels Modernes' in Paris; 1928 assisted El Lissitzky with the design of the 'Pressa' exhibition in Cologne; 1933 contributed to the exhibition 'Artists of the Last XV Years' in Moscow; 1930s onwards continued to design, exhibit and teach.

Further reading:

S. Khan-Magomedov: *Anton Lavinsky*, M: Russkii avangard, 2007.

As artists of the stage, Khrakovsky, Kiselev and Lavinsky are not widely known. But the fact that they produced such original resolutions for *Mystery-Bouffe* when they were still at the beginning of their careers and yet under contract to such a prestigious director as Meierkhold indicates the wealth and diversity that have yet to be discovered in the treasure-house of Russian stage design as a whole, especially of the 1920s. Many other artists are worthy of note for their costumes and sets, yet they are still unfamiliar to the broader public and await rediscovery, among them Orest Allegri, Yurii Bondi and Leonid Chupiatov.

True, the enounter with the avant-garde and Constructivism was not always of long duration and Kkrakovsky and Kiselev, for example, acquiesced to the more mundane demands of the academic theatre in the late 1920s onwards. At the same time, the bizarre resolutions that they made for *Mystery-Bouffe* such as Kiselev's costumes for the Angel and Clemenceau or Lavinsky's schematic Earth raise – once again – the vexed question as to how exactly such imaginary figures and constructions functioned in three dimensions on the material stage. The designs on paper are visually attractive, clever examples of Constructivist tautness, but just how far this impression would have been reinforced by the actors moving in costumes of cloth with cuts and seams against the ponderous globe is hard to envisE. The apparent discrepancy between the surface and volume, performance and reality in the projects of Kiselev and his colleagues caused one critic to observe of the 1921 premiere that the 'attempt to drag elements of the new way of life on to the stage fails. Afraid of descending into naturalism, the artists schematize – and go astray. The rejection of theatrical forms proves to be illusory'.[50] On the other hand, Alexander Fevralsky, champion of Meierkhold, observed that Lavinsky's construction 'struck one by its grandeur, coming out right at you from the conventional space of the stage',[51] a sentiment which seemed to reflect Lavinsky's call to unite art and engineering and his fascination with utopian settlements – of cities suspended on springs made of steel, aluminium and asbestos.

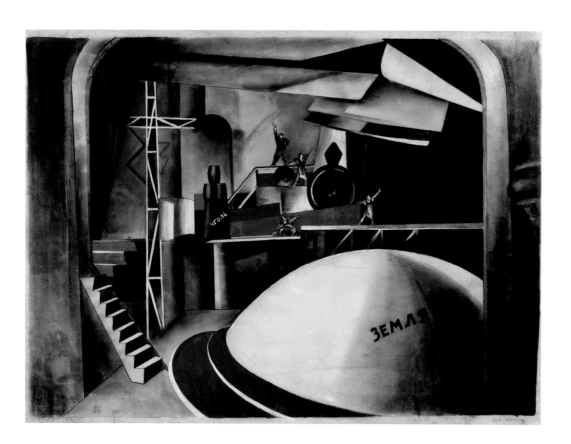

Mystery-Bouffe: A Heroic, Epic and Satirical Depiction of Our Epoch: Play with prologue and in six acts by Vladimir Maiakovsky. Produced at the Theatre of the RSFSR No. 1, Moscow, on 1 May, 1921, by Vsevolod Meierkhold and Valerii Bebutov with music compiled by Alexander Orlov and with designs by Vladimir Khrakovsky, Viktor Kiselev and Anton Lavinsky.

The entire Earth, except for the North Pole, has been liquidated by a flood. Taking refuge in an ark at the North Pole are 'seven pairs of clean' (including an Indian Rajah, a Russian speculator, a German, a Priest, an Australian, Lloyd George and an American) and 'one pair of each unclean' (including a Red Army soldier, a lamplighter, a driver, a miner, a servant, a smith, a washerwoman, an engineer and an Eskimo fisherman). The unclean deceive the clean and throw them overboard. Conquering many barriers, the unclean then visit hell and, after depositing the clean there, go on to heaven which they leave in disgust. They return to a new Earth – to the Promised Land of the Communist paradise. The two rival groups are supplemented by many other personages such as devils and saints, an intellectual, a lady with boxes (an emigrée), a conciliator etc.

54. Set Design, 1921
Gouache and ink on paper
53.6 x 73.3
Bakhrushin State Central Theatre Museum, Moscow
Inv. No. KP 88139

55. *Set Model for the Ark*, 1921
Wood, plywood, wood glue, paint, fabric, nails, pencil, tempera, gouache, watercolour, bronze, lacquer and oil and cardboard
19 x 19 x 138
Bakhrushin State Central Theatre Museum, Moscow
Inv. No. KP 313271/1-21 Mak 55

АНГЕЛ

56. *Costume Design for an Angel*, 1921
Watercolour and pencil on paper
30 x 19.7
Bakhrushin State Central Theatre Museum, Moscow
Inv. No. KP 180169/477

57. *Costume for the Frenchman Clemenceau*, 1921
Pencil, watercolour and collage on paper
29.2 x 22.2
Bakhrushin State Central Theatre Museum, Moscow
Inv. No. KP 180169/479

Note: When Vladimir Maiakovsky finished his famous satire *Mystery-Bouffe* in September, 1918, he was hard put to interest any theatre in its production, not least because many were disturbed by the blasphemous interpretation of the Biblical Flood when God instructed Noah to take seven pairs of clean animals and one pair of each unclean on to his Ark. In the end, Maiakovsky appealed to friends and volunteers to help and organized a special declamation of his text to attract potential actors. The result was the production of *Mystery-Bouffe* by Meierkhold, Vladimir Soloviev and Maiakovsky himself at the Communal Theatre of Musical Drama in Petrograd on 7 November, 1918 (after strong objections from the administration of that Theatre). Meierkhold had first invited Georgii Yakulov to work on the designs for *Mystery-Bouffe,* but the artist's proposals did not satisfy either Meierkhold or Maiakovsky, so they then turned to Kazimir Malevich. However, Malevich's costumes and sets (which have not survived), while radical in their resolution (e.g., all the 'unclean' wore costumes of the same grey material), did not seem to function well on stage, and neither Meierkhold, nor Maiakovsky were happy with the result. As the critic Andrei Levinson wrote: 'from the costumes it was impossible to tell a bricklayer from a chimney sweep.'[52] After the third night (9 November, 1918), the play was taken off.

Undaunted by the mixed reception of *Mystery-Bouffe,* Meierkhold and Maiakovsky decided to make a 'second edition' of the play in 1921. Maiakovsky then rewrote the section called 'Land of Fragments', while Meierkhold tried to make the result crisper, more forthright and more politicized and to introduce elements of the the *balagan* and the circus (the famous clown, Vitalii Lazarenko, played one of the devils). Maiakovsky also invited the trio of young experimental artists – Kiselev, Lavinsky and Khrakovsky – to design the costumes and sets and ensured that the level of acting was of the highest caliber (for example, Max Tereshkovich played the part of the Intellectual, Petr Repnin that of the Priest, Evgeniia Khovanskaia that of the Lady with Boxes and Igor Ilinsky had his first major success with his interpretations of the Conciliator and the German).[53]

The designs were striking. Kiselev and his colleagues interpreted the Earth as a spatial construction of platforms and ladders (something that anticipated Liubov Popova's construction for *The Magnanimous Cuckold* the following year). Moreover, part of the design and of the dramatic activity 'spilled over' into the auditorium, thereby bridging the gap between actor and audience. As the critic Emmanuil Beskin wrote:

There is a monumental platform half moved out into the auditorium... It has broken away from all the machinery of the stage, has elbowed away the wings and gridirons and has crowded up to the very roof of the building. It has torn down the suspended canvases of dead decorative art. It is all constructed, constructed lightly, conditionally, farcically, made up of wooden benches, sawhorses, boards and painted partitions and shields. It does not copy life with its fluttering curtains and idyllic crickets. It is all composed of reliefs, counter-reliefs and force-lines.[54]

There is no question that this 'spectacle of maximum theatrical excess'[55] reinforced the development towards Constructivism in the theatre, emphasizing the tendencies that Vladimir Dmitriev had emphasized in his designs for Meierkhold's production of *Les Aubes* in 1920. The radical critic, Nikolai Tarabukin, champion of the Formal method in the early 1920s, even identified the 1921 production of *Mystery-Bouffe* as the 'bridge towards Constructivism.'[56]

The second edition of *Mystery-Bouffe* played more than forty times and, in spite of fears to the contrary, was received well by the proletarian audience who enjoyed its spontaneous, improvisational, carnival atmosphere. 'Even the non-Party proletariat feels that this is 'their' play,' wrote the critic Vladimir Blium.[57] Indeed, *Mystery-Bouffe* achieved lasting success, not only in Moscow (where, incidentally, Alexei Granovsky also produced a version with designs by Natan Altman at the Salomonsky Circus in 1921),[58] but in other centers, too, including Kiev in 1919, Omsk, Kharkov, Tambov and Saratov in 1921, Kazan in 1923 and then in Tbilisi in 1924. The many discussions that *Mystery-Bouffe* aroused among artists, intellectuals and factory workers tended to be positive in the evaluation of the play, even though increasing criticism was addressed to the enormous sums of money that Meierkhold's theatre was consuming. In fact, *Mystery-Bouffe* was Meierkhold's last triumph at his Theatre of the RSFSR No. 1 before it was closed down in September, 1921.[59]

LENTULOV, Aristarkh Vasilievich

Born 14 (26) March, 1882, Voronie, near Penza, Russia; died 15 April, 1943, Moscow, Russia.

1897–1903 attended the Penza School of Drawing; 1903–05 studied in Kiev; 1906 studied under Dmitrii Kardovsky in St. Petersburg; 1907–08 contributed to the 'Wreath-Stephanos' exhibition in Moscow, the first of many involvements with avant-garde enterprises; 1910 moved to Moscow; with Robert Falk, Natalia Goncharova, Petr Konchalovsky, Mikhail Larionov, Ilia Mashkov et al. formed the nucleus of the Jack of Diamonds group; 1911 visited Italy and France; studied under Henri Le Fauconnier in Paris; influenced by Albert Gleizes and Jean Metzinger; 1912 exhibited first Cubist works; 1913 developed a style of painting reminiscent of the parallel experiments of Robert and Sonia Delaunay; painted *St. Basil's Cathedral*. *Red Square* and *Moscow*, two of his most important works; 1915 designed the production of the *Merry Wives of Windsor* for the Chamber Theatre, Moscow; 1918 onward professor at Svomas in Moscow; member of IZO NKP; early 1920s designed a number of productions for Petrograd and Moscow theatres; 1925 coorganizer of the group called Moscow Painters which maintained the principles of Cézanne; 1926 joined AKhRR; 1930s onwards continued to paint, especially landscapes and portraits.

Further reading:

V. Kostin: *Aristarkh Lentulov*. Catalogue of exhibition organized by the Union of Artists of the USSR, M, 1968.

M. Lentulova: *Khudozhnik Aristarkh Lentulov*, M: Sovetskii khudozhnik, 1969.

D. Sarabianov: *Aristarkh Lentulov*. Catalogue of exhibition at the Central House of Artists, M, 1987.

E. Murina: *Aristarkh Lentulov*, Milan: Teti, 1988.

V. Manin: *A.V. Lentulov*. Catalogue of exhibition at the Österreichische Galerie, Vienna, 1989.

E. Murina and S. Dzhafarova: *Aristarkh Lentulov*, M: Sovetskii khudozhnik, 1990.

V. Manin: *Aristarkh Lentulov*, M: Slovo, 1996.

LR (Vol. 2), pp. 283–84.

Primarily a studio painter, Lentulov also contributed to a number of theatrical enterprises. His first professional experience was in 1914 when he designed decors for Vladimir Maiakovsky's *Vladimir Maiakovsky. A Tragedy,* although the production did not take place. Lentulov's public debut as a stage designer came in 1915 with his work on Alexander Tairov's production of *The Merry Wives of Windsor* at the Chamber Theatre and, thereafter, his repertoire extended to both classical and modern spectacles. Just after the Revolution, Lentulov participated in several innovative productions such as Anton Rubinstein's *Demon* at the so-called Experimental Theatre within the Bolshoi Theatre and *The Unknown Lady* at the Café Pittoresque. In 1919–20 he also worked on designs for an interpretation of Igor Stravinsky's *Firebird* (not realized) and from time to time he returned to the theatre in the late 1920s and 1930s, although the portrait and the landscape were always more important to him as artistic disciplines.

Demon: Opera in three acts by Anton Rubinstein with libretto by Pavel Vistiakov based on the poem of the same name by Mikhail Lermontov. Produced by Alexander Tairov at the Opera Theatre of the Soviet of Workers' Deputies, Moscow, on 3 April 1919, with designs by Aristarkh Lentulov.

The Demon is a former rebel angel, expelled from paradise and doomed to eternal limbo. A melancholy, but vindictive, exile, he sows evil wherever he appears, yet, in the end, he wearies of his doing. Flying over the Caucasus one day, the Demon sees the beautiful maiden Tamara and falls in love. The Demon feels his love for Tamara might reconcile him to God and the universe, so he tempts her. In spite of her guardian angel, Tamara surrenders to the Demon's wooing, but no sooner does he touch her lips with his immortal kiss than she dies. Her soul is carried away by an angel, while the Demon is doomed to dwell in solitude and remorse.

58. *Set Model*, 1919
Fabric, wood, cardboard and paper
36.4 x 106.5 x 80.2
Bakhrushin State Central Theatre Museum, Moscow
Inv. No. KP 120974 Mak 85

Note: Although Lentulov had had relatively little experience as a stage designer, Tairov appreciated his potential and invited him to collaborate on the production at the Opera Theatre of the Soviet of Workers' Deputies (later a branch of the Bolshoi Theatre). In turn, Lentulov was drawn to the commission, recalling that 'for the longest time Tairov and I groped around for the right style and form which this really fantastic spectacle demanded....so imbibed with the Eastern and Caucasian poetry of colour'.[67]

LEVIN, Moisei Zelikovich

Born 16 (28) or 18 February (1 March), 1896, Vilnius, Lithuania; died 19 July, 1946, Leningrad, Russia.

1911–14 attended the Vilnius Art Institute; 1915 mobilized; 1917 served in the Red Army; 1918 moved to Petrograd; 1919 enrolled at Svomas in Petrograd; studied under Natan Altman; 1922 after being demobilized, worked on many stage productions, especially for the Theatre of the New Drama in Ligovsk; also contributed designs to the Habima, Gaideburov and Skarskaia theatres; 1923 started work as a film designer; 1924–25 worked as a puppet play designer; 1925–26 worked in the Comedy Theatre, Leningrad; 1927 designed several spectacles to commemorate the 10th anniversary of the Revolution, including *Breaking, 10 October* and *25th October*; 1927 onwards worked for the Bolshoi Dramatic Theatre, Leningrad, designing many pieces such as Valentin Kataev's *Avant-Garde* (1930) and Yurii Olesha's *Three Fat Men* (1930); began to design films; 1936 left the Bolshoi Dramatic Theatre to concentrate on film design; 1930s lived and worked in Kazakhstan; chair of the Union of Artists of Kazakhstan; Merited Art Worker of Kazakhstan; 1944 returned to Leningrad.

Further reading:

K. Tverskoi: *M.Z. Levin*, L: Academiia, 1927.

L. Oves, comp.: *M. Levin*. Catalogue of exhibition at the Stanislavsky Palace of Arts, L, 1980.

L. Oves: 'Stranitsy istorii leningradskoi stsenografii' in G. Kovalenko, ed.: *Russkii avangard 1910-kh – 1920-kh godov i teatr*, SP: Bulanin, 2000, pp. 222–38.

I. Solovieva and A. Smeliansky, eds.: *MKhAT Vtoroi. Opyt vosstanovleniia biografii*, M: Moskovskii khudozhestvennyi teatr, 2010, pp. 425–32.

LR (Vol. 2), p. 285.

Moisei Levin, like Isaak Rabinovich and Nisson Shifrin, was one of the young Jewish stage designers who joined the ranks of the avant-garde after the Revolution. His real apprenticeship was with Altman through whom he studied the new movements such as Suprematism, although he never adapted their extreme conclusions to his stage work. In any case, Levin always regarded the theatre designer as co-director or co-producer. 'Visual producership,' he wrote in 1935, 'is the art of the militant theatre artist whose effect upon both the spectator and the theatre [should be] an active one.'[68] Along with Semeon Mandel, Levin is recognized as one of the leading designers of the Leningrad theatre.

Wozzeck: Opera in three acts by Alban Berg after Georg Buchner. Produced at the State Academic Theatre of Opera and Ballet, Leningrad, on 13 June, 1927, with designs by Moisei Levin.

Desperate from poverty, Johann Christian Wozzeck kills his mistress in a jealous rage. He is arrested for the deed and beheaded for murder, the implication being that there can be no redemption for such a wicked act.

59. *Costume Design for Wozzeck*, 1927
Graphit, crayon, ink and gouache on paper
36.2 x 20.8
Bakhrushin State Central Theatre Museum, Moscow
Inv. No. KP 306069 GKS 402

60. *Costume Design for Drum Major*, 1927

Graphite pencil, crayon, Indian ink, gouache and silver paint on paper

36.2 x 20.8

Bakhrushin State Central Theatre Museum, Moscow

Inv. No. KP 297169 GKS 4640

LISSITZKY, El (Lisitsky, Lazar Markovich)

Born 10 (22) November, 1890, Polchinok, near Smolensk, Russia; died 30 December, 1941, Moscow, Russia.

1909–14 attended the Technische Hochschule in Darmstadt; traveled in France and Italy; 1914 returned to Russia; worked in Moscow as an architectural draftsman; 1915–18 attended the Riga Polytechnical Institute in Moscow (evacuated from Riga during the War); 1916 designed the cover for Konstantin Bolshakov's book of poetry *Solntse na izlete* [Spent Sun]; 1917 exhibited with the World of Art in Petrograd and thereafter at many exhibitions in the Soviet Union and abroad; 1918 member of IZO NKP; 1919 professor at the Vitebsk Popular Art Institute; close contact with Kazimir Malevich; began to work on his Prouns (Proun = Project for the Affirmation of the New); member of Unovis; close to Vera Ermolaeva, Lazar Khidekel, Ilia Chashnik and Nikolai Suetin; 1920 member of Inkhuk, Moscow; 1920–21 professor at Vkhutemas, Moscow; 1922 with Ilya Ehrenburg edited the journal *Veshch/Gegenstand/Objet* in Berlin; worked increasingly on typographical and architectural design; published *Pro dva kvadrata* [About Two Squares]; 1923 created the Proun Room for the 'Grosse Berliner Kunstausstellung'; 1923 published his six Proun lithographs in the *Kestnermappe* in Hanover and the album of figures for *Victory over the Sun*; designed the Berlin edition of Vladimir Maiakovsky's *Dlia Golosa* [For the Voice]; 1925 returned to Moscow; taught interior design at Vkhutemas; thereafter active primarily as an exhibition and typographical designer, creating new concepts for the exhibition room as in his Abstrakte Kabinett at the Niedersächische Landesgalerie in Hanover in 1927–28; 1928 joined the October group; 1930 published his treatise on modern architecture *Russland: Architektur für eine Weltrevolution*; 1930s worked for the propaganda magazine *USSR in Construction*.

Further reading:

Lissitzky is the subject of a very large number of monographs, catalogues and articles. The titles below are a representative selection only.

S. Lissitzky-Küppers: *El Lissitzky. Life, Letters, Texts*, London: Thames and Hudson, 1968; second edition, 1976.

S. Mansbach: *Visions of Totality*, Ann Arbor: UMI, 1980.

P. Nisbet et al.: *El Lissitzky 1890–1941*. Catalogue of exhibition at the Busch-Reisinger Museum, Cambridge, Massachusetts, 1987.

P. Nisbet et al.: *El Lissitzky – 1890–1941 – Retrospektive*. Catalogue of exhibition at the Sprengel Museum, Hanover, 1988.

M. Nemirovskaia: *L.M. Lisitsky 1890–1941*. Catalogue of exhibition at TG, 1990.

H. Puts et al.: *El Lissitzky. Architect, Painter, Photographer, Typographer*. Catalogue of exhibition at the Municipal Van Abbemuseum, Eindhoven, and other cities, 1990.

V. Malsy: *El Lissitzky. Konstrukteur, Denker, Pfeifenraucher, Kommunist*. Catalogue of exhibition at Mathildenhöhe, Darmstadt, 1990–91.

K. Simons: *El Lissitzky. Proun 23 oder Der Umstieg von der Malerei zur Gestaltung*, Frankfurt: Insel, 1993.

M. Tupitsyn et al.: *El Lissitsky. Jenseits der Abstraktion*, Munich: Schirmer-Mosel, 1999.

S. Morejko et al., eds.: *Sophie Lissitzky-Küppers. 36 Letters*, Jerusalem: Alphabet, 2001.

I. Prior: *Die geraubten Bilder: Der abenteuerliche Geschichte der Sophie Lissitzky-Küppers und ihre Kunstsammlung*, Cologne: Kiepebnheuer und Witsch, 2002.

N. Perloff and B. Reed, eds.: *Situating El Lissitzky*, Los Angeles: Getty Research Institute, 2003.

E. Nemirovsky, comp.: *Konstruktor knigi El Lisitsky*, M: Fortuna El, 2006.

J. Milner: *Lissitzky-Overwinning op de Zon/Lissitzky-Victory over the Sun*. Catalogue of exhibition at the Vanabbemuseum, Eindhoven, 2009–10.

I. Dukhan: *El Lisitsky*, M: Art-Rodnik, 2010.

S. Khan-Magomedov: *Lazar Lisitsky*, M: Gordeev, 2011.

Much indebted to the theory and practice of Malevich, Lissitzky developed certain aspects of Suprematism, but avoided the mystical dimension that Malevich tended to invoke. For Lissitzky and for Malevich, architecture and design in general presented themselves as obvious vehicles for the transference of basic Suprematist schemes into life itself. In this respect, Lissitzky's Prouns were of vital significance since they served as intermediate points between two and three dimensions or, as Lissitzky himself said, 'as a station on the way to constructing a new form.'[69]

The principles of the Proun – the rejection of the single axis, the convenience of entering the work at any junction, the idea of the 'flotation device' – are operative

in most aspects of Lissitzky's work during the 1920s, but especially in his graphic designs. The formative influence of his residence in Vitebsk when he extended the Suprematist system into his formulation of the Proun can be seen, for example, in his book *Pro dva kvadrata* (conceived in Vitebsk in 1920; published in Berlin in 1922). This extraordinary 'biblio-construction,' which, in many ways, is similar to the album of figures for *Victory over the Sun* (also conceived in Vitebsk in 1920), invites comparison with 'film': convinced that design, especially the geometric esthetic, could serve as a visual Esperanto and replace some of the traditional functions of verbal language, Lissitzky paid special attention to the visual appearance of the object. Yet in his earnest endeavor to 'fuse art and life,'[70] Lissitzky never lost his sense of humor and one of the appealing ingredients in his Constructivist compound is the gentle irony and whimsical jocularity evident in his subtle collocation of forms and colours.

61. Title-page for the Portfolio 'Die Plastische Gestaltung der Elektro-Mechanischen Schau 'Sieg über die Sonne'' (Figure 1), 1923

Coloured lithograph

Signed and numbered in the plate

52 x 44

State Museum of Theatrical and Musical Art, St. Petersburg (formerly in the collection of Nina and Nikita D. Lobanov-Rostovsky)

Inv. No. GIK 23273/49

62. *Design for the Sportsmen (Sportsmänner, Figure 6)*, 1923

Coloured lithograph

Signed in pencil and numbered in the plate

52 x 44

State Museum of Theatrical and Musical Art, St. Petersburg (formerly in the collection of Nina and Nikita D. Lobanov-Rostovsky)

Inv. No. GIK 23273/45

63. *Design for the Old Man with Head Two Steps Back* (*Alter: Kopf 2 Schritt Hinten*, Figure 8), 1923

Coloured lithograph

Signed in pencil and numbered in the plate

52 x 44

State Museum of Theatrical and Musical Art, St. Petersburg (formerly in the collection of Nina and Nikita D. Lobanov-Rostovsky)

Inv. No. GIK 23273/39

Note: Lissitzky's portfolio of ten figures based on the Cubo-Futurist opera *Victory over the Sun* was published by Leunis and Chapman, Hanover, in the summer of 1923 in an edition of seventy-five copies. Inspired by the production of the opera in Vitebsk in February, 1920, Lissitzky elaborated his idea of a number of figurines that would be used as a puppet interpretation of this 'transrational' spectacle. Although the version was not implemented, Lissitzky made designs for various personages in the opera, adding some of his own, and the result was the portfolio – which he hoped would appear as a Russian edition in 1920–21. One or two of the figures bear the same title as their predecessors in the 1913 Luna Park production (e.g., the *New Man*), but most do not (e.g., there is neither a *Sentinel*, nor an *Anxious One* in the 1913 libretto), and one can assume that these discrepancies were the result of Lissitzky's free interpretation rather than of an inaccurate German translation of the Russian titles. Apparently, the Hanover publication did not include all the images that Lissitzky created for his project. A gouache and ink design for a so-called *Stage Machine*, for example, is in the collection of the Theatremuseum, Cologne, the drawing and lithograph for which are in TG – but are missing from the portfolio. However divergent from the original performance, Kruchenykh, author of the 1913 libretto, seems to have liked Lissitzky's innovations.[71] Lissitzky had the following to say:

> The sun as the expression of the world's age-old energy is torn down from the sky by modern man; the power of his technological supremacy creates for itself a new source of energy. This idea is woven into the opera simultaneously with the action. The language is alogical. Individual singing parts are phonetic poems.

> The text of the opera compelled me to preserve something of the anatomy of the human body in my puppets. The colours of the individual sections of these pages are to be regarded in the same way as in my Proun works, as equivalent to materials; yellow or black parts of the puppets are not painted correspondingly, but rather they are made in corresponding material, for example in bright copper, dull iron and so on.[72]

It is important to remember that Lissitzky designed his figures primarily to teach children about the Revolution and its grandiose future. Lissitzky's concern with the visual education of children (cf. his book *Pro dva kvadrata*) began with his colourful, Chagall-like illustrations to the 1917 edition of *Khad Gadya* (a Passover book for children), but his attempts to transmit the idea of the new society and the new art through abstract images to a young audience bore fruit only in 1919–20. In 1919 Lissitzky illustrated a new edition of *Khad Gadya* with lithographed Proun designs and the following year he contributed abstract illustrations to children's

stories by Ben Zion Raskin to the 'Jewish Art Exhibition' in Kiev. That Lissitzky wished to express clearly and concisely the political importance of his interpretation of *Victory over the Sun* is demonstrated by his concluding figure, the New Man. As one critic has written, this *deus ex machina* 'forcefully implies triumphant energy… Not only is the future man's dynamic heart communistic but so is his vision, for the left eye is formed by the Soviet red star.'[73] Lissitzky himself argued that the 'Communist system of social life is creating a new man – from a tiny, insignificant wheel of a machine he has turned into its captain.'[74] Lissitzky was not alone in his conception of the puppet as a vehicle for communicating new ideas. Both Liubov Popova and Alexandra Exter applied elements of their experimental artistic systems to the marionette, thereby enriching the traditions of the modern Russian puppet theatre.

The portfolio is generally considered to be among the finest examples of Constructivist printmaking, but it is rarely found complete, especially with the wrapper intact, in part because in the late 1930s under the Hitler regime many copies were destroyed as examples of 'degenerate art.'[75]

I Want a Baby: Play in ten scenes by Sergei Tretiakov. Prepared, but not produced, by Vsevolod Meierkhold at the Meierkhold State Theatre, Moscow, in 1927-30, with designs by El Lissitzky.

Milda, a cultural education worker, decides that she wants to have a baby without a father or a family, but bred from the best proletarian stock. The child is to be raised by the communal child-rearing organizations which Milda herself is helping to establish as part of the Bolshevik effort to construct the ideal Socialist state. Doing her best to ignore the meddling and scorn of the unruly co-tenants in her crowded Moscow apartment block, Milda sets out to complete her mission. Eventually she fulfills her dream after a laborious, comic, melodramatic and tragic journey.

64. Costume Designs for Stage Hands, 1929
Watercolour, pencil, print and collage on cardboard
35.5 x 52.9
Bakhrushin State Central Theatre Museum, Moscow
Inv. No. KP 180169/1443

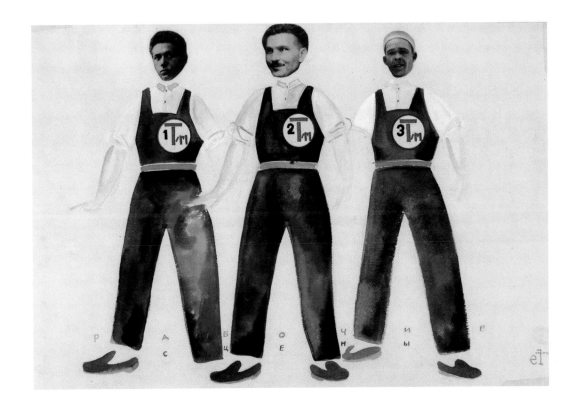

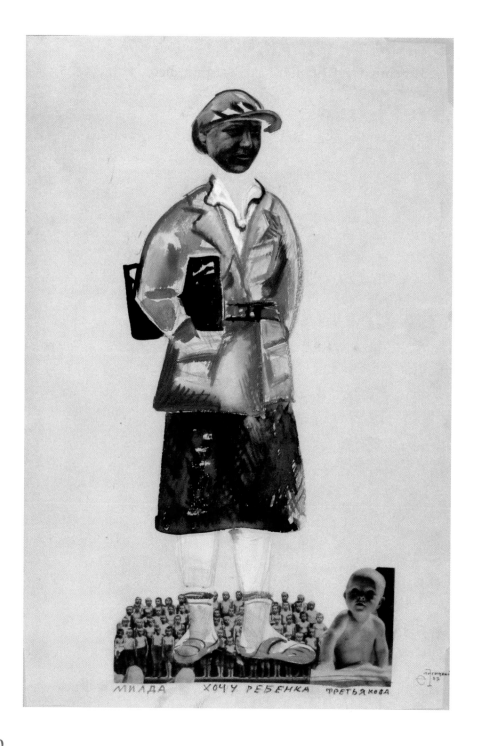

МЛАДА ХОЧУ РЕБЕНКА ТРЕТЬЯКОВА

65. *Costume Design for Milda*, 1929
Watercolour, pencil, pencil, whitening, print and collage on cardboard
52.9 x 35.4
Bakhrushin State Central Theatre Museum, Moscow
Inv. No. KP 180169/1441

MALEVICH, Kazimir Severinovich

Born 11 (23) February, 1879, near Kiev, Ukraine; died 15 May, 1935, Leningrad, Russia.

1905–10 studied under Fedor Rerberg in Moscow; ca. 1910 influenced by Neo-Primitivism; 1910–17 contributed to many exhibitions including the 'Jack of Diamonds', 'Union of Youth,' 'Donkey's Tail,' 'Target,' 'Tramway V,' '0.10' (first public showing of Suprematist works), and 'Store'; 1913 with Alexei Kruchenykh and Mikhail Matiushin took part in the Futurist conference in Uusikirkko, Finland; designed the sets and costumes for the transrational opera *Victory over the Sun* in St. Petersburg; illustrated avant-garde booklets by Velimir Khlebnikov, Kruchenykh and other poets; 1915 publicized his invention of Suprematism; 1918 active on various levels within IZO NKP; 1919–22 taught at the Vitebsk Popular Art Institute/Vitebsk Art-Practical Institute; coorganized Unovis; attracted many young artists including Ilia Chashnik, Vera Ermolaeva, El Lissitzky and Nikolai Suetin; 1922 moved to Petrograd where he began to work for Ginkhuk; 1920-late 1920s active on various levels; wrote many essays on art; turned attention to the architectural possibilities of Suprematism, inventing his so-called *arkhitektony*, *planity* and *zemlianity*; 1927 visited Warsaw and Berlin with a one-man exhibition; established contact with the Bauhaus; late 1920s returned to a figurative kind of painting, even working on social themes such as *Working Woman* and *The Smith*.

Further reading:

Malevich is the subject of a very large number of monographs, catalogues and articles. The titles below are a representative selection only.

T. Andersen, ed.: *K.S. Malevich. Essays on Art,* Copenhagen: Borgen, 1968–78 (four volumes).

T. Andersen. *Malevich,* Amsterdam: Stedelijk Museum, 1970.

J. Bowlt and C. Douglas, eds.: *Kazimir Malevich 1878–1935–1978.* Special issue of *Soviet Union,* Tempe, Arizona, 1978, Vol. 5, Part 2.

A. Gmurzynska et al.: *Malewitsch.* Catalogue of exhibition at the Galerie Gmurzynska, Cologne, 1978.

C. Douglas: *Swans of Other Worlds: Kazimir Malevich and the Origins of Abstraction in Russia,* Ann Arbor: UMI, 1980.

J. Bowlt: *Journey into Non-Objectivity. The Graphic Work of Kazimir Malevich and Other Members of the Russian Avant-Garde*. Catalogue of exhibition at the Dallas Museum of Fine Arts, Dallas, Texas, 1980.

L. Zhadova: *Malevich. Suprematism and Revolution in Russian Art 1910–1930*, London: Thames and Hudson, 1982.

E. Petrova et al.: *Kazimir Malevich. Artist and Theoretician*, Paris: Flammarion, 1990.

J. D'Andrea et al.: *Kazimir Malevich*. Catalogue of exhibition at the National Gallery of Art, Washington, D.C., the Armand Hammer Museum of Art and Cultural Center, Los Angeles; and the Metropolitan Museum of Art, New York, 1990–91.

R. Crone and D. Moos: *Kazimir Malevich. The Climax of Disclosure,*. Chicago: University of Chicago, 1991.

S. Fauchereau: *Malevich*, London: Academy, 1993.

A. Shatskikh and D. Sarabianov: *Malevich*, Moscow: Iskusstvo, 1993.

A. Shatskikh, comp.: *K.S. Malevich. Sobranie sochinenii v 5 tt.*, M: Gileia, 1995–2004 (five volumes).

E. Weiss: *Kasimir Malewitsch*. Catalogue of exhibition, Cologne: Museum Ludwig, 1995–96.

J. Milner: *Kazimir Malevich and the Art of Geometry*, New Haven: Yale University Press, 1996.

A. Shatskikh: *Kazimir Malevich*, M: Slovo, 1996.

T. Kotovich, ed.: *Malevich. Klassicheskii avangard, Vitebsk*, Vitebsk: Pankov, 1997 onwards (thirteen issues until 2012).

M. Drutt: *Suprematism*. Catalogue of exhibition at the Solomon R. Guggenheim Museum, New York, 2002.

A. B. Nakov: *Malewicz*, Paris: Biro, 2002.

A. B. Nakov: *Kazimir Malewicz. Le peintre absolu*, Paris: Thalia, 2006–07 (four volumes).

C. Douglas and C. Lodder, eds.: *Rethinking Malevich*, London: Pindar, 2007.

T. Goriacheva and I. Karasik: *Prikliucheniia chernogo kvadrata/The Adventures of the Black Square*, SP: Palace Editions, 2007.

A. Shatskikh: *Kazimir Malevich i obshchestvo Supremus*, M: Tri kvadrata, 2009.

S. Khan-Magomedov: *Kazimir Malevich*, M: Gordeev, 2010.

R. Bartlett and S. Dadswell, eds.: *Victory over the Sun*, Exeter: University of Exeter Press, 2012.

T. Goriacheva, intr.: *Nas budet troe. Kazimir Malevich, Ilia Chashnik, Nikolai Suetin*. Catalogue of exhibition at TG, 2012.

A. Shatskikh: *The Black Square and the Origin of Suprematism*, New Haven: Yale University, 2012.

E. Petrova: Kazimir *Malevich do i posle Kvadrata*, SP: Palace Editions, 2013.

A. Goldstein et al.: *Kazimir Malevich*. Catalogue of exhibition at the Stedelijk Museum, Amsterdam, 2013–14.

A. Borchard-Hume et al.: *Kazimir Malevich*. Catalogue of exhibition at Tate Modern, London, 2014.

Malevich recalled how, from a very early age, he was drawn to the element of paint and how, as a young boy in Kiev, he found a sensual delight in touching a house painter's paints: 'I was so gratified by the paint itself. I experienced a very pleasant sensation from the very paint on the brush.'[76] In other words, Malevich was drawn to the physical, tactile property of art, whether expressed in the thick strata of his Neo-Primitivist canvases of 1909–11 or in the fibrous textures of his Suprematist lithographs. There was, indeed, something vigorous and vital about Malevich, a natural, spontaneous character that brought him close to the Russian peasants whose way of life he depicted and whom he emulated.

During the period 1912–18 Malevich was at the height of his inventive powers. He produced original paintings, contributed to public debates and manifestos, participated in radical exhibitions such as '0.10' and published three versions of his important artistic credo *Ot kubizma i futurizma k suprematizmu. Novyi zhivopisnyi realizm* [From Cubism and Futurism to Suprematism. The New Painterly Realism]. Malevich welcomed the Revolution, regarding it as an overture to the complete transvaluation of esthetic values which he saw as the task of Suprematism, his particular system of abstract art.

The leftist dictatorship of the first years of the Bolshevik regime granted Malevich, together with many colleagues such as Ivan Kliun, Liubov Popova and Alexander Rodchenko, an unprecedented artistic and pedagogical freedom. Malevich exploited these new opportunities as widely as he could during his brief tenure at the Vitebsk Popular Art Institute/Vitebsk Art-Practical Institute where he exerted a profound and permanent influence on his talented students, especially Chashnik, Ivan Chervinka, Ermolaeva, Lissitzky and Suetin. No doubt, for the messianic Malevich this was the most satisfying period of his life.

Victory over the Sun: Opera in two actions with prologue by Velimir Khlebnikov, libretto by Alexei Kruchenykh and music by Mikhail Matiushin. Produced at the Luna Park Theatre, St. Petersburg on 3 and 5 December, 1913, with designs by Kazimir Malevich.

For plot summary see LISSITZKY, El

66. Design for the Backcloth for Action 1, Scene 1, 1913

Italian pencil on paper

25.9 x 20.2

Inscriptions in Russian: top margin: 'before appear[ance] of ene[my] war[riors]'; bottom: 'Scene 1; white and black; Action 1; No. 161 and 7'; right margin: 'figure of a man'

State Museum of Theatrical and Musical Art, St. Petersburg

Inv. No. GIK 5199/164 OR 5140

67. *Design for the Backcloth for Action I, Scene 2*, 1913

Italian pencil on paper

17.5 x 22

Inscriptions in Russian: right margin: 'green before the funeral'; lower margin in Russian: 'Scene 2. Green and black. Action I. No. 162.IV.6/173.'

State Museum of Theatrical and Musical Art, St. Petersburg

Inv. No. GIK 5199/165 OR 13643

68. *Design for the Backcloth for Action I, Scene 3*, 1913
Italian pencil on paper
17.7 x 22.2
Inscriptions in Russian: left margin: 'before the conversationists'; bottom: 'Pallbearers, 3 scene, action 1'
State Museum of Theatrical and Musical Art, St. Petersburg
Inv. No. GIK 3569/549 OR 5156

59. *Design for the Backcloth for Action II, Scene 6,*
1913

Italian pencil on paper

21.4 x 27.3

Inscriptions in Russian: bottom: '2 action, 6 scene;
house; No. 164 and 7'

Inscriptions: lower right in Russian: '2nd Action, 2nd
Scene, Scene 6. House. No. 164 II 7'.

State Museum of Theatrical and Musical Art,
St. Petersburg

Inv. No. GIK 5199/167 OR 5142

70. *Costume Design for the Fat Man*, 1913

Watercolour, Indian ink and Italian pencil on paper

27.2 x 21.2

Signed lower right margin in Russian: 'KMalev'. Other inscription, right margin in Russian: 'A fat man 165.II.7'

State Museum of Theatrical and Musical Art, St. Petersburg

Inv. No. GIK 5199/181 OR 515

Note: The following designs for *Victory over the Sun* are from the set of fifteen silkscreens produced as a portfolio in an edition of 150 copies by the Galerie Gmurzynska, Cologne, in 1973. The silkscreens are enlarged copies of the original designs in the State Museum of Theatrical and Musical Art, St. Petersburg, and the State Russian Museum, St. Petersburg, and were published under the title *Kasimir Malewitsch 'Sieg über die Sonne' 1913–1973*. These silkscreens, from a private collection, are of uniform dimensions, i.e. 42 x 29.2.

71. *Design for the Backcloth for Action II, Scene 5,*
1913 (1973)

Inscriptions in Russian right margin: 'No. 163
[illegible] Stupid'; lower left in Russian: 'Scene 5.
Scene ('6' crossed out). Square. Acti[on] II'; lower
margin in Russian: 'Scene 1 2nd act[ion].'

Note: Some scholars regard this design as 'abstract'
and as the point of departure for Malevich's
Suprematist painting of 1915 onward; others,
however, identify the composition as a figurative
one, namely as a picture of the surface of the sun.

72. *Costume Design for a Mugger,* 1913 (1973)

Inscribed lower right in Russian: 'Mugger.'

73. *Costume Design for Many and One,* 1913 (1973)

Inscribed lower margin in Russian: 'costume for many and one [Sun] bearer/s ([the latter] same but green)'.

74. *Costume Design for a New Man,* 1913 (1973)

Inscribed lower margin in Russian: '8 iv x costume for the new men.'

75. *Costume Design for the Enemy,* 1913 (1973)

Signed and dated lower left in Russian: 'K. Malevich 1913.'

Other inscription: lower right in Russian: 'The enemy.'

261

Note: The Cubo-Futurist or 'transrational' opera, *Victory over the Sun,* performed on 3 and 5 December 1913 in St. Petersburg, not only integrated a number of different artistic and musical ideas of the time, but also served as an important iconographic source for concurrent and subsequent paintings and graphics by Malevich. *Victory over the Sun* was an experiment in literary, musical and pictorial alogicality. The language, often neologistic and recondite, told the story of a band of Futurist strongmen who endeavored to disrupt all norms by challenging and conquering the Sun. The music depended on intense chromatics, bold consecutive fifths, and melismata produced by an out of tune piano and a student choir that sang flat. For his sets and costumes Malevich relied on a highly geometrized conception that, if still illustrating a certain scene or figure, reduced it to schematic components. Naturally, the opera caused a scandal and evoked a good deal of audience participation.

Central images from the opera such as bayonets, fish, a saw and piano keys recur in Malevich's paintings of the time, e.g., *Portrait of the Composer Mikhail Matiushin* (1913, TG) and *Englishman in Moscow* (1914, Stedelijk Museum, Amsterdam). In addition, the strutted wheels of the ill-fated airplane that crashes to the stage during the course of the action became a regular motif for Malevich and may explain the curious 'droplets' in the *Portrait of Matiushin. Victory over the Sun* played a major role in Malevich's creative life and its symbols firmly implanted themselves in his artistic imagination.

As far as the 'abstract' design for Action II, Scene 5, is concerned, later on Malevich regarded its geometry as an important junction in his own artistic development. Whether the image was, indeed, a rendering of the sun or not,[77] in preparing a second collection of designs for a new edition of the booklet *Pobeda nad solntsem* [Victory over the Sun] in May, 1915 (not published), Malevich actually drew a black square. As he wrote to Kruchenykh at that time: 'This sketch is going to have great significance in painting; what had been done unconsciously is now yielding remarkable fruits.'[78] Malevich returned to *Victory over the Sun* in 1920 in Vitebsk, when, with Vera Ermolaeva and the Unovis group, he contributed designs to a new production. What his new response to the square within a square was for this production is not known.

MELLER, Vadim Georgievich

Born 26 April (8 May), 1884, St. Petersburg, Russia; died 4 May, 1962, Kiev, Ukraine.

1892–1903 attended various schools in Erevan, Tiflis and Kiev; 1903–08 attended Law School at Kiev University; 1905–08 audited courses at the Kiev Art Institute; 1907 published caricatures in the newspaper *Kievskaia mysl* [Kiev Thought]; 1908–12 attended the Akademie der Künste, Munich; 1912–14 studied and exhibited in Paris; returned to Kiev; 1917 moved to Moscow; 1918–19 after a short residence in Odessa moved back to Kiev, working in Alexandra Exter's studio; contributed designs to the anniversary celebrations of the Revolution; collaborated with Bronislava Nijinska, producing costume designs for her ballets such as *Mephisto Valse* and *Fear*; 1921–23 worked at the Shevchenko Theatre, Kiev; 1922 onwards designer for the Berezil Theatre in Kiev; designed many productions there, including *Jimmy Higgins* (1922) and *Destruction of the Squadron* (1933); 1924–25 designed films; 1925 conributed to the 'Exposition Internationale des Arts Décoratifs et Industriels Modernes' in Paris; 1926 moved to Kharkov with the Berezil Theatre; mid-1920s active as a book illustrator; 1948 artist-in-residence for the Kiev Theatre of Musical Comedy; 1953–59 head of the Art Section of the Ivan Franko State Drama Theatre, Kiev.

Further reading:

M. Bazhan et al., eds.: *Slovnik khudozhnikiv Ukraini*, K: URE, 1973, pp. 148–49.

Z. Kucherenko: *Vadim Meller,* K: Mistestvo, 1975.

D. Gorbachev: 'Rezhisser i khudozhnik v ukrainskom opernom teatre 20-kh godov' in A. Vasiliev et al., eds.: *Sovetskie khudozhniki teatra i kino*, M: Sovetskii khudozhnik, 1980, pp. 255–64.

Z. Kucherenko: *Zasluzhennyi deiatel iskusstv USSR, Vadim Meller (1884–1962). Teatralno-dekoratyvne mystetstvo. Zhyvopis. Hrafika.* Catalogue of exhibition organized by the Union of Artists of the Ukraine, K, 1984.

I. Dychenko: 'Toi nizhnii vikhor barv' in *Ukraina,* K, 1984, No. 13, p. 16.

J. Bowlt, ed.: *Ukrainskii modernism/Ukrainian Modernism.* Catalogue of exhibition at the National Art Museum of the Ukraine, Kiev, 2005, pp. 214–21.

LR (Vol. 2), pp. 305–07.

Meller, a primary representative of the Ukrainian avant-garde, came to stage design in the late 1910s while experimenting with abstract painting and reliefs, clearly under the influence of Alexandra Exter, Kazimir Malevich and Vladimir Tatlin. Along with other young students such as Ivan Kudriashev and Anatolii Petritsky, Meller developed his conception of the new art according to the rigors of formal analysis, devoid of the often messianic and transcendental dimensions that accompanied the researches of older colleagues such as Vasilii Kandinsky and Malevich. Meller received acclaim as a designer for Bronislava Nijinska's ballets in Kiev in 1919, especially for her solo concert, *Mephisto Waltz,* among the most exciting undertakings of her studio. Subordinating colour to the 'melody of lines', Meller used his designs as an instrument for emphasizing the 'expression of the turns of the head, the rhythm of the folds and scarves… the dynamic of the dance'.[79]

The City: Dance sequence based on Sergei Prokofiev's ballet *Alla and Lolly (Ali et Lolli)*. Produced by the Bronislava Nijinska Choreographic Studio at the Opera Theatre, Kiev, in the fall of 1920, with choreography by Bronislava Nijinska and designs by Vadim Meller.

The Scythians invoke the sun. The Alien God and the Evil Spirits dance as the Scythians sacrifice Alla, daughter of Veles. The Moon Maidens descend to comfort Alla, and Lolli, the hero, saves her and, with the Sun God, defeats the Alien God, as the sun rises.

76. *Costume Design for a Man Running*, 1920

Pencil, gouache on paper on paper

55.8 x 40.7

Bakhrushin State Central Theatre Museum, Moscow

Inv. No. KP 300967

Gas: Play in five acts by Georg Kaiser. Produced by Les Kurbas at the Berezil First Theatre Studio, Kiev, on 27 April, 1923, with designs by Vadim Meller.

At loggerheads with the mechanization, greed and moral insolvency of modern civilization, an activist tries to persuade workers to exchange their dead-end jobs at the gas company for life in a garden city, but they ignore his proposal. The hero's son learns that the plant is producing poison gas and, following in his father's footsteps, blows up the plant.

77. Costume Design for a Man, 1922
Pencil, Indian ink, gouache and tempera on paper
48.2 x 23.8
Bakhrushin State Central Theatre Museum, Moscow
Inv. No. KP 294634 GKS 4629

266

Note: With its didactic plot, *Gas* brought forth immediate applause for its clear censure of the conditions into which, allegedly, Capitalist industry had thrust the international proletariat. Kurbas, in particular, was praised for his masterful directorship of the play and Meller, as artist-inresidence at the Berizil, for his sets and costumes. True, Kurbas's presence in the limelight was brief, for by the early 1930s the Berezil Theatre was being critized harshly for its 'Formalism' and was forced to adjust its sights to Socialist Realism. Refusing to accept ideological or artistic compromise, Kurbas himself was removed from Berezil in 1933 and shot in 1937.

MUKHINA, Vera Ignatievna

Born 19 June (1 July), 1889, Riga, Latvia; died 6 October, 1953, Moscow, Russia.

1898–1904 attended high school in Feodosiia, Crimea, where she took lessons in drawing and landscape; 1904–06 lived in Kursk; 1908–11 attended Konstantin Yuon's and Ivan Dudin's Art School in Moscow; also attended courses in sculpture at Nina Sinitsyna's studio in Moscow; 1911–12 worked in Ilia Mashkov's studio in Moscow; 1912 visited Paris where she enrolled in the Académie de la Grande Chaumière, taking lessons from Antoine Bourdelle; made the acquaintance of Jacques Lipchitz and Ossip Zadkine; close friends with Liubov Popova; 1914 traveled with Iza Burmeister and Popova to Italy; returned to Russia at the outbreak of World War I; 1915–16 as Alexandra Exter's assistant at the Chamber Theater, Moscow, designed costumes for various plays (not produced); 1918 married Alexei Zamkov, a physician; 1918–20s worked on posters, magazine designs and monuments such as *Flame of the Revolution* (1919); early 1920s gave increasing attention to monumental sculpture; designed posters, candy wrappers, commercial labels; 1923 worked with Exter et al. at the Atelier of Fashions, Moscow, on dress designs; helped Exter with designs for the film *Aelita*; 1925 contributed to the 'Exposition Internationale des Arts Décoratifs et Industriels Modernes' in Paris; with Nadezhda Lamanova published the album *Iskusstvo v bytu* [Art in Everyday Life]; 1926–27 taught at Vkhutemas; 1926–30 taught at Vkhutein; 1930–32 exiled to Voronezh; 1930s-40s designed porcelain and glassware, monuments and interiors; 1937 designed the *Worker and Collective Farm Girl* placed on the roof of the Soviet pavilion at the 'Exposition Universelle'

in Paris; 1941 awarded State Prize of the USSR for *Worker and Collective Farm Girl* (which became the Mosfilm logo); 1941–42 evacuated to the Urals; 1947 member of the Academy of Arts of the USSR; 1940s-50s continued to produce monumental sculptures, portraits, glassware and stage designs.

Further reading:

V. Mukhina: *A Sculptor's Thoughts*, M: Foreign Languages Publishing-House, n.d. (after 1953).

R. Klimov, ed.: *Mukhina*, M: Iskusstvo, 1960 (3 Vols.).

O. Voronova: *V.I. Mukhina*, M: Iskusstvo, 1976.

P. Suzdalev: *Vera Ignatievna Mukhina*, M: Iskusstvo, 1981.

I. Lipovich: *Vera Ignatievna Mukhina*. Catalogue of exhibition at the TG and the RM, 1989.

N. Voronov: *Vera Mukhina*, M: Izobrazitelnoe iskusstvo, 1989.

M. Kolesnikov: 'Alexandra Exter i Vera Mukhina' in *Panorama iskusstv*, M, 1989, No. 12, pp. 89–110.

I. Lipovich: *V.I. Mukhina*, L: RM, 1989.

N. Voronov: 'Rabochii I kolkhoznitsa', M: Moskovskii rabochii, 1990.

E. Vasilievskaia et al.: *Vera Mukhina*. Catalogue of exhibition at the RM, 2009.

G. Kovalenko: *Teatr Very Mukhinoi*. Catalogue of exhibition at the Moscow Museum of Contemporary Art, M, 2012.

Along with Anna Golubkina, Vera Isaeva and Beatrisa Sandomirskaia, Mukhina was one of Russia's greatest sculptresses and her influence on the course of Soviet sculpture was profound and permanent. While not avant-garde in the way Kazimir Malevich and Vladimir Tatlin were, Mukhina demonstrated a strong confidence in the classical tradition and an artistic vitality that became especially appropriate to her interpretations of Socialist Realism. True, Mukhina's admiration of Rodin and Bourdelle and her exposure to French Cubism left an imprint on her early figures such as *Pietà* (1916) and in her dynamic projects (not produced) for several plays that Alexander Tairov prepared for his Chamber Theater in the mid-1910s such as *La Cena delle Beffe* [The Jester's Supper] and *The Rose and The Cross*. Assistant to Exter, Mukhina took particular note of her mentor's

subtle conception of volume and construction, mentioning later on that 'Exter exerted a deep influence on my entire life.'[80] Mukhina combined the need for historical accuracy with an impetuous fantasy, prompting the critic, Boris Ternovets, Mukhina's long-time friend, to speak of her 'vividness and expressivity of decorative invention.'[81] Although later on Mukhina adjusted her artistic vision to the conventions of the Stalin style, her love of the histrionic was no less evident in her monumental statues such as the famous *Worker and Collective Farm Girl* created for the Soviet pavilion at the Paris 'Exposition Universelle' in 1937.

Mukhina is now remembered for her documentary and often tendentious sculpture, reflecting her commitment to the Revolution and to the fundamental tenets of Socialist Realism. The grandeur of Mukhina's artistic vision appealed to both the Party and the masses alike, ensuring her prestigious political commissions in the 1930s-50s such as her figures for the Hotel Moscow and the buxom harvesters for the New Moscow River Bridge (late 1930s), the group *We Demand Peace* (1951) and her many statues to cultural heroes, from Petr Tchaikovsky (1953) to Maxim Gorky (1952). However, Mukhina could also produce more intimate and pensive sculpture such as her renderings of relatives and friends, including several heads of her son. Moreover, Mukhina's interest in unexpected media such as glass and her numerous pencil and charcoal drawings show an esthetic diversity and flexibility that are not always apparent from her more familiar public sculpture.

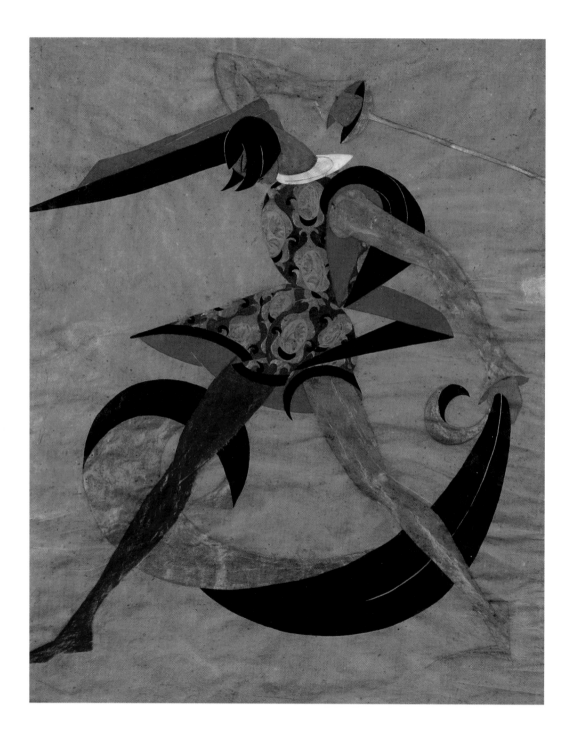

La Cena delle Beffe [The Jester's Supper]: Play in four acts by Sem Benelli translated into Russian by Valerii Briusov. Produced by Alexander Tairov at the Chamber Theater, Moscow, on 9 December, 1916, with choreography after Marius Petipa and preliminary designs by Vera Mukhina replaced by definitive designs by Nikolai Foregger.

This drama of treachery and black deeds takes place in Florence during the time of the Medici. The wicked Nera antagonizes the youth Giannetto while Ginevra, the languorous *femme fatale,* provides the target of various amorous advances as the action moves from the house of Tornaquinci to her chambers, to the subterranean rooms of the Medici Palace and back to her luxurious villa.

78. Costume Design for a Swordsman, 1916

Gouache and gold paint on wrapping paper

Signed and dated lower right in pencil in Russian: 'Vera Mukhina 1916.'

63 x 45.5

State Museum of Theatrical and Musical Art, St. Petersburg (formerly in the collection of Nina and Nikita D. Lobanov-Rostovsky).

Inv. No. GIK23272/335

79. *Costume design for a Runner*, 1916

Gouache, gold paint, pencil and black ink on paper

Initialled on reverse lower left in Russian: 'V.M.'

49.7 x 68

State Museum of Theatrical and Musical Art, St. Petersburg (formerly in the collection of Nina and Nikita D. Lobanov-Rostovsky).

Inv. No. GIK 23272/336

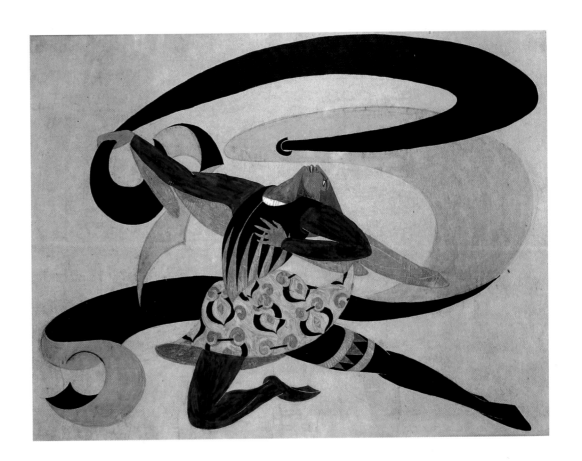

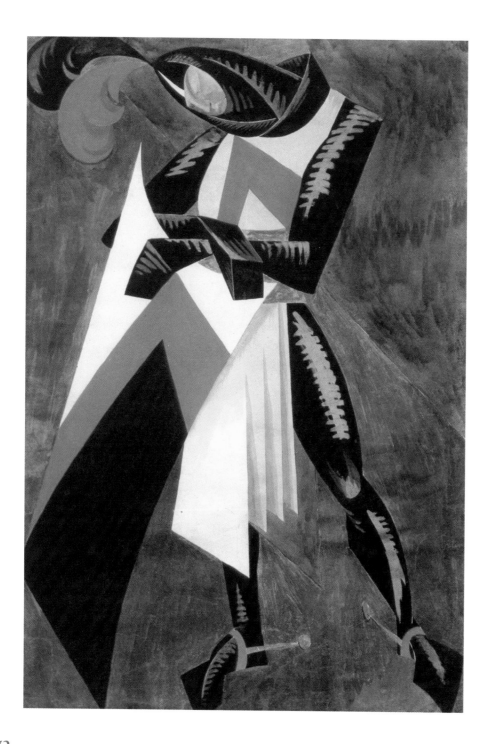

The Rose and the Cross: Play in four acts by Alexander Blok. Projected, but not produced, by the Chamber Theater, Moscow, in 1916 with designs by Vera Mukhina.

The elderly Count Archambaut, lord of a castle in Languedoc, is beset by military and conjugal rivalries. His young wife, Isaure (Izora), languorous, but bored, is courted by Aliscan the page and Bertrand the hapless knight, while her servant Alisa is pursued by the portly chaplain. Defying his own sentiments, the devoted Bertrand, bearer of the Rose, ushers Aliscan into the tower whither the Count had banished Isaure. Fatally wounded in an attack by the armies of Toulouse, Bertrand remains at his post, symbolizing the triumph of noble duty over religious bigotry and petty liaisons.

80. Costume Design for Bertrand, the Knight of Misfortune, ca. 1916

Gouache, silver and Indian ink on paper

70 x 48.5

State Museum of Theatrical and Musical Art, St. Petersburg (formerly in the collection of Nina and Nikita D. Lobanov-Rostovsky).

Inv. No. 23272/337

Note: In 1915–16 Mukhina worked on several projects for the Chamber Theater, Moscow, but none of them was produced with her designs. They included the ballet *Nal and Damaianti* and Arthur Schnitzler's *Der Schleier der Pierrette* as well as *La Cena delle Beffe* [The Jester's Supper] and Alexander Blok's *Rose and the Cross*. As Exter's assistant at the Chamber Theater, Mukhina made a close study of the former's designs for the famous production of *Thamira Khytharedes* of 1916 and there are distinct parallels between these and Mukhina's costumes for *La Cena delle Beffe.*

MUSATOV, Nikolai Alekseevich

Born 26 November, 1895, Kaluga; died 1993, Moscow, Russia.

1908–17 studied at CSIAI; concurrently worked as an assistant to the stage designer Vladimir Egorov; 1917 worked in the Theatre of Miniatures; 1917–22 studied at Vkhutemas; close to Georgiii Yakulov; 1918 in the Grand Dmitrovskii Theatre of Drama and Comedy; 1919–21 at the Neptune film studios; 1920–22 studied at Vkhutemas under Fedor Fedorovsky and Aristarkh Lentulov; 1921 collaborated with Alexander Granovsky, director of the Jewish Chamber Theatre (GOSET), on productions of Sholom Aleichen's *Masks*, Abram Goldfaden's *Sorcerers* and other plays; designed a production of *1001 Nights* for Natalia Sats's Children's Music Theatre; 1923 contributed to the exhibition of 'Theatrical and Decorative Art of Moscow, 1918–23'; 1926 designed a production of *Snegourotchka* for the Kharkov Theatre of Opera and Ballet; 1929 contributed to the 'First Theatrical and Decorative Exhibition' in Moscow; 1926 onwards designed exhibition installations and interiors; 1927 designed Boris Ber's *The Turbine* for the Bolshoi Theatre; 1920s designed various ballets and free dance experiments for Kasian Goleizovsky's Chamber Ballet such as Richard Strauss's *Salomé* and Boris Ber's *Tragedy of Masks*; 1920s onwards produced book illustrations and designed costumes and even toys for Nikolai Bartram at the Handicraft Museum; designed the façade and interior for the State Jewish Theatre; also produced exhibition interiors and agit-designs for various Soviet celebrations; illustrated books and magazines; 1946–48 taught at CSIAI.

Further reading:

Nothing substantial has been published on Musatov. For some information see:

N. Misler, ed.: *In principio era il corpo...l'Arte del Movimento a Mosca negli anni '20.* Catalogue of exhibition at the Acquario Romano, Rome, 1999.

Yu. Love, introd.: *Pamiatniki russkogo teatralnogo avangarda.* Catalogue of exhibition at the Elizium Gallery, M, 2006.

V. Rakitin and A. Sarabianov, eds.: *Entsiklopediia russkogo avangarda,* M: Global Expert and Service Team, 2013, Vol. 2, pp. 143–44.

I. Duksina: *Khudozhniki teatra Kasiana Goleizovskogo 1918–1932.* Catalogue of exhibition at Elizium Gallery, Moscow, 2012, pp. 152–73.

Along with Boris Erdman, Nikolai Foregger, Petr Galadzhev et al., Musatov was a leading member of the second wave of the avant-garde which left a profound impression on the notion of stage design in the 1920s. Musatov, in fact, was closely allied with Goleizovsky and, therefore, with the practice of free dance or the *danse plastique,* and his costume designs, in particular, relying on taut geometries and economy of colour for their dynamic effect, are meant to both liberate and enhance the movements of the body.

Whirlwind: Agit-prop ballet in one act by Kasian Goleizovsky to music by Boris Ber. Produced by Kasian Goleizovsky at the State Academic Bolshoi Theatre, Moscow, on 6 November, 1927, with designs by Nikolai Musatov.

A king makes merry in his castle as the class struggle intensifies between royalty, Capitalists and the priesthood on the one hand and the awakening masses on the other (led by a man in the first act and a woman in the second). Death enters at the end to destroy the old world.

81. *Costume Designs for Protesters, Political Prisoners and Others*, 1927

Pencil, gouache, bronze and collage on paper

54.3 x 72

Bakhrushin State Central Theatre Museum, Moscow

Inv. No KP 320696/22

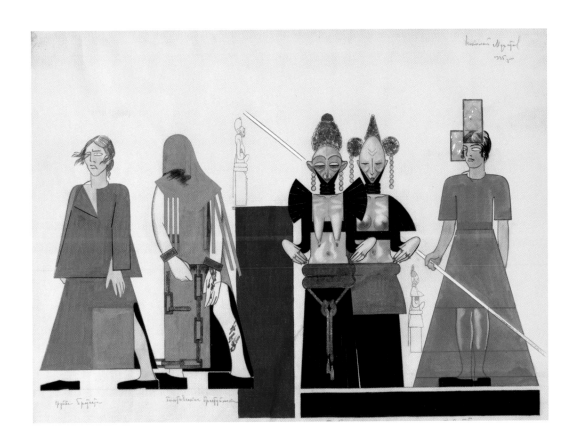

82. *Costume Designs for Freaks*, 1927
Pencil, gouache, collage on paper
54 x 72
Bakhrushin State Central Theatre Museum,
Moscow
Inv. No KP 320696/29

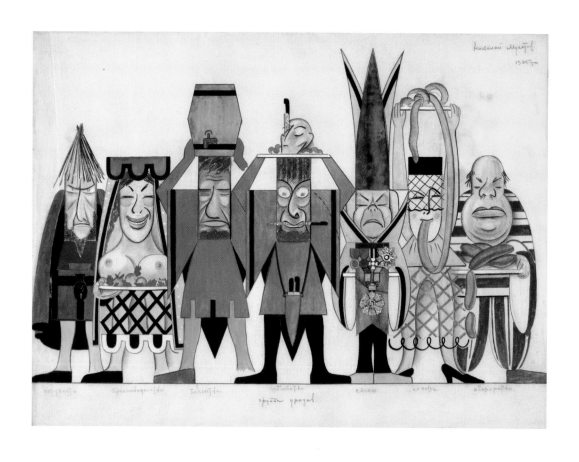

NIVINSKY, Ignatii Ignatievich

Born 30 December, 1881 (11 January, 1882), Moscow, Russia; died 27 October, 1933, Moscow, Russia.

1893–98 attended CSIAI; 1899–1906 taught there; 1900 studied under the architect Ivan Zholtovsky; 1904 onwards traveled frequently to Italy; 1906–12 supervised the interior decorations for GMII; 1908–10 attended the Moscow Archaeological Institute; 1909 took lessons from Stanislav Zhukovsky; began to contribute regularly to exhibitions; 1911 onwards worked mainly with etchings, especially of Italian landscapes; 1913 contributed to exhibitions of the World of Art and the Moscow Association of Artists; 1916 contributed to the 'Moscow Association of Artists'; 1916–17 produced a cycle of etchings devoted to the Crimean landscape; 1917–18 taught at MIPSA/Svomas; 1918 headed the Section of People's Festivities in Moscow; 1919 chairman of the Union of Engravers; 1920 began to work with Evgenii Vakhtangov, culminating in his designs for the production of *Princess Turandot* at the Vakhtangov Theatre, Moscow, in 1922; 1920–21 visited and sketched in various provincial cities such as Zvenigorod; 1921–30 taught at Vkhutemas-Vkhutein in Moscow; 1923–26 worked on etchings devoted to the Caucasus; 1924 member of the Four Arts group; worked at MKhAT; made designs for Boris Vershilov's production of *Golem* at the Habimah Theatre, Moscow; 1925 received a Gold Medal for his contribution to the 'Exposition Internationale des Arts Décoratifs et Industriels Modernes' in Paris; 1927 onwards traveled widely in Georgia and Armenia; 1928 with the Vakhtangov Theatre visited Paris where he had a one-man show; 1933 Konstantin Stanislavsky invited him to design a production of the *Barber of Seville* for his Opera Theatre in Moscow.

Further reading:

P. Ettinger and N. Romanov: *Oforty Ign. Nivinskogo.* Catalogue of exhibition at the State Museum of Fine Arts, M, 1925.

V. Polonsky: *Mastera sovremennoi graviury i grafiki,* M: Gosizdat, 1928, pp. 257–72.

N. Petoshina: *I.I. Nivinsky.* Catalogue of exhibition at RM, 1960.

V. Dokuchaeva: *I.I. Nivinsky,* M: Iskusstvo, 1969.

K. Bezmenova: *Ignatii Ignatievich Nivinsky 1880–1933*. Catalogue of exhibition organized by the Union of Artists, M, 1980.

K. Bezmenova: 'O vystavke I.I. Nivinskogo' in *Sovetskaia grafika*, M, 1983, No. 8, pp. 300–03.

LR (Vol. 2), p. 311–12.

Nivinsky found a primary inspiration in Italy and Italian culture. Embarking, as one of his biographers wrote, upon the 'trail along which the old Venetian artists had advanced.'[82] Well into the twentieth century, Italy continued to be an obligatory halting-place on the grand European tour for Russian artists (even for avant-gardists such as Pavel Filonov and Liubov Popova), an itinerary that repeated the pilgrimage of Russia's nineteenth century *pensionnaires*. Along with Andrea Beloborodoff, Eugène Berman, Konstantin Bogaevsky and Alexandre Jacovleff, in particular, Nivinsky paid homage to the Italian legacy, not, however, to Futurism, but rather to Roman antiquity, the Renaissance and Neo-Classicism. These artists refracted their Italian passion in various ways, some paraphrasing the methods of the great masters, as Bogaevsky did with the landscapes of Mantegna, others by clothing their models in period costume as Jacovleff was wont to do and yet others by simply rendering motifs from Italian sculpture and monuments. Strongly influenced by his mentor Zholkovsky, Nivinsky paid particular attention to Palladian architecture, rendering the façades and columns of countless palazzi in his pencil sketches and etchings. Drawn especially to the art of Leonardo da Vinci and Piranesi, Nivinsky expressed his Classical nostalgia in friezes, panneaux and decorations for Moscow villas, something that harmonized well with the new Neo-Classicism that in the 1910s undermined the current fashion for Art Nouveau.

Princess Turandot: Opera in three acts by Giacomo Puccini (completed by Franco Alfano) based on a drama by Carlo Gozzi. Produced by Evgenii Vakhtangov at the Third Studio of MKhAT (Vakhtangov Theatre) on 28 February, 1923, with designs by Ignatii Nivinsky.

A cruel Chinese Princess, Turandot, announces she will marry only that suitor who can solve three riddles. Inability to do so brings death. Calaf solves the riddles and then announces that he will choose death if Turandot can guess his name (Calaf=Love). Her cruelty dissipates in the presence of his love and she agrees to marry him.

83. *Set Model*, 1922

Wood, plywood, wood glue, wood paint, fabric, canvas and cardboard

44.5 x 59 x 42

Bakhrushin State Central Theatre Museum, Moscow

Inv. No. KP 168850 Mak 76

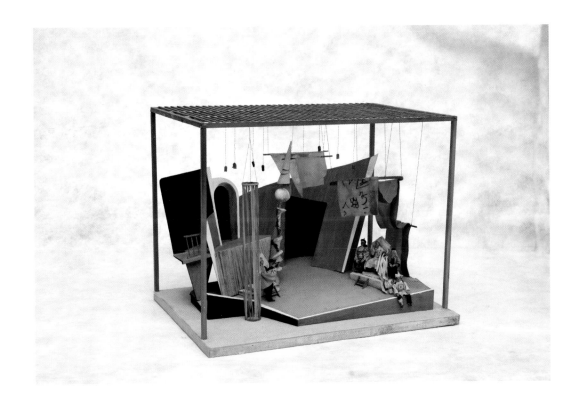

84. Set Design Showing Front of a Building, Arch and Window, 1922

Pencil, gouache, watercolour, tempera and collage on cardboard

31 x 45.5

Bakhrushin State Central Theatre Museum, Moscow

Inv. No. KP 91717

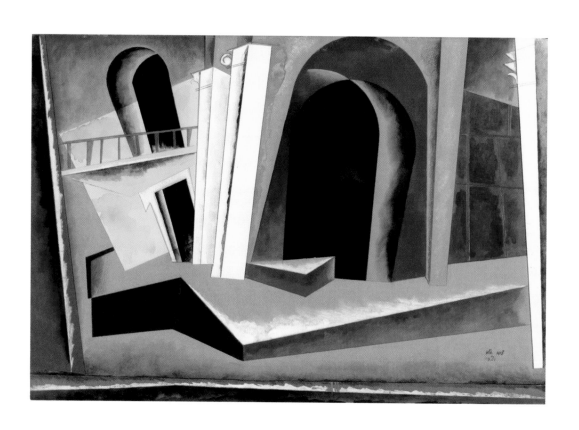

85. *Set Design for the Throne Room*, 1922
Pencil, gouache, watercolour and collage on cardboard
37.5 x 50.8
Bakhrushin State Central Theatre Museum, Moscow
Inv. No. KP 93824 GDS 1465

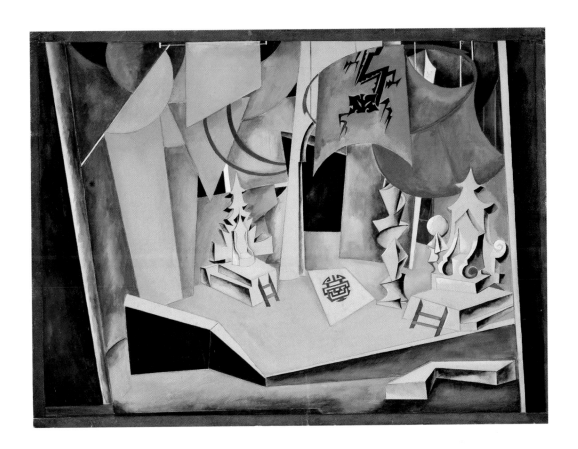

Note: Nivinsky was working on several experimental productions for the Second and Third Studios of the Moscow Art Theater at this time, all of which 'captivated by their elegance, grace, and vivid sense of theater.'[83] His major design undertaking at the Third Studio, i.e. for Evgenii Vakhtangov's production of Carlo Gozzi's *Princess Turandot* in 1922, an interpretation of 'China via Italy',[84] revealed the 'lightness, elegance, and grace peculiar to the actors of the Italian Comedy'[85] which identified Nivinsky's art in general. True, people were rather surprised at the radical nature of the production and its visual resolution, since neither Vakhtangov, nor Nivinsky were considered to be at the forefront of the 'avant-garde'.

As director of the Third Studio of MKhAT, Vakhtangov asked Nivinsky to collaborate on *Princess Turandot* in the summer of 1921 and Nivinsky, fascinated by the work of Carlo Gozzi and Italian culture, in general, accepted the invitation with alacrity and invented sets and costumes which seemed very distant from his more familiar paraphrases of the Renaissance, although, according to the critic Nikolai Romanov, they still bore a 'hidden and strange logic'.[86] Nikolai Gorchakov, who assisted Vakhtangov with the preparations for *Princess Turandot*, recorded the following conversation between producer and designer:

> Nivinsky: 'Name just some of the invididual elements of your conceptions concerning 'Turandot'.'
>
> Vakhtangov: 'Lightness, exquisiteness, grace peculiar to the actors of the Italian comedy. The decorations cannot be clumsy and, therefore [should occupy] a minimum of acting space....'
>
> Nivinsky: 'What about scene changes?'
>
> Vakhtangov: 'Instantaneous. In front of the spectator'.[87]

Princess Turandot continued to enjoy an unqualified success right up until 1941, running 1038 times.

PETRITSKY, Anatolii Galaktionovich

Born 31 January (12 February), 1895, Kiev, Ukraine; died 6 March, 1964, Kiev, Ukraine.

1910–18 attended the Kiev Art Institute; influenced by Impressionism and Post-Impressionism; close to Fedor Krichevsky; 1914 onward contributed regularly to Ukrainian, Russian and international exhibitions; 1917 onward became increasingly involved in stage design; influenced by Alexandra Exter; 1920 designed posters and agit-prop decorations; 1922 worked with Kasian Goleizovsky on Eccentric Dances for the Moscow Chamber Ballet; 1922–24 attended Vkhutemas in Moscow; exponent of Constructivism; 1924 made designs for an unrealized production of a ballet based on the theme of Richard Wagner's *Tristan und Isolde;* 1925 contributed to the 'Exposition Internationale des Arts Décoratifs et Industriels Modernes' in Paris; moved to Kharkov; 1920s with Alexander Bogomazov, Vasilii Ermilov, Les Kurbas, Mikhail Semenko and other artists, producers and writers, leading member of the Ukrainian avant-garde; active as a caricaturist and painter of proletarian scenes as well as a stage and book designer; 1928–32 painted portraits of Ukrainian literary and theatrical celebrities; 1930s–50s continued to work on theatrical design, mainly for Kiev productions, although he also worked for the Bolshoi Theatre, Moscow, in the 1940s; 1944 was made People's Artist of the USSR.

Further reading:

V. Khmuryi: *Anatol Petritsky. Teatralni stroi,* Kharkov: State Publishing-House, 1929.

I. Vrona: *Anatol Petritskii,* K: Mistetstvo, 1968.

D. Gorbachev: *Anatolii Galaktionovich Petritsky,* M: Sovetskii khudozhnik, 1971.

I. Dychenko: 'Bezoshibochnym glazom (Novoe ob Anatole Petritskom)' in *Vitchina,* K, No. 12 (1974).

D. Horbachov: 'Soviet Ukrainian Art: A Retro of Achievement' in *Ukraina,* K, 1980, November, pp. 14–17.

D. Gorbachev: 'Rezhisser i khudozhnik v ukrainskom opernom teatre 20-kh godov' in *Sovetskie khudozhniki teatra i kino,* M, 1980, No. 2, pp. 255–64.

D. Horbachov et al.: *Anatolii Petritsky. Sporadi pro khudozhnika,* K: Mistetstvo, 1981.

N. Kornienko: 'Les Kurbas i khudozhniki' in *Sovetskie khudozhniki teatra i kino*, M, 1981, No. 5, pp. 332–54.

M. Mudrak: 'Modern Expression and Folk Tradition in the Theatrical Art of Anatol Petrytskyi' in *Cross Currents*, New York, 1984, No. 3, pp. 385–95.

I. Dychenko: 'Shchedrii na barvi' in *Ukraina*, K, 1985, No. 8.

V. Ruban: *Anatol Petritsky. Portreti suchasnikiv*, K: Mistetstvo, 1991.

D. Horbachov: 'Gra-drazhnilka koviliara' in *Fine Art*, K, 2010, No. 2, pp. 23–27.

D. Horbachov et al.: *Anatol Petritsky. Teatralnyi stroi ta dekoratsii zi zbirki muzeiu teatralnogo, muzichnogo ta kinomasterstva*, K-Lvov: Maister-knig, 2012.

I. Duksina: *Khudozhniki teatra Kasiana Goleizovskogo 1918–1932*. Catalogue of exhibition at Elizium Gallery, Moscow, 2012, pp. 174–85.

LR (Vol. 2), pp. 317–19.

Petritsky was a pioneer in the artistic and theatrical renaissance that occurred in Ukraine in the late 1910s and 1920s and was a leading exponent of the Ukrainian interpretation of Constructivism in stage design. Beginning in 1918, Petritsky decorated ballets, operas and dramas for numerous theatres in Ukraine and Russia and was quickly recognized as an original practitioner and theorist of stage design. As he wrote in the avant-garde journal *Nova generatsiia* [New Generation] in 1930: 'The artist builds the theatrical costume like a functional object which embodies this or that idea of the general stage design. The artist balances this object within the general composition and creates an organic link between the object of the design, the actor and the costume by means of the mechanics of the action. The costume should also be built from the inside out.'[88]

Of particular importance to Petritsky's early development as a stage designer was his collaboration with the ballet dancer Mikhail Mordkin in Kiev in 1918 on *Spanish Dance*. Mordkin was an exponent of the 'new ballet' and, along with Nikolai Foregger, Goleizovsky, Lavrentii Novikov and Vladimir Riabtsev, did much to change the conventions of classical ballet in Moscow, Kiev and, after 1923, the year of his emigration, in New York. Mordkin also worked for the Chamber Theatre, Moscow, even instructing Alisa Koonen for her Dance of the Seven Veils in Alexander Tairov's 1917 production of *Salomé* – thereby establishing close contact with the designer Exter. Mordkin also collaborated with Georgii Yakulov on projects

for the Chamber Theatre and, as an associate of the Bolshoi Theatre in Moscow, traveled a great deal during the Civil War period, spending 1919 in Kiev and then 1921–22 in Tiflis. Thanks to Mordkin, Petritsky gained valuable knowledge and experience of the ballet and theatre worlds, and it was logical that Petritsky accepted Mordkin's invitation to design a version of *Nur and Anitra* for New York (the production not realized). After Mordkin's emigration, Petritsky continued to collaborate with experimental choreographers, contributing designs to Mikhail Moiseev's productions of *Le Corsaire* in 1926 and *Taras Bulba* in 1928 in Kharkov. As one critic has written recently of Petritsky the stage designer:

> The main thing is movement, speed. And Petritsky expressed this 'speed' thesis in his designs where – not without irony – he elucidated the energic scheme of the dance. But he was not satisfied with schemes. The artist was skeptical of those who, by the term 'contemporary,' understand a break with the culture of the past... Using new visual media and elements of bygone styles in many of his productions, the artist restored the living physiognomy of the past to the stage.[89]

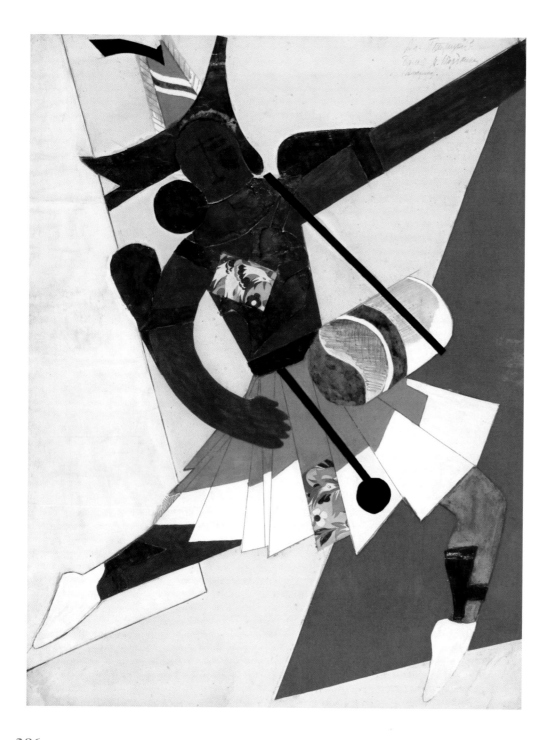

Nur and Anitra: Ballet in one act by Alexander Gorsky to music by Alexander Ilinsky. Projected, but not produced, by Morris Gest for the Greenwich Village Follies, New York, in the fall of 1923, with choreography by Mikhail Mordkin and designs by Anatolii Petritsky.

The Indian knight Nur comes to the castle of a beautiful enchantress, Queen Anitra. With the help of a talisman from a magician, Nur attempts to conquer the Queen whose charms had destroyed many before him. The dances of the Queen's maidens do not affect the bearer of the talisman, so the Queen then bears him away to a magic grotto and, with her song, lulls him to sleep. But the magician saves Nur from this induction and, much angered, the Queen and her servants express their injured pride in a frenzied dance.

86. *Costume Design for Musician*, 1923

Graphite pencil, gouache, collage and lacquer on paper

64.7 x 49.8

Bakhrushin State Central Theatre Museum, Moscow

Inv. No. KP 310788 GKS 4331

87. Costume Design, 1923
Graphite pencil, gouache and collage on paper
64.5 x 49.7
Bakhrushin State Central Theatre Museum,
Moscow
Inv. No. KP 310787

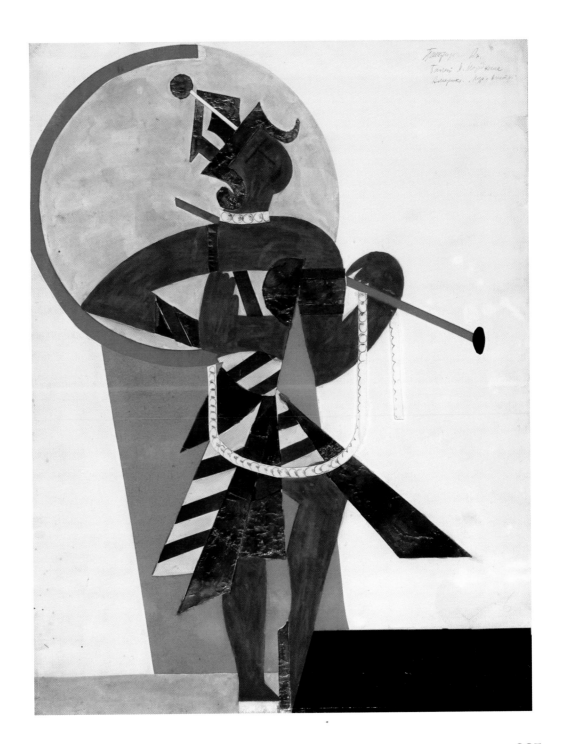

Note: Nur and Anitra, which had premiered in Moscow on 2 December, 1907, marked the high point in Mordkin's and Petritsky's artistic collaboration, even though this 1923 production was not implemented. In any case, although Petritsky had already finished his maquette and costume designs by August, 1923,[90] Mordkin arrived in the USA only at the end of November, 1924.[91] According to some observers, Petritsky managed to evoke the spirit of India, even though the costumes were 'far from any sense of everyday life… two or three characteristic details (for example, Anitra's headdress) waive any possibility of making a mistake: this is India.'[92] Seven designs by Petritsky for *Nur and Anitra* are known to exist: three are in the Bakhrushin State Central Theatre Museum, Moscow, two in a private collection in Kiev[93] and two in the State Museum of Theatre and Music in St. Petersburg (formerly in the Lobanov-Rostovsky collection).

William Tell: Opera in four acts by Gioachino Rossini. Produced by Vladimir Manzyi at the Kharkov Opera Theatre on 27 May, 1927, with choreography by Igor Moiseev and designs by Anatolii Petritsky.

William Tell, an expert with bow and arrow, lived in the Swiss mountains, then under the control of Austria and its cruel and arrogant ruler Gessler. Gessler felt that everyone should salute him constantly, so he put his hat on a pole in the center of town and commanded the citizens to bow whenever they passed it. One day Tell arrived with his son and refused to salute the hat. Instead of killing Tell for his disobedience, the vexed Gessler challenged him to shoot an apple off his son's head with one shot: if successful, Tell would go free. Tell did shoot the apple with a single arrow, but Gessler noticed that beforehand, Tell had taken two arrows out of his quiver. Gessler asked why, to which Tell replied, 'If I had missed, that second arrow would have been headed your way.' In the end, Tell did kill Gessler, an act which fueled a Swiss insurrection, forcing the Austrian invaders to withdraw.

88. Costume Design, 1923

Graphite pencil, gouache and collage on paper

64.5 x 49.3

Bakhrushin State Central Theatre Museum, Moscow

Inv. No. KP 310804 GKS 4334

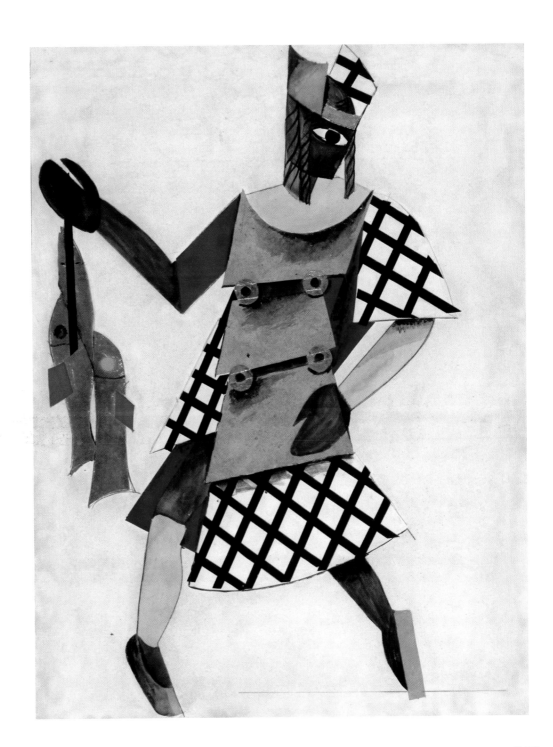

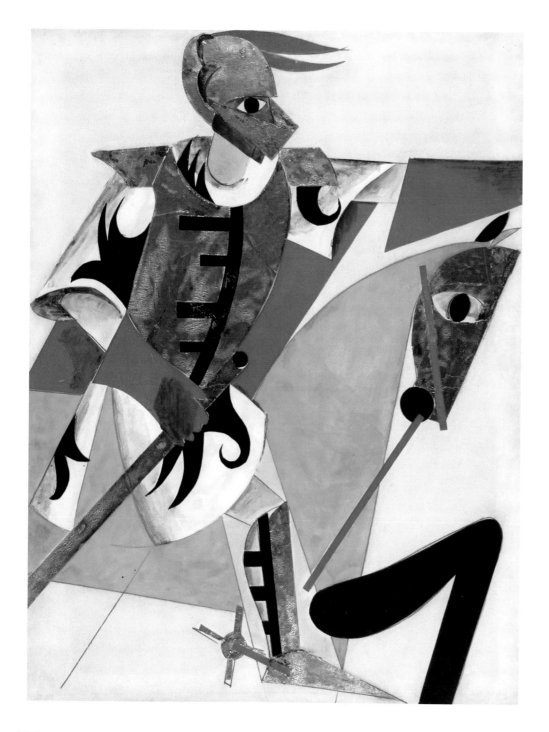

89. *Costume Design for a Knight*, 1927
Graphite pencil, gouache and collage on paper
64.8 x 49
Bakhrushin State Central Theatre Museum, Moscow
Inv. No. KP 310785 GKS 4333

90. Costume Design for a Lady, 1927
Graphite pencil, gouache and collage on paper
66 x 49.4
Bakhrushin State Central Theatre Museum, Moscow
Inv. No. KP 310794

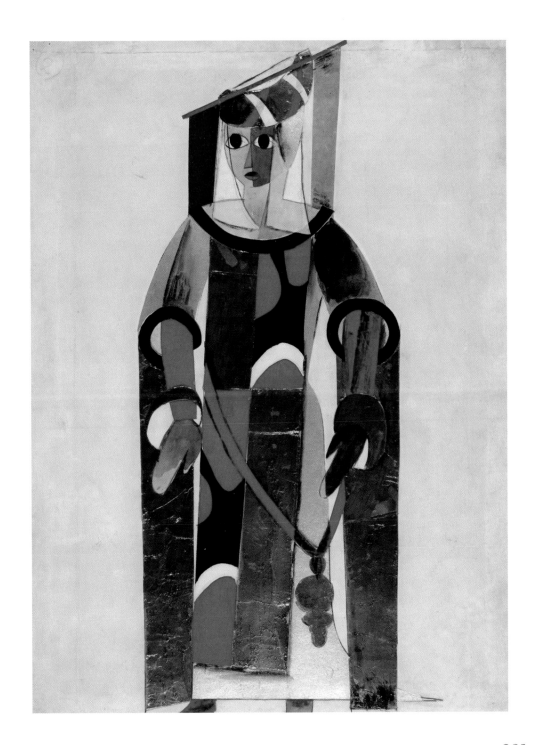

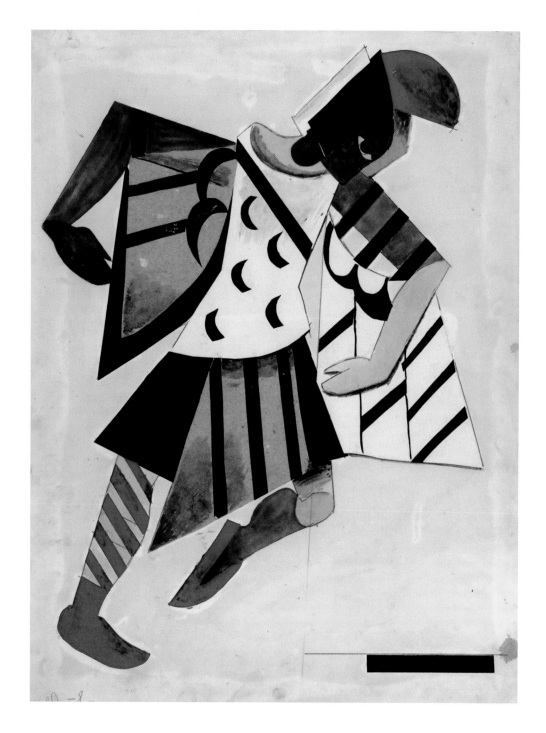

91. *Costume Design*, 1927
Graphite pencil, gouache and collage on paper
64.5 x 49
Bakhrushin State Central Theatre Museum, Moscow
Inv. No. KP 310796

The Footballer: Ballet-pantomime in three acts by Vsevolod Kurdiumov to music by Viktor Oransky. Produced by Nikolai Foregger at the Kharkov Opera Theatre on 7 February, 1930, with designs by Anatolii Petritsky.

A sportsman and a janitor, regular Soviet citizens, are in love. A certain lady tries to tempt the footballer, while a dandy tries to seduce the charwoman. However, after several misunderstandings, the lady and the dandy are rebutted and put to shame, while the footballer and the charwoman are united in their glorious Soviet love.

92. Costume Design for Volleyball Players, 1930

Graphite pencil, watercolour, tempera and ink on paper

71.8 x 54.8

Bakhrushin State Central Theatre Museum, Moscow

Inv. No. KP 315854 GKS 4335

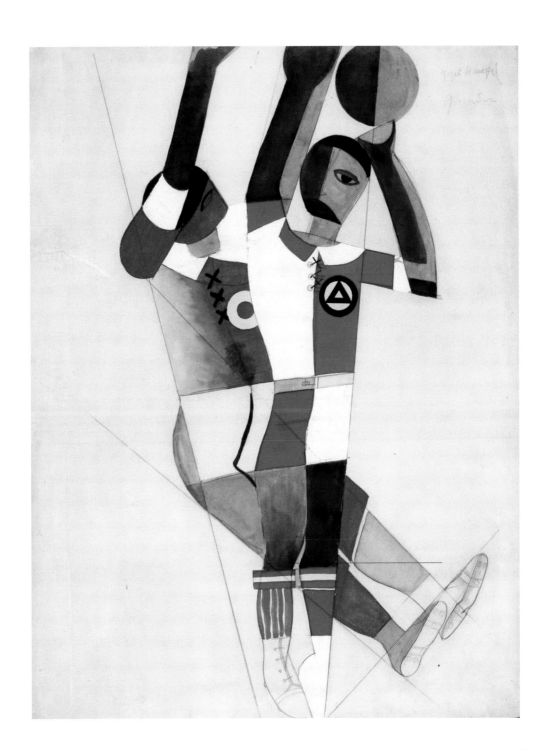

Note: After opening in the fall of 1925, the Kharkov Opera Theatre soon became a prestigious center for artistic experiment, thanks to the presence there of Foregger, Goleizovsky, Moiseev and Petritsky. Coming to the Kharkov Opera after working for Goleizovsky at the Moscow Chamber Ballet and then designing the production of Nikolai Gogol's *Vii* at the Ivan Franko Ukrainian Dramatic Theatre (also in Kharkov), Petritsky consolidated his position as a leader of the Ukrainian avant-garde. Although a Constructivist by inclination, Petritsky adjusted easily to the needs of a given spectacle and was willing to use ornament and 'illusion' if the production so dictated. Consequently, he had no difficulty in evoking the historical ambiance for operas such as *Prince Igor* (Odessa, 1926), *Taras Bulba* (Kiev, 1927; Kharkov, 1928) and, of course *Le Corsaire*; and he did this while still emphasizing the formal qualities of the piece. He wrote in 1930:

> You must… construct the costume from inside and be guided not just by nice appearances, but also by your relationship to it as a form that is supplementary to the image created by the actor – as one of the components interconnected to the logical mechanics of the whole.[94]

Petritsky had very definite ideas about the way in which his costumes were to function, especially for *Le Corsaire*. The dancer Valentina Dulenko, for example, who danced the part of Medora in Kharkov had a hard time convincing Petritsky that elementary adjustments had to be made – otherwise the costumes would have impeded the movements.[95] Petritsky also created a complex set, suspending planes of different colours and forms from the grid-iron which, as the ballet progressed, changed their shape and depiction.[96]

POPOVA, Liubov Sergeevna

Born 24 April (6 May), 1889, on the family's estate 'Krasnovidovo', Ivanovskoe Village, Moscow Region, Russia; died 25 May, 1924, Moscow, Russia.

1889–1901 received art lessons at home; 1906 graduated from the Arseniev Gymnasium; 1907 attended the private studio of Stanislav Zhukovsky; 1908–09 attended Konstantin Yuon's and Ivan Dudin's Art School; met Alexander Vesnin; 1910 visited Italy where she was especially impressed by Giotto; that summer travelled to Pskov and Novgorod to study icons; 1911 made several trips to Mediaeval Russian cities; 1912 worked in the Moscow studio known as The Tower with Ivan

Aksenov, Viktor Bart, Alexei Grishchenko, Vladimir Tatlin and Kirill Zdanevich; visited Sergei Shchukin's collection of modern French art; 1912–13 with Nadezhda Udaltsova went to Paris, enrolling in La Palette and studying under Henri Le Fauconnier, Jean Metzinger and André Dunoyer de Segonzac; 1913 met Alexander Archipenko and Ossip Zadkine; after spending May in Brittany with Vera Mukhina and Boris Ternovets returned to Russia; again worked closely with Tatlin, Udaltsova and Vesnin; 1914 visited France and Italy again, accompanied by Mukhina; 1914–15 her Moscow home became a regular meeting-place for the new artists and writers; 1914–16 contributed to the 'Jack of Diamonds', 'Tramway V,' '0.10,' the 'Store', and other exhibitions; 1916 visited Samarkand; 1916–17 member of the Supremus group; 1916–18 painted architectonic compositions; 1917 made embroidery designs for Natalia Davydova's enterprise in Verbovka; joined the Professional Union of Artists and Painters; 1919–21 painted so-called painterly constructions; 1918 married Boris von Eding; worked on agit-designs; in November gave birth to a son; 1919 contributed to the 'X State Exhibition: Non-Objective Art and Suprematism'; husband died from typhoid fever; 1920 made stage designs for *Romeo and Juliet* projected by Alexander Tairov; designed marionettes for a children's theatre; taught at Svomas/Vkhutemas, compiling a program on 'colour discipline'; joined Inkhuk; 1921 contributed to '5 x 5 = 25,' Moscow; thereafter became active as a utilitarian Constructivist, designing book covers, porcelain, stage sets, textiles; taught at the State Higher Theatre Studios; 1922 created the sets and costumes for Vsevolod Meierkhold's production of *The Magnanimous Cuckold*; contributed to the 'Erste Russische Kunstausstellung' in Berlin; 1923 designed Meierkhold's production of *Earth on End*; 1923–24 worked on textile and dress designs for the First State Textile Factory; 1924 posthumous exhibition opened in Moscow (21 December).

Further reading:

O. Brik: *Posmertnaia vystavka proizvedenii konstruktora L.S. Popovoi*. Catalogue of posthumous exhibition at the Museum of Artistic Culture, M, 1924.

J. Bowlt: 'From Surface to Space: The Art of Liubov Popova' in *The Structurist*, Saskatoon, 1976, No. 15–16, pp. 80–88.

A. Law: "Le Cocu Magnifique' de Crommelynck' in *Les Voies de la création Théâtrale*, Paris, 1980, No. 7, pp. 14–43.

J. Bowlt: 'Liubov Popova, Painter' in *Transactions of the Association of Russian-American Scholars in USA*, New York, 1982, Vol. 15, pp. 227–51.

N. Adaskina and D. Sarabianov: *Liubov Popova*, New York: Abrams, 1990.

D. Sarabianov and N. Adaskina: *L.S. Popova 1889–1924*. Catalogue of exhibition at TG and RM, 1990.

M. Dabrowski: *Liubov Popova*. Catalogue of exhibition at the Museum of Modern Art, New York, and other institutions, 1991–92.

D. Sarabianov: *Liubov Popova*, M: Galart, 1994.

M. Tupitsyn: *Rodchenko and Popova*. Catalogue of exhibition at Tate Modern, London; State Museum of Contemporary Art, Thessaloniki; and the Museo Nacional Centro de Arte Reina Sofia, Madrid, 2009–10.

N. Adaskina: *Liubov Popova*, M: Gordeev, 2011.

LR (Vol. 2), pp. 327–31.

Like Alexandra Exter, El Lissitzky and Alexander Rodchenko, Popova possessed the rare gift for thinking in terms of both two dimensions and three. Her desire to introduce space as a creative agent into her art, encouraged by her friendship with Mukhina and Tatlin, was already evident in 1915 in her series of still-lives and paintings which she subtitled 'plastic painting' and in her occasional reliefs of the same period. Popova's interest in sequential, spatial relationships was also manifest in her graphics and linocuts of 1920–21 when she often imposed a grid of conflicting lines above a complex of colour planes – a concept that she used with great success in her textile designs of 1923–24.

Romeo and Juliet: Tragedy in five acts by William Shakespeare. Projected, but not produced, by the Chamber Theater, Moscow, in 1920, with designs by Liubov Popova.

For plot summary see EXTER, Alexandra.

93. Costume Design for a Lady in a Blue Cape, ca. 1920

Watercolour, whitening and pencil on paper

Signed upper right in Russian: 'L.S. Popova.'

33 x 22.2

State Museum of Theatrical and Musical Art, St. Petersburg (formerly in the collection of Nina and Nikita D. Lobanov-Rostovsky).

Inv. No. GIK 23272/365

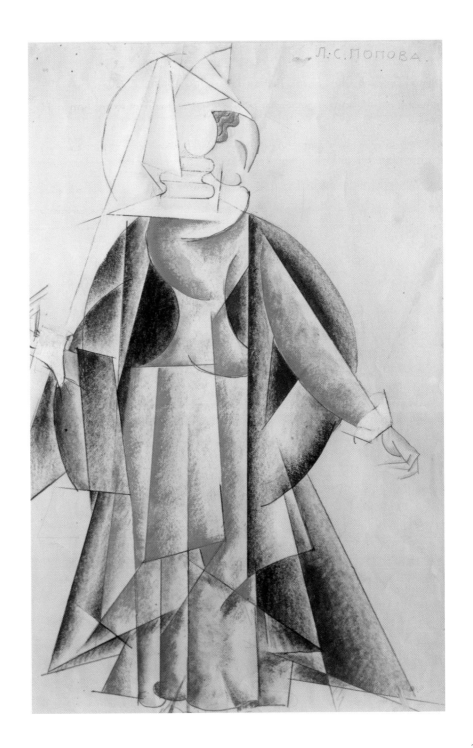

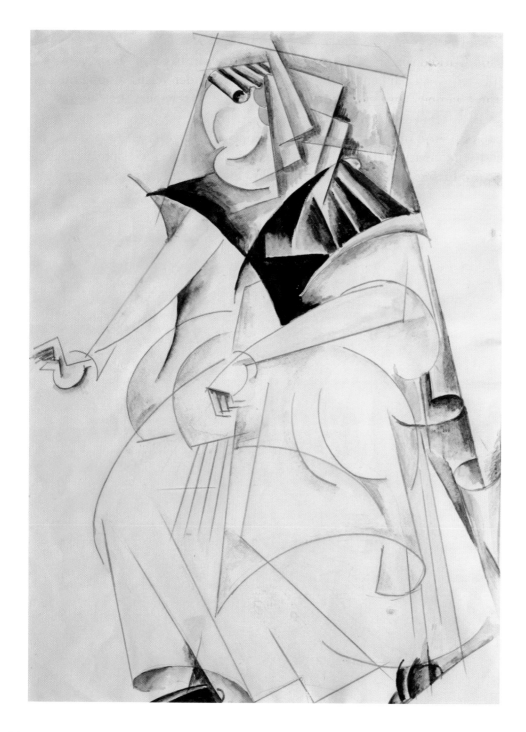

94. *Costume Design for a Lady*, 1920
Gouache and pencil on paper
35.2 × 26.8
State Museum of Theatrical and Musical Art, St. Petersburg (formerly in the collection of Nina and Nikita D. Lobanov-Rostovsky).
Inv. No. GIK 23272/364

Note: Romeo and Juliet was Popova's first major professional theatrical commission and she worked on the sets and costumes with enthusiasm and inventiveness. With Exter, Aristarkh Lentulov, Mukhina and Alexander Vesnin among the designers, the Chamber Theater at this time was a veritable scenographic laboratory and Popova must have been drawn to the theater precisely for this reason. However, perhaps because of her relative inexperience as a stage artist or because of the excessive geometry of her designs, Alexander Tairov rejected Popova in favour of Exter, producing *Romeo and Juliet* the following year with Exter's designs.

The Magnanimous Cuckold: Farce in three acts by Fernand Crommelynck, produced by Vsevolod Meierkhold for the Meierkhold Theatre, Moscow, on 25 May, 1922, with designs by Liubov Popova.[97]

A miller suspects his wife of being unfaithful and the action unfolds as he follows his farcical searches through the village in pursuit of his wife's lovers.

95. Set Model (1967 reconstruction after the 1922 original)

Gouache, wood and metal

73.5 x 135.5 x 61.5

Bakhrushin State Central Theatre Museum, Moscow

Inv. No. NV 2244

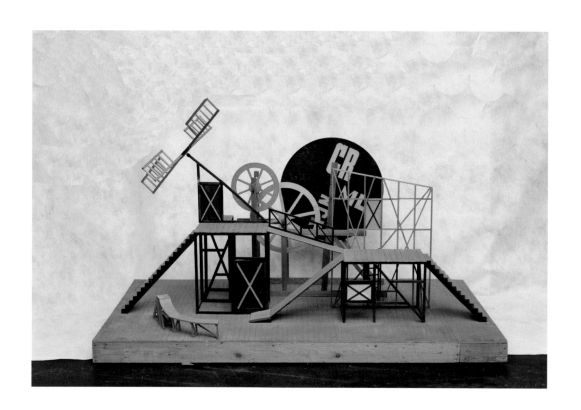

96. Costume Doll for the Count, 1922

Fabric, cardboard, buttons, string, wood and metal

46.6 x 21 x 14.3

Bakhrushin State Central Theatre Museum, Moscow

Inv. No. KP 180174/2

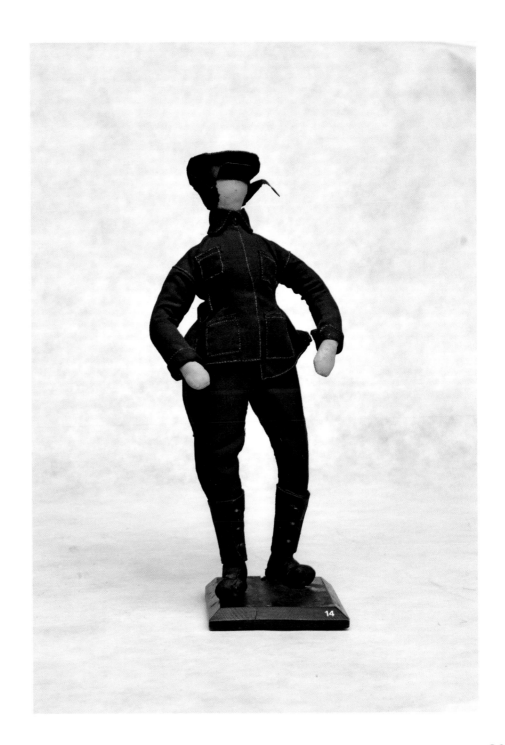

Note: A logical outcome of Popova's interest in pictorial space was her work on stage design in the early 1920s, which, she felt, would enable her to avoid the 'frontal, visual character [of art].'[98] It was in the theatre that Popova showed herself to be one of the few authentic Constructivists of the Russian theatre: in her economy of means, austerity of organization, and subtle combination of real form and real space, Popova expanded the elementary concepts of Rodchenko's wooden and metal constructions of 1918–21 into her inventions for *The Magnanimous Cuckold* which premiered in April, 1922. The artist Louis Lozowick recalled his impression of the production:

> The stage was bare – no curtain, no proscenium arch, wings, backdrop, flood lights. On the background of the bare wall of the building with its open brickwork, one saw a simple, skeleton-like construction, a scaffolding designed by Popova consisting of one large black wheel and two small ones, red and white, several platforms at various levels, revolving doors, stairs, ladders, chutes, square, triangular, and rectangular shapes.[99]

Inevitably, Popova's construction provoked criticism not only from the traditionalists who compared her interpretation to a piece of vaudeville, but also from the Constructivists themselves, some of whom regarded it as mere ornament and descriptive scenery.[100] Whatever the responses, Popova's work for *The Magnanimous Cuckold* marked the culmination to her relentless effort to resolve the dichotomy between surface and space and to move from pictorial space to open, real space.

RABINOVICH, Isaak Moiseevich

Born 27 February (11 May), 1894, Kiev, Ukraine; died 4 October, 1961, Moscow, Russia.

1906–12 attended the Kiev Art Institute, studying under Alexander Prakhov, Grigorii Diadchenko and Alexander Murashko; 1911 onwards worked regularly as a stage designer; 1914 contributed to the 'Ring' exhibition, Kiev; 1917 worked closely with Nikolai Evreinov at the Petrograd cabaret Bi-Ba-Bo; 1918 worked closely with Alexandra Exter in Kiev; close to other students there such as Boris Aronson, Liubov Kozintseva, Nisson Shifrin, Alexander Tyshler and Sofia Vishnivetskaia; 1919 worked on May Day agit-designs for Kiev; member of Kultur-Lige; designed a production of Lope de Vega's drama *Fuente Ovejuna*

directed by Konstantin Mardzhanov in Kiev (assisted by Tyshler); 1920 lived briefly in Kharkov before moving to Moscow permanently; 1920 made Moscow debut as a stage designer for a production of Anton Chekhov's *The Wedding* at the Third Studio of MKhAT; 1923 designed *Lysistrata* for the MKhAT Musical Studio; 1924 designed the sets for Yakov Protazanov's film *Aelita* (Exter designed the costumes); 1926–30 taught at Vkhutein in Moscow; 1920s-30s designed many productions for various theatres, including the State Jewish Chamber Theatre, the Bolshoi Theatre, and the Maly Theatre; 1936 designed a lavish production of *Sleeping Beauty* for the Bolshoi Theatre; 1939–48 artist-in-chief for the projected Palace of Soviets in Moscow.

Further reading:

A. Efros: 'Khudozhniki teatra Granovskogo' in *Iskusstvo*, M, 1928, Book 1–2, pp. 53–74.

F. Syrkina: *I. Rabinovich*, M: Sovetskii khudozhnik, 1972.

A. Shifrina: *Isaak Moiseevich Rabinovich 1894–1961*. Catalogue of exhibition at the Bakhrushin State Central Theatre Museum, M, 1984.

'Isaak Rabinovich' in S. Barkhin et al.: *Khudozhniki Bolshogo teatra*. Catalogue of exhibition at the Manège, M, 2001, pp. 180–91.

G. Kazovsky: *Khudozhniki Kultur-Ligi/The Artists of the Kultur-Lige*, Jerusalem: Gesharim; M: Mosty kultury, 2003, passim.

E. van Voolen et al.: *Russisch-Joodse Kunstenaars, 1910–1940. Moderne meesterwerken uit Moskou/Russian Jewish Artists, 1910–1940. Modern Masterpieces from Moscow*. Catalogue of exhibition at the Joods Historisch Museum, Amsterdam, 2007, passim.

G. Kazovsky et al.: *Kultur-Liga: Khudozhnii avangarda 1910–1920-kh rokiv/ Artistic Avant-Garde of the 1910s-1920s*. Catalogue of exhibition at the National Art Museum, Kiev, and other venues, 2007, passim.

Rabinovich was one of the most gifted students of Alexandra Exter in Kiev, so it is not surprising that she chose him to assist her with the decorations for the 'All-Russian Agricultural Exhibition' in Moscow in 1923 and to design the sets for *Aelita* the following year. Rabinovich kept in close contact with other young artists who attended Exter's studio in 1918–19, especially Shifrin and Tyshler, and often referred to her influence on his artistic development. As Rabinovich wrote

to Shifrin in 1918, Exter was 'practically and theoretically the herald of the French.'[101] Rabinovich's assimilation of French Cubism via Exter is especially noticeable in his early stage designs as for *Salomé* at the Solovtsov Theatre, Kiev, in 1919.

Fuente Ovejuna [The Sheep's Well]: Play in three acts by Lope de Vega. Produced by Konstantin Mardzhanov at the Lenin Second Theatre of the Ukrainian SSR in Kiev on 1 May, 1919, with designs by Isaak Rabinovich and Alexander Tyshler.

Civil War serves as the background to the uprising of the villagers of the town of Fuenteovejuno against the tyrannical Comendator de Calatrava, while the siege of Ciudad Real continues – undertaken by the Order of Calatrava on behalf of the Portuguese Crown.

97. *Set Model*, 1919

Foam plastic, cardboard, gouache, colour paper, curtain lace and electrical equipment

25 x 37 x 25

Bakhrushin State Central Theatre Museum, Moscow

Inv. No. NV 1959

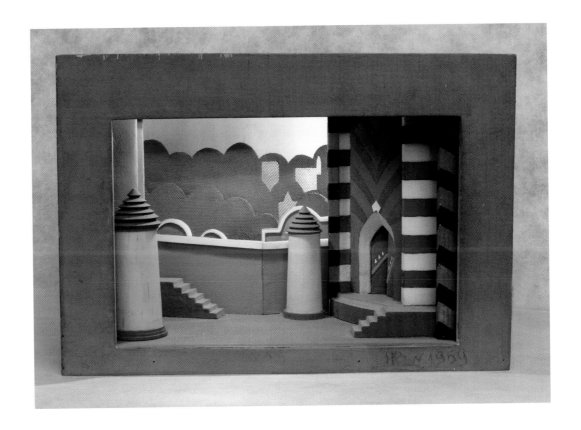

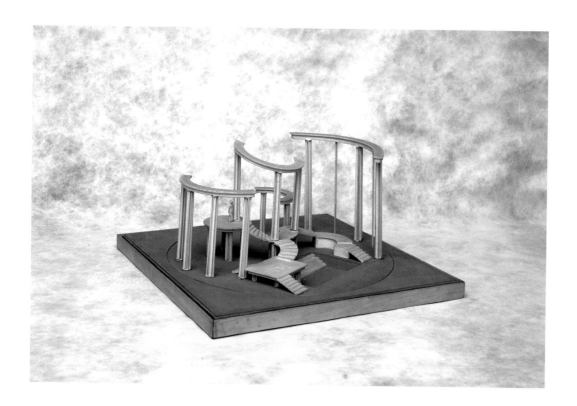

Lysistrata: Comedy by Aristophanes set to music by Reingold Glière. Produced by Vladimir Nemirovich-Danchenko and Leonid Baratov at the MKhAT Music Studio on 16 June, 1923, with choreography by Lika Redega and designs by Isaak Rabinovich.

Lysistrata plans a meeting between all the women of Greece to discuss how to end the Peloponnesian War. As she waits for the women of Sparta, Thebes and other municipalities to meet her, she curses the weakness of women, asking them to refuse the solicitations of their husbands until a treaty for peace has been signed and she has made plans with the older women of Athens to seize the Acropolis. As the women sacrifice a vessel of wine to the Gods, they hear the sounds of the older women taking the Acropolis, the fortress that houses the treasury of Athens.

98. *Set Model*, 1923
Wood, cardboard, glue and glue paints
53 x 53 x 26.5
Bakhrushin State Central Theatre Museum, Moscow
Inv. No. NV 1730

99. Costume Design for a Warrior, 1922
Graphite, crayon, and water base paint on paper on paper
30.6 x 22.4
Bakhrushin State Central Theatre Museum, Moscow
Inv. No. KP 116611

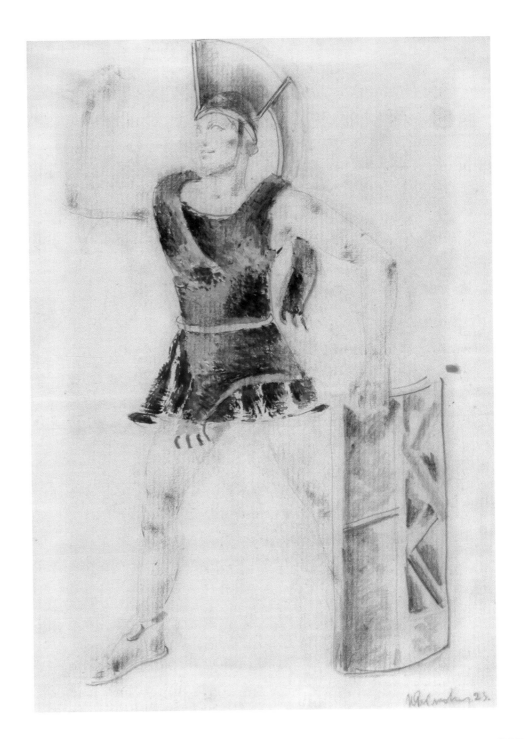

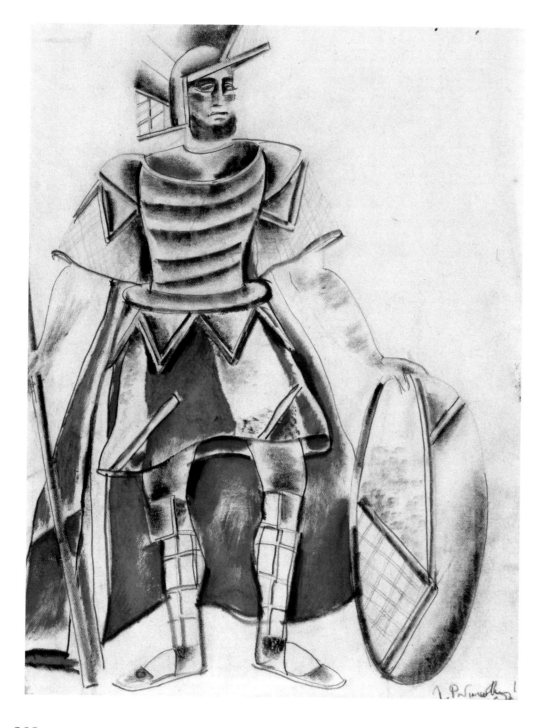

100. *Costume Design for a Warrior,* 1922
Graphite, crayon and water base paint on paper on cardboard
36.6 x 29.5
Bakhrushin State Central Theatre Museum, Moscow
Inv. No. KP 116609 GKS 4494

101. Costume Design for Lysistrata, 1923
Graphite pencil, tempera, water base paint on paper
on paper
31.6 x 23.8
Bakhrushin State Central Theatre Museum, Moscow
Inv. No. KP 116610 GKS 4631

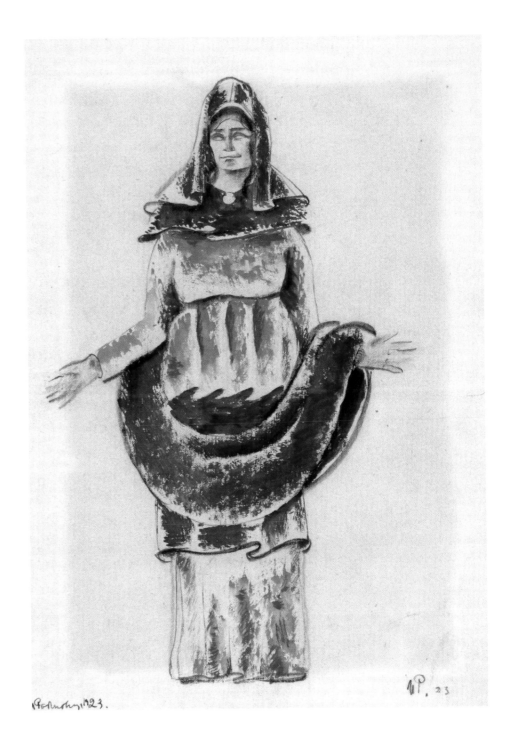

Don Carlos: Play in five acts by Friedrich Schiller. Produced by Vasilii Sakhnovsky at the Comedy Theatre, Moscow, on 15 November, 1922, with designs by Isaak Rabinovich.

The dramatis personae are many and varied, from the Duke of Alva to a fictional Dominican monk, from Domingo to the Duke of Medina Sedonia (who speaks of the loss of the Spanish Armada about twenty years before this really happened), from the passionate Princess Eboli engaged to Ruy Gómez (the real Prince Eboli) to her true love, Don Carlos. Eboli joins Alva and Domingo in a plot against Don Carlos, trying to prevent him from becoming king. When Carlos asks to lead the army in Flanders, Philip insists it go to Alva. Posa and Philip had never met until Posa swears his loyalty and agrees to spy on Carlos. When Philip tells the King of the terrible conditions in Flanders, Philip warns him of the Inquisition. Posa arrests Carlos and detains Eboli and then comes to Carlos, begging forgiveness. After Posa is shot, the King gives Carlos his sword back, but the prince accuses his father of the murder of his friend. When the Inquisitor berates Philip for depriving the Inquisition of its victim (Posa), he hands Carlos over to him and the curtain falls.

102. Set Design. Arch Construction, 1922
Oil and lacquer on cardboard
24 x 19.9
Bakhrushin State Central Theatre Museum, Moscow
Inv. No. KP 309565 Zh 1310

Love for Three Oranges: Farcical opera in four acts by Sergei Prokofiev based on the comedy by Carlo Gozzi. Produced by Alexei Dikii at the Bolshoi Theater, Moscow, on 17 May, 1927, with designs by Isaak Rabinovich.

The son of the King of Clubs suffers from a hypochondria that defies all curative attempts to make him laugh. The Prime Minister, Leondro, and the King's niece, Princess Clarissa, wish to thwart the cure in the hope that they will rule instead of the Prince. The latter is protected by Tchelio, the Magician, whereas Leondro is protected by Fata Morgana, the Witch. One day Fata Morgana makes the Prince laugh and then puts a curse on him according to which he falls in love with three oranges that he pursues through many lands and adventures. Finally, the Prince comes home to rule with Ninetta, one of the Princesses imprisoned in the oranges. The evildoers are revealed, but Fata Morgana helps them escape by ushering them through a trapdoor.

103. Costume Design for the Doctor, 1927
Gouache on burgundy paper on cardboard
60.9 x 49.8
Bakhrushin State Central Theatre Museum, Moscow
Inv. No.KP 291915 GKS 2808

104. *Costume Design for the Glutton*, 1927

Gouache on paper on board

Signed and dated lower right in blue pencil in Russian: 'Isaak Rabinovich 1927.'

63 x 48

State Museum of Theatrical and Musical Art, St. Petersburg (formerly in the collection of Nina and Nikita D. Lobanov-Rostovsky).

Inv. No. GIK 23272/377

Note: Accustomed to the intimate stage, e.g., of the State Jewish Chamber Theatre, Rabinovich brought a rich theatrical experience to his scenographic resolutions for *Lysistrata* and *Don Carlos*. Rabinovich's artistic psychology was a dynamic and expansive one and he was able to move with ease from tragedy to comedy, from cabaret to high drama. In this sense, he maintained the artistic flexibility of Exter, one of his principal mentors.

Although Rabinovich elicited criticism for his experimental sets and was obliged to mollify his enthusiasm for Constructivism, he did avoid the political obviousness of the new didactic Realism. His sets for *Lysistrata* of 1923, for example, emphasized the restrained harmony of Constructivist forms and the hieratic simplicity of Classical columns, while his sets and costumes for *The Love for Three Oranges* seemed to recapture more of the cabaret atmosphere of Bi-Ba-Bo and Crooked Jimmy than of a professional opera. He described his work on the production:

> In this work all the elements of the vivid stage action reach their flowering. Suffice it to refer to the scenes in which about fifty masks participated, from minute ones to very big ones… It was here that, for the first time, I made use of light not only as a source of illumination, but also as a source of design: I use the light apparatus to create an even greater visual effect.[102]

Although Prokofiev was still living in Paris in 1927 and, therefore, did not supervise the Soviet premiere of his opera (conducted by Nikolai Golovanov), the production enjoyed a distinct musical success, especially since Antonina Nezhdanova, Nadezhda Obukhova, Alexander Pirogov and other distinguished singers took part; the production was even broadcast and recorded, so that Prokofiev was actually able to hear the rendering (in 1928). As for the scenic resolution, Rabinovich interpreted the opera as a *bouffonerie* with sharp contrasts in colour and form, volumetrical decors that were light and transparent and exaggerated, caricatural costumes. Flora Syrkina, Rabinovich's biographer, emphasizes just how eccentric and unexpected the designs were: 'By intensifying and underlining the expressivity of the constructed architecture, he created an architecture of light, achieving a fantastic, fairy-tale spectacle.'[103]

Not everyone was pleased, the Bolshoi management noting that the general sequence of designs was full of 'external appurtenances… creating a sharp breach with the musical content.'[104] In fact, in February, 1928 a special committee was

established to 'rework *Three Oranges* from the scenographic standpoint'[105] – a sign for Rabinovich of more difficult times ahead. Nevertheless, Rabinovich's satirical costumes and masks for the Glutton, the Drunkards, etc. found a further, strictly political application: according to the historian Samuil Margolin, they formed the basis for a series of effigies representing the Pope, International Capitalism, Fascism, etc., that Rabinovich and his students built for a political carnival in the Park of Culture and Recreation in Moscow.[106]

RODCHENKO, Alexander Mikhailovich

Born 23 November (5 December), 1891, St. Petersburg, Russia; died 3 December, 1956, Moscow, Russia.

1910–14 attended the Kazan Art School under Nikolai Feshin (Fechin) and then CSIAI; influenced by Art Nouveau; 1913 met Varvara Stepanova who became his life-long companion; 1916 contributed to the 'Store'; 1917 with Vladimir Tatlin, Georgii Yakulov et al. designed the interior of the Café Pittoresque, Moscow; 1918 onward worked at various levels in IZO NKP; contributed to many national and international exhibitions; 1918–26 taught at the Moscow Proletcult [Proletarian Culture] School; 1918–21 worked on spatial constructions; 1920 member of Inkhuk; 1921 contributed to the third exhibition of Obmokhu [Society of Young Artists] and to '5 x 5 = 25' in Moscow at which he showed three monochrome paintings; 1920–30 professor at Vkhutemas/ Vkhutein; 1920 created costumes for Alexei Gan's unrealized spectacle *We*; 1922–28 associated with the journals *Lef* [Left Front of the Arts] and *Novyi lef* [New Left Front of the Arts], which published some of his articles and photographs; 1925 designed a worker's club, contributed to the 'Exposition Internationale des Arts Décoratifs et Industriels Modernes' in Paris; 1930 joined October, a group of designers which also included Alexei Gan, Gustav Klutsis and El Lissitzky; late 1920s onward concentrated on photography, including pess photographs of sports meets and the building of the White Sea Canal; contributed to the propaganda journal *USSR in Construction*; early 1940s produced paintings in an Abstract Expressionist style.

Further reading:

Rodchenko is the subject of a very large number of monographs, catalogues and articles. The titles below are a representative selection only.

G. Karginov: *Rodcsenko,* Budapest: Corvina, 1975 (and subsequent translations into French and English).

V. Rodchenko, comp.: *A.M. Rodchenko. Stati. Vospominaniia. Avtobiograficheskie zapiski. Pisma,* M: Sovetskii khudozhnik, 1982.

K. Schmidt et al.: *Alexander Rodtschenko und Warwara Stepanowa.* Catalogue of exhibition at the Wilhelm-Lehmbruck Museum Duisburg, 1982.

W. Rodtschenko and A. Lawrentjew: *Alexander Rodtschenko,* Dresden: VEB Kunst, 1983.

S. Khan-Mogomedov: *Rodchenko: The Complete Work,* Cambridge: MIT, 1987.

J. Bowlt and A. Lavrentiev: *Alexander Rochenko. Museum Series Portfolio,* M: Rodchenko/Stepanova Archives, and Los Angeles/New York: Schickler Lafaille, 1994.

M. Dabrowski: *Alexander Rodchenko.* Catalogue of exhibition at the Museum of Modern Art, New York, 1998.

A. Rennert: *Rodčenko Metapmorphosen,* Munich: Deutsche Kunstverlag, 2008.

M. Tupitsyn: *Rodchenko and Popova.* Catalogue of exhibition at Tate Modern, London; State Museum of Contemporary Art, Thessaloniki; and the Museo Nacional Centro de Arte Reina Sofia, Madrid, 2009–10.

A. Lavrentiev: *Alexander Rodchenko,* M: Russkii avangard, 2011.

M. Philipp and O. Westheider: *Alexander Rodtchenko.* Catalogue of exhibition at the Bucerius Kunstforum, Hamburg, 2013.

Rodchenko's artistic evolution was rapid, encompassing the early Symbolist pieces of ca. 1913, the graphics done with compass and ruler of 1915, the non-figurative paintings and three monochrome canvases exhibited at '5 x 5 = 25,' the free-standing and suspended constructions of 1918–21 and the photographic work of the 1920s and 1930s. While Rodchenko's studio painting was innovative, it derived from various sources, including the Suprematism of Kazimir Malevich (Rodchenko's *Black on Black* of 1918 was an obvious gesture to Malevich's original black on white square of 1915) and Liubov Popova's architectonic painting. However, Rodchenko's experiments in three dimensions were, indeed, pioneering, and his suspended constructions acted as the brilliant culmination to the tradition of the relief initiated by Tatlin in 1914.

In transferring his energies to typography and photography in the 1920s, Rodchenko, ostensibly, moved from the esthetic exercise of the abstract painting to a utilitarian medium – to stage and book design, interior design, clothing and even playing cards. At the same time, Rodchenko did not cease to experiment with the purely formal aspects of his new disciplines, and 'Rodchenko perspective' and 'Rodchenko foreshortening' became current terms in the 1920s. Furthermore, it seems probable that Rodchenko's innovative use of light and shadow exerted an appreciable influence on Sergei Eisenstein, Lev Kuleshov and Dziga Vertov. In true Constructivist fashion, Rodchenko attempted to expose the mechanism of the camera and to exploit the photographic method to its maximum, just as he had disclosed the essence of space and form in his constructions. For this, Rodchenko came under strong attack during the hegemony of Socialist Realism in the 1930s and 1940s.

We: Play (unfinished) by Alexei Gan. Prepared, but not produced, by Sergei Eisenstein at the Proletcult Studio, Moscow, in 1920 with designs by Alexander Rodchenko.

An agitational action about the old and new societies with 'impure' characters, such as a merchant, an officer and a policeman and 'pure' characers, such as a sailor, a peasant and a worker.

105. Costume Design for the Chansonette, 1920

Graphite pencil, ink, tempera and gouache on paper

52.9 x 36.8

Bakhrushin State Central Theatre Museum, Moscow

Inv. No. KP 307252

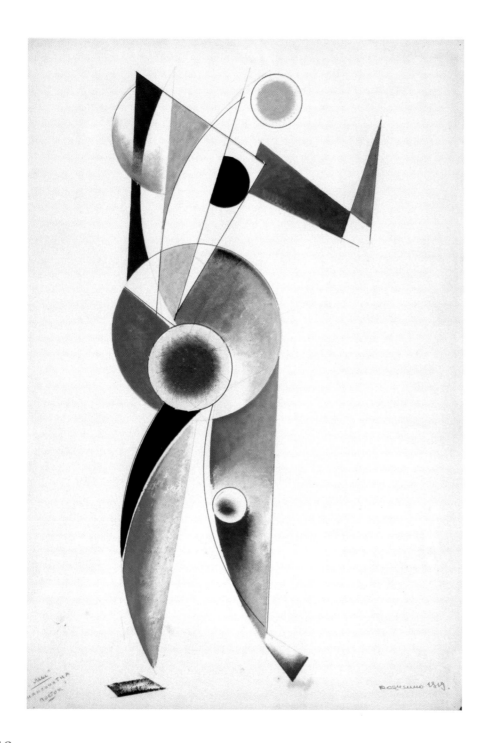

106. Costume design for the Oriental Chansonette,
1920

Graphite pencil, gouache, tempera and ink on
paper

52.5 x 36.7

Bakhrushin State Central Theatre Museum,
Moscow

Inv. No. KP 307253

107. *Costume Design for the Officer*, 1920

Graphite pencil, gouache, tempera and ink on paper

52.9 x 36.7

Bakhrushin State Central Theatre Museum, Moscow

Inv. No. KP 307251

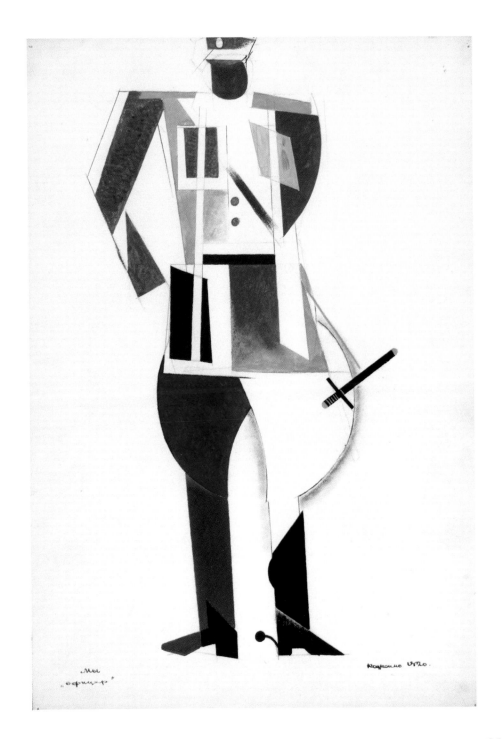

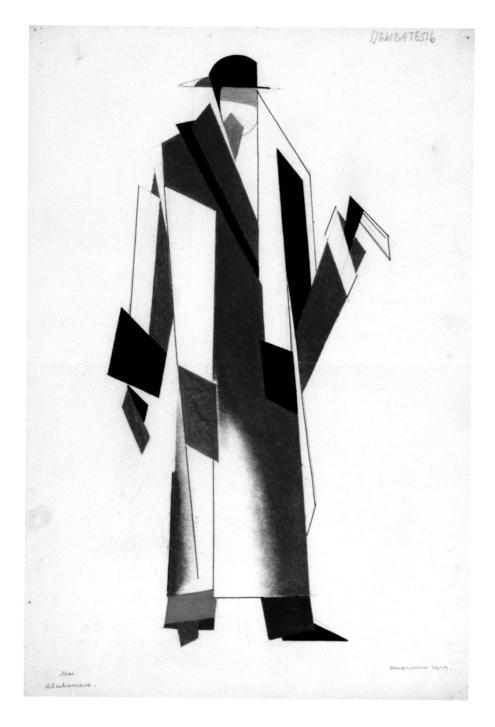

108. *Costume Design for the Philistine*, 1920
Graphite pencil, gouache, tempera and ink on paper
52.9 x 36.5
Bakhrushin State Central Theatre Museum, Moscow
Inv. No. KP 307247

320

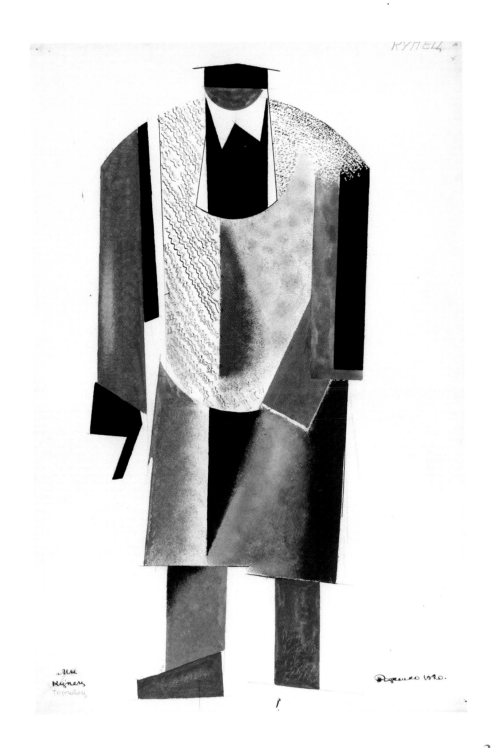

109. Costume Design for the Merchant, 1920
Graphite pencil, ink, tempera and gouache on paper
52.9 x 36.7
Bakhrushin State Central Theatre Museum, Moscow
Inv. No. KP 307249

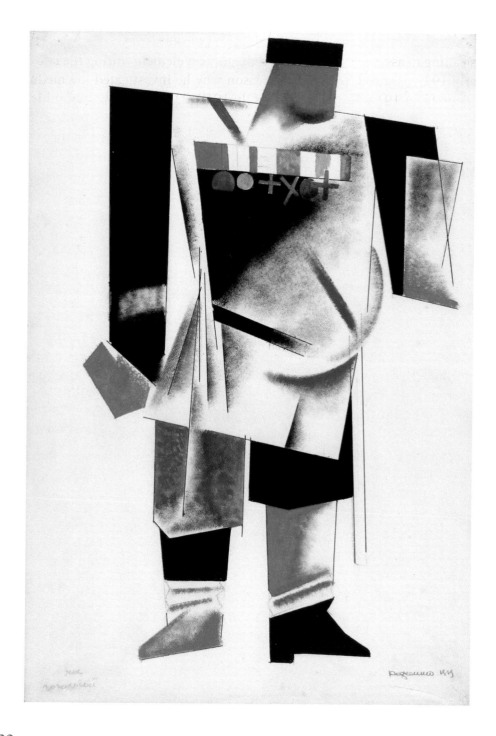

110. Costume Design for the Policeman, 1920
Pencil, tempera and ink on paper
52.8 x 36.5
Bakhrushin State Central Theatre Museum, Moscow
Inv. No. KP 307246 GKS 4542

Note: While Rodchenko is often remembered for his abstract paintings, it would be misleading to assume that he ignored the human element during the late 1910s and early 1920s. Indeed, perhaps one reason why he investigated the medium of the collage from 1915 onwards (especially 1918–21), using photographic fragments, pieces of newspaper and advertisements (all with direct references to concrete life), is that it helped to reintroduce a 'readable' content to the work of art and, in this sense, to oppose the self-sufficient studio paintings of the same period. Certainly, it would be an exaggeration to claim that, while producing non-figurative art, Rodchenko felt nostalgia for the figurative content, but one cannot help noticing the anthropomorphic forms in some of the so-called abstract paintings, constructions and architectural designs of 1918–21. Conversely, if some of Rodchenko's abstractions can be perceived as schematic figures, similarly, some of his costume designs for the theatre can be read as abstract paintings. This is true, for example, of his renderings for Alexei Gan's play *We*, which Gan commissioned in November, 1920 (Gan never completed the play and the plot has been lost).[107]

Gan is remembered above all for his support of the Constructivist movement and for the book, *Konstruktivizm,* his volatile manifesto of 1922 (its cover was designed by Rodchenko). Naturally, the publication was prompted by the many debates on construction and production which took place at Inkhuk during 1921 and in which Boris Arvatov, Osip Brik, El Lissitzky, Liubov Popova, Rodchenko, Varvara Stepanova and Nikolai Tarabukin played a formative role. At loggerheads with studio artists, Gan was an indefatigable apologist of industrial art, the cinema and architecture, although his terminology and literary style did not always make for clarity: 'Tectonics is synonymous with the organicness of thrust from the intrinsic substance… Texture is the organic state of the processed material… Construction should be understood as the collective function of construction.'[108]

The costumes for *We* are a clear specimen of Rodchenko's constant, if sometimes latent, concern with the human form, or rather, with the 'New Man', and extend his life-long interest in the circus, the sports rally and martial arts, which he painted and photographed throughout the 1920s and 1930s. Some of Rodchenko's costume designs for *We* bear an uncanny resemblance to Kazimir Malevich's figures in the 1913 *Victory over the Sun*; Lissitzky's marionettes for *Die Plastische Gestaltung der Elektro-mechanischen Schau 'Sieg über die Sonne'* of 1923 also come to mind.

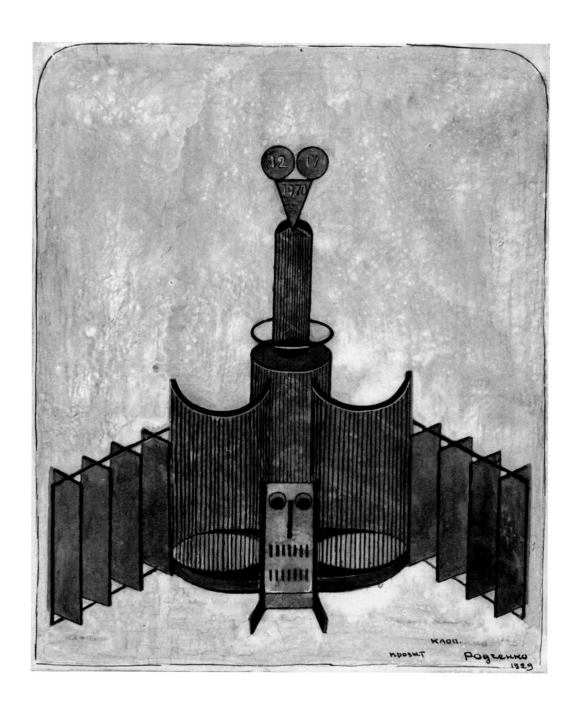

The Bed Bug: Comedy in nine scenes by Vladimir Maiakovsky. Produced by Vsevolod Meierkhold at the Meierkhold Theatre, Moscow, on 13 February, 1929, with music by Dmitrii Shostakovich and designs by Meierkhold, the Kukryniksy and Alexander Rodchenko.[109]

A crafty operator by the name of Prisypkin, who is a product of the new Soviet bourgeoisie, tries to ingratiate himself with the Party. But the result is a disaster: he is immersed in ice and unfrozen by scientists in 1979 in what was meant to be the ideal Communist world. Prisypkin is quarantined together with his only possessions – a guitar and a bed bug. Having found the bed bug on himself, he keeps it as his one and only friend.

111. Set Design, 1929

Ink, lacquer and whitening on paper on cardboard

32.4 x 24.7

Bakhrushin State Central Theatre Museum, Moscow

Inv. No. KP 180169/117

112. Costume Design for Figure in Overall and Gas Mask, 1929

Pencil, ink, whitening, pastel and collage on black paper on paper

41.8 x 29.4

Bakhrushin State Central Theatre Museum, Moscow

Inv. No. KP 180169/434

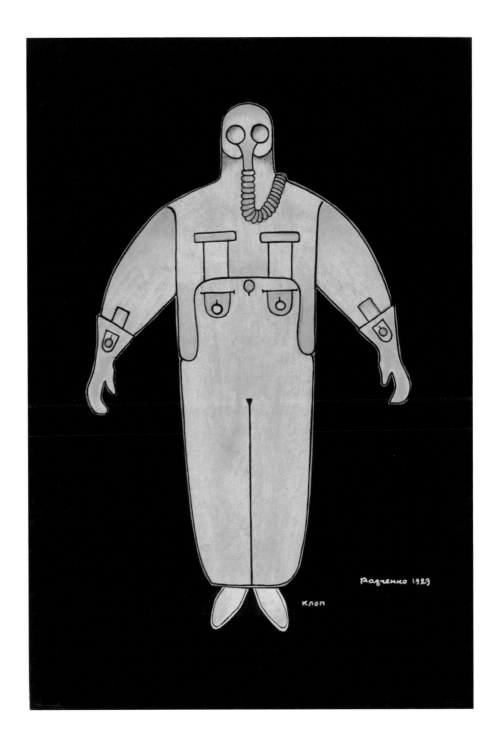

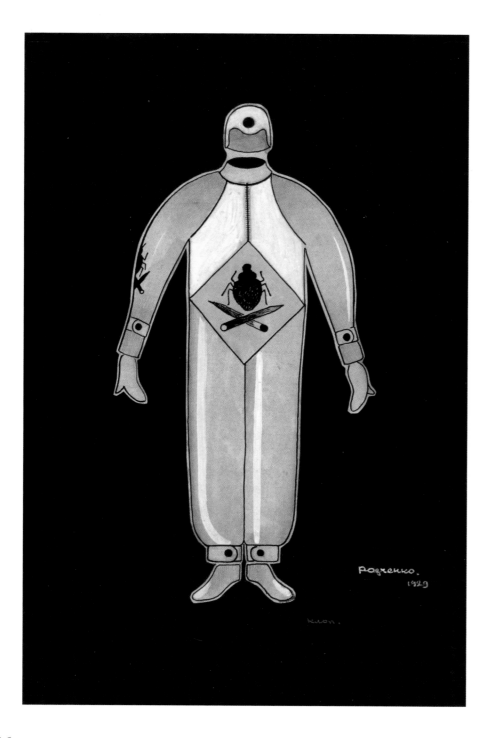

113. *Costume Design for Figure in Overall with Image of Bed Bug on Chest*, 1929

Pencil, ink, whitening, pastel and collage on black paper on paper

41.8 x 29.7

Bakhrushin State Central Theatre Museum, Moscow

Inv. No. KP 180169/433

114. Costume Design for Figure in Overall, 1929
Crayons, ink, pencil, whitening, pastel and pencil
on black paper on paper
41.8 x 29.7
Bakhrushin State Central Theatre Museum,
Moscow
Inv. No. KP 180169/431

Note: The Bed Bug was a satire on the life of the new Soviet bourgeoisie and bureaucracy emerging in the wake of NEP (the New Economic Policy which allowed a partial return to the free enterprise system during 1921–29). *The Bed Bug* was, as Maiakovsky said, intended to 'expose the philistines of today… this is a great heap of philistine facts which came into my hands and head from all over the place during my newspaper and publishing work.'[110] This was one of Meierkhold's major productions, even though, theatrically, it was not an unqualified success, mainly as a result of the bizarre sets and costumes. According to one commentator:

> Nearly all the costumes and properties were bought over the counter in Moscow shops in order to demonstrate the pretentious ugliness of current fashions… Part Two, set in 1979, was designed by the Constructivist artist, Alexander Rodchenko; but his vision of a disciplined, scientific Communist future was so lifeless and hygienic that the spectator was hard put to decide where the parody really ended.[111]

Other reviews were more favorable. Isaak Turkeltaub praised Rodchenko for his 'splendid, material design,'[112] while Pavel Novitsky liked the 'simple and clear forms created by an industrial and scientific-laboratorial technology.'[113]

Rodchenko's costumes for *The Bed Bug* are of particular interest since they extend the principles of *prozodezhda* which Varvara Stepanova elaborated in 1922–23 and which Rodchenko applied to his project for a worker's overall.[114] To Rodchenko, who in his work for the second part of *The Bed Bug* was attempting to predict clothes of the future, the simple, undecorated costume with its associations with mechanical precision and industrial efficiency (qualities which the Constructivists advocated), seemed to be a reasonable solution.

Although Rodchenko had already contributed designs to a number of stage and film undertakings, including Gan's *We* (1920, not produced) and Dziga Vertov's *Kino-Truth* (1922 onward), and although he had worked on clothes and textile design in 1923–24, *The Bed Bug* marked Rodchenko's real entry into the theatre and his first collaboration with Meierkhold. Rodchenko worked on *The Bed Bug* on Maiakovsky's initiative from 14 January through 13 February, 1929, and produced about sixty costumes and decors. Stepanova recalled that 'Meierkhold passed the designs without making any corrections, something which astonished everyone in the theatre.'[115] Immediately after *The Bed Bug*, Rodchenko went on to design Anatolii Glebov's play *Inga* staged by Nikolai Gorchakov at the Theatre of the

Revolution also in 1929. Gorchakov then employed Rodchenko for the ambitious production of *One Sixth of the World* in 1931 and the same year Rodchenko designed *The Army of the World* for Zavadsky's Studio in Moscow – Rodchenko's last major theatrical endeavour.

SHKOLNIK, Iosif (Osip) Solomonovich

Born 30 November (12 December), 1883, Balta, Ukraine; died 26 August, 1928, Leningrad, Russia.

Early 1900s attended the Odessa Art Institute; 1905–07 attended IAA; 1906 contributed caricatures to the journal *Kosa* [Scythe]; 1908 contributed to the 'Contemporary Trends' exhibition in St. Petersburg; 1909 contributed to the 'Impressionists' in St. Petersburg; close to Nikolai Kulbin; influenced by Henri Matisse and the Fauves; 1910 joined the Union of Youth society, becoming its secretary and contributing to its exhibitions; 1911 travelled extensively in Northern Europe; 1912–13 studied antiquities in the Ukraine; 1913 with Pavel Filonov worked on the designs for the production of Vladimir Maiakovsky's *Vladimir Maiakovsky. A Tragedy*; 1914–17 artist-in-residence at the Troitskii Theater, St. Petersburg; 1910s worked on a number of theatrical presentations such as *Cain, Fée des poupées, The Swan, Salomé, A Merry Day of Princess Elizabeth* and *The Guslar Player*; 1917 worked on agit-designs for the Revolutionary celebrations; 1918–19 worked as designer for the Maly Theater in Petrograd; 1918–26 directed the Institute of Decorative Art in Petersburg; 1920s continued to contribute to exhibitions, such as the 'Exhibition of Paintings and Sculpture by Jewish Artists' (Moscow, 1918), the 'I State Free Exhibition of Works of Art' (Petrograd, 1919), the 'Erste Russische Kunstausstellung' (Berlin, 1922) and the 'Exhibition of the Latest Trends in Art' (Leningrad, 1927).

Further reading:

Nothing substantial has been published on Shkolnik, although most studies of the avant-garde carry passing references to him as a stage designer and member of the Union of Youth (for example, A. Sarabianov and N. Gurianova: *Neizvestnyi avangard*, M: Sovetskii hudozhnik, 1992, pp. 305–07).

Recent exhibitions of stage designs have featured Iosif Shkolnik's work. See, for example, Yu. Love, introd.: *Pamiatniki russkogo teatralnogo avangarda*. Catalogue of exhibition at the Elizium Gallery, M, 2006, p. 14.

As a member of the St. Petersburg Union of Youth, Shkolnik was close to many radical artistss including Pavel Filonov and Olga Rozanova. Although he did not share their extreme ideas and did not investigate abstract painting, he was especially interested in the relationship of indigenous, primitive traditions to modern art, studying the art of the old store signboard and painted trays, for example, and incorporating their images into his own compositions. Indeed, one of Shkolnik's favorite motifs was the main square of the provincial town, where vestiges of Old Russia – such as signboards – could still be encountered. In its bright colours and choice of subject, his painting is reminiscent of the Neo-Primitivism of the Jack of Diamonds artists, such as Alexander Kuprin and Ilia Mashkov, even though his cityscapes and still-lives seem to be more contemplative, more melancholy and more 'Jewish' than their more boisterous canvases. In any case, Shkolnik was able to integrate these various influences into the pleasing, if not always radical, 'stylistics of Fauvism'.[116]

Vladimir Maiakovsky. A Tragedy: Play in verse with prologue and epilogue and in two acts by Vladimir Maiakovsky. Directed by Vladimir Maiakovsky and produced by the Union of Youth at the Luna Park Theater, St. Petersburg on 2 December, 1913, with designs by Pavel Filonov and Iosif Shkolnik.

Various strange characters, fragments of Maiakovsky's persona, recount the tragedy of the poet's anquish in the City-Hell which cripples and dismembers its inhabitants. The poet is surrounded by grotesque individuals, such as a man without an ear, a man without a head and a man with black cats who misunderstand him, mimick him and reject him.

115. Set Design for Act 2, 1913

Watercolour and gouache on grey paper

54.5 x 46.5

State Museum of Theatrical and Musical Art, St. Petersburg

Inv. No. GIK 3569/3645 OR 8504

Note: Vladimir Maiiakovsky. A Tragedy was the first of two spectacles presented by the Union of Youth as part of the repertoire of the newly established Theater of the Futurists in the World, at first known as the Budetlianin Theater, the other spectacle being *Victory over the Sun* designed by Kazimir Malevich. The sets for the prologue and epilogue and most of the costumes were painted by Filonov (destroyed during a flood in Leningrad in 1924) and the sets for Acts I and II by Shkolnik. Mark Etkind described the visual arrangement of *Vladimir Maiakovsky* as follows:

> The scenographic composition of the spectacle bore a circular character: the action was framed by a square panneau which served as a pictorial headpiece for the prologue and as a tail-piece for the epiloque: a lubok-like, cheerful pile of painted toys and in the middle a 'big, beautiful rooster'.[117]

The most comprehensive description of *Vladimir Maiakovsky* belongs to the actor Alexander Mgrebrov, who attended the premiere and, as a matter of fact, sat next to the poet Velimir Khlebinikov.

> The lights went down and up went the curtain… A half-mystical light palely illuminates the stage enclosed in cloth or calico and the tall backdrop made of black cardboard – which, essentially constitutes the entire decoration. What this cardboard was meant to represent, I don't know… but the strange thing is that it was impressive: there was a lot of blood and movement in it.[118]

SOSUNOV, Nikolai Nikolaevich

Born 1908, Moscow, Russia; died 1970, Moscow, Russia.

Graduated from the Moscow District Art Institute; 1920s worked for the Blue Blouse troupe; 1936 contributed to the 'Exhibition Dedicated to the Creativity of the Great Russian Playwright, A.N. Ostrovsky' in Moscow; artist in residence for Anatolii Efros's Theatre, Moscow; worked at the Central Children's Theatre, the Ermolova Theatre and other institutions in Moscow; 1959 and 1960 published textbooks for stage designers.

Further reading:

N. Sosunov: *Izgotovlenie butaforii,* M: Iskusstvo, 1959.

N. Sosunov: *Teatralnyi maket: Posobie dlia khudozhnikov teatralnykh kollektivov samodeiatelnosti,* M: Iskusstvo, 1960.

Unidentified production by the Blue Blouse troupe,
Moscow, 1920s

116. Costume Design in Blue and Gray, 1920s

Graphite pencil, gouache, whitening, application,
print on paper on plywood

35.5 x 20.9

Bakhrushin State Central Theatre Museum,
Moscow

Inv. No. KP 6120 GKS 4634

117. Costume Design for an Uzbek Woman, 1920s
Graphite pencil, gouache, watercolour on plywood
36.7 x 17.4
Bakhrushin State Central Theatre Museum,
Moscow
Inv. No. KP 6128 GKS 4635

118. *Costume Design for Two Dancing Girls: The Bourgeoisie*, 1920s

Graphite and crayon, gouache, collage and print on paper on plywood

35.3 x 20.8

Bakhrushin State Central Theatre Museum, Moscow

Inv. No. KP 6169 GKS 4636

119. Costume Design for a Member of the Bourgeoisie, 1920s

Graphite pencil, gouache, whitening, collage, ink and print on paper on plywood

32.3 x 21

Bakhrushin State Central Theatre Museum, Moscow

Inv. No. KP 6130 GKS 4637

For context and commentary see AIZENBERG, Nina Evseevna

STENBERG, Georgii Avgustovich

Born 20 March (2 April), 1900, Moscow, Russia; died 15 October, 1933, Moscow, Russia.

STENBERG, Vladimir Avgustovich

Born 23 March (4 April), 1899, Moscow, Russia; died 1 May, 1982, Moscow, Russia.

1912–17 attended CSIAI; 1917–19 attended Svomas, Moscow, where they enrolled in the so-called Studio without a Supervisor; with Nikolai Denisovsky, Vasilii Komardenkov, Sergei Kostin, Konstantin Medunetsky, Nikolai Prusakov and Sergei Svetlov they were among the first Svomas graduates; 1918 contributed to May Day agit-decorations in Moscow, working on designs for the Napoleon Cinema and the Railway Workers' Club; 1919–21 members of Obmokhu; 1920 members of Inkhuk; 1921 with Alexei Gan, Alexander Rodchenko, Varvara Stepanova and others opposed 'pure art' and championed industrial Constructivism; 1922 with Medunetsky worked on a production of *The Yellow Jacket* for the School of the Chamber Theatre, Moscow, the first of several collaborations with Medunetsky; 1923 began to work on film posters; 1923–25 closely associated with the journal *Lef*; 1924–31 worked on sets and costumes for productions at Alexander Tairov's Chamber Theatre in Moscow; 1925 contributed to the 'Exposition Internationale des Arts Décoratifs et Industriels Modernes' in Paris; 1929–32 taught at the Architecture-Construction Institute, Moscow; after Georgii's death, Vladimir continued to work on poster design.

Further reading:

D. Aranovich: '2 Stenberg 2' in *Krasnaia niva*, M, 1929, No. 40, pp. 20–21.

M. Constantine and A. Fern: *Revolutionary Soviet Film Posters*, Baltimore: Johns Hopkins University Press, 1974.

A. Nakov: *2 Stenberg 2*. Catalog of exhibition at Annely Juda Fine Art, London; and the Art Gallery of Ontario, Toronto, 1975.

N. Baburina and G. Marivicheva: *Stenbergi. Teatr. Monumentalnoe iskusstvo. Plakat, Dizain.* Catalogue of exhibition organized by the Union of Artists of the USSR, M, 1984.

2 Stenberg 2. Catalogue of exhibition at the Central House of Writers, M, 1989.

T. Riley et al.: *Stenberg Brothers: Constructing a Revolution in Soviet Design*. Catalogue of exhibition at the Museum of Modern Art, New York, 1997; and the Armand Hammer Museum and Cultural Center, Los Angeles, 1999.

M. Tillberg: '2 Stenberg 2: Constructivists and Designers for the Revolutionary Mass Stagings at the Red Square' in *Konsthistorisk Tidskrift*, Stockholm, 1998, Vol. 67, No. 3, pp. 175–88.

S. Khan-Magomedov: *Vladimir i Georgii Stenberg*, M: RA, 2008.

The Stenberg brothers were typical of the young generation of artists sympathetic to the cause of the Revolution, moving rapidly from the traditional conception of art as a purely 'esthetic' experience (the free-standing constructions of 1919–20) to that of art as a utilitarian, social activity (the stage designs and film posters). True, even the 'esthetic' constructions of the Stenberg brothers, like those of Rodchenko and Medunetsky, diverged from the process of 'deformation' that the Cubists and Futurists had pursued so swiftly and drastically. The new constructors now reaffirmed form, i.e., the interaction of material and space, they rebuilt it consciously and logically and produced an art that, to paraphrase Rodchenko, was one of analysis, not of synthesis.[119] The possibility of experimenting with an entire range of new formal combinations imbued the Stenberg constructions with a vitality and potency and, just as 'you can't cut off space',[120] so the upward thrust of the Stenberg structures seems to contain an unfinished movement, a line of direction that will carry on into external space.

The Stenbergs applied their formal experiments to functional art, specifically to stage designs and film posters (which often carry the joint signature '2 Sten' or '2 Stenberg 2'). The sets and costumes, especially for Tairov's major productions, such as *The Storm* and *Saint Joan* (both 1924), maintained the principles of dynamic interaction between solid and space identifiable also with the 'esthetic' constructions. Moreover, like Liubov Popova and Varvara Stepanova, the Stenbergs regarded the actor and not the text as the central attribute of theatre and ensured a maximum of movement by using multi-level constructions, ladders, inclines, etc. The actors, therefore, now operated in a variety of positions, relating to each other and to the audience vertically, horizontally and diagonally.

As for the more decorative film posters of the mid- and late 1920s, such as *October* (1927) and *Man with a Movie Camera* (1929), the Stenbergs continued to emphasize dramatic contrasts in form and movement. The thrust of diagonals,

rendered often by a figure's outstretched arms, as in the poster for *Man with a Movie Camera,* the skillful photomontage and hence the inclusion of several strata of action often produce the impression of a three-dimensional construction rather than of a two-dimensional surface. The peculiarly mobile, *trompe l'oeil* effect of these posters forms a striking parallel to the illusion of perpetual movement in space which the constructions create by means of their forceful lines of direction.

Day and Night (Le Jour et la Nuit): Opera-bouffe in three acts by Charles Lecocq based on a text by Eugène Leterrier and Albert Vanloo. Produced by Alexander Tairov at the Chamber Theatre, Moscow, on 18 December, 1926, with dance numbers by Natalia Glan and designs by Georgii and Vladimir Stenberg.

A merry farce about amorous misunderstandings involving many personages, including Prince de Calabazos, Don Braseiro, Miguel, Anita, Catana and Manola.

120. Maquette, 1926

Wood, cardboard, plywood, glue paint, wire and electrical equipment

80 x 94 x 66

Bakhrushin State Central Theatre Museum, Moscow

Inv. No. NV 5055/48

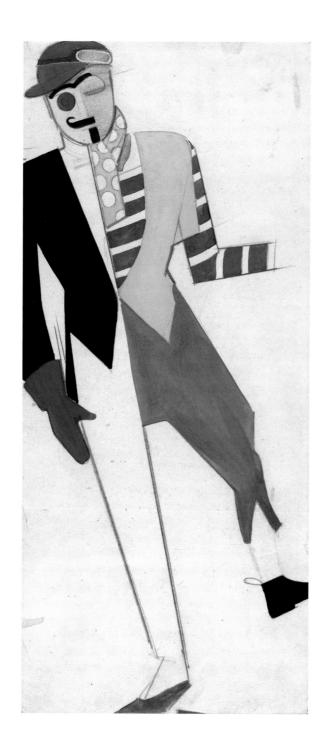

121. *Ccostume Design in Two Halves*, 1926
Graphite, crayon and gouache on paper
36.1 x 16.2
Bakhrushin State Central Theatre Museum, Moscow
Inv. No. KP 234797 GKS 314

122. Costume Design, 1926
Graphite pencil, gouache and whitening on paper
37 x 19.5
Bakhrushin State Central Theatre Museum,
Moscow
Inv. No. KP 234774 GKS 4299

123. *Costume Design for Prince de Calabazos*, 1926

Graphite and colored pencil, gouache on cardboard

34.8 x 23.5

Bakhrushin State Central Theatre Museum, Moscow

Inv. No. KP 234791 GKS 4286

124. Costume Design Viewed from Front and Back,
1926

Graphite, crayon and gouache on paper

34.8 x 18.7

Bakhrushin State Central Theatre Museum,
Moscow

Inv. No. KP 234800 GKS 4288

The Hairy Ape: Play in eight scenes by Eugene O'Neill produced by Alexander Tairov at the Chamber Theatre, Moscow, on 14 January, 1926, with designs by Georgii and Vladimir Stenberg.

The workers who shovel coal into the engine of a Transatlantic ocean liner are one hour out of New York City. Yank and his comrades drink, telling the men to shut up because he is trying to 'tink.' The men erupt into a chorus of 'Drink, don't think!' In the general confusion, a drunken tenor sings a tune about his lass at home, but talk of home infuriates Yank and he tells the tenor to shut up, too. The worker Long stands up and makes a Marxist speech, so Yank tells him to join the Salvation Army and get a soapbox. Paddy, an older fireman, tells the men that life on an ocean liner is hell by comparison to life on a clipper ship. Yank tells Paddy that he is 'living in the past of dreams' and glorifies his own job as being the driving-axle of the ship's speed.

125. *Costume Designs for Five Children*, 1926

Lacquer, graphite pencil, crayon and gouache on plywood

40.7 x 61.2

Bakhrushin State Central Theatre Museum, Moscow

Inv. No. KP 238272/415 GKS 4632

126. Set Design for Act II, 1926
Pencil and gouache on paper
58.5 x 78.8
Bakhrushin State Central Theatre Museum,
Moscow
Inv. No. KP 314947

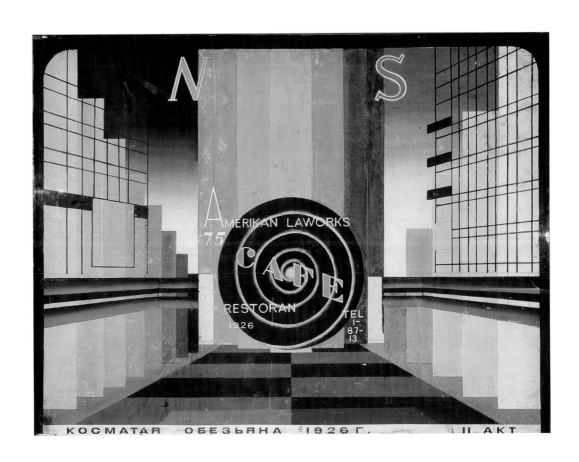

Negro (All God's Chillun Got Wings): Play in two acts by Eugene O'Neil. Produced by Alexander Tairov at the Chamber Theatre, Moscow, on 21 February, 1929, with designs by Georgii and Vladimir Stenberg.

An abusive white woman, resenting her husband who is black, destroys his promising career as a lawyer.

127. Maquette, after 1928

Plywood, canvas, size paint, steel wire, glue, cardboard and electrical equipment

83.5 x 94 x 75

Bakhrushin State Central Theatre Museum, Moscow

Inv. No. NV 5055/49

Note: The Stenbergs initiated their collaboration with Alexander Tairov and the Chamber Theater with incidental designs for the production of *Phèdre* in 1922, although their real debut came with their sets and costumes for the productions of *The Lawyer from Babylon* and *The Storm* and *Kukirol*. Thereafter, they were involved in the designs for eight major productions, including Bernard Shaw's *Saint Joan* (1924) and Berthold Brecht's *The Beggars' Opera* (1930). The Stenbergs' experimental sets and costumes of the 1920s elicited a variety of responses, Anatolii Lunacharsky, for example, referring to the 'rather artificial constructive decoration' in *The Storm*,[121] and Pavel Markov praising the 'starkness of exterior design' in Eugene O'Neill's *Love Under the Elms* (1926).[122] The Stenbergs' fruitful cooperation with Tairov, which prompted them to elaborate a theory of stage design,[123] ended with Georgii's premature death in 1933.

STEPANOVA, Varvara Fedorovna (pseudonym: Varst)

Born 23 October (4 November), 1894, Kovno (Kaunas), Lithuania; died 20 May, 1958, Moscow, Russia.

1910–13 attended the Kazan Art Institute; 1913 moved to Moscow; studied under Mikhail Leblan, Ilia Mashkov and Konstantin Yuon; met Alexander Rodchenko who became her life-long companion; 1913–14 attended CSIAI; gave private lessons; 1914 exhibited with the 'Moscow Salon'; 1915–17 worked as an accountant and secretary in a factory; 1917 onward composed experimental visual poetry, producing graphic poems, such as 'Rtny khomle' and 'Zigra ar'; 1918 contributed to the 'First Exhibition of Paintings of the Young Leftist Federation of the Professional Union of Artists and Painters'; closely involved with IZO NKP; 1919 contributed to the 'V State Exhibition' and the 'X State Exhibition: Non-Objective Creativity and Suprematism'; illustrated Alexei Kruchenykh's book *Gly-Gly*; 1920–23 member of Inkhuk; 1921 contributed to the exhibition '5 x 5 = 25'; 1920–25 taught at the Krupskaia Academy of Social (Communist) Education; 1922 made collages for the journal *Kino-fot*; designed sets and costumes for Vsevolod Meierkhold's production of *The Death of Tarelkin*; made linocuts on the subject of Charlie Chaplin; 1923–28 closely associated with the journals *Lef* and *Novyi lef* ; 1924–25 worked for the First State Textile Factory as a designer; taught in the Textile Department

of Vkhutemas; 1925 contributed to the 'Exposition Internationale des Arts Décoratifs et Industriels Modernes' in Paris; 1928 designed sets and costumes for the film *Alienation;* 1926–32 worked predominantly as a book and journal designer, fulfilling major government commissions; 1941–42 lived in Perm; 1940s-50s continued to paint, design and exhibit.

Further reading:

V. Stepanova: 'Aufzeichnungen/Occasional Notes (1919–1940)' in K. Gmurzynska et al.: *Von der Fläche zum Raum/From Surface to Space.* Catalogue of exhibition at the Galerie Gmurzynska, Cologne, 1974, pp. 122–44.

E. Kovtun: 'Das Antibuch der Warwara Stepanova/Varvara Stepanova's Anti-book', ibid., pp. 57–64, 142–51.

A. Lavrentiev: 'V.F. Stepanova o rannem konstruktivizme' in *Trudy VNIITE,* M, 1979, No. 21, pp. 111–17.

A. Law: "The Death of Tarelkin'. A Constructivist Vision of Tsarist Russia,' in *Russian History,* Tempe, 1982, Vol. 8, Parts 1–2, pp. 145–98.

V. Quilici: *Rodcenko/Stepanova.* Catalogue of exhibition at the Palazzo dei Priori, Perugia, and elsewhere, 1984.

K. Gmurzynska et al.: *Sieben Moskauer Künstler/Seven Moscow Masters.* Catalogue of exhibition at the Galerie Gmurzynska, Cologne, 1984, pp. 292–339.

A. Lavrentiev and N. Misler: *Stepanova,* Milan: Idea Books, 1988.

A. Lavrentiev and J. Bowlt: *Stepanova,* Cambridge, Mass.: MIT, 1988.

A. Garcia: *Rodchenko/Stepanova.* Catalogue of exhibition at the Fundacion Banco Centrale Hispanoamericano, Madrid, 1992.

V. Rodchenko and A. Lavrentiev, eds.: *Varvara Stepanova: Chelovek ne mozhet zhit bez chuda,* M: Sfera, 1994.

A. Lavrentiev: *Geometricheskie tsvety na konstruktivistskom pole,* M: Grant, 2002.

A. Lavrentiev: *Varvara Stepanova,* M: Russkii avangard, 2009.

N. Avtonomova et al.: *Alexander Rodchenko and Varvara Stepanova: Visions of Constructivism.* Catalogue of exhibition at the Metropolitan Teien Art Museum, Tokyo, and other venues, 2010.

LR (Vol. 2), pp. 383–86.

Until ca. 1921 Stepanova was concerned primarily with studio painting and graphics, investigating abstract art and transrational poetry, as she demonstrated in her statement for the 'X State Exhibition' in 1919: 'Non-objective creativity is still only the beginning of a great new epoch, of an unprecedented Grandiose Creativity, which is destined to open the doors to mysteries more profound than science and technology.'[124] Of the leading members of the Russian avant-garde who concerned themselves with industrial and functional design in the 1920s, only Stepanova had received training in the applied arts (at CSIAI) and she drew particular benefit from this while working on her textile designs at the First State Textile Factory, where she strove to eradicate

> the ingrown view of the ideal artistic drawing as the imitation and copying of nature. To grapple with the organic design and to orient it towards the geometrization of forms. To propagate the productional tasks of Constructivism.[125]

Perhaps the most remarkable consequence of Stepanova's theory was her designs for *prozodezhda*, especially her sports tunic, in which she combined an economy of material with emphatic contrasts in colour (for the purposes of identification on the sports-field), while removing ornamental or 'esthetic' elements as superfluous. Stepanova followed a similar conception in her work for the theatre, as evidenced by her sets and costumes for *The Death of Tarelkin* and her projects for evenings of propaganda entertainment at the Academy of Communist Education in Moscow in the early 1920s.

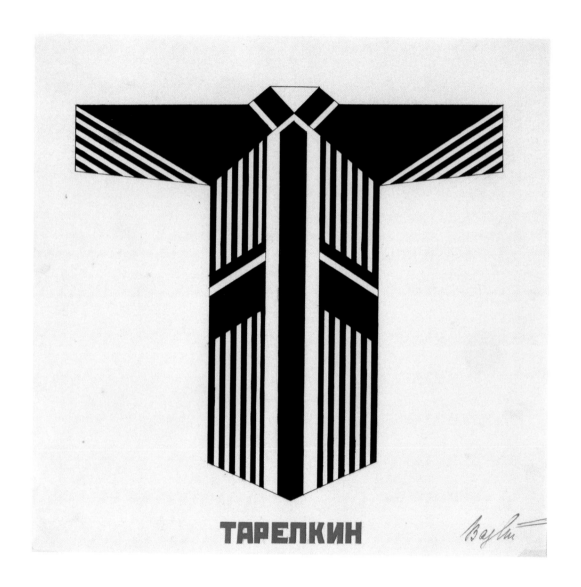

ТАРЕЛКИН

The Death of Tarelkin: Play in three acts by Alexander Sukhovo-Kobylin. Produced by Vsevolod Meierkhold at the Meierkhold Theatre, Moscow, on 24 November, 1922, with designs by Varvara Stepanova.

For plot summary see EXTER, Alexandra

128. *Costume Design for Tarelkin*, 1922
Ink, pencil, gouache and whitening on paper
34.7 x 35.5
Bakhrushin State Central Theatre Museum, Moscow
Inv. No. KP 180169/523

129. Costume Design for Raspliuev, 1922

Ink and whitening on paper

34.6 x 35.5

Bakhrushin State Central Theatre Museum, Moscow

Inv. No. KP 180169/528

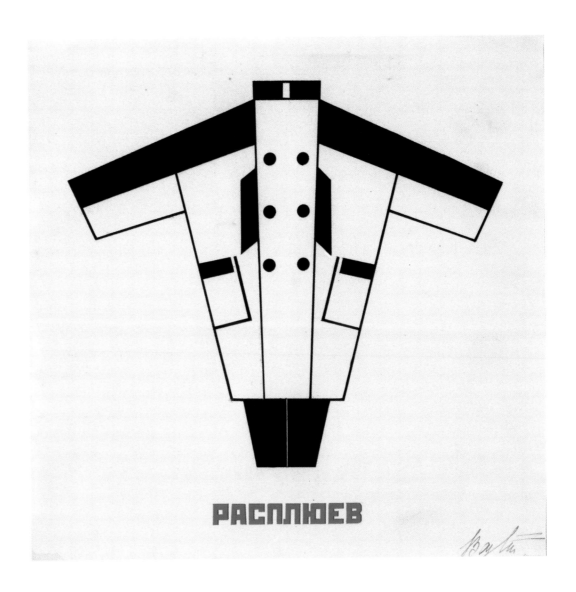

РАСПЛЮЕВ

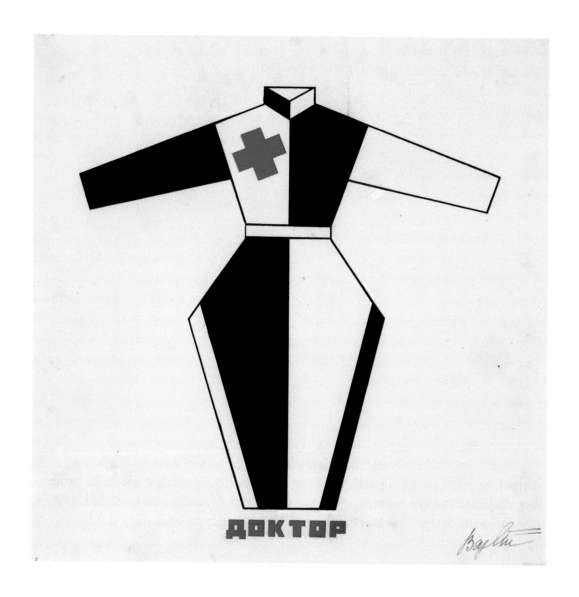

ДОКТОР

130. *Costume Design for the Doctor*, 1922
Watercolour and ink on paper
34.8 x 35.6
Bakhrushin State Central Theatre Museum,
Moscow
Inv. No. KP 180169/529

354

Note: Stepanova's sets and costumes for *The Death of Tarelkin* owed an appreciable debt to Liubov Popova's Constructivist conception for *The Magnanimous Cuckold* produced earlier in 1922, as well as to Rodchenko's ideas for *prozodezhda*. Meierkhold even went so far as to speak of Stepanova's jealous wish to 'outdo' Popova.[126] Still, the rivalry between Popova and Stepanova and the strained relations between Meierkhold and Stepanova notwithstanding, it is clear that Stepanova was genuinely concerned with the Constructivist notion of maximum effect through economy of means. In this sense and like Popova and Rodchenko, Stepanova stood in complete antithesis to the World of Art designers, who, as one observer mentioned, 'wrapped up the actor like candy in a pretty piece of paper.'[127]

Stepanova and her colleagues unwrapped him. This return of the body as a highly visible, but controlled, mechanical force to costume design was paralleled by Meierkhold's rejection of make-up and, in broader terms, by the general concern in the 1920s with mass gymnastics and athletics inside and outside the Soviet theatre, an appropriation that Stepanova also welcomed. Inevitably, some critics rejected Stepanova's costumes in *The Death of Tarelkin* with their 'patent estheticism of all these stripes, tabs and little pockets',[128] arguing that, as a result, the actors looked too severe for Meierkhold's fairground interpretation.[129] But Stepanova herself countered such remarks by arguing that she had not been given enough time to coordinate the actors and the costumes. On the other hand, she felt that she had succeeded in 'showing spatial objects in their utilitarian content wherein I wished to present genuine objects – a chair, a table, armchairs, screens, etc.'[130]

The play *The Death of Tarelkin* enjoyed popularity with the Russian avant-garde: Meierkhold first produced it at the Alexandrinsky Theatre, Petrograd, in October, 1917, and Alexandra Exter also designed a production for the First Studio of MKhAT in 1921 (not realized). Looking back, critics agree that the 1922 production, dedicated to the memory of Evgenii Vakhtangov who had intended to stage the play with designs by Isaak Rabinovich, marked a milestone in the history of the Russian theatre:

> Today we can appreciate this extraordinary production as a landmark of 'Eccentricism' in the theatre and as one of the most fascinating pages in the history of theatrical Constructivism. At the time, however, this *Tarelkin* pleased almost no-one.[131]

TATLIN, Vladimir Evgrafovich

Born 16 (28) December, 1885, Moscow, Russia; died 31 May, 1953, Moscow, Russia.

Ca. 1900 ran away from home to join the merchant navy; 1902–03 attended MIPSA; 1904-09 attended the Penza Art Institute where he studied under Ilia Goriushkin-Sorokopudov and Alexei Afanasiev; 1904-08 as a seaman visited many ports in the Mediterranean; 1909–10 returned to MIPSA; 1908–11 close to the Burliuk brothers, Mikhail Larionov and other members of the avant-garde; 1910–11 contributed to Vladimir Izdebsky's 'Salon 2'; 1912 onwards contributed to many exhibitions, including the 'Donkey's Tail' and the 'Target'; 1914 visited Berlin and Paris where he met Picasso; on his return to Moscow began to work on reliefs; worked closely with Liubov Popova, Nadezhda Udaltsova, Alexander Vesnin and other avant-garde artists; 1915 contributed reliefs to 'Tramway V'; 1915–16 contributed to '0.10'; organized the 'Store' exhibition; 1917 helped with the interior decoration for the Café Pittoresque, Moscow; 1918 appointed Head of IZO NKP in Moscow; 1918–20 professor at Svomas; 1919–24 professor at Pegoskuma; 1919 began to work on his model for the Monument to the III International; 1910s-40s produced stage designs for various plays and operas; 1922–26 Head of the Department of Material Culture at the Museum of Artistic Culture/Ginkhuk in Petrograd/Leningrad; 1923 organized a production of Velimir Khlebnikov's dramatic poem *Zangezi* in Petrograd; 1925–27 professor at the Kiev Art Institute; 1927–30 professor at Vkhutein, Moscow; 1929–32 developed project for a glider called Letatlin; 1931–33 headed the Scientific Research Laboratory for the Plastic Arts, Moscow; 1930s-40s returned to figurative painting.

Further reading:

N. Punin: *Tatlin (Protiv kubizma)*, P: IZO NKP, 1921. Reprinted as *O Tatline*, M: RA, 1994.

T. Andersen: *Vladimir Tatlin*. Catalogue of exhibition at the Moderna Museet, Stockholm, 1968; and the Van Abbemuseum, Eindhoven, 1969.

A. Strigalev: 'O proekte 'Pamiatnika III Internatsionala' khudozhnika V. Tatlina' in I. Kriukova et al., eds.: *Voprosy sovetskogo izobrazitelnogo iskusstva*, M: Sovetskii khudozhnik, 1973, pp. 409–52.

L. Zhadova: *V.E. Tatlin*. Catalogue of exhibition organized by the Union of Writers of the USSR, the Union of Artists of the USSR and other agencies, M, 1977.

J. Bowlt: 'Un voyage dans l'espace: l'oeuvre de Vladimir Tatlin' in *Cahiers du Musée National d'Art Moderne*, Paris, 1979, No. 2, pp. 216–27.

L. Zhadova et al.: *Tatlin*, London: Thames and Hudson, 1987.

M. Ray: *Tatlin e la cultura del Vchutemas, 1920–1930*, Rome: Officina, 1992.

A. Strigalev and J. Harten, eds.: *Vladimir Tatlin. Retrospektive.* Catalogue of exhibition at the Kunsthalle, Dusseldorf, and other venues, 1993–94.

Yu. Nagibin: *Tatlin/Vermeer,* Milan: Spirali, 1993.

J. Harten, ed.: *Tatlin: Leben, Werk, Wirkung; ein internationales Symposium,* Cologne: DuMont, 1993.

N. Lynton: *Tatlin's Tower. Monument to Revolution*, New Haven: Yale University Press, 2009.

A. Strigalev: *Bashnia 3-go Internatsionalnogo*, M: Gordeev, 2011.

A. Strigalev: *Tatlin*, M: Gordeev, 2011.

S. Baier at al.: *Tatlin. New Art for a New World.* Catalogue of exhibition at the Museum Tinguely, Basel, 2012.

LR (Vol 2), pp. 397–99.

Tatlin's artistic activities – his reliefs, his Monument to the III International, his functional designs, his glider – represent a consistent extension of the endeavour to replace the particular by the universal, to 'reach out' and to change the concept of art as a vehicle of individual, private expression into an object of social need and public consumption. Both before and after the Revolution, Tatlin worked as the leader or member of a collective and his Moscow studio witnessed the fruitful collaboration between many artists. Even though Alexander Vesnin felt that it was 'impossible to work with Tatlin,'[132] the studio was reminiscent of a Mediaeval guild where common ideas and materials were shared and explored and where topical issues such as Byzantine art, the Russian icon and Cubism were discussed and interpreted.

Tatlin summarized his attitude to the work of art as an anonymous and collaborative endeavour when he declared that in the art of the past 'every connection between painting, sculpture and architecture has been lost; the result was individualism, i.e., the expression of purely personal habits and tastes.'[133] Symptomatic of this spirit of collectivity is the fact that the drawings and designs

for the Monument to the III International were exhibited in Petrograd as the 'collective work of the central group of the Association of New Trends of Art.'[134]

Tatlin's attempt to move from the surface of the traditional painting out into public space was evident on many levels – in his concern with the method of display in the Tretiakov Gallery in Moscow,[135] in his active participation in societies such as the Professional Union of Artists-Painters in Moscow in 1917, in his efforts to establish (with Nikolai Punin) the journal *Internatsional iskusstv* [International of the Arts] in 1918 and even in his demand for a motorcycle in 1922 so that he could visit 'at least fifteen factories.'[136] Tatlin's 'impersonality' was also demonstrated by his unchanging mode of dress and hairstyle – the old jacket and sagging polo-neck sweater visible in photographs of 1916 or 1950. Viewed against this simple physical and psychological background, Tatlin's creation of the reliefs, the stage designs, the Monument and the glider can be regarded as attempts to resolve what he called 'the problem of the correlation between man and the object'[137] so as to produce an art that would be material, concrete and universally accessible.

The Emperor Maximilian and His Disobedient Son Adolf: Tragedy in two acts based on an eighteenth century folk drama. Produced by Mikhail Bonch-Tomashevsky at the Literary-Artistic Circle, Moscow on 6 November, 1911, with music by Mikhail Rechkunov and designs by Vladimir Tatlin.

The Emperor demands obedience from his son Adolf to the gods of trade, but Adolf refuses, is imprisoned and executed. The narrative is accompanied by fights and dances and is enhanced by the traditional folk characters, such as a priest, a doctor, a gravedigger, a tailor, etc.

131. Set Design: Maximilian's Tent, 1911

Watercolour and pencil on paper

48.7 x 66.8

State Museum of Theatrical and Musical Art, St. Petersburg

Inv. No. GIK 5199/303 OR 8543

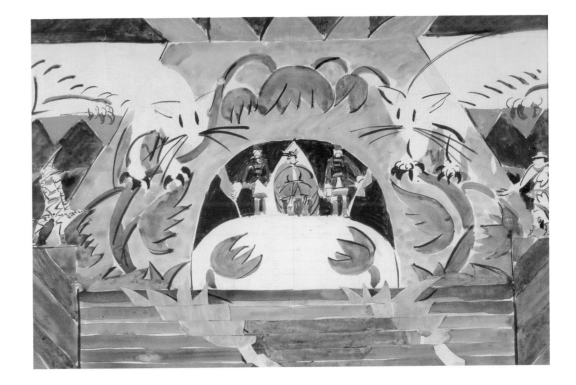

Note: Actor and critic Mikhail Bonch-Tomashevsky produced the folk drama *The Emperor Maximilian and His Disobedient Son Adolf* (the name 'Maximilian' often appears as 'Maxemian') with the help of the Union of Youth society in St. Petersburg on 27 January, 1911 – with designs by Avgust Ballier, Alexander Gaush, Mikhail Ledantiu, Savelii Shleifer, Eduard Spandikov et al., supervised by Evgenii Sagaidachnyi.[138] In an attempt to revitalize modern theatre by incorporating the 'low' elements of folk theatre, Bonch-Tomahevsky even acted in a real *balagan* (fairground) theatre so as to 'sense the popular psychology more intimately.'[139] Bonch-Tomashevsky then reworked the play, staging a new version in Moscow in November, 1911 (for which Tatlin assumed responsibility for the designs), before taking it back to St. Petersburg (at the Troitsky Theatre), in January, 1912. Even so, as one critic wrote of the Moscow production, 'the outer thoroughness of the production, all the vivid details, could not conceal the squalor and decrepitude of the action itself.'[140]

A Life for the Tsar (also called *Ivan Susanin*): Opera in four acts and an epilogue by Mikhail Glinka based on a text by Egor Rozen. Production projected, but not realized, in Moscow, 1913, with designs by Vladimir Tatlin.

Ivan Susanin, a peasant, reports that the Polish army is advancing on Moscow. Sobinin, a Russian soldier, allays the people's fears and expresses his hope that he will soon marry Antonida, Susanin's daughter. Meanwhile the first Romanov Tsar is elected and the Poles plan to capture him. The Polish troops enter and order Susanin to take them to the tsar. But he leads them astray, admits his action and is executed.

132. Costume Design for the Boyar, 1913-15

Pencil, Indian ink, pencil, lacquer and bronze on paper

49.8 x 32.1

Bakhrushin State Central Theatre Museum, Moscow

Inv. No. KP 264421/17 GKD 1248

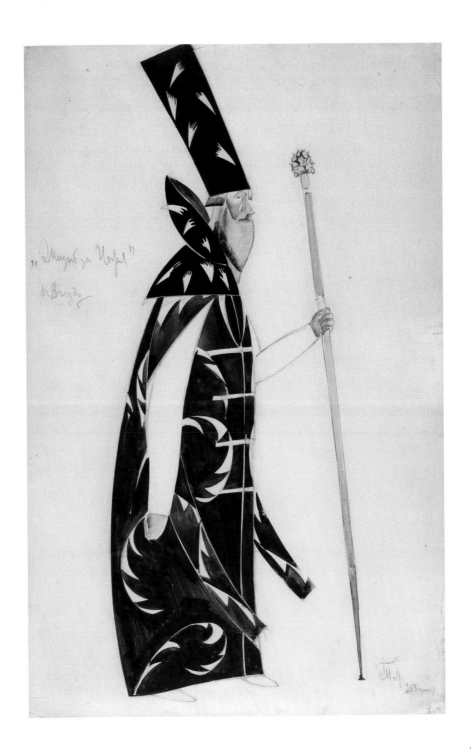

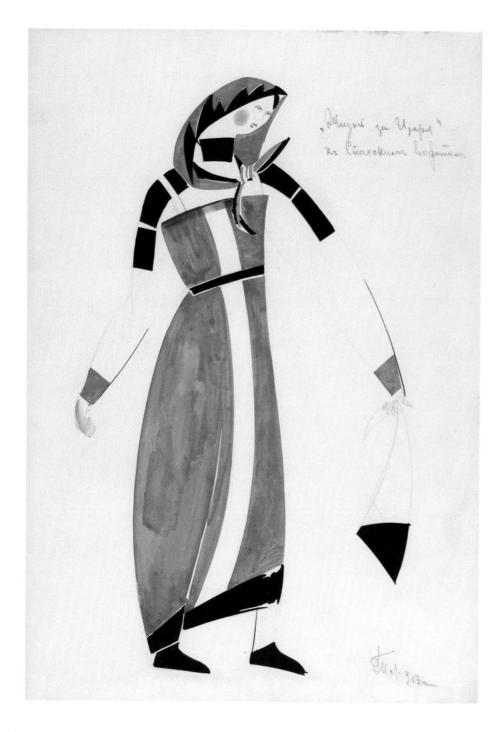

133. Costume Design. Epilogue, 1913-15

Gouache, Indian ink and pencil on paper on cardboard

44.2 x 31.1

Bakhrushin State Central Theatre Museum, Moscow

Inv. No. KP 6005 GKD 1256

134. Costume Design for a Peasant, 1913-15

Gouache, pencil and Indian ink on paper on cardboard

48.2 x 31.5

Bakhrushin State Central Theatre Museum, Moscow

Inv. No. KP 91564 GKD 1250

135. Costume Designs for the Archers, 1913-15

Pencil, Indian ink and gouache on cardboard

48.8 x 64.4

Bakhrushin State Central Theatre Museum, Moscow

Inv. No. KP 264421/540 GKD 1258

Note: In the late 1900s Tatlin's colleagues, especially Goncharova and Larionov, were giving particular attention to the icon, the *lubok*, and other traditional arts, an interest that Tatlin supported with particular enthusiasm, and, not surprisingly, certain formal parallels between Tatlin's work of ca. 1912 and that of Goncharova and Larionov can be distinguished. Tatlin's folkloristic, florid backgrounds and costumes for *The Emperor Maximilian and His Disobedient Son Adolf*, for example, are reminiscent of Goncharova's Neo-Primitivist designs, such as her sets and costumes for Sergei Diaghilev's Paris production of *Le Coq d'Or* in 1914.

The Flying Dutchman: Opera in three acts by Richard Wagner. Prepared, but not produced, in 1915–18, with designs by Vladimir Tatlin.

A ghostly ship is condemned to wander the oceans forever. An enthralling score, illuminated by striking stage imagery, powers a thrilling journey into an unsettling, mythic world, where a tormented spirit seeks true love as redemption.

136. *Set Design for a Ship's Deck*, 1915–18

Oil on canvas

87 x 156

Bakhrushin State Central Theatre Museum, Moscow

Inv. No. KP 264421/538 Zh 870

137. Design for a Mast, 1915–18
Graphite pencil on tracing paper
73 x 51
Bakhrushin State Central Theatre Museum,
Moscow
Inv. No. KP 264421/552 GDD 1175

367

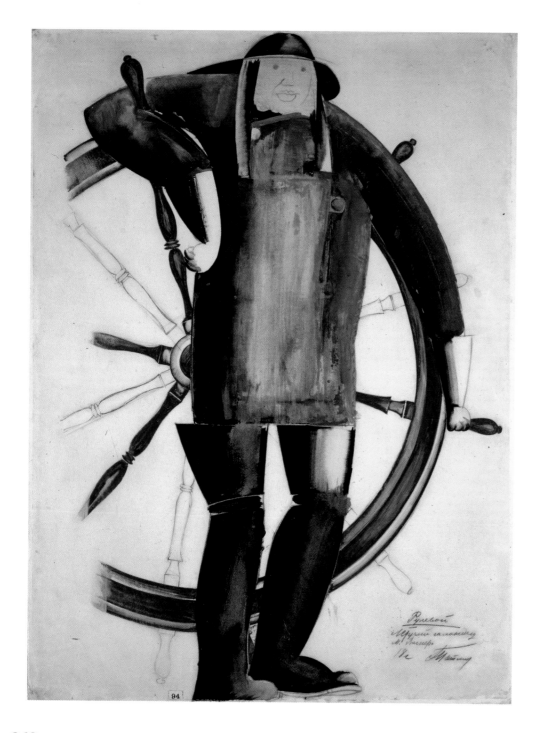

138. Costume Design for the Helmsman, 1915–18
Graphite pencil on paper
63.8 x 47.9
Bakhrushin State Central Theatre Museum,
Moscow
Inv. No. KP 264421/539 GKD 1340

139. Costume Design, 1915–18
Graphite pencil on paper
65.1 x 49.5
Bakhrushin State Central Theatre Museum,
Moscow
Inv. No. KP 264421/578 GKD 1338

140. *Costume Design*, 1915–18
Graphite pencil on tracing paper
71.6 x 37.3
Bakhrushin State Central Theatre Museum, Moscow
Inv. No. KP 264421/582 GKD 1335

Note: Tatlin worked on his designs for *The Flying Dutchman* without a commission, indulging his love of the sea and ships and remembering his own experiences as a seaman. Just as he was elaborating his ideas for sets and costumes, he was also working on his counter-reliefs and, certainly, some of the designs here reveal the artist's concern with volume, three-dimensions and construction. As Anatolii Strigalev has observed, the natural culmination to these parallel pursuts was the Monument to the III International which, on the one hand, may be regarded as a gigantic relief and, on the other, as an extension of theatre into public, collective space.[141]

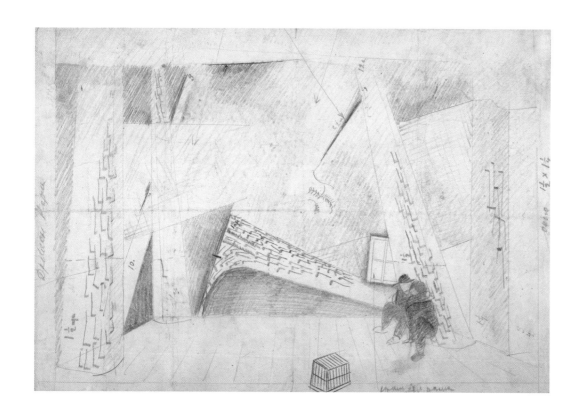

Zangezi: Dramatic poem (supertale) in 19 planes by Velimir Khlebnikov. Produced by Nikolai Punin and Vladimir Tatlin at the Museum of Artistic Culture, Petrograd, on 30 May, 1923, with designs by Vladimir Tatlin.

The drama has no plot, but advances by nineteen so-called planes (sections) which explore various linguistic registers, such as bird talk and divine language. The planes also provide references to Mongolian, Chinese, Zulu, Slav and other exotic cultures and phenomena, including the fool of the forest, Zangezi, who declaims his Tables of Destiny.

141. *Set Design with Bird-Catchers*, 1923

Graphite pencil on paper

34.5 x 50.6

Bakhrushin State Central Theatre Museum, Moscow

Inv. No. KP 264421/610 GDS 823

142. Costume Design for Laughter, 1923
Photograph on paper
56 x 38.4
Bakhrushin State Central Theatre Museum, Moscow
Inv. No. NV 2545/1

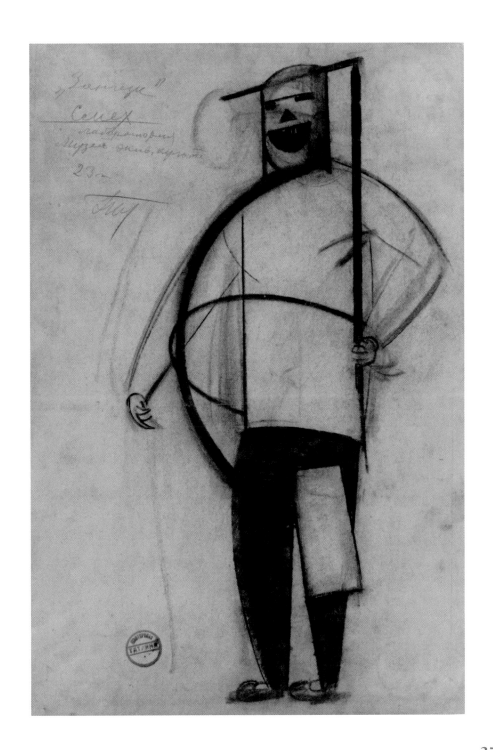

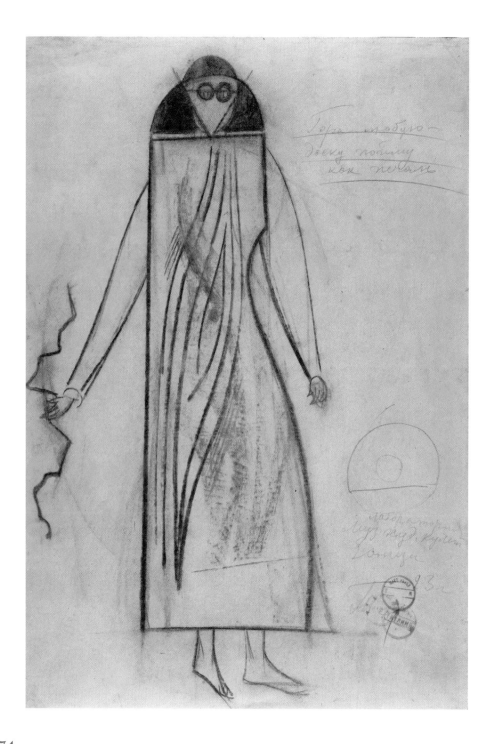

143. *Costume Design for Grief*, 1923
Photograph paper and printing
54.6 x 38.4
Bakhrushin State Central Theatre Museum,
Moscow
Inv. No. NV 2545/2

Note: In paying homage to the great avant-garde poet, Velimir Khlebnikov (1885–1922), Vladimir Tatlin and the critic and historian, Nikolai Punin, both champions of Khlebnikov's transrational language, approached *Zangezi* as a laboratory of forms, i.e. as a material and linguistic platform upon which they could experiment with new notions of the set, the costume and the performer on stage. Essentially, Tatlin regarded the physical presentation of the Khlebnikov masterpiece as a gigantic relief, applying devices from his painterly, counter and corner reliefs to the wider space of the proscenium. He geometrized objects and figures, reduced the actors to formal elements and, above all, built enormous, vertical and diagonal 'planes' on which the actors climbed, walked and recited. Tatlin's conception of *Zangezi* in 1923 as a relief, or rather as constructed volume is both a clear illustration of the transference of ideas from one discipline (studio art) to another (applied art) and also of his fundamental belief in the need to 'put the eye under the control of touch'.[142]

TELINGATER, Solomon Benediktovich

Born 29 April (12 May), 1903, Tiflis, Georgia; died 1 October, 1969, Moscow, Russia.

Grew up in an artistic family; attended gymnasium in Baku and graduated from the Baku Art Institute; 1920–21 studied at Vkhutemas in Moscow under Vladimir Favorsky; 1921–24 contributed designs to various newspapers in Baku such as *Rabota* [Work]; 1922 illustrated an edition of Alexander Blok's *Dvenadtsat* [The Twelve] in Baku; 1923 designed a poster for the Baku Soviet elections, his first major typographical exercise; 1925 back in Moscow, started work for various publishing-houses as a designer of books and journals; influenced by the Constructivist concepts of the Lef group of artists, such as Alexei Gan, Gustav Klutsis and Alexander Rodchenko; 1927 contributed to the exhibition 'The Moscow Ex-Libris for the Year 1926' in Moscow; received a diploma in industrial design; 1927–32 much influenced by Lissitzky; produced Constructivist covers for journals; 1928 with Lissitsky et al. helped design the layout for the Soviet pavilion at the 'Pressa' exhibition in Cologne; 1928 member of the October group, co-signing its manifesto and designing its booklet (1931); 1932 worked for the

Down with Illiteracy Publishing-House; 1936 with Sergei Tretiakov produced the first monograph on John Heartfield; 1943 became a member of the Communist Party of the Soviet Union; 1946 winner of the Stalin Prize followed by other accolades; 1963 received the Gutenberg Award in Leipzig for his lifetime achievements in typography.

Further reading:

Telingater's own writings on typographical design and layout are of particular interest, e.g., (with L. Kaplan): *Iskusstvo aktsidentnogo nabora,* M: Kniga, 1965. The following sources provide information on his life and work:

Yu. Gerchuk: 'S.B. Telingater' in *Iskusstvo knigi 1963–1964,* M, 1968, No. 5, pp. 134–45.

Yu. Molok: *Solomon Benediktovich Telingater.* Catalogue of exhibition organized by the Union of Artists of the USSR, M, 1975.

M. Zhukov: 'Aktsidentsii Telingatera' in *Dekorativnoe iskusstvo,* M, 1978, No. 12, pp. 34–38.

S. Telingater: *Telingater: Typograf 1922–1933* (facsimile album of eleven designs by Telingater), Hamburg: Hochschule für bildende Kunst, 1979.

V. Telingater: 'Monia komsomolets' in *Iskusstvo kino,* M, 2004, No. 8, pp. 111–27.

V. Telingater: *Solomon Telingater. Konstruktor graficheskikh ansamblei,* M: Galart, 2008.

LR (Vol. 2), pp. 422–23.

Although Telingater is now remembered for his typographical designs and his concern with the 'architectonic totality of the book,'[143] his interests were wide-ranging and he did much to propagate the 'new' arts of the 1920s, such as radio, photography, statistical diagrams, etc. He believed that art could serve the cause of ideology without compromising its esthetic effect, as he emphasized in his many articles of the late 1920s onwards:

> We are profoundly convinced that the spatial arts … can escape their current crisis only when they are subordinated to the task of serving the concrete needs of the proletariat, the leaders of the peasantry and the backward national groups.[144]

To this end, Telingater produced many political posters such as his anti-League of Nations collage of 1925 and photo-montages that illustrated the topical issues of the time.[145]

Telingater was not a professional stage designer, but he was fascinated by the possibilities of the theatre as a mass medium and produced a number of related works, such as book covers for the Moscow Theatrical Publishing-House. In 1926 he even designed costumes for Shakespeare's *Twelfth Night* (not produced), in 1931 made a foldout program for the revue *They're Getting Ready* at the Central Club of the Red Army in Moscow and in 1933 he designed a poster for the Red Army Theatre.

144. Design for a Propaganda Lorry for the Red Army, 1932

Collage, watercolour and ink on paper.

Signed upper left in pencil in Russian: 'S. Telingater.'

25 x 62

Other inscriptions in pencil in Russian: upper left: 'Solomon. Prepared for…'; lower right carries censor's authorization.

State Museum of Theatrical and Musical Art, St. Petersburg (formerly in the collection of Nina and Nikita D. Lobanov-Rostovsky).

Inv. No. GIK 23272/453

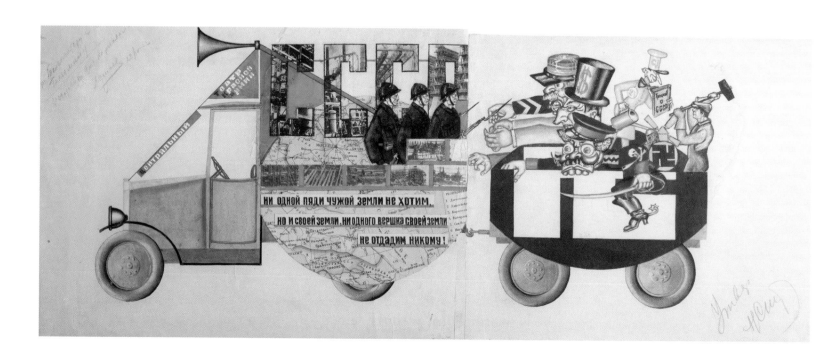

Note: Like his colleagues in the October group, Telingater was drawn to the concept of the mass festival, arguing that, along with architecture and the design of objects for mass consumption, it was a new and vital area of concentration.[146] For the October artists such as Klutsis, Lissitzky and Sergei Senkin, the mass festival was important because it could both transmit a direct political and social message and involve the public more actively in the artistic process. As at a fairground, the Communist carnival and procession (like the mass actions of ca. 1920) enabled the viewer to 'join in.'

This design for a propaganda or agit-lorry is for one such carnival organized by the Maly Theatre of the Red Army (later the Central State Academic Theatre of the Red Army) in Moscow on 22 December, 1932, and, in fact, the caption strung diagonally above the front of the lorry reads: 'Central Theatre of the Red Army'. The idea of agit-transport (propaganda floats) had been developed with particular enthusiasm just after the Revolution, especially in the form of trains and steamboats, although agit-buses and agit-lorries were also used. These vehicles participated in the parades and manifestations that became an integral part of Soviet public life, especially for May Day and the October anniversary.

This particular piece shows the USSR riding in the front part of the lorry (with the letters 'CCCP' on top, Red Army soldiers, photographs of industrial scenes, a map of part of Soviet Russia and the lines from a popular song 'We do not want a single foot of foreign land, but we will not give up an inch of our land to anyone!'), which is still attached to the 'chariot of world imperialism' containing representatives of the foreign powers, i.e. Marshal Foch (?) of France, Henry Hoover (?) of the USA, and Paul von Hindenburg (?) of Germany. The 'Mad Hatter' with the long (Jewish) nose is Lev Trotsky, who had adopted an especially hostile position towards Stalin in 1923 and who had been expelled from the Soviet Union in 1929: he is wearing a hat with the letters SD (a reference to his conciliatory attitude towards the Social Democrats in Europe – something that had caused Lenin to distrust him) and carrying his book *Trotsky o SSSR* [Trotsky on the USSR].[147] This particular group of enemies was a popular subject for agit-processions in 1931–32 and appeared in other propaganda trucks, statues and 'avenues of enemies' in public spaces in Moscow and Leningrad.[148]

VESNIN. Alexander Alexandrovich

Born 16 (28) May, 1883, Yurevets, near Nizhnii Novgorod, Volga Region, Russia; died 7 November, 1959, Moscow, Russia.

The youngest of the three Vesnin brothers (the others being Leonid and Viktor), who worked closely on many architectural and design projects during the 1910s, 1920s, and early 1930s; 1901–12 after graduating from the Moscow Practical Academy, Alexander Vesnin entered the Institute of Civil Engineers, St. Petersburg; 1912–14 worked in Vladimir Tatlin's Tower studio in Moscow, establishing contact with Liubov Popova, Nadezhda Udaltsova et al.; 1918 worked on agit-decorations for the streets and squares of Petrograd and Moscow; 1920 designed sets and costumes for Paul Claudel's *L'Annonce faite à Marie* produced by Alexander Tairov at the Chamber Theatre, Moscow; thereafter active in a number of stage productions, including his most experimental, i.e. Racine's *Phèdre* and G.K. Chesterton's *The Man Who Was Thursday,* both produced by Tairov in 1922 and 1923 respectively; joined Inkhuk; 1921 contributed to the exhibition '5 x 5 =25'; 1923–25 close to *Lef;* keen supporter of Constructivism; 1923–33 worked with his brothers on various architectural and industrial designs; co-founded OSA (Association of Contemporary Architects); late 1920s with his brothers worked on important architectural projects, such as the Lenin Library, Moscow, the Palace of Soviets, Moscow, communal housing for Stalingrad, etc.; 1930s-40s with the death of Leonid in 1933 and the censure of Constructivism, Alexander Vesnin reduced his architectural and artistic activities considerably.

Further reading:

A. Chiniakov: *Bratia Vesniny,* M: Stroiizdat, 1970.

K. Usacheva: 'Teatralnye raboty A.A. Vesnina' in I. Kriukova et al., eds.: *Voprosy sovetskogo izobrazitelnogo iskusstva i arkhitektury.* M: Sovetskii khudozhnik, 1975, pp. 304–31.

A. Lupandina: 'Khudozhniki Kamernogo teatra' in *Tvorchestvo,* M, 1980, No. 19, pp. 14–18.

E. Vasiutinskaia et al., comps.: *Katalog-putevoditel po fondam muzeia. Vesniny,* M: TsNTI, 1981 (catalogue of the Vesnin holdings at the Shchusev Museum, Moscow).

S. Khan-Magomedov: *Alexander Vesnin,* M: Znanie, 1983.

S. Khan-Magomedov: 'A. Vesnin – khudozhnik teatra' in *Dekorativnoe iskusstvo,* M, 1983, No. 6, pp. 37–40.

A. Manina: *Arkhitektory bratia Vesniny.* Catalogue of exhibition at the Shchusev Museum, M, 1983.

S. Chan-Magomedov: *Alexandre Vesnine.* Catalogue of exhibition at the Institut Français d'Architecture, Paris, December, 1984.

K. Rudnitsky: 'Khudozhniki teatra Tairova' in *Dekorativnoe iskusstvo,* M, 1985, No. 10, pp. 30–35.

S. Khan-Magomedov: *Alexander Vesnin,* New York: Rizzoli, 1986.

M. Petrova: 'Teatralnyi khudozhnik Alexander Vesnin' in *Muzei,* M, 1987, No. 7, pp. 101–11.

S. Khan-Magomedov: *Alexander Vesnin i konstruktivizm,* M: Arkhitektura 'S', 2010.

LR (Vol. 2), pp. 435–39.

Alexander Vesnin is remembered as a Constructivist architect rather than as a stage designer. However, he made a vital contribution to the development of Soviet stage design, especially through his sets and costumes for five major spectacles for the Chamber Theatre, Moscow – *L'Annonce faite à Marie, The Pearl of Adalmini, Romeo and Juliet* (not realized), *The Man Who Was Thursday* and *Phèdre,* the latter being the most famous. Vesnin was a prolific theatre artist: the Shchusev Museum in Moscow, for example, contains over five hundred of his costumes and decors.

Vesnin made his debut as a stage designer in 1919–20 when he collaborated on several productions for the Maly Theatre, Moscow, including *The Marriage of Figaro,* Nikolai Gogol's *The Inspector General* and Anatolii Lunacharsky's *Oliver Cromwell.* In 1921 Vesnin also worked with the composer Ilia Sats at the Children's Theatre, Moscow, and with Popova and Vsevolod Meierkhold on a 'mass action' installation to celebrate the Second Congress of the Third Communist International (not realized). However, the most important period of Vesnin's theatrical career began when Alexander Tairov commissioned him to design the productions of *L'Annonce faite à Marie* (usually translated as *Tidings Brought to Mary*) in 1920 and *Romeo and Juliet* in 1921. True, Vesnin's costume designs for these pieces were informed by the ideas of Alexandra Exter and Popova – indeed, his set for *Phèdre* is very reminiscent of Exter's for *Salomé* produced by Tairov in 1917. In turn, and again like Exter, Vesnin seems also to have derived inspiration from the simple,

but emotive, forms for his scenic constructions, levels and inclines from Adolphe Appia's earlier formulations of scenic space: 'Stairs by their straight lines and breaks maintain the necessary contrast between the curves of the body and the sinuous lines of its evolution, Their practical use offering at the same time distinct facilities of expression'.[149]

Phèdre: Tragedy in five acts by Jean Racine, translated into Russian by Valerii Briusov. Produced by Alexander Tairov for the Chamber Theater, Moscow on 8 February, 1922, and presented on tour in Berlin (Deutsches Theater) and Paris (Théâtre des Champs-Elysées) in February and March, 1923, with designs by Alexander Vesnin and renderings for program publicity by Konstantin Medunetsky and Georgii and Vladimir Stenberg.

Hippolytus is the son of Theseus, King of Athens. Phaedra, Theseus's Queen, is in love with Hippolytus – which is the doing of Aphrodite whom Hippolytus has slighted, preferring a life honoring the chaste and athletic Artemis. When Phaedra's passion is revealed to Hippolytus, he reacts so violently that Phaedra fears his anger and kills herself. Because of an oath not to admit the real course of events, Hippolytus cannot tell the truth to Theseus. Theseus, therefore, banishes him. As Hippolytus is riding away, a bull of unnatural size appears from the sea and frightens his horses who stampede, dragging Hippolytus with them. Artemis then appears to tell the truth to Theseus, but not in time to save Hippolytus who dies in the arms of his father.

145. Stage Design, ca. 1922.

Gouache on wrapping paper

17 x 21.5

State Museum of Theatrical and Musical Art, St. Petersburg (formerly in the collection of Nina and Nikita D. Lobanov-Rostovsky).

Inv. No. GIK 23272/157

Note: Alexander Tairov began to prepare his production of *Phèdre* in October, 1921 and, already familiar with Vesnin's experimental designs for other projects, invited him to collaborate. Vesnin made at least three maquettes for *Phèdre* which, as Tairov asserted, not only served 'as an apparatus for the acting, but also in turn demonstrate a tendency ... to become an image of objective reality, to become an environment in constant contact with the images of the actors.'[150] Tairov liked Vesnin's central set because it was like a boat deck 'at the moment of imminent shipwreck, of catastrophe.'[151]

The restrained, hieratic form of the Racine tragedy with its reliance on the equal functioning of all artistic components appealed to Tairov and Vesnin and they used their production as a vehicle for integrating an elegant Classicism with a calculated Constructivism. Alisa Koonen, who took the part of Phèdre, remembered that 'visually, *Phèdre* gave the impression of severe beauty and majesty. The arrangement of the stage was remarkably successful. It afforded the director much scope and was very convenient for the actors. The costumes looked great. They were simple, severe.'[152] Although critics were not unanimous in their appreciation of Tairov's production of *Phèdre,* most felt that Vesnin's costumes, rather than his sets, were the more original feature of the decoration. As Abram Efros remarked:

> Certain basic characteristics of the Hellenic dress were expressed by the *plastique* of new forms: the helmet, cloak, shield, spear, sword, tunic, the woman's headgear. They were all reduced to two or three planes, volumes, inflexions, colours... new expressions had been given to the laws of the Classics.[153]

The Man Who Was Thursday: Play based on the novel, *The Man Who Was Thursday: A Nightmare*, by G.K. Chesterton. Produced by Alexander Tairov at the Chamber Theatre, Moscow, on 6 December, 1923, with music by Alexander Metner and designs by Alexander Vesnin.

Scotland Yard recruits Gabriel Syme into a secret anti-anarchist police corps. Syme and Lucian Gregory, an anarchistic poet, debate the meaning of poetry, Gregory arguing that revolt is its basis. Gregory then takes Syme to an anarchist meeting, revealing that he is an influential member of the local chapter of the European anarchist council, consisting of seven men, each using the name of a day of the week as a code: the position of Thursday is about to be elected by Gregory's local chapter and Gregory expects to win, whereupon Syme reveals that he is a secret policeman, makes a rousing speech and is sent as the chapter's delegate to the central council. However, Syme discovers that, masterminded by their president Sunday, five of the other six members are also undercover detectives. The dream ends when Sunday himself is asked if he has ever suffered. His last words, 'Can ye drink of the cup that I drink of?', is the question which Jesus had posed to St. James and St. John, challenging their commitment to his discipleship.

146. *Costume Design*, 1923

Indian ink, tempera and collage on paper

39.5 x 27.3

Bakhrushin State Central Theatre Museum, Moscow

Inv. No. KP 238272/423 GKS 141

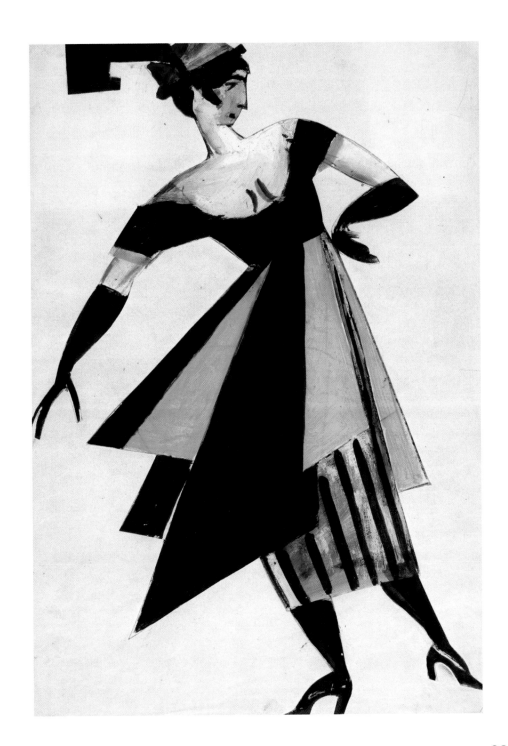

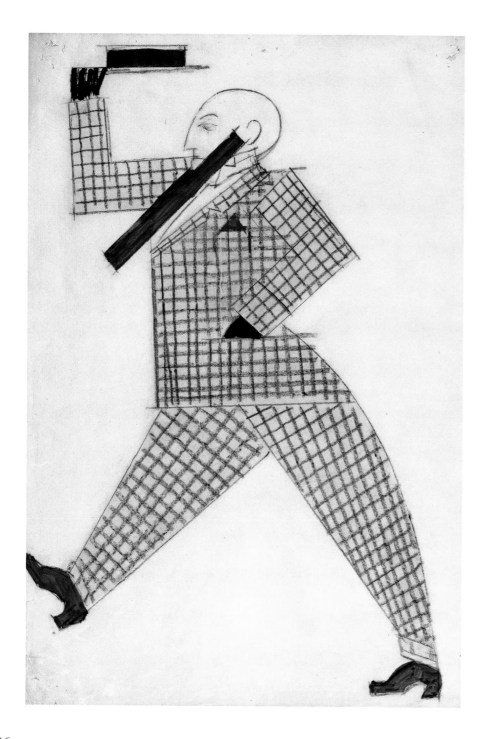

147. *Costume Design for a Man in Checked Suit,*
1923
Charcoal, gouache, pencil and ink on paper
39.6 x 27.8
Bakhrushin State Central Theatre Museum,
Moscow
Inv. No. KP 238272/447 GKS 110

148. Costume Design for Monday, 1923
Charcoal and gouache on paper
39.6 x 27.2
Bakhrushin State Central Theatre Museum,
Moscow
Inv. No. KP 238272/444 GKS 101

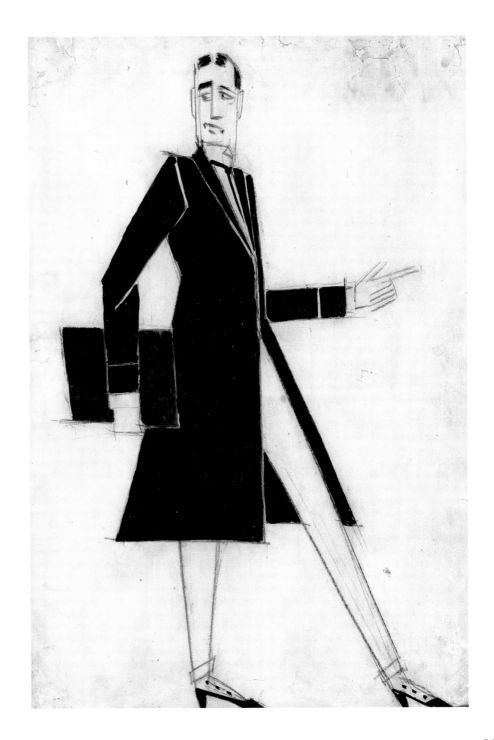

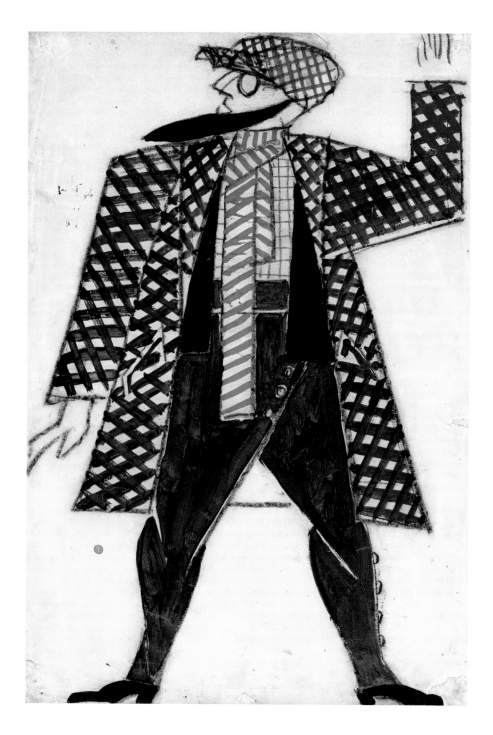

149. Costume Design for an Anarchist, 1923
Charcoal and gouache on paper
39.7 x 27.3
Bakhrushin State Central Theatre Museum,
Moscow
Inv. No. KP 238272/466 GKS 111

150. Costume Design for a Worker, 1923
Charcoal and gouache on paper
39.5 x 28
Bakhrushin State Central Theatre Museum,
Moscow
Inv. No. KP 238272/465 GKS 146

Note: Vesnin made his debut in the Chamber Theater with his designs for the 1920 production of Paul Claudel's *L'Annonce faite à Marie*. A Neo-Classicist in architectural training, Vesnin possessed a rigor, sense of measure and equilibrium which appealed to Tairov and which Vesnin also observed in his costumes and construction for *The Man Who Was Thursday*. Although, clearly, Vesnin was fascinated by the stage as an architectonic, three-dimensional site, the set which he designed here was little more than a paraphrase of Liubov Popova's radical set for *The Magnanimous Cuckold* of 1922, whereas the costumes were novel, laconic and dynamic.

VIALOV. Konstantin Alexandrovich

Born 6 (19) April, 1900, Moscow, Russia; died 12 July, 1976, Moscow, Russia.

1914–17 attended CSIAI; specialized in textile design; 1917–23 attended Svomas/Vkhutemas, studying under Aristarkh Lentulov and Alexei Morgunov; 1922–25 directed the Visual Arts Studio of the Teenagers' Club attached to the NKP Test Station; developed his theory of 'montage of meaning', using an often stenographic, poster-like style; 1924 designed a production of *Stenka Razin*; 1924 co-founded OST, contributing to its exhibitions until 1928; 1925 contributed to the 'Exposition Internationale des Arts Décoratifs' in Paris; during the 1920s designed many books and posters; 1932 joined the Moscow Union of Soviet Artists; 1932–41 took part in numerous naval and other expeditions to Kronstadt, Leningrad, Archangel, Sebastopol and other areas; 1930s painted industrial scenes; 1937–40 worked on designs for the 'All-Union Agricultural Exhibition' in Moscow; 1930s onwards continued to painting and exhibit, giving increasing attention to landscape; 1941–42 designed anti-Fascist posters; thereafter continued to paint and design.

Further reading:

V. Lobanov: *Konstantin Vialov*, M: Sovetskii khudozhnik, 1968.

V. Kostin: *OST*, L: Khudozhnik RSFSR, 1976, passim.

V. Leshin: *Konstantin Vialov*. Catalogue of exhibition organized by the Union of Artists of the USSR, M, 1981.

J. Bowlt: 'The Society of Easel Artists (OST)' in *Russian History,* Tempe, 1982, Vol. 9, Parts 2–3 pp. 203–26.

T. Durfee: *A Glimpse of Tomorrow.* Catalogue of exhibition at the Institute of Modern Russian Culture, Los Angeles, 1992.

LR (Vol. 2), pp. 439–42.

Many artists of the second generation of the Russian avant-garde who matured just after the Revolution derived their creative strength from either Kazimir Malevich or Vladimir Tatlin. For those who followed Tatlin, the relief – the three-dimensional assemblage of modern materials – formed an exciting departure-point for further constructive experiments: Lev Bruni, Vladimir Lebedev, Konstantin Medunetsky, Georgii and Vladimir Stenberg and Vialov were among those disciples who, albeit briefly, investigated the possibilities of the relief and the three-dimensional construction, although some, including Lebedev and Vialov, shortly returned to figurative painting and sculpture. Interested in the new set and costume resolutions elaborated by Liubov Popova and Alexander Vesnin, in particular, Vialov also explored space and volume as esthetic agents through his scenic designs as, for example, in the 1924 *Stenka Razin.* Even so, Vialov's involvement in the theatre was sporadic and his real vocation was studio painting, for he and his colleagues in OST 'defended visual art and saw in it the intrinsically valuable elements of the painterly craft. They insisted that the painting as such would not die and would, in fact, continue to develop'.[154]

Stenka Razin: Play by Vasilii Kamensky with music by Nikolai Popov. Produced by Valerii Bebutov at the Theatre of Revolution, Moscow on 6 February, 1924, with designs by Konstantin Vialov.

Stenka Razin, leader of a pirate host, routs government troops in Central Russia. Attracting increasing popular support, he equips a fleet and sails the Caspian Sea as far as Persia. He then sails up the River Volga as far as Astrakhan, pirating and plundering, killing nobles and looting shops and churches. After bloody encounters he is caught by the Ataman of the Don Cossacks and is sent to Moscow to be is executed.

151. Set Design as a Modular Construction, 1923-24

Graphite pencil and Indian ink on paper

23 x 20.2

Bakhrushin State Central Theatre Museum, Moscow

Inv. No. KP 289307

152. Set Design. Boats Away, 1923-24
Graphite pencil, ink and tinting on paper
17.4 x 24.8
Bakhrushin State Central Theatre Museum,
Moscow
Inv. No. KP 325726 GDS 1024

СТАРУХА

№ 17

153. Costume Design for an Old Woman, 1923-24
Graphite pencil and gouache on paper
22.7 x 16.5
Bakhrushin State Central Theatre Museum,
Moscow
Inv. No. KP 304890

154. Costume Design for the Boyar's Daughter, 1923
Graphite pencil, gouache and bronze on paper
26.5 x 17.8
Bakhrushin State Central Theatre Museum,
Moscow
Inv. No. KP 304892 GKS 4646

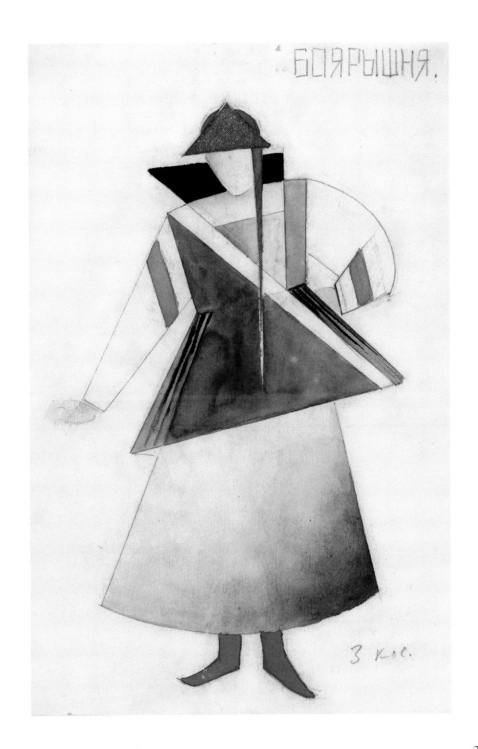

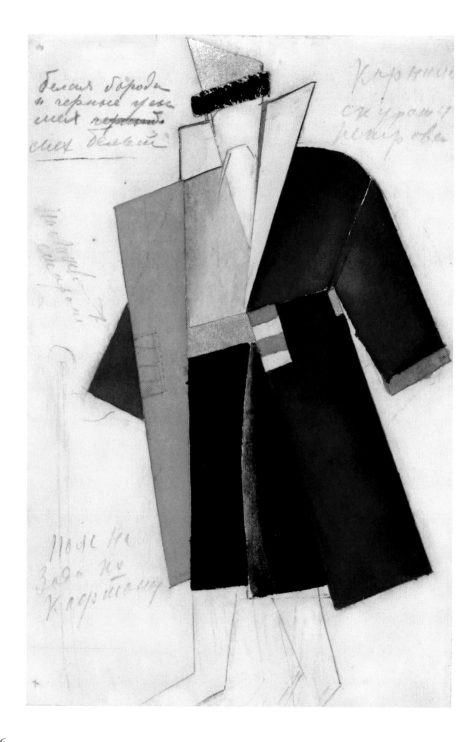

155. *Costume Design for Ataman Kornila*, 1923
Graphite pencil, gouache, silver paint and collage on paper
26.5 x 17.8
Bakhrushin State Central Theatre Museum, Moscow
Inv. No. KP 304893

156. Costume Design for Stepan (Stenka) Razin,
1923

Graphite pencil, Indian ink, gouache and collage
on paper

32.3 x 22.8

Bakhrushin State Central Theatre Museum,
Moscow

Inv. No. KP 289903 GKS 4645

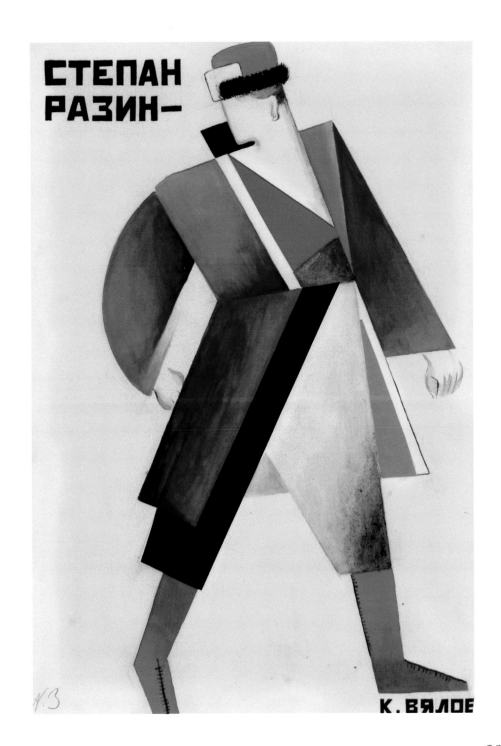

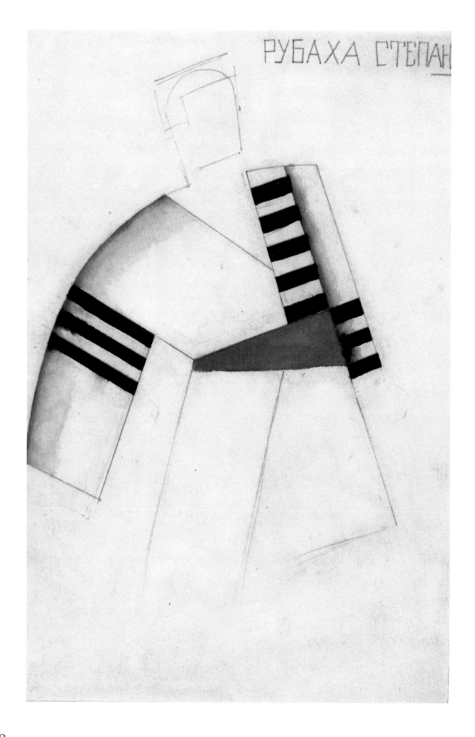

157. *Costume Design for Stenka Razin's Blouse*, 1923-24

Graphite pencil and gouache on paper

26.5 x 17.8

Bakhrushin State Central Theatre Museum, Moscow

Inv. No.KP 304891

Note: The theme of Stenka Razin was a popular one just after the Revolution when this legendary insurgent was widely identified as a positive manifestation of the class struggle and revolutionary process in Tsarist Russia. Consequently, Razin was celebrated in art, literature and the theatre, because 'each of us is Stenka Razin.'[155] But Kamensky's text left a lot to be desired and Yurii Annenkov even wondered how this gifted Cubo-Futurist poet could have written something so devoid of talent.[156] As far as the Bebutov production of Kamensky's play is concerned, Vialov tried consciously to apply the lessons he had learnt from his observations of the Projectionist Theatre. He conceived the play as a 'buffoonery,' using 'Cubist constructions, bright light effects, music and dynamic elements,'[157] and the surviving set and costume designs certainly demonstrate this. As Bebutov remarked, the company wished to avoid all references to the '*style russe* ' and 'cabaret falsification.'[158]

YAKULOV, Georgii (Georges) Bogdanovich

Born 2 (14) January, 1882, Tiflis, Georgia; died 28 December, 1928, Erevan, Armenia.

Born into an Armenian family; 1893–99 attended the Lazarev Institute of Oriental Languages in Moscow; 1901–03 attended MIPSA; 1903 served in the army; 1904 mobilized for the Russo-Japanese front; spent time in Manchuria; 1905 began to develop his theory of light; 1907 contributed to the 'Moscow Association of Artists'; thereafter contributed to many exhibitions in Russia and abroad; 1910–11 often involved as a decorator in private balls, amateur theatricals, etc.; 1913 visited Paris where he met the Delaunays, finding that his ideas on light related to their theory of Simultanism; 1914–17 military service (with interruptions); 1917 assisted by Alexander Rodchenko, Vladimir Tatlin, Nadezhda Udaltsova et al., designed the interior of the Café Pittoresque in Moscow; 1918 onward active as a stage designer, particularly for Alexander Tairov's Chamber Theatre; 1919 close to the writers Sergei Esenin and Anatolii Mariengof; co-signed the Imaginist manifesto; professor at Svomas; painted murals for the Stable of Pegasus Café; early 1920s active principally as a stage designer, but also involved in fashion design; 1923 designed monument to the 26 Baku Commissars (not realized); 1925 visited

Paris; contributed to the 'Exposition Internationale des Arts Décoratifs et Industriels Modernes'; worked on the decor for Sergei Diaghilev's production of *Le Pas d'Acier* (realized in 1927); returned to Moscow later that year.

Further reading:

M. Sarkisian: *Georgii Yakulov.* Catalogue of exhibition at the State Picture Gallery of Armenia, Erevan, 1967.

Notes et Documents Edités par la Société des Amis de Georges Yakoulov, Nos. 1–4, Paris, 1967–75.

S. Aladzhalov: *Georgii Yakulov,* Erevan: Armenian Theatrical Society, 1971.

M. Sarkisian et al.: *Georgii Yakulov.* Catalogue of exhibition at the State Picture Gallery of Armenia, Erevan; and the State Museum of Art of the Peoples of the East, M, 1975.

V. Lapshin: 'Iz tvorcheskogo naslediia G.B. Yakulova' in I. Kriukova et al., eds.: *Voprosy sovetskogo izobrazitelnogo iskusstva i arkhitektury,* M: Sovetskii khudozhnik, 1975, pp. 275–303.

E. Kostina: *Georgii Yakulov 1884–1928,* M: Sovetskii khudozhnik, 1979.

R. Casari and S. Burini: *L'Altra Mosca: Arte e Letteratura nella cultura russa tra ottocento e novecento,* Bergamo: Moretti & Vitali, 2000, pp. 158–86.

V. Badalian: *Georgii Yakulov 1884–1928, Khudozhnik, teoretik iskusstva,* Erevan: National Gallery of Armenia, 2010.

E. Sidorina: «Etot slozhnyi konstruktivizm: Georgii Yakukov» in her *Konstruktivizm bez beregov,* M: Progress-Traditsiia, 2012.

LR (Vol. 2), pp. 446–51.

The art of Georgii Yakulov cannot be contained within one stylistic category. He gave his artistic allegiance neither to Cubism, nor to Futurism or Constructivism, and yet he derived his strength from all these movements. As one critic noted, Yakulov, like Vsevolod Meierkhold, carried the theatre within, 'his own evolution was a theatre unto itself.'[159] It was in two productions in particular – *Princess Brambilla* (1920, in which Yakulov himself performed) and *Giroflé-Girofla* (1922), both of which played at the Chamber Theatre, Moscow – that Yakulov demonstrated his acute sense of theatre. As a matter of fact, Yakulov's set and costume designs for these two spectacles seemed destined more for the circus or 'happenings' than for the conventional stage: he used chance, coincidence and intuition, qualities which

resulted either in brilliant success (as with *Giroflé-Girofla*) or in lukewarm audience response (as with *Signor Formica* of 1922). But this element of guesswork also imbued Yakulov's art with a spontaneity and immediacy that appealed to a broad public, for, as he liked to say, 'Art exists for the ignoramus. The greatness of art lies in its right to be illiterate.'[160]

Consequently, Yakulov tended to regard the theatre precisely as a mass circus experience and, in turn, emphasized its simplest and most basic ingredient – 'the principle of perpetual motion, the kaleidoscope of forms and colours.'[161] In order to express this movement in *Giroflé-Girofla,* Yakulov resorted to an intricate system of kinetic 'machines' which 'moved forward some parts, removed others, rolled out platforms, let down ladders, opened up traps, constructed passageways.'[162] This crazy, chaotic spectacle, which Yakulov repeated in modified form in his conception of *Le Pas d'Acier* (in 1927), could not fail to evoke mirth and it was the most popular entertainment in Moscow in 1922. As Anatolii Lunacharsky said, the common man had the right to relax after the hard days of the Revolution, and Yakulov gave him the chance to do so.[163]

Rienzi: Opera in five acts by Richard Wagner based on the novel by Edward Bulwer-Lytton. Projected, but not produced, by Valerii Bebutov and Vadim Shershenevich for the RSFSR Theatre No. 1, Moscow, in 1921 with pantomime scenes directed by Vsevolod Meierkhold and designs by Georgii Yakulov. A smaller version was produced at the Great Hall of the Moscow Conservatoire on 8 July, 1921, and Yakulov also contributed the same and supplementary designs to Nikolai Prostorov's production of the opera at the Free Theatre, Moscow, on 3 April, 1923.

Set in Rome, the opera treats of the life of Cola di Rienzi, a medieval populist who outwits the nobles and raises the power of the people. In turn, he crushes the nobles' rebellion against the people, but popular opinion changes and even the Church, which had urged him to action, turns against him. In the end the people burn down the Capitol in which Rienzi and his adherents had made a last stand.

158. Set Design for the Town Square, 1921-23

Newspaper print, watercolour and whitening on paper on cardboard

15 x 15

Bakhrushin State Central Theatre Museum, Moscow

Inv. No. KP 197302/3. Formerly DG-1789

Note: Originally, Yakulov designed this and analogous sets for an intended production of Vladimir Maiakovsky's *Mystery-Bouffe*, which Meierkhold entertained at his Theatre of the RSFSR in 1920. However, the production was cancelled and Yakulov then adusted his designs to the 1921–23 productions of *Rienzi*. Indeed, a distinctive aspect of Yakulov's theatrical activity was his scenic flexibility and ready ability to approach both old and new repertoires in a fresh and experimental manner. His sets and costumes for *Measure for Measure* (1919) and *Oedipus* (1921), both at the Moscow State Model Theatre, for the projected production of *Hamlet* at the RSFSR Theatre No. 1 in 1920 and for *Rienzi*, demonstrate a clear understanding of the principles of classical drama, while providing a new 'urban' interpretation.

ZDANEVICH, Kirill Mikhailovich

Born 9 (21) July, 1892, Tiflis, Georgia; died 1 September, 1969, Tbilisi, Georgia.

Older brother of Ilia (Iliazd), avant-garde poet and artist; 1902 attended a local art school in Tiflis; ca. 1910 studied in Moscow; 1912 met the Georgian primitive painter Niko Pirosmanashvili; close to Natalia Goncharova and Mikhail Larionov, contributing to their 'Donkey's Tail' exhibition; 1913 signed the Rayonists and Futurists manifesto and contributed to the 'Target' (together with Goncharova, Larionov, Kazimir Malevich and radical); studied in Paris where he soon gained a reputation as an accomplished Cubist painter; made the acquaintance of Alexander Archipenko and Serge Charchoune; 1914 mobilized; 1917–19 with Ilia Zdanevich, Alexei Kruchenykh and Igor Terentiev organized the Futurist group known as 41° in Tiflis; 1920 visited Paris; returned to Tiflis; 1920s onward continued to paint, design theatre productions and publish books and articles, particularly on Pirosmanashsvili.

Further reading:

B. Kerdimun: *Kirill Zdanevich and Cubo-Futurism.* Catalogue of exhibition at Rachel Adler Gallery, New York, 1987.

O. Voltsenburg et al., eds.: *Khudozhniki narodov SSSR. Biobibliograficheskii slovar v shesti tomakh,* M: Iskusstvo, 1983, Vol. 4, Book 1, pp. 274–75.

T. Sanikidze: *Kirill Zdanevich. Ilia Zdanevich*. Catalogue of exhibition at the State Museum of Arts of the Georgian SSR, Tbilisi, 1989.

I. Arsenishvili: *Zdanevich*. Catalogue of exhibition at the National Museum of Georgia, Tbilisi, 2009.

The diaspora that followed in the wake the Revolution led Russian artists and writers to converge in the most unlikely places as they sought refuge from the Bolsheviks dominant in Petrograd and Moscow. One such bohemian center was the 'fantastic city'[164] of Tiflis (renamed Tbilisi in 1936), capital of Georgia and of what in May, 1918, became the new Menshevik Republic of Georgia. It was here and not only in Berlin or Paris that the Russian avant-garde continued to develop iconoclastic ideas. Even though 'only the main streets are cleaned,'[165] Tiflis boasted an active and vociferous intellectual community *au courant* with the latest trends in European and Russian Modernism and had long attracted the Russian avant-garde: David Burliuk, Vasilii Kamensky, Nikolai Kulbin and Vladimir Maiakovsky had all lectured in Tiflis before World War I, Ilia Zdanevich, a native of Tiflis, published his manifesto 'What Is Futurism' there in 1914, and he and his brother propagated Neo-Primitivism, Cubo-Futurism and Everythingism, organized Kirill's one-man exhibition in 1917 and entertained Kruchenykh in their home for much of 1919.

By the beginning of 1917, in spite of war and civil malcontent, Tiflis had become an important laboratory for avant-garde activity: Kruchenykh arrived there in 1916 and Kirill Zdanevich returned from the front to publish, with Kruchenykh and Kamensky, the collection *1918* in which the latter reproduced his Futurist map of Tiflis. New little magazines sprang up and exhibitions opened, ranging from children's drawings to 'Paintings and Drawings by Moscow Futurists,' while Kruchenykh, Terentiev and Ilia Zdanevich even ran a so-called 'Futurvseuch-bishche' (a neologism that might be translated as 'Futurist University'). Radical poetry and painting flourished thanks especially to the talent of Kruchenykh who in January, 1918, organized the First Evening of Transrational Poetry and who served as a primary stimulus to the group called 41º and the single issue of its magazine (July, 1919).

Unidentified production, ca. 1919.

159. Design for a Backcloth, ca. 1919

Blue pencil and Indian ink on paper on paper

19 x 25.7

Bakhrushin State Central Theatre Museum,
Moscow

Inv. No. KP 182794

Note: One of the most important cultural phenomena in Tiflis in the late 1910s was the opening in November, 1917, of the bohemian cabaret called the Fantastic Tavern which witnessed many Dada events during its brief existence of less than two years. Tempered by the 'ironic wisdom' of the poet Yurii Degen,[166] the Fantastic Tavern became a meeting-place for poets, painters, composers, actors and critics who aspired to maintain the momentum of the St. Petersburg and Moscow bohemia. Together with Lado Gudiashvili, David Kakabadze, Sergei Sudeikin, Iraklii Gamrekeli, Ilia Zdanevich and others, Kirill Zdanevich contributed designs to a number of avant-garde productions at the 41o Theatre and the Fantastic Tavern. Unfortunately, it is not known for which spectacle Zdanevich designed this piece.[167]

Bibliography

The titles below are a representative selection only. For a comprehensive bibliography of modern Russian stage design see J. Bowlt, N. Lobanov-Rostovsky, N.D. Lobanov Rostovsky and O. Shaumyan: *Masterpieces of Russian Stage Design 1880–1930*, Ipswich, UK: Antique Collectors' Club, 2012, Vol. 1, especially pp. 318–22, 334–46, 350–64.

L. Zheverzheev (intro.): *Opis vystavlennykh v polzu lazarety shkoly narodnogo iskusstva ee Velichestva Gosudaryni Imperatritsy Alexandry Fedorovny pamiatnikov Russkogo teatra iz sobraniia L.I. Zheverzheeva*, P: Shmid, 1915

O. Sayler: *The Russian Theater under the Revolution*, Boston: Little, Brown, 1920

H. Carter: *The New Theatre and Cinema in Soviet Russia*, New York: Chapman and Dodd, 1924

E. Gollerbakh, ed.: *Teatralno-dekoratsionnoe iskusstvo v SSSR 1917–1927*, L: Komitet vystavki teatralno-dekoratsionnogo iskusstva, 1927

J. Gregor and R. Fülöp-Miller: *Das Russische Theater*, Vienna: Amalthea, 1927. English translation: *The Russian Theatre*, London: Harrap, 1930; American edition: New York: Blom, 1968; Spanish translation: *El teatro ruso*, Barcelona: Gili, 1931

W. Fuerst and S. Hume: *Twentieth-Century Stage Decoration*, New York: Knopf, 1929

H. Carter: *The New Spirit in the Russian Theatre, 1917–1928*, London: Brentano's, 1929

L. Moussinac: *Tendances nouvelles du théâtre*, Paris: Lévy, 1931

S. Margolin: *Khudozhniki teatra za 15 let*, M: Ogiz, 1933

A. Efros: *Kamernyi teatr i ego khudozhniki 1914–1934*, M: VTO, 1934

H. Rischbieter: *Art and the Stage in the 20th Century*, New York: New York Graphic, 1968

A. Yufit et al., eds.: *Sovetskii teatr. Dokumenty i materialy 1917–1967*, L: Iskusstvo, 1968–84 (four volumes): Vol. 1: *Russkii sovetskii teatr 1917–1921*, 1968; Vol. 2, *Teatr narodov SSSR 1917–1921*, 1972; Vol. 3, *Russkii sovetskii teatr 1921–1926*, 1975; Vol. 4, *Russkii sovetskii teatr 1926–1932*, 1982

N. Sokolova, ed.: *Khudozhniki teatra*, M: Sovetskii khudozhnik, 1969

M. Pozharskaia: *Russkoe teatralno-dekoratsionnoe iskusstvo kontsa XIX nachala XX veka*, M: Iskusstvo, 1970

A. Shifrina and N. Yasulovich: *Muzei imeni Bakhrushina*, M: Sovetskii khudozhnik, 1972

F. Syrkina, comp.: *Khudozhniki teatra o svoem tvorchestve*, M: Sovetskii khudozhnik, 1973

M. Davydova: *Ocherki istorii russkogo teatralno-dekoratsionnogo iskusstva XVIII-nachala XX v.*, M: Nauka, 1974

D. Bablet: *Esthètique générale du décor de théâtre de 1870 à 1914*, Paris: Centre National de la Recherche Scientifique, 1975

D. Oenslager: *Stage Design. Four Centuries of Scenic Invention*, New York: Viking, 1975

J. Bowlt: *Stage Designs and the Russian Avant-Garde (1911–1929). A Loan Exhibition of Stage and Costume Designs from the Collection of Mr. and Mrs. Nikita Lobanov-Rostovsky*, circulated by the International Exhibitions Foundation. Washington, D.C., 1976–78

F. Syrkina and E. Kostina: *Russkoe teatralno-dekoratsionnoe iskusstvo*, M: Iskusstvo, 1978

J. Bowlt, ed.: *Twentieth Century Russian Stage Design*. Special issue of *Russian History*, Tempe, 1981, Vol. 8, parts 1–2

I. Verikivska: *Stanovlennia ukrainskoi radianskoi stsenografii*, K: Naukova dumka, 1981

E. Pankratova: *Russkoe teatralno-dekoratsionnoe iskusstvo kontsa XIX-nachala XX veka*, L: Leningradskii gosudarstvennyi institut teatra, muzyki i kinematografii, 1983

R. Vlasova: *Russkoe teatralno-dekoratsionnoe iskusstvo nachala XX veka*, L: Khudozhnik RSFSR, 1984

D. Bablet et al.: *Die Maler und das Theater im 20. Jahrhundert*. Catalogue of exhibition at the Junsthalle, Frankfurt, 1986

A. Schouvaloff: *The Theatre Museum*, London: Scala, 1987

K. Rudnitsky: *Russian and Soviet Theater 1905–1932*, New York: Abrams, 1988

F. Ciofi degli Atti and D. Ferretti: *Russia 1900–1930: l'arte della scena*. Catalogue of exhibition at the Ca' Pesaro, Venice, 1990

N. Van Norman Baer: *Theatre in Revolution. Russian Avant-Garde Stage Design 1913–1935*, San Francisco: California Palace of the Legion of Honor, and other institutions, 1991–92

V. Berezkin: *Istoriia stsenografii mirovogo teatra*, M: Gosudarstvennyi Institut iskusstvoznaniia, 1995

A. Mikhailova: *Meierkhold i khudozhniki*, M: Galart, 1995

V. Ivanov, ed.: *Mnemozina*, M, 1997–2009 (four issues)

N. Meteliza et al.: *Polifonia. Da Malevic a Tat'jana Bruni 1910–1930*. Catalogue of exhibition at the Padiglione d'Arte Contemporanea, Milan, 1998

E. Strutinskaia: *Iskaniia khudozhnikov teatra. Peterburg-Petrograd-Leningrad, 1910–1920 gg.*, M: GII, 1998

N. Makerova: *Istoriia otechestvennogo teatralno-dekoratsionnogo iskusstva*, M: RGGU, 1999

M. Davydova: *Khudozhnik v teatre nachala XX veka*, M: Nauka, 1999

J. Bonet et al.: *El teatro de los pintores en la Europa de las vanguardias*. Catalogue of exhibition at the Museo National Centro de Arte Reina Sofia, Madrid, 2000

G. Kovalenko: *Russkii avangard 1910-kh-1920-kh godov i teatr*, SP: Bulanin, 2000

M. Konecny: *The Bestiary of the Russian Cabaret: Flying Mice and Blue Birds, Black Cats and Stray Dogs. Designs and Documents from the Institute of Modern Russian Culture and Other Collection.* Catalogue of exhibition at the Doheny Library, University of Southern California, Los Angeles, 2002

A. Rosenfeld: *A World of Stage Design for Theater, Opera and Dance (from the George Riabov Collection of Russian Art).* Catalogue of exhibition at the Jane Voorhees Zimmerli Art Museum, New Brunswick, 2004

Yu. Love et al.: *Pamiatniki russkogo teatralnogo avangarda* at Elizium Gallery, M, 2006

I. Duksina and T. Klim: *Obrazy russkogo teatra v kollektsii Valentina Solianikova,* M: SSV, 2006

T. Goriaeva et al.: *Artists of the Theater and Cinema. Paintings and Photographs from the Russian State Archive of Literature and Art.* Catalogue of exhibition at the Russian State Archive of Literature and Art, M, 2006

N. Misler: *Vnachale bylo telo. Ritmoplasticheskie eksperimenty nachala XX veka,* M: Iskusstvo XXI vek, 2011

V. Berezkin: *Iskusstvo stsenografii mirovogo teatra: Teatr khudozhnika. Ot istokov do serediny XX veka,* M: LKI, Krasand, and KomKniga 2011–12

J. Bowlt, N. Lobanov-Rostovsky, N.D. Lobanov-Rostovsky and O. Shaumyan: *Masterpieces of Russian Stage Design 1880–1930,* and J. Bowlt, N. Lobanov-Rostovsky and N.D. Lobanov-Rostovsky: *Encyclopedia of Russian Stage Deisgn 1880–1930,* Ipswich, UK: Antique Collectors' Club, 2012 and 2013 (two volumes)

Artists' Biographies and Context Endnotes

1. See Meierkhold's untitled article in the collection of articles edited by S. Makovsky et al.: *Kuda my idem*, M: Zaria, 1910, pp. 104–05.

2. The term 'blue blouse' is a reference to the blue coveralls worn by industrial workers.

3. For information on Nikita Baliev and the Bat see L. Senelick: 'Nikita Baliev's Le Théâtre de la Chauve-Souris: An Avant-Garde Theater' in *Dance Research Journal,* Edinburgh, 1986–87, Winter, Vol. 18, No. 2 (Russian Folklore Abroad), p. 17–29; and M. Konecny, ed.: *An Intimate Gathering: Russian Cabaret at Home and Abroad.* Special issue of the journal *Experiment*, Los Angeles, 2006, No.12.

4. O. Brik: "Siniaia bluza' i Moselprom' in *Siniaia bluza*, M, 1928, No. 4, p. 55. Quoted in E. Uvarova, ed.: *Russkaia sovetskaia estrada*, Vol. 1: 1917–29, M: Iskusstvo, 1976, p. 330.

5. Uvarova: *Russkaia sovetskaia estrada*, Vol. 1, p. 338.

6. I would like to thank Irina Duksina for supplying the biographical information on Anzimirova.

7. I. Solertinsky: Untitled essay in the program *Bolt. Balet v 3-kh deistviiakh,* M: Nauka, 1976, p. 40.

8. Information supplied by Tatiana Drozd in letters to John E. Bowlt dated 30 November, 1984 and 15 February, 1985.

9. Article in *Pravda*, M, 28 January, 1936. Quoted in B. Schwarz: *Music and Musical Life in Soviet Russia 1917–1970,* New York: Norton, 1972, p. 123.

10. S. Volkov, ed.: *Testimony. The Memoirs of Dmitri Shostakovich,* New York: Harper and Row, 1979, p. 85.

11. See Schwarz, *Music and Musical Life in Soviet Russia 1917–1970*, p. 75.

12. Z. Stepanov: *Kulturnaia zhizn Leningrada 20-ykh – nachala 30-ykh godov,* L: Nauka, 1976, p. 40.

13. Binevich: 'Tatiana Bruni,' p. 82.

14. Drozd: 'Roman ee zhizni,' p. 31.

15. Quoted in Elizarova, 'Tatiana Georgievna Bruni,' p. 99. For other information on Bruni's designs for *Bolt* see Levitin, *Tatiana Bruni*, pp., pp. 24–38.

16. O. Pokrovsky:'Trevogoi i plamenen'. Undated manuscript, private collection, p. 14.

17. For more information on the Collective of Masters of Analytical Art see Misler and Bowlt, *Pavel Filonov*, passim.

18. For information on Terentiev see T. Nikolskaia: 'Igor Terentiev v Tiflise' in L. Magarotto, M. Marzaduri, G. Pagani Cesa, eds.: *L'Avanguardia a Tiflis.* Venice: Università degli studi di

Venezia, 1982, pp. 189–209; also S. Kudriavtsev, ed.: *Terentievskii sbornik,* M: Gileia, 1996 (No. 1) and 1998 (No. 2).

19. Untitled note in the newspaper *Smena,* L, 1927, 6 April, p. 3.

20. 'Shkola Filonova' in *Krasnaia gazeta* (Evening Issue), L, 1927, 5 May, p. 5.

21. Filonov compiled a list of his students who worked at the Press House. See Misler and Bowlt, *Pavel Filonov,* p. 34.

22. B. Piotrovsky: 'Revizor v teatre Doma pechati' in *Krasnaia gazeta* (Evening Issue), 1927, 11 April, p. 4,

23. N. Zagorsky and A. Gvozdev: 'Revizor na Udelnoi' in *Zhizn iskusstva,* L, 1927, 19 April, p. 5.

24. For further information on *King Gaikin I* see 'Filonov v teatre' in *Krasnaia gazeta* (Evening Issue), 1929, 29 April, p. 13; and Misler and Bowlt, *Pavel Filonov,* p. 38.

25. Tretiakov, *V. Dmitriev,* p. 5.

26. *Ibid.,* p. 9.

27. F. Syrkina and E. Kostina: *Russkoe teatralno-dekoratsionnoe iskusstvo,* M: Iskusstvo, 1978, p. 154.

28. A. Borovsky: 'Leonid Chupiatov' in Kurnikova, *Rakurs Chupiatova,* p. 30.

29. L. Chupiatov: 'Put podlinnogo realizma v zhivopisi' (1926). Quoted in Kurnikova, *Rakurs Chupiatova,* p. 60.

30. Yutkevich: *Sergei Eizenshtein. Izbrannye proizvedeniia v shesti tomakh,* Vol. 1 (1964), p. 95.

31. Sidorov: 'Boris Erdman, khudozhnik kostiuma,' p. 4.

32. K. Rudnitsky: *Russian and Soviet Theater 1905–1932,* New York: Abrams, 1988, p. 97.

33. V. Parnakh: 'Novoe ekstsentricheskoe iskusstvo' in *Zrelishcha,* M, 1922, No. 1, p. 5.

34. A. Lunacharsky: 'Zadacha obnovlennogo teatra' in *Vestnik teatra,* M, 1919, No. 3. Quoted in K. Valts: *65 let v teatre,* L: Akademiia, 1928, p. 26.

35. See, for example, his article 'Nepovtorimoe vremia' in *Tsirk i estrada,* M, 1928, No. 3–4, pp. 6–7.

36. See his article 'V poiskakh 'trekhmernoi' dekoratsii' in *Vestnik teatra,* M, 1920, No. 50, pp. 7–8.

37. Ya. Tugendkhold: 'Pismo iz Moskvy' in *Apollon,* P, 1917, No. 1, p. 72. Exter also contributed five tipped-in tone plates to a special, limited edition of *Thamira Khytharedes* in 1919 (I. Annensky: *Famira Kifared,* SP: Grzhebin, 1919).

38. J. Rouché: *L 'Art théâtral moderne,* Paris: Blond et Gay, 1923, p. 70.

39. See N. Van Norman Baer: *Bronislava Nijinska. A Dancer's Legacy.* Catalogue of exhibition at the Cooper-Hewitt Museum, New York; and Palace of the Legion of Honor, San Francisco, 1986–87, passim.

40. N. Giliarovskaia: *Teatralno-dekoratsionnoe iskusstvo za 5 let.* Catalogue of exhibition at the Museum of Decorative Painting, Moscow, 1924 (catalogue published in Kazan, 1924), p. 29.

41. Quoted in O. Voronova: *V.I. Mukhina.* M: Iskusstvo, 1976, p. 43.

42. K. Derzhavin: *Kniga o Kamernom teatre,* L: Khudozhestvennaia literatura, 1934, p. 68.

43. J. Gregor and R. Fülöp-Miller: *Das Russische Theater,* Vienna: Amalthea, 1927, plate 197.

44. V. Rakitin: 'Marsiane A. Exter' in *Dekorativnoe iskusstvo,* M, 1977, No. 4, p. 29.

45. Tugendkhold: 'Pismo iz Moskvy.', op. cit., p. 17.

46. N. Lvov: 'Analiticheskii teatr' in *Vestnik iskusstva,* M, 1922, No. 2, p. 6. Quoted in Ivanov, 'Bunt marginala. Analiticheskii teatr Borisa Ferdinandova', p. 219.

47. P. Galadzhev: 'K tebe – khudozhnik kino'. Quoted in Isaeva, *Petr Stepanovich Galadzhev*, unpaginated.

48. I. Gamrekeli: [Memoirs], undated. Quoted in Gudiashvili, *Gamrekeli*, p. 8. For information on Mardzhanov see D. Kantadze: *Riadom s Mardzhanishvili*, M: VTO, 1975; L. Pizzini: 'Creativitá e fantasia di un regista russo K.A. Mardzanov' in *Il Cristallo*, Bolzano, 1996, Vol. 38, No. 1, pp. 101–12.

49. E. Tsitsishvili: *Dizainovoe proektirovanie v Gruzii*, Tbilisi: Khelovneba, 1985, pp. 27–28.

50. Anon.: 'Teatr im. Meierkholda' (1928). Quoted in Mikhailova et al., *Meierkhold i khudozhniki*, p. 150.

51. A. Fevralsky: 'Iz proshlogo pervomaiskikh spektaklei' in *Rabochii i iskusstvo*, M, 1930, 30 April. Quoted in Mikhailova et al., *Meierkhold i khudozhniki*, p. 150.

52. A. Levinson: "Misteriia-buff' Maiakovskogo' in *Zhizn iskusstva*, M, 1918, 11 November. Quoted in K. Rudnitsky: *Meyerhold The Director*, Ann Arbor: Ardis, 1981, p. 257. One of Malevich's designs for *Mystery-Bouffe* is reproduced in *Novyi zritel*, M, 1927, 7 November, p. 6.

53. See Ilinsky's memoirs in P. Markov: *Kniga vospominanii*, M: Iskusstvo, 1983, pp. 195–98.

54. E. Beskin: 'Revoliutsiia i teatr' in *Vestnik rabotnikov iskusstv*, M, 1921, No. 7–9, p. 31.

55. S. Glagolin: 'Vesna teatralnoi chrezmernosti' in *Vestnik rabotnikov iskusstv*, M, 1921, No. 11–12, p. 122. Quoted in Rudnitsky, *Meyerhold The Director*, p. 278.

56. N. Tarabukin. Quoted in ibid., p. 274.

57. V. Blium: 'Teatr RSFSR Pervyi. 'Misteriia-Buff'' in *Vestnik teatra*, M, 1921, No. 91–92, p. 10. Quoted in Yufit et al., *Sovetskii teatr. Dokumenty i materialy 1917–1967*, Vol. 1, p. 154.

58. For the reproduction of one of Altman's designs for this see M. Etkind: *Natan Altman*, M: Sovetskii khudozhnik, 1972, p. 125. The same design is attributed to Samokhvalov in Gregor and Fülöp-Miller, *Das Russische Theater*, plate 278.

59. For further information on the 1921 production of *Mystery-Bouffe* see Yufit, *Sovetskii teatr. Dokumenty i materialy 1917–1967*, Vol. 1, pp. 141–159; and Rudnitsky, *Meyerhold The Director*, pp. 273–81.

60. Gorbachev: *Olexandr Khvostenko-Khvostov*, p. 9

61. For a reproduction of a set for *Die Walkürie* see I. Ciszkewycz et al.: *The Berezil Theatre*. Catalogue of exhibition organized by the Organization of Modern Ukrainian Artists, New York, 1980, unpaginated.

62. I. Ciszkewycz: 'The Berezil Theatrical Association and Its Revolutionary Makeup,' ibid., unpaginated.

63. Such is the inscription on one of the *Dynamic Cities* reproduced, for example, in C. Leclanche-Boule: *Typographies, Photomontages Constructivistes*, Paris: Papyrus, 1984, p. 6.

64. V. Komardenkov: *Dni minuvshie*, M: Sovetskii khudozhnik, 1973, p. 66.

65. *Ibid.*, p. 7.

66. Quoted in Mudrak, *Borys Kosarev*, p. 29.

67. Quoted in Murina and Dzhafarova, *Aristarkh Lentulov*, p. 131.

68. M. Levin: 'Izobrazitelnaia rezhissura' in *Teatr i dramaturgiia*, M, 1935, No. 10. Reprinted with cuts in *M. Levin* (1980), pp. 5–9. This excerpt from p. 7.

69. I. Erenburg: *A vse-taki ona vertitsia*, Berlin: Gelikon, 1922, p. 85.

70. See Lissitzky's article: 'Kniga s tochki zreniia zritelnogo vospriiatiia – vizualnaia kniga' in *Iskusstvo knigi*, M, 1962, No. 3, pp. 164–68.

71. A photograph of Kruchenykh holding the Lissitzky portfolio is reproduced in M. Marzaduri, comp.: *Igor Terentiev. Sobranie sochinenii,* Bologna: S. Francesco, 1988, between pp. 416 and 417.

72. From Lissitzky's foreword to the portfolio *Die Plastische Gestaltung der Elektromechanischen Schau 'Sieg über die Sonne,'* Hanover: Leunis and Chapman, 1923. Translation in Lissitzky-Küppers, *El Lissitzky,* p. 352.

73. Mansbach, *Visions of Totality,* p. 25.

74. L. Lisitsky: 'Novaia kultura' in *Shkola i revoliutsiia,* Vitebsk, 1919, No. 23, p. 11. For an English translation see P. Nisbet: 'El Lissitzky: The New Culture' in *Experiment,* Los Angeles, 1995, No. 1, pp. 257–84.

75. The entire set of the figures, except for the wrapper, is reproduced in Richter, *El Lissitzky,* unpaginated; part of the set is reproduced in colour in Lissitzky-Küppers, *El Lissitzky,* plates 52–62. For detailed commentary on the folio see Milner, *Lissitzky-Overwinning op de Zon/Lissitzky-Victory over the Sun.*

76. K. Malevich: 'Autobiography' (1923) in *Malewitsch,* pp. 16–17.

77. For additional information on the decorations for *Victory over the Sun* see M. Etkind: "Soiuz molodezhi' i ego stsenograficheskie experimenty' in A. Vasiliev et al., eds.: *Sovetskie khudozhniki teatra i kino,* M: Sovetskii khudozhnik, 1981, pp. 258–59.

78. Letter from Kazimir Malevich to Alexei Kruchenykh dated 27 May, 1915. Quoted in N. Khardzhiev: *K istorii russkogo avangarda,* Stockholm: Almqvist and Wiksell, 1976, p. 95.

79. Kucherenko: *Vadim Meller,* p. 39.

80. Quoted in Voronova, *V.I. Mukhina,* p. 42.

81. B. Ternovets: *V.I. Mukhina,* M-L: Ogiz, 1937, p. 24.

82. Dokuchaeva, *I. Nivinsky,* p. 40.

83. Vera Dokuchaeva writing on *La Dama Duende* in Dokuchaeva, p. 206.

84. From a conversation between Nivinsky and Vakhtangov. Quoted in Dokuchaeva, p. 94.

85. *Ibid.,* p. 194.

86. N. Romanov: 'Zadachi Nivinskogo v grafike' in *Oforty Ign. Nivinskogo,* p. 14.

87. Quoted in Dokuchaeva, p. 194.

88. A. Petritsky: 'Oformleniia stseni suchasnogo teatru' in *Nova generatsiia,* Kharkov, 1930, No. 1, pp. 41, 42.

89. D. Gorbachev: *Problema traditsii i novatorstva v tvorchestve A. G. Petritskogo,* K: Academy of Sciences of the Ukrainian SSR, 1970, p. 10. This is the typewritten summary of Gorbachev's *kandidat* dissertation for the Rylsky Institute of Art History, Folklore and Ethnography, Kiev.

90. See 'Khronika' in *Zrelishcha,* M, 1923, No. 50–52, p. 11.

91. A notice in *Teatr i muzyka,* M, 1923, No. 35, p. 1119, indicates that Mordkin was leaving for the USA at the end of October, 1923, but, in fact, he delayed his trip for one year.

92. E. Kuzmin on Petritsky's designs for *Nur and Anitra.* Quoted in Gorbachev, *Anatolii Galaktionovich Petritsky,* p. 38.

93. For the reproduction of one of the designs in the private collection in Kiev (a *Warrior*) see *Mistetska tribuna,* K, 1974, December, p. 164.

94. Petritsky: 'Oformleniia stseni suchasnogo teatru', op. cit., p. 42.

95. V. Dulenko: 'Maister baletnogo kostiuma' in Horbachov et al., *Anatolii Petritsky. Sporadi pro khudozhnika*, pp. 44–45. Dulenko recalls that Petritsky designed five costumes for *Medora*. This piece would seem to be for Scene 2.

96. This according to Gorbachev, *Anatolii Galaktionovich Petritsky*, p. 66.

97. For a detailed discussion of Meierkhold's production of *The Magnimous cuckold*, see A. Law: '*Le Cocu magnifique* de Crommelynck' in D. Bablet, ed.: *Les Voies de la Créâtion Théâtrale. Mises en scène anneés 20 et 30,* Paris: Centre National de la recherche scientifique, 1980, Vol. 7, pp. 14–43.

98. From Popova's lecture on her set for *The Magnanimous Cuckold* which she delivered at Inkhuk on 27 April 1922. Quoted in E. Rakitina: 'Liubov Popova. Iskusstvo i manifesty' in E. Rakitina, comp.: *Khudozhnik. Stsena. Ekran*, M: Sovetskii khudozhnik, 1975, Vol. 1, p. 154.

99. V. Marquardt, ed.: *Survivor from a Dead Age. The Memoirs of Louis Lozowick,* Washington, D.C.: Smithsonian, 1997, p. 246.

100. Popova was the subject of the most varied evaluations in the early 1920s. On the one hand, she was nicknamed (benevolently) the 'mother of scenic Constructivism' (Anon.: ('Samoe predstavlenie 'Velikogo rogonostsa'' in *Zrelishcha*, M, 1923, No. 67, p. 8); on the other, people wondered whether her designs were 'charlatanism or stupidity' (P. Krasikov: 'Sharlatanstvo ili glupost' in *Rabochaia Moskva*, M, 1922, No. 16).

101. Undated Letter from Rabinovich to Shifrin in RGALI, Call number: f. 2422, op. 1, ed. khr. 314, l. 5.

102. E. Gollerbakh, ed.: *Teatralno-dekoratsionnoe iskusstvo v SSSR 1917–1927*, L: Komitet vystavki teatralno-dekoratsionnogo iskusstva, 1927, p. 220.

103. Syrkina, *Rabinovich*, p. 30.

104. Yufit, *Sovetskii teatr. Dokumenty i materialy 1917–1967*, Vol. 2, p. 134.

105. *Ibid.*

106. Margolin, *Khudozhniki teatra za 15 let*, p. 111.

107. See A. Lavrentiev: *Alexei Gan*, M: Russkii avangard, 2010, pp. 58–59.

108. J. Bowlt: *Russian Art of the Avant-Garde. Theory and Criticism 1902–1934*, New York: Viking, 1988, pp. 218–25.

109. The Kukryniksy is the composite abbreviation of three names – Mikhail Vasilievich Kupriianov (1903–91), Porfirii Nikitich Krylov (1902–91), and Nikolai Alexandrovich Sokolov (1903–2001). This three-man team, best known for its political caricatures and cartoons, designed the first four scenes of *The Bed Bug*, while Rodchenko designed the last five scenes – the so-called utopian part.

110. Maiakovsky on *The Bed Bug*. Quoted in Ch. Zalilova, ed.: *V.V. Maiakovsky. Sochineniia v trekh tomakh,* M: Khudozhestvennaia literatura, 1970, Vol. 3, p. 571.

111. E. Braun, trans. and ed.: *Meyerhold on Theatre*, New York: Hill and Wang, 1969, p. 236.

112. Quoted in K. Rudnitsky: *Rezhisser Meierkhold*, M: Nauka, 1969, p. 404.

113. *Ibid.*

114. The photographs of Rodchenko wearing his overall, taken by Stepanova, have been reproduced many times. See, for example, the frontispiece to Karginov, *Rodcsenko*. For information on the principles of *prozodezhda* as formulated by Liubov Popova and Varvara Stepanova, see C. Lodder: *Russian Constructivism*, New Haven: Yale University, 1983, passim.

115. V. Stepanova: 'Occasional Notes' in A. Gmurzynska et al.: *Von der Malerei zum Design/From Painting to Design.* Catalogue of exhibition at the Galerie Gmurzynska, Cologne, 1981, p. 139.
116. A. Sarabianov and N. Gurianova: *Neizvestnyi avangard,* M: Sovetskii khudozhnik, 1992, p. 305.
117. M. Etkind: "Soiuz molodezh' i ego stsenograficheskie eksperimenty' in *Sovetskie khudozhniki teatra i kino ' 78,* M, 1981, No. 3, p. 157.
118. A. Mgrebrov: *Vospominaniia* (1932). Quoted in V. Katanian: *Maiakovsky. Literaturnaia khronika,* M: Gosudarstvennoe izdatelstvo khudozhestvennoi literatury, 1961, pp. 53–54.
119. A. Rodchenko: 'Sistema Rodchenko,' in catalogue of 'X Gosudarstvennaia vystavka 'Bespredmetnoe tvorchestvo i suprematizm" M, 1919. English translation in Bowlt, *Russian Art of the Avant-Garde. Theory and Criticism 1902–1934,* pp. 148–51.
120. P. Florensky: 'Nebesnye znameniia' in *Makovets,* M, 1922, No. 2, p. 15.
121. A. Lunacharsky: 'K desiatiletiiu Kamernogo teatra' in *Iskusstvo trudiashchimsia,* M, 1924, No. 4–5, p. 5.
122. P. Markov: 'Liubov pod viazami' in *Pravda,* M, 1926, 19 November. Quoted in P. Markov, ed.: *A. Ya. Tairov. Zapiski rezhissera. Stati, besedy, rechi, pisma,* M: VTO, 1970, p. 517.
123. See, for example, their article 'Kakim dolzhno byt nashe teaoformlenie' in *Brigada khudozhnikov,* M, 1931, No. 7, p. 14.
124. V. Stepanova: 'Bespredmetnoe tvorchestvo' in catalogue of 'X Gosudarstvennaia vystavka 'Bespredmetnoe tvorchestvo i suprematizm','' M, 1919. English translation in Bowlt, ed.: *Russian Art of the Avant-Garde. Theory and Criticism 1902–1934,* pp. 141–42.
125. Statement by V. Stepanova. Quoted in T. Strizhenova: *Iz istorii sovetskogo kostiuma,* M: Sovetskii khudozhnik, 1972, p. 97.
126. Fevralsky, *V. E. Meierkhold. Stati, pisma, rechi, besedy,* Vol. 2, p. 79.
127. A. Ivanov: 'Teatralnyi kostium' in Yanov, *Teatralnaia dekoratsiia,* p. 157.
128. V. Bezard: 'Meierkhold i russkii teatr' in *Zrelishcha,* M, 1922, No. 15, 5–11 December, p. 9.
129. See S. Margolin: 'Balagannoe predstavlenie' in *Teatr i muzyka,* M, 1922, No. 11, 12 December, p. 231. The poet and critic Sergei Bobrov was especially negative in his appraisal of Stepanova's designs, referring to the 'murder of Tarelkin.' See S. Bobrov: 'V poriadke ideologicheskoi borby… Istoriia ubiistva Tarelkina' in *Zrelishcha,* 1922–23, No. 18, 26–31 December/1–2 January, p. 10.
130. [A. Gan]: 'Beseda s V.F. Stepanovoi' in ibid., No. 16, 12–18 December, pp. 11–12.
131. A. Law: 'The Death of Tarelkin' in J. Bowlt, ed.: *Twentieth Century Russian Stage Design.* Special issue of *Russian History,* Tempe, 1981, Vol. 8, parts 1–2, p. 145.
132. From a letter from Alexander Vesnin to his brother Leonid dated January, 1915. Quoted in A. Chiniakov: *Bratia Vesniny,* M: Stroiizdat, 1970, p. 38.
133. V. Tatlin, T. Shapiro, I. Meerzon and P. Vinogradov: 'Nasha predstoiashchaia rabota' (1920). From the translation in Anderson, *Vladimir Tatlin,* p. 51.
134. Zhadova, *V.E. Tatlin,* p. 8.
135. Appointed director of the Tretiakov Gallery in 1912, Igor Grabar embarked on an ambitious programme of reforms, something that incurred the wrath of many conservatives. One result was a heated debate and exchange of letters on the aims and intentions of Grabar. Many young artists encouraged Grabar, and, on 4 February, 1916, they published a joint declaration

under the title 'Zaiavlenie khudozhnikov i deiatelei iskusstva' in the Moscow newspaper *Russkie vedomosti* in order to demonstrate support. Among the co-signatories was Tatlin.

136. Tatlin in his lecture 'Doloi tatlinizm' in Petrograd, 1922. Quoted in K. Miklashevsky: *Gipertrofiia iskusstva*, P: Academia, 1924, p. 60.

137. This is the title of one of Tatlin's articles, i.e., 'Problema sootnosheniia cheloveka i veshchi' in *Rabis*, M, 1930, No. 15, p. 9.

138. See A. Zhurin: 'Poeziia balagana' in *Studiia*, M, 1911, 16 October, No. 3, pp. 8–10. For further commentary see M. Konecny: 'Flying Mice, Stray Dogs and Blue Birds: Russian Intimate Theatre» in this catalogue.

139. 'Khronika' in *Studiia*, M, 1911, No. 4, p. 27.

140. Max-li: 'Tragicheskii balagan' in *Studiia*, 1912, 5 November, No. 6, p. 7.

141. Strigalev and Harten: *Vladimir Tatlin. Retrospektive*, p. 31.

142. This was Tatlin's slogan in 1913. In 1920 he replaced it by 'Via the exposure of material towards the new object.' Both slogans appear on the last page (unnumbered) of N. Punin: *Tatlin (Protiv kubizma)*, P: IZO NKP, 1921.

143. Untitled statement by Telingater. Quoted in Gerchuk, 'S.B. Telingater', pp. 144–45, where neither source, nor date are given.

144. S. Telingater et al.: 'Oktiabr. Obedinenie khudozhestvennogo truda. Deklaratsiia' (1928). Translation in Bowlt, *Russian Art of the Avant-Garde. Theory and Criticism 1902–1934*, pp. 274–75.

145. For a list of relevant designs see Molok, *Solomon Benediktovich Telingater*, unpaginated.

146. See Telingater et al., 'Oktiabr.' in Bowlt, *Russian Art of the Avant-Garde. Theory and Criticism 1902–1934*, p. 277.

147. Trotsky's book was not, of course, published in the Soviet Union, but an English translation, introduced by Max Eastman, appeared in New York (Harcourt, Brace and Co.) in 1928 as *The Real Situation in Russia*.

148. For the reproduction of another agit-lorry called *Trotsky in the Chariot of World Imperialism* see V. Tolstoi, ed.: *1917–1932. Agitatsionno-massovoe iskusstvo. Oformlenie prazdnestv*, M: Iskusstvo, 1984, Vol. 2, No. 299.

149. Adolphe Appia. Quoted in D. Oenslager: *Stage Design. Four Centuries of Scenic Invention*, New York: Viking, 1975, p. 185, where original source is not given.

150. Markov, *A. Ya. Tairov. Zapiski rezhissera. Stati, besedy, rechi, pisma*, p. 207.

151. Rudnitsky, *Rezhisser Meierkhold*, p. 441.

152. A. Koonen: *Stranitsy zhizni*, M: Iskusstvo, 1975, p. 273.

153. A. Efros: *Kamernyi teatr i ego khudozhniki 1914–1934*, M: VTO, 1934, p. XXXIV.

154. T. Durfee: 'Konstantin Alexanderovich Vialov 1900–1976' in *A Glimpse of Tomorrow*, p. 4

155. Quoted in M. Neumeister, ed.: *Raumkonzepte. Konstruktivistische Tendenzen in Bühnen- und Bildkunst 1910–1930*. Catalogue of exhibition at the Universität zu Köln, Cologne; and the Städtische Galerie, Frankfurt, 1986, p. 78, where the source is not given.

156. Yu. Annenkov: Untitled, undated note on Vasilii Kamensky in RGALI, f. 2618, op. 1, ed. khr. 14, l. 2.

157. Kostin, *OST*, p. 73.

158. From a conversation between Valerii Bebutov and a correspondent for the journal *Zrelishcha* (January, 1924). Quoted in Yufit, *Sovetskii teatr. Dokumenty i materialy 1917–1967*, Vol. 2,

p. 235. For information on the first production of Kamensky's *Stenka Razin* in Perm in 1920 (with designs by Alexander Kuprin) and this 1924 production see T. Gints: *Vasilii Kamensky*, Perm: Permskoe knizhnoe izdatelstvo, 1974, pp. 142–44.

159. Giliarovskaia, *Teatralno-dekoratsionnoe iskusstvo za 5 let*, p. 15.

160. *Ibid.*, p. 46.

161. *Ibid.*, p. 45.

162. Efros, *Kamernyi teatr i ego khudozhniki 1914–1934*, p. XXXVI.

163. A. Lunacharsky: 'Zhirofle-Zhirofla' in L. Okhitovich, ed.: *Kamernyi teatr. Stati, zametki, vospominaniia*, M: Khudozhestvennaia literatura, 1934, p. 36.

164. G. Robakidze in *1928*, No. 4, p. 71. Quoted in F. Le Gris-Bergmann: *Iliazd, Maître d'oeuvre du livre moderne*. Catalog of exhibition at the Galérie d'art de l'Université du Québec, Montreal, 1984, p. 11.

165. G. Moskvin: *Prakticheskii putevoditel po Kavkazu*, Odessa: Levinson, 1899, pp. 303–05, 333.

166. M. Marzaduri, *Dada Russo*, Bologna: Il cavaliere azzurro, 1984, p. 29.

167. For information on cultural life in Tiflis in the late 1900s see J. Bowlt, ed.: *The Salon Album of Vera Sudeikin-Stravinsky*, Princeton: Princeton University Press, 1995.